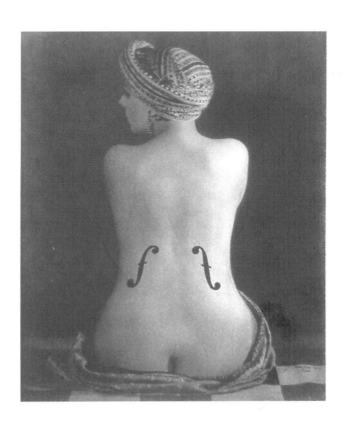

Published in 2004 by I.B. Tauris & Co. Ltd
6 Salem Road, London W2 4BU
175 Fifth Avenue, New York NY 10010
www.ibtauris.com

In the United States of America and in Canada distributed
by Palgrave Macmillan, a division of St Martin's Press,
175 Fifth Avenue, New York NY 10010

ISBN 1 86064 378 7 hb ISBN 1 86064 379 5 pb

A full CIP record for this book is available from the British
 Library
A full CIP record for this book is available from the Library
 of Congress
Library of Congress catalog card: available

Printed and bound in Great Britain by MPG Books, Bodmin
Set in Monotype Bembo and Futura Bold by Ewan Smith,
London 20 04003035

Contents

Acknowledgements

This book was written over several years without any special research leave. Nevertheless, or perhaps because of this, I should particularly like to thank Nick Morris at the Surrey Institute of Art and Design, for enabling crucial research trips to Paris and to Andy Golding, Paddy Scannell and Rosie Thomas at the University of Westminster for their subsequent help and support.

Friends and colleagues have helped in ways they were probably not even aware of: Kate Bush, Andy Darley, Peter Hall, Anne Cooper, Reina Lewis, Olivier Richon and many others who know who they are. My gratitude to Professor Griselda Pollock for her enthusiasm and valuable conversations, and to Bryony Fer, for reading earlier versions of Chapters 1, 4, 6 and 7. Also thanks to Adrian Rifkin for his scepticism and general knowledge of the period and who, along with Céline Surprenant, gave some early help with language and translation issues. Miriam Guitterez-Perez saved me some valuable time. Virginia Zabriskie gave encouragement, and thanks to Véronique Leroux-Hugon for her kind support at the Bibliothèque Charcot, Hôpital de la Sâlpetrière in Paris and to David Evans for the loan of some materials. Lastly and mostly I should like to thank Philippa Brewster at I.B. Tauris for her interest, patience and perspicacious support.

Preface

Why a book on photography and surrealism? Writing about photography and surrealism first began as the response to a practical issue. As a teacher of undergraduate photography students, 1920s and 1930s European photography was on the curriculum because it was a defining moment for twentieth-century photography. The radical experiments in photography by various avant-garde artist groups across Europe (in particular Germany, France and Russia) and the fluidity between them offered a world of different uses of photography and debates for students committed to a critical visual practice. Surrealism was obviously part of this.

From my own point of view, surrealism also offered a field of inquiry charged with my own interests: avant-garde culture, photography, Marxism and psychoanalytic theory. Of all the avant-gardes that used photography, none other was so clearly involved in attempting to reconceptualize what a cultural practice could be in relation to concepts of subjectivity and the social. (Although in early Soviet photography the debates were exciting, questions of subjectivity and the consequences of psychoanalytic theory were more or less suppressed, even before Stalin had finally implemented a state-governed 'socialist realism'.)

The materials then available to give students on photography and surrealism seemed inappropriate. They were either too difficult, too simple, ahistorical or actually missed the whole point of surrealism. Some were chronological descriptions, almost biographical and without any critical analysis, others were positivist without any politics or, elsewhere, were dominated by anecdotes about surrealists which, although interesting, had little relation to surrealist images. All these are still endlessly recycled. For me, such approaches were lacking in any theory of surrealism. On the other hand texts which discuss surrealism critically tended to do so in the terms of an existing discourse on art, literature, or film etc., rather than in the terms of surrealism's own disregard for disciplinary boundaries. In art history, for

example, surrealism is often collapsed as simply another artist movement solely described by its paintings and located in a chronological continuum – rarely is surrealism recognized as an interdisciplinary movement using different forms and modes of articulation that were resistant to such definitions. Surrealism tried to maintain its own discursive space, independent from other discourses upon which it nevertheless had to encounter and negotiate for its activities, literary culture, visual arts (publications, gallery spaces for exhibitions, cinema etc.), politics and so on. Yet surrealism is constantly studied as though it existed only within the terms of one (or other) of those discourses so that the study of surrealism as a whole is overly abstract, partial and fragmented. As a consequence, the aims, functions and purpose of surrealism remain obscure and hard to grasp. This is by no means simply a fault of writers, as these problems are the result of difficulties in surrealism as a topic, where even its very definition seems to become elusive and slippery as soon as it has been stated. Needless to say, the intention of this book, although framed by 'photography and surrealism', is to situate those terms within the larger culture of surrealist practice.

Understanding of surrealism is further compromised by the fact that a common-sense notion of surrealism as 'surreal', meaning something strange, bizarre or incomprehensible, is already a familiar term in everyday language. That notion of the *surreal* is doubly a problem in that it is itself an obstacle to understanding *historical* surrealism as a movement because that popular sense of 'surreal' itself is a non-explanation of an experience.

Such are the issues a teacher has to confront. How, then, to give an understanding of surrealism and an account of the ways in which photography was used within it? One solution was to research it more for myself. Sitting next to the historical problems in the curriculum were theoretical tools for tackling photography, a virtual tool kit: 'photography theory'. Derived from semiotics, sociology, a theory of ideology, discourse and psychoanalysis, photography theory offered a way to discuss the production and consumption of meanings in any photographic image. Yet these had never really been tested on surrealism. So it seemed useful to

common assumptions of how surrealism is understood today. A typical view of surrealism regards it as the antics of a bunch of sexist young men totally preoccupied with their own chaotic internal thoughts; it is reduced to an 'art movement' concerned with selfish instincts remote from politics and 'serious' issues like colonialism. Against such clichéd preconceptions I want to consider the relations between surrealism and *anti*-colonialism as evident in historical documents of the period. Consequently, the contribution of surrealism as a discourse to the field of anti-colonialist politics and thinking in early twentieth-century French culture needs to be recognized, included within post-colonial history and criticism.

But just as I want to argue that surrealism was part of colonial resistance and needs to be considered in terms of its contribution to anti-colonialism, so the reverse is true too. That is to say, colonialism and anti-colonial struggle were formative of surrealism itself. As already noted, for Breton, the defining moment of surrealist's maturity was the Moroccan colonial war in 1925.[23] But the surrealists continued to be publicly active in opposing colonialism from the Moroccan (Abd-el-Krim) 'Riff War' onwards, through to Haiti where Breton's speech reputedly sparked a rebellion there, to opposition of the French in Vietnam, to support for the 1950s uprising in Hungary and the FLN in Algeria in the 1960s. Surrealism's impact on anti-colonialism is manifest in several overlapping senses. First, surrealism was engaged in direct active support for anti-colonial struggles through their own images and texts (individual and collective works across exhibitions, published periodicals and manifesto statements) and by participating in anti-colonial activities organized with others. Second, surrealism opened a new discursive space itself as a vital forum in which others, colonial subjects, were able to enunciate anti-colonial issues. Third, surrealist thinking had an effect on other contemporary disciplines, for example, ethnography and documentary.

It might, of course, be argued that surrealism was 'inevitably' part of the 'colonizing culture' since it is a product of 'the West'. However, such an argument is to homogenize relations of colonizer/colonized into a binary opposition polarity that is far from constructive

23 Breton, in Rosemont (ed.), *What is Surrealism?*, p. 117.

for historical analysis. To refuse to consider how the hierarchy of colonizer/colonized power relations were internally opposed and resisted within European culture is to perpetuate precisely the dynamics of a colonialist culture. It condemns histories of culture eternally to repeat the same power relations, unwittingly reinscribing an oppression as a history of the powerful and powerless. Within accounts of 'what happened?' in colonialism, it is important to address the resistances to the historical processes of colonialism.

It would be possible, perhaps desirable, to include several other journals within a study of surrealism as constituting the main corpus of their periodicals. However, there are other reasons for limiting my analysis to the three above, beyond the obvious problem of having to limit vast amounts of material. First, it is not the purpose here to make an exhaustive description and analysis of all photographic utterances made under the aegis of surrealist activity. Second, these key journals are already sufficiently abundant for the arguments I want to make and, third, the journals which are most notably omitted here, namely *Documents* and partly *Minotaure*, are not strictly speaking 'surrealist'. *Documents*, which consisted of only eight issues across 1929–30 was, as has so often been argued, a 'dissident' surrealist journal. Its main contributors were those who either had defected, never were or were only loosely connected with surrealism. (To then treat this as a key surrealist journal would be like doing a history of a government by its opposition – viable but not my intention.) What can be said is that those other journals like *Documents* took surrealism into other disciplines, like ethnography, reportage, documentary and literary fiction, and for that reason are not part of my project here. *Minotaure*, which lasted a period of six years, was not explicitly controlled by the surrealists and was more an art and literature journal, even if the surrealists dominantly published in it, although, perhaps as a concession, *Minotaure* is discussed in the last chapter (8) on 'Fascism and exile'.

Criticisms

Any book is a document of its research and this one is no exception. It could have been longer and

it could have been shorter. It could have included far
more images and fewer. There could have been more
time spent on more images, or it could have referred
more often to questions and issues raised along the
way. It could have drawn on a wider set of disciplines
for analysis or given more details of the ones it does
use and so on. No doubt this book could also be crit-
icized for what it has left out, but it should not be
criticized for what it has included. If Man Ray appears
as a dominant photographer in it, it is because he was
dominant during these times. Not only was his own
work usually present in the main journals, he was also
involved in selecting work by others to be included in
them. His close partnership and friendship with Marcel
Duchamp during this period – also a friend to surrealism
– should not be overlooked either. It is also perhaps
interesting to note at this point that, in contrast to the
writers, many (if not most) of the visual artists involved
in surrealism were not French in origin and were more
often émigrés to Paris from other parts of Europe or
further afield – itself a topic worthy of a separate study
on diaspora, migration and the arts.

If surrealism has raised uncomfortable questions
about male sexuality and its attitudes, there is a sense
that such issues have either been swept under the carpet
(ignored) or dealt with in a politics of denunciation
(dismissed), rather than argued through and recognized
as part of the critical project of surrealism. As with
Freud's work on sexuality, it is perhaps not surprising
if what is revealed about the unconscious, particularly
in surrealist use of 'Woman' as a sign, is problematic.
In this respect this book is not 'revisionist', it does
not specifically try to dislocate the existing canon (by
replacing it with a more acceptable one), but rather
re-examines the canon from a different axis. Instead of
denunciation or rejection, a historical and theoretical
critical analysis is needed. In this spirit Chapter 5, 'The
Sadean eye', explores the murky work of surrealist
sadism and the apposite overvaluation of a love object
in courtly love. Sadism turns out as a revenge of the
ego on the love object which has robbed it of its self-
love, as manifested in the ambivalent idealization and
dissatisfaction enacted upon the *image* of the female body

in surrealism. The fact that surrealists dared to broach these topics of sexuality and love in public discourse as issues demanding serious social intellectual thought at all should not be ignored or taken for granted. The surrealists were certainly avant-garde in this respect, addressing the issue of desire and courting controversy by breaking moral codes, social taboos and risking arrest for some of their political acts.

'Shock' has been offered as a simple explanation for this 'aesthetics' of the avant-garde. This primarily sociological conception of the avant-garde is premised upon the idea that a minority social group (an 'avant-garde') gains influence by making an impact on or in other larger social groups through 'shock' in the public sphere. Peter Bürger, in his book *Theory of the Avant-Garde*, makes precisely this point, arguing that the avant-gardes set out to shock a bourgeois culture with the intention of changing their outlook, conduct or life.[24] Needless to say, this failed – shock is a temporary state. However, this whole conception of the avant-garde is an ideological inversion. Bürger mistakes effect (shock) for the cause. Shock was not the *aim* of the surrealist group's research, even if it was sometimes the outcome of their activities. In any case, the effect of surrealism in 'shocking the public' was at the time relatively minor, slight even.[25] Newspaper reports of its 'scandals' were few and far between, and given the context of post-First World War France, where social violence was commonplace, with street fights, political 'gangs' working out the politics of the day on one another with fists and sticks, or worse (guns were still commonly used and in circulation, left over from the First World War), the idea of shock in avant-garde practice is a much exaggerated phenomenon. In comparison with the turmoil of the social and political world in which they lived, the scandals of the surrealist world were very small.

Another sociological complaint that surrealists were only or all men is simply wrong, even as a description of the early years. As Penelope Rosemont has pointed out, 'the first women of surrealism have been almost entirely overlooked in the historical and critical literature'.[26] Thus it is writers and anthologists who have colluded with the exclusion of women by simply ignoring those

24 Peter Bürger, *Theory of the Avant-Garde*, trans. Michael Shaw (Minneapolis: University of Minnesota Press, 1984), p. 80.

25 See Elyette Guiol-Benassaya, *La presse face au surréalisme de 1925 à 1938* (Paris: Centre National de la Recherche Scientifique, 1982).

26 Penelope Rosemont, *Surrealist Women: An International Anthology* (London: Athlone, 1998), p. xxix.

who were involved and contributed to the development of surrealism. When women are acknowledged as involved in surrealism some are still sometimes dismissed as merely surrealists' wives or muses. Again the problem is in the accounts of the movement. Rosemont counts at least ten women active in surrealism in the early 1920s (although they were not involved in photography).[27] To dismiss and write women in surrealism out of its history because someone thinks their desire takes a relatively 'passive' position is another general misconception about women in the period.

Although women in France did not have the right to vote until after the Second World War, this is not an indication of their general social position. Surrealism emerged at a time of massive social change. During the 1914–18 First World War in France women had been employed in many occupations formerly reserved for men in the manual labour and growing service industries, buses and trains, etc. After the war, unlike in Britain, these women workers increased, with an assumed right to work even after marriage. The newer employment for women was in shops and banks, as assistants, typists and copyists. The larger Parisian establishments even provided nurseries to enable mothers to continue working.[28] The massive growth of an industry in cosmetics, manicure, hydropathy, chiropody, hairdressing (the new fashion of short hair for women) and general health care, meant that the public sphere was far from being dominated by men and that many metropolitan women could live in relative economic and social independence. Surrealism recognized and addressed this new independence of women, as the lives of some of the women in and around surrealism testify. But surrealism also engaged with this new sphere to make a critique of the ideals of bourgeois femininity manifested within it, a factor ignored in criticism about women represented within surrealism (e.g. in Luis Buñuel's films).

On the matter of gender and sexuality there is frequently a confusion between the vocabulary of a sociology of gender and psychoanalytic theory of sexuality in discussion of 'representations'. Whereas sociological literature tends to assume social identities of men and women, psychoanalytic theory has different concepts.

27 Ibid., p. 3.

28 Apparently, by 1926, 44,000 women were working in banks in France; see Frances I. Clark, *The Position of Women in Contemporary France* (London: P. S. King, 1937), p. 21.

Active and passive pleasure in looking (voyeurism and exhibitionism) are oppositions which should not be reduced to biological categories of male and female (distinctions which are themselves far from absolute) or the gender roles of 'masculine' and 'feminine'. The 'sex' of the producer of the image therefore should not automatically be assumed to dictate the scopophilic investment in looking at an image by a viewer. Apart from being theoretically simplistic, a biological assumption about male/female politics of looking locks critical readings into a structure that simply re-inscribes the prejudice. More importantly, such an economy leaves no space for considering the important realm of fantasy structure, enjoyed by both sexes. The positions occupied within a fantasy scene (as *mise-en-scène* for desire) are not necessarily fixed and can transgress any given social position. While surrealism certainly privileges active passion, so does feminism – these are critical issues for any interpretation.

How the political public sphere in which the surrealists lived is usually portrayed is also a critical problem. The breakdown of pre-First World War 'civilized' values in European culture was noted by the populations of its colonies (many of whom had fought for them in the war) and marks the long beginning of anti-colonial consciousness and the demise of colonialism in its nineteenth-century sense. This book attempts to begin to address some of these issues in terms of their appearance within the culture surrealism inhabited, directly and indirectly.

Finally, this book does not attempt to give a comprehensive overview of photography in surrealism, it does not extend to ask technological questions about the development of photography. What it does try to do is to see how photography in surrealism is made to function and used as a component in the means and ends of surrealism. Surrealism is a knot which binds complex overlapping issues together, sexuality and colonialism, politics, madness and passion, photography and the visual arts, dream-things and objects with a theory of imaging. Whether that knot is a little tighter or is looser as a consequence of this book, I leave the reader to judge.

1 · What is a surrealist photograph?

Do you like photography? You will find photographs to your heart's content at M. Druet's gallery. They are lovely and quite accurate reproductions of famous paintings from Leonardo da Vinci to Maurice Denis, including works by Titian, Ingres, Toulouse-Lautrec, and Cézanne. Guillaume Apollinaire[1]

To start with the question 'what is a surrealist photograph?' might be taken to presuppose that such a thing simply exists and that this chapter sets out to explain, or at least identify, its characteristics. But what is it that defines a 'surrealist' picture? Is it when an image is used within surrealism, or is it in the property of a particular type of image regardless of historical surrealism? Invariably the common assumption is the latter: a surrealist image is a particular sort of picture that is 'recognized' as simply *being* 'surreal', as a particular type of picture. A consequence of this assumption in the study of surrealism is to disregard other types of photograph within surrealism, the ones that do not fit a 'surreal' category. In contrast to this thinking, I want to ask what relations between surrealism and photography are established within historical surrealism. What needs to be raised is the issue of whether such a category as 'surrealist photograph' has any coherence at all? In this respect, perhaps a better way to put the question is: *when* is a photograph surrealist? This at least has the virtue of not immediately assuming that any photograph used in surrealism is 'surrealist' and less easily allows a general distinction between surrealism and photography (as different fields of practice) to be elided. It also throws up the challenge of making distinctions about what types of photographs are used, how they figure and what uses they are put to within surrealism. Since assumptions about the answers to these questions already precede any argument made here, I will immediately state my case.

Sign Systems

I propose that what people name as 'surreal' should be described as a type of meaning, not a type of

1 Guillaume Apollinaire, 'The Art World' (10 January 1911), in Leroy C. Breunig (ed.), *Apollinaire on Art: Essays and Reviews, 1902–1918*, trans. Susan Suleiman (New York: Da Capo, 1988), p. 129.

picture. The surreal is, semiotically speaking, a signifying effect, the confusion or a contradiction in conventional signifier–signified relations in representations and where a meaning is partially hidden, where the message appears 'enigmatic' regardless of how (or in what technological form)[2] it has been produced. The concept of an *enigmatic* message within signification processes is borrowed from its use in psychoanalytic theory by Jean Laplanche. He clarifies the meaning of an enigma by comparison with the 'riddle':

> An enigma, like a riddle, is proposed to the subject by another subject. But the solution of a riddle in theory is completely in the conscious possession of the one who poses it, and thus it is entirely resolved by the answer. An enigma, on the contrary, can only be proposed by someone who does not master the answer, because his message is a compromise-formation in which his unconscious takes part.[3]

In short, the author of an enigmatic message is not fully aware of the signification involved in a message they have sent. I want to use this concept for discussion of the analysis of surrealist images in surrealism.[4] But first, there is a need to be able to assess and describe the different types of photograph used within surrealism.

It is quite clear when looking at photographs used in surrealist periodicals, exhibitions and books that the image types are heterogeneous, diverse and mixed: various ordinary and experimental photographs made by surrealists, anonymous found images, postcards, scientific pictures, newspaper cuttings, film stills, portraits and so on. Obviously, in terms of examining a surreal effect, such sociological categories are useless, since they do not describe their use within surrealism. What is required to address the relations of these various types of photograph within surrealism is a framework that acknowledges the differences, but which specifies the attributes and characteristics of their functions and use (including what it is that constitutes a 'surreal' photograph) in terms of their production of 'surrealist' meanings. I propose three categories (i.e. types of signifier) of distinction relevant for such a discussion of photographic signifying functions:

1. Mimetic; 2. Prophotographic; 3. Enigmatic.

2 In this respect what I am arguing might be extended beyond the domain of photography to all other forms of signification used in surrealism.

3 Jean Laplanche, *Essays on Otherness* (London: Routledge, 1999), pp. 254–5, note 46.

4 It is particularly true of images in surrealism that, in the creative play of the signifier, meanings were produced that were always elusive even for the surrealists. This is not to say that authors are unable to speak about what they intended, nor that they could not say what the picture 'meant' to them. This is not to deny that authors have intentions, but rather that whatever is uttered as its meaning is *not all* of what is signifying – no 'transcendental signified' to be found in the author's intention, even though an author may give their own 'intended' meanings.

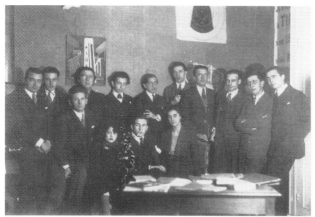

1 Man Ray, *Centrale Surréaliste* (1924). The surrealists photographed at the Bureau of Surrealist Research in 1924: Max Morise, Roger Vitrac, Jacques-André Boiffard, André Breton, Paul Eluard, Pierre Naville, Giorgio de Chirico, Philippe Soupault, Simone Colinet-Breton, Robert Desnos, Jacques Baron, Raymond Queneau, Louis Aragon and Marie-Louise Soupault. Used on the front cover of *La Révolution surréaliste*, no. 1, December 1924.

Such distinctions are, of course, provisional and subject to revision. They are in no way meant as a 'new' ontology of the photographic image, despite any neologisms. There are images – and critics – likely to test such categorical distinctions. Despite the possibility of 'deconstructing' them by attending to the 'fringe' areas, with images that might fall across or between them, I will nevertheless maintain them in a provisional working hypothesis, so long as they have a general validity and use. A brief description will help elucidate what is intended by their scope and sense.

Mimesis

By a mimetic photograph is meant the totally conventional, 'normal' use of photographs, as an 'illustrative' representation. In mimesis a photographic sign serves as a mimetic reproduction of the referent (the thing depicted or referred to), which is held to be 'reproduced' photographically. This signifying 'naturalism' sees not the picture but only the thing depicted, ignoring the techniques of mediation, perspective, geometry, chemistry, lighting, etc. Within or outside surrealism such mimetic photographs are commonly used to 'reproduce' paintings, people or places where to all intents and purposes, the photograph remains invisible, ideologically 'transparent'. A typical example in surrealism is the top photograph on the front cover of *La Révolution surréaliste*, no. 1 (December 1924) by Man Ray (see Figure 1). The group of surrealists (the referent) in this picture (the signifier)

5 See Umberto Eco, 'A Cri-
tique of the Image', in Victor
Burgin (ed.), *Thinking Photography*
(Basingstoke: Macmillan, 1982)
which, along with the editor's
essays, remains the best summary
of the sustained structuralist
inquiry into the semiotic study of
photographic images when read
in conjunction with Roland
Barthes's essay 'Rhetoric of the
Image', in *Image–Music–Text*, ed.
and trans. Stephen Heath
(London: Fontana, 1980).

6 Roland Barthes, *Camera
Lucida*, trans. Richard Howard
(London: Fontana, 1984), p. 5.

7 In 'Photography and Fetish'
Christian Metz notes, 'indexicality,
of course, leaves room for sym-
bolic aspects, as the chemical
image often looks like the object
(Peirce considered photography as
an index and an icon)' *October*,
no. 34, Autumn, 1985, p. 82.
Charles Sanders Peirce's triadic
semiotic definition of the sign as
index, icon and symbol is the
reference here. For Peirce, an
indexical sign is 'a sign which
refers to the Object that it
denotes by virtue of being really
affected by that object'. An icon is
'a sign which refers to the Object
that it designates merely by virtue
of characters of its own'; as
compared with the symbol, which
is 'a sign which refers to the
Object that it denotes by virtue
of a Law, usually an association of
general ideas'. Quoted from
Charles Sanders Peirce, *Collected
Papers* (Cambridge, MA: Harvard
University Press, 1958), para.
2.249, cited in Umberto Eco,
*Semiotics and the Philosophy of
Language* (Basingstoke: Macmillan,
1988), p. 136. See also Peter
Wollen, *Signs and Meanings in the
Cinema* (London: Secker and
Warburg/BFI, 1987), especially pp.
120–54.

are shown as gathered together as in a conventional group portrait of 'the surrealists' (the signified meaning) and the picture (sign) mimics a believable scene (the referent). This is despite the fact that we know from the semiotic study of photographic images that this type of (signifier + signified =) sign, as a 'copy' of the thing represented, is nevertheless produced through a complex coding of the image.[5] Roland Barthes is right when he complains in *Camera Lucida* that people generally fail to distinguish a photograph 'from its referent (from what it represents)'.[6] The photograph, presumed to be essentially 'indexical' as a recording device, an imprint of light on chemicals spread across a base support (film or paper), remains the dominant ontological definition of photography. We readily and easily conflate the picture with the thing represented – the *illusion* of photographic realism. Although the photograph is commonly defined semiotically as in-dexical, it is nevertheless wrong to confuse the mimetic verisimilitude of 'realism' with indexicality. Photographic realism of the sort we encounter daily in various types of photographs is predominantly iconic. Indexicality means that a sign is caused by its referent, whereas an iconic sign has relation of resemblance, as in 'copying' the referent (mimesis) in the sense of its appearance.[7] (An iconic image is a sign that is analogous to aspects of an object [referent] in relation to its appearance in conventional perceptive codes of vision.) Thus visual mimesis is a form of iconic logic caught up in a play of resemblance within the field of perspectival vision more than it is indexical. So, just to make the difference clear, a photogram, for example (an image produced in a darkroom by putting objects into the beam of light directed at photographic paper), is certainly an indexical trace of the objects used to create the shapes in the image, but there is no automatic guarantee of 'realism', in that the image produced does not necessarily re-present the objects used to make the image. We need only consider those playful visual illusions in which shadow puppeteers, using their hands in a beam of light, simulate the (iconic) shadow images of various birds, animals or caricatures of individuals. In such images the picture-sign conjured up (bird, animal etc.) has no necessary

meaningful relation to the human hands (referent) which produced them. Indeed, this conjuring up of an image in shadow puppetry is precisely the same structure (if not the same level of sophistication) as the 'magic' which pervades the photographic illusion of reality.

In semiotic terms, the production of meaning of a mimetic photograph is thoroughly iconic but only by masking its own presence. In these instances, the signifier (the material, graphic aspects of the photograph) and its signified (the concept represented by that sign) join to create a stable signifying system. It is precisely a network of such stable 'quilting points' that lends what we call 'reality' its sense of veracity and our discursive certainty about its existence. However, even nouns, those names of objects that are seemingly the most stable elements in language, are historically mutable and subject to cultural (often dramatic or violent) change.[8] Certainty is quite fragile, for example, the correspondence between signifier and the signified in statements like 'this is a table' is taken for granted as a matter of denotative certainty when said in an appropriate context, i.e. with reference to a square flat surface with four legs as a 't-a-b-l-e'. Yet the same meaningful statement can be easily re-employed to remind us of the fragility of semiotic certainty (one function of jokes) by, for example, pointing to a dog and saying 'this is a table'. In short, language and non-linguistic sign systems are used to secure social meanings (more than to undermine or disrupt them). The surrealists used these pre-existing ideological, normative functions of mimetic language across diverse representational forms (paintings, drawings, sculpture, photographs, writing etc.), and exploited them: 'The surrealists typically created disjunctions between conventional signifiers and signifieds of a sign, exploiting the reader's desire for closure by refusing it, or at least inducing a hesitation as to the texts' "proper" meaning.'[9]

Prophotographic

The second type of image '*prophotographic*' is like the mimetic image and its signifier–signified relation except that the content (the referent/thing depicted) is already surreal prior to being photographed. The surreal effect is

8 The names of places, events and even concepts of time have all been changed and subject to radical criticism in times of revolution, for example France in 1789.

9 David Bate, 'The *Mise-en-scène* of Desire', in *Mise-en-Scène* (London: Institute of Contemporary Arts, 1994), p. 8.

2 Man Ray's photograph, *The Enigma of Isidore Ducasse* (1920) in the 'Preface' to *La Révolution surréaliste*, no. 1, December 1924.

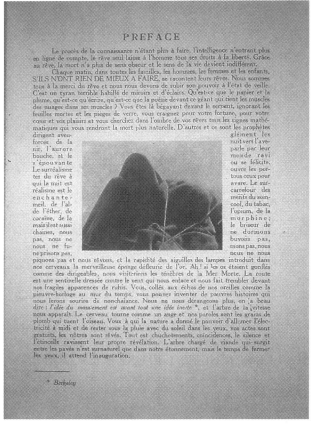

not produced by any photographic trick or technique in the camera or darkroom. The term 'prophotographic' is a neologism of the film theory term 'profilmic' used by Christian Metz. Metz uses 'profilmic' to describe special cinematic effects (an actual car crash or ET are profilmic effects) achieved prior to the filmic moment and not dependent on special in-camera or post-production techniques.[10] Such a distinction would appear simply to displace the issue of defining the 'surreal' or surreality away from the photograph itself on to the object(s) shown. This is indeed the case, but it is nevertheless an important distinction because it helps to show where a surreal effect is achieved.

For example, the picture in the centre of the 'Preface', in the first issue of *La Révolution surréaliste* (no. 1, December 1924) depicts 'something' that we cannot see

10 See Linda Williams on surrealism and film in her *Figures of Desire* (Oxford: University of California Press, 1992), where she refers to Metz's use of the pro-filmic.

because it is wrapped up in cloth and tied with rope (see Figure 2). Even without any caption or available explanation, the photograph is nevertheless an entirely 'believable' sign; we see and recognize what it shows. The picture depicts something wrapped up, or rather, a thing which we believe to be something 'wrapped up'. Here the mimetic function of the photograph is itself not challenged or disturbed, merely frustrated, in that we cannot see beyond the 'wrapping' and can only guess as to the thing underneath it. Any strangeness is thus attributed to the enigma of the thing signified, not to the photographic sign itself and we are in fact dependent upon mimesis for the enigma. Even if we were confronted by the object in the photograph (the three-dimensional object wrapped and covered in cloth), there would be little more that we could tell about the object 'underneath' except by the size and overall three-dimensional shape.[11] The wrapping acts as a veil to frustrate our 'lust of the eye' to see more, to see *beyond* the veil cloth in either circumstance of the picture or the object.[12] What is enigmatic in the picture is *the object* (the signified meaning), not the picture as a signifier (no matter how much this violates common-sense notions of the object and picture as the same thing), as the title Man Ray gave the picture confirms: *The Enigma of Isadore Ducasse*.[13]

The prophotographic structure is valid so long as the content does not contaminate the form of the photograph itself, which is where an image would fall into the third category of 'enigmatic' signi*fier*, not an enigmatic signi*fied*.[14] A test case of these distinctions can be made with another photograph by Man Ray, this time from the first surrealist periodical *Littérature* (no. 5, October 1922; see Figure 3).

The use of photographs as a feature in their own right by the surrealists began in 1922 in *Littérature* with this image by Man Ray. Titled *Voici le domaine de Rrose Sélavy. Vue prise en aéroplane 1921. Comme il est aride. Comme il est fertile. Comme il est joyeux. Comme il est triste!*, an image more commonly known today simply as *Dust Breeding*. In *Littérature* this picture accompanied an article on Marcel Duchamp. Is this picture an 'illustration' of the object of which it was taken (the *Large Glass* art work

11 This object does, of course, exist and Man Ray remade *L'Enigme d'Isadore Ducasse* (original 1920).

12 The phrase 'lust of the eye' is from Karl Abraham's essay 'Restrictions and Transformations of Scoptophilia in Psycho-Neurotics; with Remarks on Analogous Phenomena in Folk-Psychology', in *Selected Papers of Karl Abraham*, trans. Douglas Bryan and Alix Strachey (London: Hogarth Press, 1928), p. 170. Readers of Pliny will note the resemblance to the story of Parhassius and Zeuxis in *Natural History: A Selection* (Book XXXV, 65) (Harmondsworth: Penguin, 1991), p. 330.

13 Man Ray did not in general make any distinctions between his photographs of surrealist objects and those where the photograph is itself the surrealist object. Indeed, Man Ray was touchy in interviews about making any distinctions between his activities across different forms.

14 See Williams, *Figures of Desire*, p. 48.

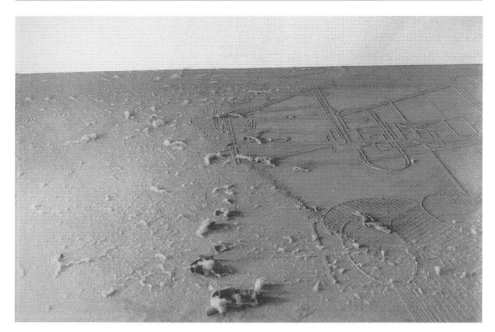

3 Man Ray, *Voici le domaine de Rrose Sélavy. Vue prise en aéroplane 1921. Comme il est aride. Comme il est fertile. Comme il est joyeux. Comme il est triste!* as reproduced in *Littérature* (1922). More commonly known today simply as *Elevage de poussière,* (*Dust Breeding*) 1920, there are two versions of this picture of Marcel Duchamp's glass in his New York studio by Man Ray. The one most commonly reproduced is not this version from *Littérature*, which is taken from a higher angle and shows the top edge of the glass as a horizon at the top of the picture. This is the first photograph to be published in a surrealist periodical as a photograph in its own right.

of Marcel Duchamp) or a 'surreal' image?[15] The actual effect of the image is to some degree produced by the angle of the camera, lighting and lack of any sense of scale due to the close cropping of the picture. Point of view, focus, framing, lighting, subject–background relationships etc. are all normal stock-in-trade choices or decisions about techniques that any photographer has to make. In this instance any 'surreal' effect is produced at least as much by the use of the photographic form, the signifier, as it is by the thing signified. It is precisely to such an ambivalence in the status of the photographic signifier that the third category attends.

Enigmatic

The third category of 'enigmatic' refers to the type of picture typically described as 'surreal'. It is the type of image that has most exercised critics in attempts to define 'surrealist' imagery and generally proved to be the most resistant to analysis. The photograph in the last issue of *Littérature* (no. 13, June 1924), Man Ray's famous *Le Violon d'Ingres*, is one such example (see frontispiece and Figure 22).[16] Here the signifying plane of the photograph itself has been disrupted, not

just a gap opened between signifier and signified, but an explicit intervention and signifying contradiction (oxymoron) introduced into the signifier itself. Exactly what is being communicated, 'signified', is not clear; it has become opaque, 'enigmatic'. No longer purely mimetic, the photograph confuses the usual status and conventions of a photographic image with respect to reality. It introduces fantasy. Any range of techniques can be used to produce disruptions of a conventional photographic signifier, with the camera (lens shifts, focal plane and angles of view, uses of lighting etc.); or in prophotographic imagery the stage set, geometry, props and tricks; or laboratory techniques in the darkroom (double exposures, solarization, photograms, masking frame distortions etc.); or the use of collage, extra-visual text or montages fabricated on a studio table — as is the case in *Le Violon d'Ingres*.

Thus far, the respective differences between the three categories are briefly summarized in semiotic terms: (1) *mimetic* — a believable signifier of a believable signified; (2) the *prophotographic* — a believable signifier of a surreal (unbelievable) signified; and (3) *enigmatic* (enigraphic!) — a signifier which is itself 'surreal' and obfuscates a 'proper' signified meaning or sense. I want to argue that in fact any of these three categories of photograph can be and is employed in historical surrealism to produce surreal meanings. It should be stressed that these three modes are types of signifying relations rather than types of sign with exclusive differences, even if the last category of 'enigmatic' appears at first to have a privileged (though not necessary) claim as a 'surreal' sign. It is also important to recognize that all these categories of photograph, mimetic, prophotographic and enigmatic (as signifiers) have potential for enigmatic/surreal effects (as signified meanings), because surrealism as a discursive practice is a mode of treating signs, rather than any essential particular type of sign. Indeed, like Charles Sanders Peirce's triad model of signs as index, icon and symbol, any image or text in surrealism may have one, two or a combination of all three — mimetic, prophotographic, enigmatic — modes of signification operating at the same time. Surrealism shows itself as an interruption within 'rational' discourse of precisely what can be signified in

15 The photograph was actually taken in New York (where Marcel Duchamp's *Large Glass* was in storage) before Man Ray left for Paris in 1922.

16 See Chapter 4, 'The Oriental signifier'.

29

and with representations across existing sign systems. This is why it is a feature of surrealism that, through a number of techniques, it turned mimetic signs into enigmatic surreal ones. The surrealists exploited common-sense assumptions about the 'realistic' values of photography in the very production of surrealist discourse. Across the exhibitions, magazines and various publications by the surrealists, they exploited all types of signs, juxtaposing them, 'messing up' conventions while nevertheless using them. This can be seen at work in the surrealist periodicals.

Semiotic Revolution

That the quantity of photographs dramatically increased with the journal *La Révolution surréaliste* when compared with the earlier review that preceded it, *Littérature*, was due to more than simply chance. From the first issue, *La Révolution surréaliste* was designed to mimic and mock the style of a scientific review; it was a parody of 'scientific' inquiry. As Dawn Ades has pointed out, the overall design of *La Révolution surréaliste* was based on *La Nature*, a long-established French scientific magazine (see Figures 4 and 5).[17] Like other popular periodicals of the time, *La Nature* used photographs throughout to 'illustrate' objects, experiments, inventions and so on. All the images, photographs, drawings and diagrams within *La Nature* are captioned to anchor clear meanings to the objects or scenes depicted within them. Images of experiments, equipment, inventions, objects and places of study are all given explanations either in the accompanying articles or captions. Visual images are mostly used to 'illustrate' articles, or in some cases, articles illustrate images. In either case, the relationship of image to text, of the visual to the script is one of anchorage, each element is used to 'certify' and bind the other into providing a secure and coherent meaning. Anchorage is used to establish 'reality' through the representations in *La Nature*, to insure a certainty of the signified discourse as part of the 'real world', the doxa of most illustrated magazines.

In contrast, in *La Révolution surréaliste*, pictures (photographs, drawings etc.) are presented that do not have any explicit relation to the written articles; even though in

17 Dawn Ades, *Dada and Surrealism Reviewed* (London: Haywood Gallery/Arts Council of Great Britain, 1978), p. 189.

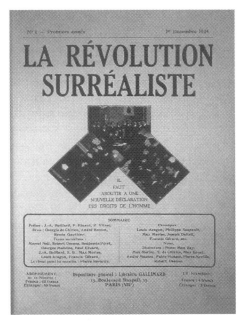 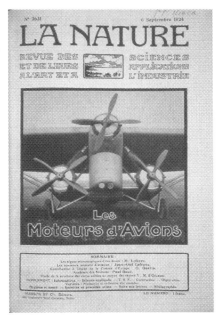

the list of contents on the front cover of the magazine authors of the various images are credited as providing 'Illustrations'. These 'Illustrations' should not be taken for granted, since exactly what the images are supposedly 'illustrating' is never indicated in the magazine and, in contrast to *La Nature*, some images have no captions at all. On the front page Man Ray is given the credit for 'Photos' and although several of them are made by him, certainly not all of them are. One picture is a film still from a Buster Keaton movie. Only one of the nine photographs used inside this first issue of *La Révolution surréaliste* is captioned in a conventional way like *La Nature*. The photographic image of an object, a cubist 'guitar' sculpture, is given an author in the caption, simply titled as 'Pablo Picasso'. That Picasso is the attributed author invests the image with a meaning as the reproduction of a work of art. The use of photography there is mimetic, emphasizing its realist capacity to represent things.

Other photographs in this issue of *La Révolution surréaliste* have no such explicit caption or clear reference made in relation to the published texts. The photographs are in that sense '*hors texte*' without being named as such, yet they are not, as they appear on the page, entirely

4 The first cover of *La Révolution surréaliste*, no. 1, December 1924, with three photographs juxtaposed by Man Ray. All the covers of *La Révolution surréaliste* were bright orange.

5 The cover of *La Nature*, no. 2631, September 1924. *La Nature* had blue-toned images and texts on its cover in contrast to the orange *La Révolution surréaliste*.

separate from the texts either. Formally, the layout of photographs is in, above, or across the magazine's standard two-column format of texts, as in *La Nature*. The formal placing of images and written texts on a printed page 'together' leads us to assume a connection between the elements in terms of related meanings, by the fact of their contiguity, as Roland Barthes has shown us.[18] In *La Révolution surréaliste* any such expectation of a relationship is raised but frustrated: explicit or implicit connections are not provided. This opens up a semiotic space, a gap in meaning between images and texts. In contrast to the ideological assumptions of realism and verisimilitude in scientific, news and popular illustrated magazines, in *La Révolution surréaliste* the already poly-semic status of images is left open to semiosis, a drift of meanings from one to another along any chain a spectator cares to construct. This ambiguous, 'floating signified' of a playful surrealist semiotic openness of the image was worked out a decade before Walter Benjamin wrote his well-known comment that captions were an 'essential component of pictures'.[19] But the surrealists also exploited the possibilities of picture–text relations as a way to introduce ambiguity.

Yet *La Révolution surréaliste* was more than a mere formal play on the layout of 'scientific' illus-trated magazines like *La Nature*. The very aim of *La Nature* (a popular forum for scientific debate) was also imitated by *La Révolution surréaliste*. Just as *La Nature* was devoted to a 'review of the sciences and their application in arts and industry' (the subtitle of the magazine), so *La Révolution surréaliste* also had a scientific research project of collecting and examining everyday pathological phenomena of ordinary people, dreams, slips and products of 'psychic automatism'. The surrealists' research was to examine, as the title of one of Sigmund Freud's books conveniently puts it, *The Psychopathology of Everyday Life*, those manifestations of psychological thought processes and social actions of the human subject in everyday life (dreams, poetic acts, automatic writing etc.) which were usually disregarded as unimportant, except in psychoanalysis and surrealist life. Already in the 'Bureau for Surrealist Research' three months before the first issue of *La Révolution surréaliste*,

18 Roland Barthes, 'The Photographic Message', originally published in *Communications*, no. 1, 1961; reprinted in *Image–Music–Text*, p. 15.

19 See Walter Benjamin's 'A Short History of Photography' (1931), reprinted in Alan Trachten-berg (ed.), *Classic Essays on Pho-tography* (New Haven, CT: Leete's Island Books, 1980), p. 215.

the surrealists were exploring the 'interior reality' of the mind as a kind of public scientific project. They had opened the Centrale surréaliste in October 1924 for public participation until it was so totally overwhelmed and besieged by response that they had to close it to the public. (They continued to interact with a wider public through the periodicals, exhibitions and via questionnaires and surveys.)[20]

Pictures of activities in the Surrealist Bureau 'laboratory' are shown on the front cover of the first *La Révolution surréaliste* (Figure 4). The three photographs are juxtaposed with one another with an outline drawn around them so that, ludicrously, they collectively look like a pair of shorts. The central and top image (the torso) shows the members of the surrealist 'researchers' in a formal group portrait at the bureau, while the two 'leg' pictures show surrealists engaged in their 'research' experiments. In the left-hand image, a hypnotic trance is depicted and on the right, a group of surrealists puzzling over automatic writing in an 'automatic machine' – the typewriter (see also Figure 12). Under this 'pair of shorts' icon above the 'Contents' listing is a triangular-shaped manifesto proclamation, paraphrased from the French Revolution of 1789: 'WE MUST FORMULATE A NEW DECLARATION OF THE RIGHTS OF MAN' [*sic*]. Here again the surrealists mimic the picture-text cover format of *La Nature* (Figure 5). The *La Nature* cover (no. 2631, September 1924) illustrates the exciting scientific theme of 'aviation motors' with the picture of an aeroplane. In *La Révolution surréaliste* the 'new declaration of the rights of man' is accompanied by the images of their research activities. 'The surrealist revolution' is shown through hypnotic states and automatic writing. This surrealist activity becomes a kind of imperative for the 'new declaration of the rights … '; the 'caption' does not so much anchor their images (as 'this is a picture of') as make a 'relay' between image and text, opening the image to different levels of reading.

The obfuscation of any 'normal' captioning relation of picture to text is common to all the other covers of *La Révolution surréaliste*.[21] On the front of *La Révolution surréaliste* number 11 (15 March 1928) a conventional photograph shows two men peering down a hole in the

20 The Bureau of Surrealist Research was opened on 11 October 1924 at 15 rue de Grenelle, Paris (see André Breton, *Conversations: The Autobiography of Surrealism*, trans. Mark Polizzotti [New York: Paragon, 1993], pp. 84–5).

21 The use of linguistic text to anchor an image for Barthes means 'With respect to the liberty of the signifieds of the image, the text has thus a *repressive* value and we can see that it is at this level that the morality and ideology of a society are above all invested.' Barthes, *Image–Music–Text*, p. 40.

33

6 Cover page: *La Révolution surréaliste*, no. 11, March 1928 (anonymous photograph).

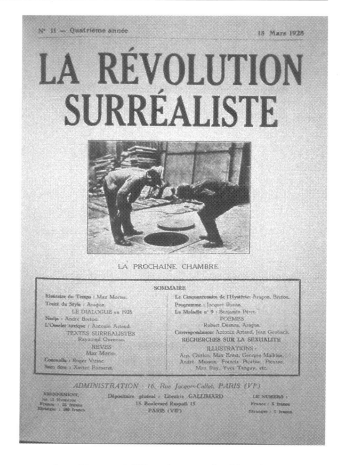

street (see Figure 6). That they are looking into a street drain, sewer or water conduit hole is an assumption made about the picture based on our experience of such things. We cannot, in fact, 'see' that it is a sewer in the picture, even though this would be a reasonable assumption to make. Beneath the picture, the caption LA PROCHAINE CHAMBRE (The Next Room) anchors the image to a different axis of meaning, linking the postures of the two workmen to an obtuse meaning implied by the caption that the two figures are indeed looking somewhere else into 'a room'. The dark and unknown space of THE NEXT ROOM is less a drain hole for sewage than a hole in experience, read as 'that other place' in the mind. The room is the space of the unknown: the unconscious. (Indeed, in that issue of *La Révolution surréaliste* the first

French translation of Freud's famous text on the 'royal road to the unconscious', *The Interpretation of Dreams*, is advertised.) The linguistic caption 'directs' the reader to particular signifieds of the photograph, away from its assumed mimetic signification. The disruption of the conventional relation of photographs to social reality interrupts our happy assumptions about the ontological property of the photograph as located in material 'reality, even if only temporarily'. The picture–text relations of these representations work to signify against the expectation of contiguously coherent meanings and move them towards an allegorical signification. Is this all? Such an explanation of the surreal – surrealism as a mode of treating signs – is far from exhaustive or satisfactory.

Marvellous Beauty

We know that the surrealists themselves proposed the category of the 'marvellous' as a means of attaining 'surreality', although the meaning they gave the marvellous was never very precise.[22] Historically, the marvellous had already been proclaimed as 'the poet's aim' in sixteenth- and seventeenth-century European thinking.[23] The aim was to produce a marvellous image in the mind of the reader. In fact, the picture–text relations of *La Révolution surréaliste* covers are very like the organization of *emblematic* images that were once so popular in the seventeenth century, conceived as a means to produce marvellous images. Although largely ignored today as a theory, an emblem is a signification traditionally composed of a figure and motto juxtaposed to produce an ensemble of meaning. In this respect it is similar to the way that a picture and a catch-phrase or 'slogan' plus a strap line and explanatory text is a common advertising technique today.[24] The figure (picture), caption and motto (texts) are combined in a way to create a poetic image in the reader's mind, sparked off by the juxtaposition of a figural image and literary phrase; as Mario Praz describes it: 'The emblem combined the "mute picture" of the plate, the "talking picture" of the literary description, and the "picture of signification", or transposition into moral and mystical meanings.'[25]

22 As soon as Breton has introduced the marvellous in the manifesto he adds a footnote: 'What is admirable about the fantastic is that there is no longer anything fantastic, there is only the real.' Breton, *Manifestos of Surrealism*, ed. and trans. Richard Seaver and Helen R. Lane (Ann Arbor: University of Michigan Press, 1997), p. 15.

23 See Mario Praz, *Studies in Seventeenth-Century Imagery*, Vol. 1 (London: Warburg, 1939/1963), p. 47.

24 Whereas the emblematic tradition is an open form, both in its non-closure of meaning and 'free' historical usage, it contrasts with the *impresa* or 'device' which is the more 'closed' form in the seventeenth-century period, with fixed rules laid down by printers and academics (See Praz, p. 81). Modern advertising is far closer to the *impresa*/device, more generally closed in terms of a semiosis or mutability of meaning than the emblem, in that the signified of advertising in the last instance is always the product itself.

25 Praz, *Studies in Seventeenth-Century Imagery* (1963), p. 171.

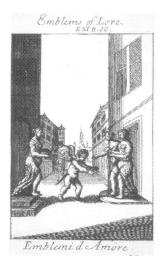

7 Emblem figure. 'Blind Love' from Philip Ayres, *Emblem Amatoria* (in four languages) published in London: W. Likely, 1714.

Praz cites an example from 1653 of a literary phrase by St Teresa: 'I saw the devils playing with my soul' is given a counterpart picture image of a 'God who deals with kings as with tennis-balls'.[26] Or in the very common Love Emblems of the period, the picture of a blindfolded Cupid figure with the caption, 'blind love', could allegorically signify numerous things, a blindness of the soul (insensitivity), blind in the body (physical ignorance) or 'blind anger' (see Figure 7). Cupid and his arrow is another such motif. In the tradition of emblems is to be found a similar enthusiasm as the surrealists, for marvellous images to provoke 'astonishment', with an 'element of wonder and wit' which reveals some thought or intention, but not to reveal all that is intended in that it retains some 'divine secrets'.[27] Essentially a picture–text convention, the emblem was intended to nourish 'the heart, the intellect and fancy' and regarded by theorists (incorrectly) as a modern equivalent signifying system to the ancient hieroglyphs.[28] Mario Praz: 'On one side emblematics, following in the tracks of hieroglyphics, aims at establishing a mode of expression which only a few may understand; in a word, an esoteric language. On the other hand, it aims at being a way of making ethical and religious truths accessible to all, even to the illiterate and to children, through the lure of pictures.'[29]

More often these aims were combined. In the 'lure of pictures' the mode of discourse (based on a model of rhetoric rather than aesthetics),[30] the emblematic sign, generates an intoxicating dream-image which imprints itself on the mind of the viewer as a 'poetic image':

> The fixity of the emblematic picture was infinitely suggestive; the beholder little by little let his imagination be eaten into as a plate is by an acid. The picture eventually became animated with an intense, hallucinatory life, independent of the page. The eyes were not alone in perceiving it, the depicted objects were invested with body, scent, and sound; the beholder was no longer impressed only, but obsessed.[31]

Thus the function of the emblem was other than any supposed intrinsic pictorial 'aesthetic' value as a work of art (as in formalism and modernism). That was an attitude shared by the surrealists too, although the 'moral

26 Ibid., p. 16. See also Karl Joseph Höltgen's description of the emblem as 'an epigram which describes something so that it signifies something else', *Aspects of the Emblem* (Edition Reichenberger, 1986), p. 24.

27 Praz, *Studies in Seventeenth-Century Imagery*, p. 13.

28 Praz suggests that the misreading of hieroglyphs was due to the dependency on interpretations by 'Pliny, Plotinus, etc.', ibid., p. 19.

29 Ibid., p. 169.

30 Tzvetan Todorov charts the historical fortunes of rhetoric in *Theories of the Symbol*, trans. Catherine Porter (Ithaca, NY: Cornell University Press, 1982).

31 Praz, *Studies in Seventeenth-Century Imagery*, p. 170.

and religious truths' which emblems so often preached were certainly not shared by the surrealists.

When the marvellous is introduced in the 1924 *Manifesto of Surrealism*, André Breton invokes a novel called *The Monk* as a foremost example.[32] Written by Matthew Lewis in 1796 when he was nineteen, this 'Gothic' eighteenth-century novel tells the story of a monk who, enamoured with a nun in his care, begins a path of obsession, ambition and rape, eventually ending in murder and death. Laced with ghosts, dreams and 'visions', the story carries enough unexplained events to be classified as a fantastic or marvellous text. No doubt the subject matter of the book – sex, religion, desire and the eventual downfall of the monk – specifically appealed to the anti-clerical views of the surrealists. So when Breton claims that 'the marvellous is always beautiful, anything marvellous is beautiful, in fact only the marvellous is beautiful',[33] the concept of beauty in surrealism is not some picturesque ideal, but the revelation of contradictions repressed in the social: beauty is 'convulsive'. In *The Monk* it is the suspicion (and surrealist delight) that a monk does not entirely give up his libidinal drive – 'love' – to a non-worldly 'God'. If contradictions being revealed can be described as 'negative feelings', then the surrealists shared this pleasure of 'undoing' in the articulation of contradictions. Beauty as such is thus a 'negation'. Elsewhere Breton argued that a conventional notion of beauty no longer had any relevance, irrevocably damaged, partly because it did not consider 'interior reality' and partly because of the society they now lived in:

> The 'clear' and 'beautiful' prescriptions of so many works of art which remain content with the conscious and superficial layer of being, like it or not, are no longer able to arouse our interest. It is altogether possible that the violent economic and social contradictions of our time have had everything to do with the depreciation of this ridiculous lustre.[34]

Instead, the 'beauty of the marvellous' was the weapon with which the surrealists, André Breton and Louis Aragon in particular, opposed what they regarded as the insipid form of 'realism' among the writers of their

32 Matthew Lewis, *The Monk* (Oxford: Oxford University Press, 1973). Breton refers to it in the *Manifesto of Surrealism* (1925) reprinted in *Manifestos of Surrealism*, pp. 14–15.

33 Breton, *Manifestos of Surrealism*, p. 14.

34 Breton, 'The Automatic Message', *What is Surrealism?*, p. 100.

time. In the 1924 *Manifesto* Breton writes: 'I believe in the future resolution of these two states, dream and reality, which are seemingly so contradictory, into a kind of absolute reality, a *surreality*, if one may so speak.'[35]

Louis Aragon also writes near the end of his book *Paris Peasant*,

Reality is the apparent absence of contradiction.
The marvellous is the eruption of contradiction within the real.[36]

Thus a fusion of dream and life, reality and fantasy or breaching of the distinctions between them becomes the 'eruption of contradiction' and what delighted the surrealists was the disturbance created by the beauty of marvellous images.

The problem with any modern notion of the marvellous is that it is now usually defined within the field of literary theory as a specific genre of fantasy, distinguishable in Tzvetan Todorov's tripartite distinctions of the uncanny, the fantastic and the marvellous.[37] Among the genres of fantasy literature, the marvellous is the genre of the supernatural, whereas the key condition for the fantastic, according to Todorov, is a text which induces the reader to 'hesitate between a natural and supernatural explanation of the events described'.[38] Todorov's theories try to show how the fantastic is produced in literary narratives, but since photographs, as single images, constitute non-narrative units, the narrative (syntactic) aspect of his arguments have to be modified in order to be used for visual images.[39] Although 'photographic narrative' is a phrase often heard in discussions about photography there is no narrative or narration in a single still picture. Any so-called 'story' in a single picture is the product of a spectator's active interpretation – often aided or led by a caption or text – in which the picture has sparked the memory of an already read story.

In surrealism, the marvellous was not specific to any form or medium, although it was obviously first formulated in relation to the 'poetic image' in literary practices. The marvellous remained a constant term used throughout surrealism, while the means of achieving it shifted, from automatic writing and its variants in drawing and painting, through to photography, film and

35 Breton, *Manifestos of Surrealism*, p. 14.

36 Louis Aragon, *Paris Peasant* (London: Pan Books, 1980), p. 217. The book was written and published in instalments between 1924 and 1926 the quoted passage is from the last part.

37 See Todorov, *The Fantastic*, and Rosemary Jackson's 'Psychoanalytical Perspectives' chapter in her *Fantasy: The Literature of Subversion* (London: Methuen, 1980).

38 Todorov, *The Fantastic*, p. 33. In Todorov's account distinctions between these categories are usually decided in the narrative resolution or closure of the text, e.g. 'it was only a dream'. *The Sandman* story by E. T. A. Hoffmann and cited by Freud in his 'The "Uncanny"' is one such example where uncertainty is not resolved.

39 There is obviously a difference here between the status of the signifier in film and literature as temporal in their very constitution and drawing, painting and photography as spatial. See Peter Wollen's 'Fire and Ice' essay, in J. X. Berger and Olivier Richon (eds), *Other than Itself* (Manchester: Cornerhouse, 1986).

surrealist objects. Photography nevertheless occupied a particular central place at that time, in that it was during this period of the early twentieth century that it increasingly became the mass and dominant pictorial form in which reality, 'the world', was visually seen and articulated. It would be a singular failure, then, if a movement committed to an attack or negation of that world had ignored the means of signification through which it was daily being constituted. That the reality of the world as proposed by photographs was as susceptible as any other signifying system (literature, 'poetry', paintings etc.) to positing dream and reality in the same ('surreal') image is precisely one reason why surrealism is of historical importance in a history of photography.

Uncanny Signs

In recent years commentators on surrealism have supplanted the marvellous with the 'uncanny', which at first glance has an obvious use in the discussion of disturbing images. Various writers have focused on different motifs as part of the 'troubling' aesthetic of 'uncanny' photographs in surrealism: Rosalind Krauss with 'doubling',[40] Hal Foster on a death-drive[41] and Bryony Fer on automata and mannequins,[42] all themes that appear in Freud's essay 'The "Uncanny"' (1919) (note that 'Uncanny' is already in scare quotes in Freud's essay title).

As others have reported, Freud's actual essay on the uncanny is a rambling bundle of observations which itself can give rise to uncanny disturbances and strange feelings; or as it might otherwise be translated, as having a 'disquieting strangeness'.[43] Nevertheless, Freud's 'The "Uncanny"' essay can be summarized as making a single proposition: the uncanny is something repressed which recurs – a habit already noted in surrealism. But it is not merely the 'return of the repressed'; something has to be added since not all 'return of the repressed' gives an 'uncanny' feeling. From this, Freud deduces two major avenues through which the uncanny is achieved, although he claims it is most successful when the two are combined. One is by effacing distinctions between imagination and reality, creating an 'intellectual

40 Rosalind Krauss, 'The Photographic Conditions of Surrealism', October, no. 19, Winter 1981.

41 Hal Foster, Compulsive Beauty (London: MIT Press, 1993).

42 See Bryony Fer, 'Surrealism, Myth and Psychoanalysis', in Bryony Fer, David Batchelor, Paul Wood (eds), Realism, Rationalism, Surrealism (London: Open University Press, 1993).

43 'Disquieting strangeness' is close to the sense of the French translation of Freud's 'Das Umheimlich'. Freud's essay was first published in French as 'L'inquiétante étrangeté' in Essais de psychoanalyse appliqué (Paris: Gallimard, 1933) much later than when the surrealists could have used it. Mladen Dolar (October, no. 58, Fall 1991) introduces a term from Jacques Lacan, extimité (a condensation of the two terms 'intimate exteriority'), suggesting that this is closer to the sense of ambiguity in the German 'Das Umheimlich'.

uncertainty'. The second is through the evocation of infantile complexes (Oedipus complex) and surmounted infantile beliefs (omnipotence of thought). Examples of these motifs can be extrapolated from Freud's essay (mainly from his discussion of E. T. A. Hoffmann's *The Sandman* story) and listed as follows:

1. fear of losing eyes (e.g. the eye-slitting scene in *Un Chien andalou*)
2. inanimate objects coming to life (e.g. dolls and mannequins)
3. characters who are identical (e.g. 'doubling' in dolls, portraits)
4. repetition of features, actions (e.g. same thing recurring again, numbers etc.)
5. involuntary repetitions as more than mere 'chance' ('coincidences')
6. dread of the 'evil eye' (Man Ray's *Indestructible Object*)
7. death and dead bodies (e.g. spirits, ghosts and reanimation of the dead)
8. states of madness and epilepsy (e.g. hysteria, 'convulsive beauty')
9. being buried alive (e.g. rooms locked or with no doors, windows with no glass)
10. darkness, silence or solitude (e.g. child's fear of the dark never overcome)

It is certainly striking that all these themes and motifs which Freud describes as 'uncanny' also appear across surrealism in various guises and make up a substantial body of the iconography of its imagery. The fact that 'Woman' has been the bearer of many of these themes is an issue that should not be neglected, not least since it has a bearing on the questions of sexuality which the surrealists were, in various degrees of consciousness, themselves raising.[44] If surrealism is based in a relation to the uncanny, this is not to reduce it to the motifs or themes that constitute it. And to say that the enigmatic signifiers of woman are 'uncanny' (as signified meaning) in surrealist photographs is not an answer to anything, but simply to identify the terms of a question.[45] The question still remains, what are the signified meanings of these enigmatic signifiers? In emblem theory the

44 See here especially Chapters 3, 4 and 5. Useful readings of 'The "Uncanny"' are also in Sara Kofman, *Freud and Fiction* (London: Polity Press, 1991) and Hélène Cixous, 'Fiction and Its Phantoms', *New Literary History*, no. 7, Spring 1976.

45 One is spoilt for choice here for the range of examples available within surrealism. Max Ernst's collage work would be a good place to start beyond the material in the periodicals, i.e. his *La Femme 1000 têtes* (Paris: Editions du Carrefour, 1929).

function of the mysterious signification was to point to a moral philosophy, ethics or theological meaning, but to grasp the meanings at work in surrealism we will need to exchange those fields of thought (philosophy and theology) for that which more obviously fascinated the surrealists, of sexuality and the unconscious – and the discipline which theorized it – psychoanalysis.

Primal Scenes

Historically, the 'uncanny' has an emergent use in the 1770s prior to its more recent 'psychoanalytic' sense, as meaning 'not quite safe to trust'. In 'The "Uncanny"' essay Freud notes that the German word for it, *das Unheimlich*, has two meanings, both the 'homely' and the 'unhomely', so that one meaning – the opposite – is always behind the other.[46] Thus something homely can become 'unhomely' and something unhomely can become uncanny by also being 'homely' (yet strange). In effect, the 'uncanny' is like a return of the repressed of an antithetical meaning. In an earlier paper, 'The Antithetical Meaning of Primal Words' (1910), Freud had already drawn the connection between the way that dreams combine contrary things into a unity in the same way that words in ancient (Egyptian to Semitic and Indo-European) languages also have antithetical meanings at their origin.[47] '"No" seems not to exist so far as dreams are concerned,' Freud says.[48] Such is also the logic of fantastic and marvellous tales and what we see there is not the collapse of reality into a 'dream-world', but the emergence of a psychical reality imposed upon the real. Laplanche and Pontalis: 'This notion [psychical reality] is bound up with the Freudian hypothesis about unconscious processes: not only do these processes take no account of external reality, they also replace it with a psychical one. In its strictest sense, "psychical reality" denotes the unconscious wish and the phantasy associated with it.'[49]

What is described here is not only the characteristics of surrealist practice, the imposition of psychical reality on the real, but also the strategy that the surrealists used on existing signifying systems of representation. The captioning of the photograph of two 'workers' gazing down a hole on the cover of *La Révolution*

46 Sigmund Freud, 'The "Uncanny"' (1919), *Art and Literature*, PFL 14 (Harmondsworth: Penguin, 1985).
47 Sigmund Freud, 'The Antithetical Meaning of Primal Words', S.E., Vol. XI, trans. James Strachey (London: Hogarth, 1986).
48 Freud, 'The Antithetical Meaning of Primal Words', p. 155.
49 Laplanche and Pontalis, *The Language of Psychoanalysis*, p. 363.

surréaliste (Figure 6) overlays this psychical, 'reality of thought' (through the linguistic text) on to an existing photographic sign system of 'reality'. A 'surrealist image' and its uncanny effect is produced not by ambiguity around the image (polysemy), but by an ambivalence in fundamental distinctions (e.g. fear *and* excitement, good *and* bad, love *and* hate and so on)[50] and a condensation of these conflicting values at the level of a signifier. This is what produces the enigma and drives on our wish to resolve it, to 'see' beyond the already seen. The text of the manhole picture 'reveals' a space that we cannot know by looking, like a dark space in 'the night' – or the contents of the void posited in the back of *Le Violon d'Ingres*.

By violating the common sense of the photographic reference to concrete 'reality', potential meanings are propelled towards a rhetoric of contradiction. In each of the three categories given above (mimetic, pro-photographic, enigmatic) a photograph can be made 'surreal' by the fact that it draws attention to itself as sign or as a component of a sign as in the emblem, which perplexes the spectator as to its proper 'meaning'. Whether enigmatic, prophotographic (including collage) or mimetic (including image-text), the surrealist signifier plays with the status of signs, troubling what Barthes called the 'stubbornness of the referent' in photography with what the surrealists hailed as the marvellous, a conflation of material and psychical reality. In this clash of material and psychical reality, each image as sign comes close to the assumption of a 'dream-image',[51] a rebus, picture-puzzle and the surreal – staged as enigmatic signifier.

Jean Laplanche introduces the concept of enigmatic signifier into the Freudian theory of sexuality as a means of analysis of 'the enigmatic sexual pleasure of the other', which like the uncanny is 'that which is "other-wise"', comes originally *from* the other'.[52] In discussing enigmatic signifiers Laplanche gives 'pride of place' to the primal scene, how a child perceives parental copulation, and quotes Freud's original account in his text:

It is, I may say, a matter of daily experience that sexual intercourse between adults strikes any child who may

50 In the unconscious love and hate are not available as contradictions, since contradiction 'negation' is not recognized in the unconscious.

51 The visual image in surrealism is often conceived as a 'dream-image', as epitomized in Salvador Dali's paintings (but begun earlier by Yves Tanguy) or even René Magritte. This stylized painterly genre of the dream-image falls across the prophotographic and enigmatic categories, due to the painted verisimilitude of enigmatic signs. See also Chapter 2, 'The automatic image'.

52 Laplanche, 'Time and the Other', *Essays on Otherness*, p. 248.

observe it as something uncanny [*unheimlich*] and that it arouses anxiety in them. I have explained this anxiety by arguing that what we are dealing with is a sexual excitation with which their understanding is unable to cope and which they also, no doubt, repudiate because their parents are involved in it.[53]

Unable to assimilate the scene, it remains as a fragment of a message which has not been signified, an enigma which the child is unable to symbolize. But it is precisely this enigma, Laplanche argues after Freud, that propels, 'seduces' the infant into curiosity, the process of finding a meaning for the enigmatic 'message'.[54] The enigmatic signifier (as a message without a signified) is inscribed in constituting the subject's unconscious. What I propose here is that Freud's theory of the uncanny is, in effect, a version of Jean Laplanche's enigmatic signifier as discussed around the primal scene in particular and primal fantasies in general: 'intra-uterine existence, primal scene, castration, seduction'.[55] That is to say, the repertoire of uncanny motifs and themes are all, in one way or another, so many elements and fragmentary references to primal fantasies. The uncanny effect is the re-emergence of an enigmatic signifier for the subject who remains innocent as to its unconscious meaning.

The uncanny effect is the (to be) signified of enigmatic signifiers, an enigmatic return to elements of a primal fantasy unconsciously recognized by the subject. It thus follows that the motifs and traumatic 'scenes' listed in Freud's uncanny are all related in some way to the circumstances in which a child might see, hear or feel but not 'know' the original fantasies, seduction, primal scene and castration.[56] In this context, the nocturnal fear of the dark, reanimation of the dead, doubling, ghosts wailing, a (voracious) evil eye (fear of being seen), a fear of losing eyes (a fantasy reconstruction of punishment for looking), all these and the other various uncanny themes appear as fragments and aspects, as 'translations' of a traumatic 'return of the repressed'. The motifs and themes identified by Freud are 'uncanny' re-visions of an infant's original fantasy scenes. What provokes the uncanny feeling, as the return of something familiar, is the 'message', the presence of an enigmatic signifier in

53 Jean Laplanche, *New Foundations for Psychoanalysis*, trans. David Macey (Oxford: Basil Blackwell, 1989), p. 127, cited from Freud, *The Interpretation of Dreams*, S.E., Vol. IV–V, p. 585.

54 See Jean Laplanche, *The Unconscious and the Id*, trans. Luke Thurston and Lindsay Watson (London: Rebus Press, 1999), pp. 103–7.

55 Jean Laplanche and J.-B. Pontalis, 'Primal Phantasies', *The Language of Psychoanalysis* (London: Karnac Books, 1988), p. 331.

56 I am not reducing the concept of the uncanny to castration and the 'death-drive'. Laplanche situates life and death as two modalities of the drive which is single and sexual. See his *Life and Death in Psychoanalysis* (London: Johns Hopkins University Press, 1985).

the material. But the register in which to 'read' enigmatic signifiers (in psychoanalysis or surrealism) is not given because part of the signification is unconscious. This, however, does not mean that the photographic signifier *is* the unconscious.[57]

Drawing on Jacques Lacan, Laplanche modifies the conventional concept of the signifier into two aspects. The enigmatic signifier

> is both a signifier *of* (the signified, or so it is implied), and a signifier *to*. This foregrounding of 'signifying to' is extremely important, as a signifier can signify *to* without its addressee necessarily knowing *what* it signifies … know *that* it signifies, but not what it signifies … we know that *there is* 'a signifying' somewhere, but there is not necessarily any explicit signified. Lacan suggests the image of hieroglyphs in the desert, or of cuneiform characters carved on a tablet of stone; we know that they signify, and that, as such, they have their own kind of existence, an existence which is phenomenologically different to that of things; they are intended to signify something to us, but we do not necessarily have a signified which we can ascribe to them.[58]

The enigmatic signifier can be considered in relation to the poetic image of the surrealists (in whatever medium) as a signifier *to* some thing in which what is (unconsciously) signified is, as Laplanche puts it, 'designified'.[59]

In analogy with the 'enigmatic signifier' in psychoanalysis, the surreal image in surrealism offers a meaning (an unresolved contradiction) to the spectator while another message is nevertheless 'hidden' or 'designified'.

Like the dream image, surrealist images were not necessarily intended to be read, they are not like normal acts of communication. So surrealist images might be treated like Freud treated the dreams of his patients, only here, without the presence of the author of the image, we cannot ask them for their associations. Instead, though, we can work up chains of association along historical paths and build their analysis by reconstructing the fields of connotation in which the images were produced and sparked original fantasies. This is the model of research in this book. Freud's *Interpretation*

57 Usually cited from Freud's text is the complex E. T. A. Hoffmann story of *The Sandman*, a fantastic tale discussed at length and from which many motifs of the uncanny catalogued above are drawn. Freud also mentions a 'naive enough story' from an English magazine which, he says, produced a 'quite remarkable' uncanny feeling: 'a story about a young married couple who moved into a furnished house in which there is a curiously shaped table with carvings of crocodiles on it. Towards evening an intolerable and very specific smell begins to pervade the house; they stumble over something in the dark; they seem to see a vague form gliding over the stairs – in short, we are given to understand that the presence of the table causes ghostly crocodiles to haunt the place, or that the wooden monsters come to life in the dark, or *something of the sort*.' [my italics]. Freud, 'The "Uncanny"', S.E., Vol. XVII, pp. 244–5.

The fantasy of the story, the 'very specific smell' of the reptilian 'animal' pervading the house, coupled with the haunting sense of movement in the dark are sufficient clues to the enigma of a primal scene. Such 'trashy' forms of culture are neglected in studies on the uncanny.

58 Laplanche, *New Foundations for Psychoanalysis*, pp. 44–5.

59 Ibid., p. 151.

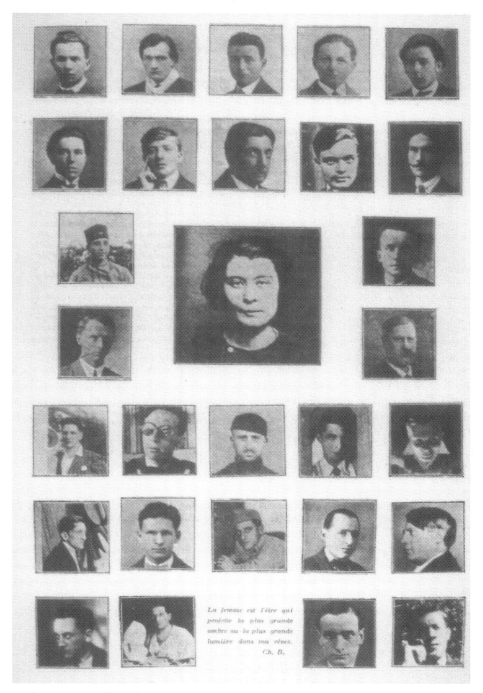

La femme est l'être qui
projette la plus grande
ombre ou la plus grande
lumière dans nos rêves.
Ch. B.

8 Photomontage of Germaine Berton (police photograph) portrait with surrealists and Sigmund Freud. Published in *La Révolution surréaliste*, no. 1, December 1924.

of Dreams offers a textbook model for the analysis of historical images, following their associations along the paths of mechanisms of the dream-work to reconstruct the meaningful context of the 'designified' meanings. An example might help clarify what I mean by taking a well-known image from surrealism (see Figure 8).

The Meaning of Revenge

A full-page image in *La Révolution surréaliste* displays a montage of portrait photographs around the figure of Germaine Berton, whose historical meaning for surrealism has, I argue, today been 'lost'. Often reproduced, this image is usually described in commentaries on surrealism as a celebration of the shocking fact that Germaine Berton, the 'anarchist', had shot the right-wing political leader Marius Plateau.[60] So the discussion of this picture (always brief) is linked to a political act of violence. This she had in fact committed, in January 1923, almost two years before the surrealists published her image in this issue of the surrealist magazine.[61] But what is important for the publication of the montage in the surrealist periodical is that the image of Germaine Berton had another topical association besides her assassination of Plateau two years earlier that everyone discussing this picture in surrealism assumes as the most important reason for it. Actually, the publication of this montage in the first issue of *La Révolution surréaliste* on 1 December 1924 was more topically linked to the fact that the woman depicted in the central image, Germaine Berton, had just killed herself with poison on 1 November 1924. This suicide has never been mentioned in subsequent discussions on surrealism, although it was a widely known public fact at the time. So Germaine Berton had an association with death in two senses. More than a political scandal, Germaine Berton was the image of a personal tragedy. When we look at the issue of *La Révolution surréaliste* in which this montage appeared, what pervades its pages is the inquiry: 'Is suicide a solution?' Reports of suicide cases were printed throughout the magazine, extracts from newspaper cuttings on recent suicides were cited as evidence of its currency. In the 'Preface' (or editor's page) are remarks on suicide which can be read as a

60 Maurice Nadeau, *The History of Surrealism*, trans. Richard Howard (London: Plantin, 1987), p. 94. Iwan Goll, who is one of those pictured around the image of Germaine Berton, published a book on her shortly afterwards, *Germaine Berton, die rote Jungfrau* (Berlin: Verlag die Schmiede, 1925).

61 It is Maurice Nadeau who is responsible for this historical date 'slip' (*History of Surrealism*, p. 94). He reports that Germaine Berton 'had just murdered … ' at the time of the first issue. It is quite clear that his text should really read 'she had just committed suicide … ' Given that Nadeau's source for this was most likely his own memory, it is tempting to speculate on the motive for this 'lapsus', which turns her into a 'murderess', as he so sharply puts it, when she was in fact acquitted of murder.

parallel commentary on Berton's suicide: 'We live, we die. What is the share of will in all this? It seems that we kill ourselves the way we dream. It is not a moral question we are asking: *Is suicide a solution?*'[62]

More explicitly, a few pages later, Louis Aragon writes a few triumphant lines under the subtitle heading 'Germaine Berton' that, along with 'a few other men', her 'admirable act' represents the 'greatest defiance of slavery, the most beautiful protest before world opinion against the hideous lie of happiness'. Again, this is usually presumed by critics to be about her shooting of Plateau; Aragon can, in fact, be read as extolling her suicide. Suicide is − scandalously − praised as a worthy act, the murder of herself.

The montage of Berton is itself like an emblematic sign, composed of a motto with symbolic pictorial elements. It was most likely made by Louis Aragon and Pierre Naville, with Man Ray providing many of the photographic portraits.[63] The pictorial elements are spatially organized so that the twenty-eight pictures on the page form an architectural frame which, as a series of square blocks, holds and supports the slightly larger central image of Berton. In this respect it is like a funerary monument in which they are the bearers of her image.

Yet, read spatially, the montage also speaks as a collective support *for* Germaine Berton. The mimetic attribute of each image (denotation) is overlaid by the fact that the juxtaposition of 'mugshots' on the page suggests (connotes) that they are all actually part of a group collected together. This is only a 'collective' in the context of the juxtaposition of photographs on this page; they never actually existed as a group even if the surrealists had wished it.[64] Freud, for example, was far from interested in these 'young poets' and even less in being recruited as one them.[65] In other words, the group is *only* constituted in and by the representation, a point so obvious that we tend to ignore it. In our attention to the reading of images in surrealism we need to consider these spatial relations of elements as themselves part of the visual argument of the sign; this is how 'logical' connections between things are often visually represented in dreams: spatiality in a visual image has

62 *La Révolution surréaliste*, no. 1, December 1924, p. 2.

63 According to Pierre Daix this first issue of the magazine was taken to the printers at Alençon on 6 December, even though the date of publication on it is 1 December. Pierre Naville and Louis Aragon worked on the first issue for a day and a half at the printers, while the others (Paul Eluard and André Breton) apparently sat around in cafés (Pierre Daix, *La Vie quotidienne des surréalistes, 1917–1932* [Paris: Hachette, 1993], p. 255).

64 Many of those depicted were surrealist members, but Freud, de Chirico and Picasso, although 'fellow travellers' were not members. From top to bottom in alphabetical order from left to right are: Louis Aragon, Antonin Artaud, two Baron brothers, Jacques-André Boiffard, André Breton, 'Carrive' (the youngest surrealist at sixteen), de Chirico, René Crevel, Joseph Delteil, Robert Desnos, Germaine Berton, Paul Eluard, Max Ernst, Sigmund Freud, Francis Gérard, Georges Limbour, Mathias Lübeck, Georges Malkine, Max Morise, Pierre Naville, Noll, Benjamin Péret, Pablo Picasso, Man Ray, Alberto Savino, Philippe Soupault and Roger Vitrac all placed around a photograph of Germaine Berton. Source for this list is Maurice Nadeau, *The History of Surrealism*, p. 94.

65 Breton visited Freud in October 1921 in Vienna where by all accounts he received a lukewarm response, Freud apparently bidding him farewell with the sentence: 'Fortunately we are counting a lot on the young.' See Elisabeth Roudinescou, *Jacques Lacan and Co., a History of Psychoanalysis in France*, trans. Jeffrey Melman (London: Free Association Books, 1990), p. 23.

the equivalent function to what temporal syntax has in linguistic or verbal representations. In this spatial aspect of the picture, Germaine Berton is 'more important' than other pictures, because her image is literally and symbolically larger. Thus, the image reads like: 'the group acts as a support for Germaine Berton' ('we are *like* a monument for her image'), or 'we support Germaine Berton'. This visual support also offers an imaginary identification with Germaine Berton in her look at the spectator of the picture. All these men with their eyes wide open (they see what they are doing), mostly stare out at the viewer along with Berton. They all look at us and – this is a paradox of the photograph – she is *still alive* in the picture. Metaphorically the surrealists are 'alive' when they are *with* her and yet, in her death, they support her in 'the admirable act' of suicide. This is a provocative challenge.

At the bottom of the image a 'motto' text takes up a space where another portrait might have been. To C. B., Charles Baudelaire (who, incidentally had loathed the popularity of the photographic portrait),[66] is given a voice which by its contiguity with the other portraits seems to speak for all of them with his words: *La femme est l'être qui projette la plus grande ombre ou la plus grande lumière dans nos rêves.* (Woman is the being who projects the greatest shadow or the greatest light in our dreams.) The text acts like a relay for a further distinction between the portraits. Woman (the portrait of Berton) is 'the greatest shadow/light' projected into Man (the depicted men) 'in *our* dreams'. Reductively, 'Woman' is the ambivalent 'muse' of their dreams; ambivalent because she brings darkness and light. Writing about Baudelaire's poetic language, Julia Kristeva notes, 'The contradictory logic of Baudelaire's metaphors foreshadows surrealism and takes root in a fantastic or Baroque tradition … '[67] 'Woman' offered as 'the greatest shadow or the greatest light' in (their) dreams is the sign in which two attitudes to 'Woman' are condensed. Kristeva points to this ambivalent splitting in Baudelaire's poetry towards its 'amatory objects', poised between ideal ('sublime mother') and abject ('lowly body') and between 'image and emptiness'.[68] We can begin to see here how, at an enigmatic level, the immediate history of Germaine

66 See Charles Baudelaire, 'The Modern Public and Photography', reprinted in *Classic Essays on Photography*, pp. 83–9.

67 Julia Kristeva, *Tales of Love*, trans. Leon S. Roudiez (New York: Columbia University Press, 1987), p. 331.

68 Ibid., p. 327. Kristeva also notes that E. T. A. Hoffmann's writing was a favoured reference for Baudelaire, p. 329.

Berton is woven into a more complex and deeper enigmatic set of meanings pertaining to attitudes to women, men and death (so often linked with issues of sexuality) within the rhetoric of the image itself. It is here that we must delve a little more into the history-work (dream-work) of the Germaine Berton case to unearth the social-cultural chains of association that led to these things being in the image in the first place.

Death, Politics and Sex

At the age of twenty Germaine Berton walked into the office of L'Action Française on 22 January 1923 and requested an interview with two of its key figures Charles Maurras (the anti-Semite in the 'Dreyfus affair') and Léon Daudet. L'Action Française was an important right-wing newspaper and an influential political organization with popular support (among Catholics, aristocratic families and monarchist sympathizers) and the Republican government. Having failed to see the two people she intended to kill, she obtained an interview with Marius Plateau whom she then 'shot several times'. She was stopped from turning the gun on herself as she had supposedly intended.[69] The man she had shot dead, Marius Plateau, was general secretary of a Royalist group called 'Camelots du Roi', an organized political group for young thugs, 'rioting' boys, 'hawkers of the king', a fighting wing instigated by the L'Action Française in 1908. They had orchestrated 'impressive student riots'.[70] They sold party newspapers and as political agitators were involved in instigating demonstrations and (organized) beatings of political opponents.[71] The Camelots group avenged Plateau's murder by wrecking premises of left-wing newspapers (L'Oeuvre, L'Ere nouvelle and Bonsoir) and beat up socialist deputies. Although Germaine Berton had stated that she was an anarchist, L'Action Française published articles claiming that she was part of an international conspiracy against them and the policies of the French government. The editor, Léon Daudet, one of her would-be victims, wrote arguing that her assassination 'plan' had been the miscarriage of a whole plot by the French 'pro-German police'. He claimed that the murder had been part of a plan to kill the president of France (Alexandre

69 See Eugen Weber, *Action Française; Royalism and Reaction in Twentieth-Century France* (Stanford, CA: Stanford University Press, 1962), p. 139.

70 By all accounts, the riots were caused by the insults that a university lecturer had made about Jeanne d'Arc, the adopted (unofficial) nationalist saint of *L'Action Française* (see Alfred Cobban, *A History of Modern France*, Vol. 3 [Penguin, 1990], p. 89).

71 See Edward R. Tannenbaum, *The Action Française: Die-hard Reactionaries in Twentieth-Century France* (London: John Wiley, 1962), pp. 95–6. One of the Camelots leaders claimed in defence that they only ever used the amount of violence that was 'necessary' and they had not ever killed anyone (see Maurice Pujo, *Les Camelots du Roi* [Paris: Flammarion, 1933], p. xviii).

Millerand) and the prime minister (Poincairé) as well as Maurras and himself, and that this conspiracy was linked in their minds to the French aim of occupying the German Ruhr. (Poincairé had sent French troops there to collect reparation payments for the First World War.) The description of Plateau's death as a 'Germano-police murder' is typical of the fanatical nationalist and inflammatory anti-German sentiment of the right wing in France following the First World War.

Berton was tried almost a year after she shot Marius Plateau, in December 1923. She was acquitted on the grounds of temporary insanity, of being 'demented'. The *Action Française* called for a national protest against her release, but these events were overshadowed by another death in relation to *L'Action Française*. The editor's son, Philippe Daudet, was found shot in the head in a taxi in November 1923, a month before Berton was tried and acquitted.[72] The fourteen-year-old had gone missing for five days. He had run away from home and tried to get a passage to Canada from Le Havre, but failed and returned to Paris three days later. Instead of going home, he turned to the anarchist opponents of *L'Action Française* (and his father) and told them that his father beat him constantly. Returning repeatedly to anarchist newspaper offices and bookshops, Philippe offered his services to 'get rid of opponents', which would have obviously included his father. Finally, on Saturday, 24 November, he was reported going to Pierre Le Flaouter's anarchist bookshop and asking for ammunition for a gun he had acquired and a copy of Baudelaire's *Les Fleurs du Mal* (*The Flowers of Evil*). (Pierre Le Flaouter was known to have procured guns and ammunition for *camerades*.) Astonishingly, Philippe declared that he was going to kill either Millerand, the French president, the prime minister Poincairé, or his father. Flaouter alerted the police. In the end Philippe supposedly 'shot himself' dead in a taxi. His father Léon Daudet, famous as an unscrupulous political journalist, told the press that Philippe had died of a 'lightning spinal meningitis' as a means to hide from the courts judiciary the 'shameful' conclusion that it had been an act of suicide.[73]

This whole event spiralled as a public story in the press when Philippe's father, Léon Daudet, again insisted

72 According to Tannenbaum's account, Philippe was found with two bullets in his head; nevertheless the police verdict was of suicide (see Tannenbaum, *The Action Française*, p. 203).

73 Despite the fact that suicide had been erased in France as a legal crime in 1789, suicide, as Emile Durkheim pointed out, 'inspires an aversion in popular consciousness' (see Emile Durkheim, *Suicide*, trans. John Spalding and George Simpson [London: Routledge and Kegan Paul, 1970], p. 327).

that Germaine Berton had been part of a conspiracy and that now the death of his son was in some way connected with this 'plan'. Supposedly, the murdered body of his son had been dumped in the taxi after the event and Daudet targeted the taxi driver who had been driving Philippe, calling him a liar in court. The taxi driver, 'Bajot', sued Léon Daudet for slander (the case was heard in November 1925). Daudet's appearance in court turned into a farce when he began extolling his conspiracy theories and ranting anti-German mania. The taxi driver won and Daudet was sentenced to five months in prison.

It also turned out that Philippe had shot himself in the taxi while in front of the prison where Germaine Berton was then awaiting trial. In a spate of conflicting stories (later published as books on these events) various parties argued their different versions. One idea was that Philippe had already met Germaine Berton long before her crime and that they were lovers.[74] This inspired theories that Philippe had, through his encounter with her, become an anarchist and had done so secretly to oppose his father, whom he anyway hated. By adopting the political views of his father's opponents he could have his revenge. In this version Philippe had known that Germaine Berton initially wanted to murder his father and his act was in some way an imitation of hers, when he also declared an intention to murder a politician.[75] Another theory was that Germaine Berton had been the mistress of Pierre Le Flaouter and that it was he who had 'transformed her into a latter-day anarchist like Charlotte Corday'.[76] Of course, it is to be noticed that these 'theories' introduce Berton's sexuality into the equation, just as Philippe's actions are linked to filial hatred. Such stories circulated, much as they do today in 'tabloid' forms, almost mythical as stories. Germaine Berton's murder of Marius Plateau, her trial, the activities of *L'Action Française*, the death of Philippe Daudet followed by her own suicide, were in the realm of 'public knowledge'. These popular stories are all clues as to the connotative interests of Berton's 'image' in the surrealist montage – the connections between love and death, politics and sex, hatred and family relations.

There is another aspect to the photomontage added

74 Le Flaouter, *Comment j'ai tué Philippe Daudet* (Paris: Le Flaouter, 1925), p. 85.

75 Marcel Guitton and André Seguin, *Du Scandale au meutre; La mort de Philippe Daudet* (Paris: Cahiers de la Quinzaine, 27 November 1925). Léon Daudet had once been a student of Charcot.

76 See Maurice Privat, *L'Enigme Philippe Daudet* (Paris-Neuilly: Les Documents Secrets, 1931), p. 27. (In 1793 Charlotte Corday had murdered Marat in the French Revolution [see Leslie Dick on 'The Skull of Charlotte Corday', in Berger and Richon (eds), *Other than Itself*].)

by these stories. It was known that Philippe Daudet had aspired to become a poet, so much so that he had written a collection of poems in the vein of Baudelaire called *Les parfums maudits*.[77] Also at the same time that Philippe had asked for ammunition from Pierre Le Flaouter at the bookshop, he had asked for the book by Baudelaire, *Les Fleurs du Mal*. It might then be supposed, conjectured, that the relations between Philippe Daudet and Germaine Berton as lovers were joined in death (like Romeo and Juliet). Baudelaire's 'motto' printed under the picture of Germaine Berton thus serves as a symbolic presence of Philippe.[78] In other words, Baudelaire's motto in the montage is not arbitrary; it signifies Philippe, an epigraph as epitaph.

As for the function of light and darkness of Woman, we only have to refer to 'light' in everyday language, let alone the iconography of pictures or the visual logic of dreams, to know that light is associated with awakening knowledge and revelation.[79] It has already been noted that darkness and 'the night' are an uncanny feature in tales, the (enigmatic) source of which Freud indicates: 'the attacks of night terror accompanied by hallucinations (*pavor nocturnus*) which are so frequent in children … In this case too it can only be a question of sexual impulses which have not been understood and which have probably been repudiated.'[80]

Required here, to return to Laplanche's proposal, is the move from the enigma *of* woman (Germaine Berton) to the function of the enigma *in* woman. This leads back to the surrealists and their group, the enigma *in* Germaine Berton of her terrible conflicts as the light and dark of their dreams. Death and love, suicide and murder ('criminality' and 'madness'), these are themes of a dialectics of desire and patriarchal law which governs them, and all issue forth from the associative trains of thought of the montage. The bleak 'nocturnal' existence of primal revenge (seduction, desire, castration) is brought to the surface in enigmatic form, but 'enlightened' by the acts of Germaine Berton. It is in a perverse fulfilment of wishes that Germaine Berton provided the surrealists with an allegorical or 'emblematic' image for liberating the darkness (and light) of dreams. In the fatal, almost fantastic, struggle of her desire in the real and its tragic

77 Weber, *Action Française*, p. 170.

78 Freud notes that words and speeches in dreams are not invented by the dreamer, but derived from words heard the day before. 'For the dream-work cannot actually create speeches' (Freud, *The Interpretation of Dreams*, p. 545). In a similar sense the Baudelaire text would be something that had already been heard by the surrealists.

79 This is certainly confirmed in literature on dreams. Freud's patient's dream at the beginning of Chapter 7 in the *Interpretation of Dreams* has a father awoken by the light pouring into his room and the child's immortal demanding words: 'Father can't you see I am burning'? (PFL 4, 1980), p. 652.

80 Ibid., p. 742.

end, the surrealists put themselves alongside her in the image. They share with her a wish for the fulfilment of wishes, yet nevertheless ask themselves, as much as anyone else, the interrogative question: 'Is suicide a solution?'[81] Such a discussion of the montage is far from finished or closed: as Freud had noted, a dream analysis is not easily exhausted. Indeed, perhaps the lack of closure in interpretation of surrealist images and texts is what partly accounts for the continued historical interest in surrealism; the resistance of the images to analysis can itself be fascinating.

Treatment

A surrealist image names enigmas, but by itself the enigma cannot be fathomed. The paths of historical association can lead us closer to reconstructing the issues. For the immediate question 'what is a surrealist photograph?' there can be no simple aesthetic definition. The photographic image and its meanings in surrealism are framed by its cultural 'date-stamp' as much as its relation to the three categories of use of image outlined earlier in this chapter, mimetic, prophotographic and enigmatic. Any of these sign types can be mobilized to produce uncanny feelings or strange effects in an image, attributes which are unquestionably what tend to characterize, no matter how feebly, a particular response to surrealist pictures.[82] For an understanding of the uses of photography in surrealism it is important not to unify the three types of photograph. Attempts to give an ontological or 'aesthetic' definition of photography in surrealism inevitably exclude certain types and functions of photographs from the corpus. In short, then, the three modes of photograph lend themselves to the surrealist project because surrealism is to be defined as a mode of treating signs by introducing an ambivalence between material reality and psychical reality. To invoke a primal or original fantasy, surrealism was not dependent upon any particular form or type of sign, but through signs paid attention to the very foundation of our being, turning, changing so-called objective signs into significations of subjective states, 'inventing' a theory for their translation from the psyche to a material representative via the automatic image.

81 Suicide was topical. That same year the Belgian review *Le Disque Vert* (no. 1, 1925) ran a special issue on suicide and included contributions from surrealists.

82 Outside surrealism the type of image that is commonly referred to as a 'surreal' picture is predominantly of the prophotographic or enigmatic categories.

2 · The automatic image

> The real is beyond the automaton …
> *Jacques Lacan*[1]

In surrealism, automatic writing is the means to attempt a notation of psychic expression without control by conscious thought or reason. Thus the automatic image is that which is conjured up as the psychical thought, the 'mental image'. Automatism appears in the first *Manifesto of Surrealism* in 1924 and is fundamental to early 'intuitive' surrealism. 'Psychic automatism' is the definition of all surrealism:

> SURREALISM, *n.* psychic automatism in its pure state, by which one proposes to express – verbally, by means of the written word, or in any other manner – the actual functioning of thought. Dictated by thought, in the absence of any control exercised by reason, exempt from any aesthetic or moral concern.[2]

This notion of 'psychic automatism' defined what the surrealists had already been doing. Their earlier products of automatic writing had first been published five years earlier in *Littérature* (no. 7, first series) in 1919. These were parts of what is now known as *Les Champs Magnétiques* (*The Magnetic Fields*) co-authored by André Breton and Philippe Soupault, 'written' during intense periods, eight to ten hours at a time. The sessions were their attempts to 'capture and fix spoken thought of the kind that analysts encourage their clients to produce, in the form of rapid, spontaneous, unself-critical monologues'.[3] The title of the book, *The Magnetic Fields*, also invoked the values of the old magnetizers, Franz Mesmer (1734–1815) and his followers, who had reputedly cured illnesses with the use of magnets and their magnetic fields.[4] However, with Breton and Soupault there was no therapeutic claim for their technique. It was intended to show the capacity of the human mind to produce literary texts beyond conscious control and free from the values of existing literature or poetry; taking inspiration from Lautréamont's *Chants de Maldoror*, reputedly written

1 Jacques Lacan, *The Four Fundamental Concepts of Psycho-Analysis*, trans. Alan Sheridan (Harmondsworth: Penguin, 1979), p. 53.
2 André Breton, 'Manifesto of Surrealism' (1924) in Richard Seaver and Helen R. Lane (eds), *Manifestos of Surrealism* (Ann Arbor: University of Michigan Press, 1997), p. 26.
3 David Gascoyne, 'Introduction', in *The Magnetic Fields* (London: Atlas, 1985), pp. 10–11.
4 See Henri F. Ellenberger, *The Discovery of the Unconscious* (New York: Basic Books, 1970), p. 57.

from beginning to end in a matter of days in complete solitude. The surrealists aimed to act as 'modest *recording instruments*' of psychical thoughts and not as poets. Thus they declared in the 1924 *Manifesto of Surrealism*: 'We do not have any talent.'[5] Psychic automatism, they argued, could be practised by anyone and the *Manifesto* went on to encourage everyone to do so and, especially for those with aspirations to become writers, offered the following advice:

> Forget about your genius, your talents, and the
> talents of everyone else. Keep reminding yourself
> that literature is one of the saddest roads that leads to
> everything. Write quickly, without any preconceived
> subject, fast enough so that you will not remember
> what you are writing and be tempted to reread what
> you have written.[6]

Psychic automatism was a means to produce literary writing that avoided the contrived expressions of their peers and forebears. In the 1924 *Manifesto* Breton complained of the 'mediocrity, hate, and dull conceit' in the 'realistic attitude' of the literature of his time, its 'vacuity' of realist description and 'clarity bordering on stupidity, a dog's life'.[7] Deprived of 'imagination', humans are the less for it and the surrealists set about repairing the split. Breton argues:

> Under the pretence of civilization and progress, we
> have managed to banish from the mind everything
> that may rightly or wrongly be termed superstition, or
> fancy; forbidden is any kind of search for truth which
> is not in conformity with accepted practices. It was,
> apparently, by pure chance that a part of our mental
> world which we pretended not to be concerned
> with any longer – and, in my opinion by far the most
> important part – has been brought back to light. For
> this we must give thanks to the discoveries of Sigmund
> Freud.[8]

In Freud, the issue of automatism appears most frequently in the two books *The Psychopathology of Everyday Life* and *Jokes and Their Relation to the Unconscious*. It was the first book, *The Psychopathology of Everyday Life*, that surrealists had read first hand by the time of the

5 Breton, 'Manifesto of Surrealism', p. 28.
6 Ibid., pp. 29–30.
7 Ibid., p. 6.
8 Ibid., p. 10.

First Manifesto of Surrealism in 1924. The title of Freud's essays, 'Slips of the Pen', 'Bungled Actions', 'Symptomatic and Chance Actions' among others, easily provided fuel for thinking that psychical activity can be provoked as 'poetic' activity by inducing states of distraction. In the various essays of *The Psychopathology of Everyday Life* Freud demonstrates how these parapraxes, 'Freudian slips', are motivated and not arbitrary. They are all species of the same psychical phenomenon: evidence of other 'unwanted' motives, the irruption of unconscious thoughts in consciousness. That is, a contamination or interference of automatic mental and motor activities, like talking, walking, writing and so on with desire.

Yet despite crediting Freud with their interest in psychical thought, the sources of automatism for surrealism are at least threefold: the old spiritualists, French psychiatry and Freudian theory (from which they gained a loose grasp of the concept of 'repression' which the other two practices did not have). While surrealism claimed psychic automatism as its own, it drew freely on these different sources to cut another path, different from the previous spiritualist (or 'spiritist') use of automatic writing by mediums before them and the therapeutic aims in French psychiatry contemporary with them.

As for Freud's work, although Breton had certainly developed a knowledge of it, in the early years it was essentially through French psychiatric interpretations of Freud, primarily, E. Régis and A. Hesnard's *Psycho-analyse des névroses et des psychoses* which appeared just before the First World War in 1913.[9] Remarkably late compared with elsewhere, translated fragments of Freud's work in French began to appear in 1921 and the first book by Freud published in French was *The Psychopathology of Everyday Life* in 1922. By this time Breton had been to meet Freud in Vienna, a matter of months before, in October 1921, and had, with Philippe Soupault, already published the automatic texts of *The Magnetic Fields* (1920).

Spirit Messages

The concept of automatic writing was not new. Automatic writing was a practice common in French

9 See Elisabeth Roudinesco; I am indebted to her chapter 'Surrealism in the Service of Psychoanalysis', in her *Jacques Lacan and Co.; a History of Psychoanalysis in France, 1925–1985*, trans. Jeffrey Mehlman (London: Free Association Books, 1990), p. 22.

psychiatry and nineteenth-century spiritualists. For spiritualist mediums, automatic writing was a means to explore occult phenomena not hidden human thoughts. Frederic Myers, for example (read by Breton), was a key member of the Society for Psychical Research and believed in life after death.[10] 'Automatists' in this context employed various devices ranging from tables with movable tops to a simple pencil to produce messages which, 'did not, so far as they could judge, originate in their own minds'.[11] Myers wrote liberally about these 'psychic' phenomena and much debate was conducted over the handwriting, content and source of the messages produced, supposedly elicited 'from the spirits' while the medium was in a state of somnambulism. The mediums became practised at invoking a trance or dreamlike state between sleep and waking in which the messages could emerge. The members of the Society for Psychical Research had a hazy fixation on evaluating whether automatic writing and other forms, speech, gestures and 'spirit' photography (with ancestors suddenly appearing in contemporary photographs and strange 'apparitions' appearing in pictures not otherwise accounted for) were debated for their merits as evidence of other-worldly activities.[12] Myers described the 'messages' and related 'spirit' phenomena in terms of 'a *subliminal uprush* – an emergence into ordinary consciousness of ideas matured below the threshold'.[13] These spiritualists had a conception of the mind in two layers, the conscious mind and subliminal or 'subconscious' layer – an idea that Freud was to reject. For the spiritualists, the medium was a transmitting vessel, but Breton made a clear distinction between the surrealist use of automatism from the mediums and occult spiritualists. His interest in spiritism anyway came more via psychology.

Breton had read the writings of Theodore Flournoy, Professor of Psychology at the University of Geneva, who was interested in the phenomenon of 'mediums' and conducted a study of Hélène Smith (pseudonym of Catherine Muller). She was renowned for being able to get in touch with her previous 'multiple selves', her different identities in former lives: a fifteenth-century Indian Princess, Marie Antoinette and even more astonishingly as an inhabitant of the planet Mars.[14]

10 F. W. H. Myers, *Human Personality and Its Survival of Bodily Death*, 2 vols (London: Longmans, 1903). For a graphic account of first-hand automatic writing experiments see Gertrude Stein and Leon M. Solomons, *Motor Automatism* (1898) (New York: Phoenix Book Shop, 1969).

11 W. H. Salter, *The Society for Psychical Research, an Outline of Its History* (London: Society for Psychical Research, 1948), p. 32.

12 See, for example, *Proceedings of the Society for Psychical Research*, 1891–92.

13 Myers, *Human Personality*, p. 20. The 'uprush' of subliminal forces included: 'genius', hysteria, motor automatisms, sensory automatisms and automatic writing (see p. 222).

14 Theodore Flournoy, *Des Indes à la Planète Mars* (Paris: Fischbacher, 1899). See also Ellenberger's account, on which I have drawn here (Ellenberger, *Discovery*, pp. 315–17).

Such material was fascinating. To the psychologist, the origin of these messages was quite different from Smith's mediumistic explanation. Flournoy attributed the source of Smith's vivid hallucinations to books that she had read as a child; thus the medium's visions and utterances were projections of 'forgotten' memories and wish fulfilments (a return of the once familiar as an uncanny other self). Breton and the surrealists were closer to the psychological interest in spiritism of Flournoy, motivated by the idea of an 'unconscious' split off from consciousness, rather than any deep mysticism about living spirits sending messages from parallel, other or past worlds. In this respect, the surrealist concept of psychic automatism was based in a rationalist account of the mind rather than a spiritualist one and due no doubt to the medical and psychiatric training that Breton and other surrealists had received.[15]

Psychical Training

At the beginning of the 'Great War' in 1914, André Breton at the age of eighteen had become a medical student at Val-de-Grâce auxiliary hospital, and (unknown to him then) Louis Aragon too. From here Breton was conscripted into medical military service at the French Second Army division at the Saint-Dizier psychiatric hospital in Nantes. This is important in the history of surrealism because of Breton's meeting, in 1916, with Jacques Vaché, a soldier being treated for a calf wound who seemingly spent his time in a permanent state of distraction, often intoxicated by opium.[16] Vaché, who was well read, showed Breton the virtue of directing his path in life according to the whims of his desire; for example, they hopped from one cinema to another whenever the film bored them and ate a picnic in the cinema when they felt like it. With their refusal to be sutured into one film they created through these disruptions their own montaged 'hybridized' multi-film movie (a cinematic precursor to today's television 'zapping'), a combination of bits from different films.

Breton's encounter with Vaché was clearly an important one for surrealism, but the effects of the whole clinical experience of psychiatry at these hospitals on Breton should not be underestimated, especially in terms

15 Many of the surrealists had backgrounds in medical or psychiatric training, apart from Breton. This included Louis Aragon, Jacques-André Boiffard, Max Ernst, Pierre Naville. Some of the surrealists had analysis, René Crevel, Raymond Queneau and many of the key 'dissidents': Antonin Artaud, Georges Bataille and Michel Leiris. According to Elisabeth Roudinescou, Philippe Soupault 'was the son of a renowned gastroenterologist and refused to become a physician' (*Jacques Lacan and Co.*, p. 5).

16 Maurice Nadeau gives a short account of Breton's meeting with Vaché in *The History of Surrealism*, pp. 53–4. On Nantes and surrealism see *Le rêve d'une ville, Nantes et le surréalisme* (Nantes: Museé des Beaux Arts de Nantes, 1994).

of what he and the surrealists took from it to surrealism. It was at Saint-Dizier that Breton first heard of Freud's 'associative' techniques and (unofficially) experimented with them, recording patients' dreams and encouraging them to make free associations. The startling images produced by these traumatized soldiers, many from the front and suffering delirium from 'shell-shock', astonished the young Breton.[17] One soldier Breton met was a war hero for his actions on the front, but owed his heroism to the fact that in his mind the war was a complete simulacrum; the bodies were real but had been taken from operating tables of hospitals and distributed around the battlefields at night, shells were blanks, injuries were make-up and so on. Other soldiers suffered from hysterical attacks, condemned to relive the traumatic horrors of the trenches, muttering in their dreams or tortured by the sight of certain objects and uncertain fears. Breton drew on these experiences later in his life and work. In 1917 he moved to the famous La Salpêtrière Pitié Hospital in Paris where Jean Charcot had once developed his studies in hysteria (attended by Freud). Breton became a temporary assistant under Joseph Babinski, with whom he was apparently much impressed.[18] In a book on hysteria in 1918, Babinski wrote, 'The number of soldiers suffering from hysterical disorders is considerable, and many of them have been kept idle in hospitals for months.'[19] At the end of the First World War Breton was familiar with the poor clinical treatments that psychically traumatized ('shell-shocked') soldiers endured in psychiatric hospitals. With this and a brief spell at the war front as a medic he saw for himself the brutal physical and psychological effects of trench warfare. His experiences of the military barbarism, the patent disregard for treatment of psychological aspects of war neuroses by these institutions, were to fuel Breton's unremitting hostility to psychiatric institutions as much as to war itself. Thus, by the time Breton and Soupault were conducting their experiments in automatic writing, psychological theories were already something they were both familiar with.

In French psychiatry 'automatism' had been observed in human beings by Jean Charcot, but was most famously taken up and developed by his student, Pierre Janet, in

17 See Breton's interview with André Parinaud, *Conversations: The Autobiography of Surrealism*, trans. Mark Polizzotti (New York: Paragon, 1993), pp. 20–1. Also Mark Polizzotti, *Revolution of the Mind: The Life of André Breton* (London: Bloomsbury, 1995), p. 51.

18 Sarane Alexandrian, *Le Surréalism et le rêve* (Paris: Gallimard, 1974), p. 49.

19 Joseph Babinski, *Hysteria or Pithiatism* (London: University of London Press, 1918), p. xv. Babinski's book makes no reference to Freud's work on hysteria at all, but this is perhaps less due to the post-war taboo on 'Germanic' ideas as it was to the radical concepts to be found there. Freud himself noted the poor reception of his ideas in France in 1927. The first translations of Freud were by Jankelevitch in 1921. A sense of the mood of the period is given by a Dr Berillon, reported as responding to a question about 'German Psychology' by saying that he was writing an article called 'Odeur infecte des Allemands' (see Angelo-Louis-Marie Hesnard, *De Freud à Lacan* [Paris: Editions ESF, 1970], p. 25).

his huge volume *L'Automatisme Psychologique* (1889).[20] Janet, a trained philosopher who became Professor of Psychology at the Collège de France, observed through his clinical work at a Le Havre hospital and studies with Charcot that hysterical patients had the capacity to manifest thoughts in writing which, due to their illness, they were not otherwise conscious of: 'a patient who declares that they cannot remember certain events' could with 'involuntary writing' recall them. From this, Janet developed 'automatic writing' as a cathartic treatment where, under hypnosis, a patient could write down, if asked, things which they could not consciously remember. Automatic writing could work, Janet reports, only 'when the patient is in a state of distraction; as soon as they pay any attention to their writing everything stops and the remembrance is no longer obtainable'.[21] Further he notes, 'conscious attention, far from facilitating automatic writing as would happen to a simulator [fake], absolutely represses it'.[22] The surrealists drew on these ideas in Janet for automatic writing, but they rejected his moral views about this state of 'distraction'.

Separate from automatic writing as a form of treatment, Janet classified 'psychological automatism' as a mental condition prone to malady and divided it into two groups: total and partial. Total automatism extended to the human subject as a whole where the entire 'personality' became submerged in 'automatic' behaviour as, for example, in artificial somnambulism (like hypnosis) or in catalepsy (a trance or a 'convulsive' seizure) as suffered by many hysterical patients. Partial automatism meant that only a part of the subject was affected, as split off from the awareness or consciousness of the 'personality'. It was this split part that could become autonomous, or total even, as a 'subconscious' development.[23] For Janet, hysterical illness was the product of an abnormal restriction in consciousness due to lack of synthesis between what he called the 'higher' and 'lower' tendencies in the mind.[24] Janet claimed that the origin of this lack of synthesis was 'psychological weakness' (a synonym for the then popular notion of inherited 'degeneracy') which supposedly caused the 'activation of an inferior tendency'.[25] Janet saw hysterics as suffering from a kind of mental weakness, a degrading

20 Pierre Janet, *L'Automatisme Psychologique* (Paris: Alcan, 1889).

21 Pierre Janet, *The Mental State of Hystericals* (London: Knickerbocker Press, 1901), p. 105.

22 Ibid., p. 281.

23 See Ellenberger, Chapter 6, *Discovery*, especially pp. 359–66. Also Herman Rapaport, 'Theories of the Fantasm', *Between the Sign and the Gaze* (London: Cornell University Press, 1994). Both accounts reassess the legacy of French psychiatry for subsequent French psychoanalysis though in different ways, and posit Janet's work as a key source for surrealists and Lacan.

24 Freud and Breuer take issue with Janet in their *Studies on Hysteria*, PFL 3.

25 Pierre Janet, *Principles of Psychotherapy* (London: George Allen and Unwin, 1925), p. 138.

of elementary 'automatic' mechanisms, where the things that 'normal' individuals do mechanically, 'without thinking', had simply collapsed. For example, a pinch on the arm resulting in its automatic withdrawal, or food placed on the pharynx causing a swallowing action to occur might cease to function in hysteria. Janet summarized:

> If, in a general way, we call automatism the activation of an inferior tendency that escapes from the control of superior tendencies and especially the provocation of an immediate assent, instead of a reflective assent, we may say that the essential part of the treatments we are considering is the provocation of automatic actions instead of superior and reflexive actions.[26]

For Janet the hysteric's automatic actions had fallen outside the sphere of consciousness as though the subject had 'forgotten' to do them. Without any concept of 'repression' or the unconscious, this pre-Freudian theory determined that automatic actions were synonymous with 'subconscious' actions. Hence Janet used suggestion on patients under hypnosis to 're-instal' automatic functions where they had declined or failed in an attempt to put them back into the 'higher tendencies' of consciousness proper.

Breton argued that in surrealism automatic writing was used to find 'nothing less than the *unification* of that personality'.[27] This was like Janet's view of hysterics, in that a part of the whole 'personality' was missing or lacking and had to be reunified with the 'higher tendencies'. In this respect the surrealists could be seen to be 'imitating' Janet's treatment of hysterics, using automatic writing in a state of distraction to 'capture' unpremeditated thoughts and induce psychically automatic images. Breton's medical experience for this was crucial. He would certainly have understood that the subject could be 'divided' from his experience of the traumatized soldiers in hospitals where terrible scenes recurred insistently in their nightmares but not in their waking life.[28] From such 'splitting' the surrealists could conceive 'psychical automatism' as a means to produce not only images of stunning vivacity, but also bring

26 Ibid., p. 138.

27 André Breton, 'The Automatic Message', reprinted in F. Rosemont (ed.), *What is Surrealism?* (London: Pluto, 1989), p. 105.

28 This is what Freud explored as the phenomenon of the 'compulsion to repeat' as a symptom of traumatic neurosis in 'Beyond the Pleasure Principle' (1920). That the patient was fixated to the traumatic experience in their dreams, but positively avoided it in conscious thought is made clear: 'I am not aware, however, that patients suffering from traumatic neurosis are much occupied in their waking lives with memories of their accident' (*On Metapsychology*, PFL 11, p. 283).

hidden mental thoughts to light. But the surrealists differed from Janet's automatic writing treatment, since they were not in the first place clinically ill and second, they advocated what in Janet's view was actually a state of 'mental weakness'. Here were the surrealists, not only claiming that a state of distraction was worthy of attention, but also that it could give rise to literary works.

While today Janet's pre-Freudian theory might sound crude, it was nevertheless part of the advance away from nineteenth-century mechanical models of the mind. In 1868 'psychological automatism' had been defined by Prosper Despine as the product of a 'living machine devoid of consciousness', a sort of brain-dead automaton, an uncanny image (of death), an animated inanimate 'walking dead' robot.[29]

Janet's achievement was the demonstration that a human is involved in automatic actions in everyday life activities without being reduced to the status of an android machine. He proved that psychological automatism is a fact of human activity and defined it as 'a psychological phenomenon in its own right, always entailing a rudimentary consciousness'.[30] However, what this theory did not have or recognize was the concept of the unconscious or its connection with sexuality. It was Joseph Breuer and Sigmund Freud who developed the unconscious as subject to and constituted by repression and psychical conflict in their studies of hysteria.[31] Hysteria was the enigmatic illness of the nineteenth century. The sudden unaccountable paralysis of a limb, organ, or temporary loss of function of part of the body (with no explicable organic cause) were all symptoms that scientists found hard to explain. Invariably, prior to Freud and Breuer hysteria was attributed to either laziness (no doubt because of the apparent theatricality of hysterical attacks), a mental malfunction or a congenital deficiency of the brain. The debates over the cause of the illness 'hysteria' as a form of neurosis developed from Charcot's attempts to treat the symptoms as signs of a psychical disorder. The physical expressions (contortions, paralysis etc.) were representations, substitutes for mental ideas that had been (sometimes long) 'forgotten', repressed. (It was Freud who noticed that the

29 Prosper Despine, *Psychologie Naturelle* (Paris: Savy, 1868), Vol. 1, pp. 490–1, cited in Ellenberger, *Discovery*, p. 359.

30 Ibid., p. 355.

31 Sigmund Freud and Joseph Breuer, *Studies on Hysteria* (London: PFL 3, 1988).

babbling talk was also a symptom and developed from this psychoanalysis as a 'talking cure'.) A simple typical hysterical symptom is given by Breuer and Freud: 'We may take as a very commonplace instance a painful emotion arising during a meal but suppressed at the time, and then producing nausea and vomiting which persists for months in the form of hysterical vomiting.'[32]

In Janet's account of hysteria (the illness in which medical/psychological problems and theories were then fought out) he argued that the subject's consciousness had been split due to psychological 'weakness' (a double consciousness), thus the aim of 'automatic' therapy was to help resynthesize the weaker part into the stronger part. Breuer, with whom Freud first worked on hysterical patients in Vienna, disagreed with Janet's thesis. Breuer argued that the 'weakness' observed by Janet was an effect of the divided state of mental activity in hysteria, not its cause.[33] Janet had inverted the effect for the cause. For Breuer and Freud 'psychological weakness' was a product of hysteria; the cause lay elsewhere. Freud and Breuer argued that hysteria in men and women was not derived from 'mental weakness' but from a repression of the function due to a psychical conflict between different agencies, conscious and unconscious, a conflict whose origin was primarily sexual. (An argument that Janet never accepted, even though he noted the endemic 'baseness' in his patients' crises.)

Clearly missing from Janet's account and scandalous when introduced by Freud was the part played by sexuality. The obstinate refusal on the part of psychologists like Janet (a repression as deep among psychologists as their patients) of recognizing any connections between hysteria and sexuality left the 'babbling' content of hysterics without any signifying motivation. Their 'language' was dismissed as mere 'gibberish', a nonsensical avoidance of 'work'. It was significantly this issue of sexuality, repression and symptom as signifying cause which divided Freud's theories from Janet in the path of theorization he was to take. Freud looked at the patient's symptoms *and* listened to him or her.

The surrealists went their own way, drawing their own different (non-clinical) conclusions. When they celebrated 'The Fiftieth Anniversary of Hysteria' in *La*

32 See Freud and Breuer, 'On the Psychical Mechanism of Hysterical Phenomena: Preliminary Communication' (1893), *Studies on Hysteria*, p. 54.

33 See ibid., especially pp. 309–13.

9 'The Fiftieth Anniversary of Hysteria' as a double-page spread published in *La Révolution surréaliste*, no. 11, March 1928. Photographs are from Charcot's nineteenth-century experiments at La Salpêtrière Hospital in Paris (see also Figure 15).

Révolution surréaliste (no. 11, March 1928) with photographs it was as a 'poetic' discovery of automatic expression more than to make a social scandal (see Figure 9).

The six photographs of Charcot's famous hysterical patient Augustine (taken from volume two of Bournville and Regnard, *Iconographie photographique de la Salpêtrière*, 1877–78) were accompanied by a brief assessment of contributions by Charcot, Babinski and Freud to the study of hysteria. The short article concluded with the surrealists' own 'fresh' definition: 'Hysteria is not a pathological phenomenon and may in all respects be considered as a supreme means of expression.'[34] Hysteria is conceived as a kind of 'emotional attack', as a worthy form of expression outside literature or illness. These views by Louis Aragon and André Breton directly contradicted those of Babinski who, they note, 'dared' to publish in 1913, 'When an emotion is sincere and profound, and it stirs the human soul, there is no room for hysteria.'[35] For Babinski, they claimed, hysteria was 'a pathological condition manifested by disturbances which in certain subjects can be reproduced with complete exactness and are apt to vanish under the influence of persuasion (counter-suggestion) alone'.[36] Against Babinski's dismis-

34 The text is translated and published in Rosemont (ed.), *What is Surrealism?*, pp. 320–1.

35 Ibid., p. 320.

36 Ibid., p. 321.

sive attitude towards hysteria, the surrealists celebrated it as an expression (but not symptom) and aligned themselves against the dominant views of French psychiatry and closer to Charcot and Freud. Elisabeth Roudinesco comments: 'For the surrealists, hysteria was a language, a means of expression, a work of poetry whose subversive form ought to be championed against art itself, against literature … They refused to reduce hysteria to malingering and differentiated it from systematic forms of madness …'[37]

Like Babinski, Charcot, Janet, Breuer and Freud, the surrealists used hypnosis, but on themselves, again without the therapeutic clinical aims of cure or analysis. That the discovery of hidden 'repressed' thoughts under hypnosis could reveal seriously unpleasant material became quite evident in the surrealist so-called 'period of trances' between 1922 and 1923.[38] Accounts of the experiments were written up in *Littérature*. Conducted by Breton and those around him, the group experimented with hypnotic trances to bring out automatically produced material in speech, writing and drawing. René Crevel and Robert Desnos in particular showed their susceptibility to hypnosis, but also showed dangerous violent tendencies. Breton, familiar with these techniques from his hospital days, stopped the experiments when they became dangerous; he caught Crevel apparently leading a group of entranced men and women into an attempt at collective suicide by hanging. On another occasion Robert Desnos chased Paul Eluard with a knife, trying to kill him.[39]

This was all very different from hypnosis in psychiatry. Janet conceived of the 'sick' individual as suffering from a constitutional incapacity to bring 'lower' automatic processes into connection with higher ones, and used hypnosis (artificial automatism) to rejoin them. Freud used hypnosis in the treatment of hysterical patients to discover the repressed dramas causing the symptoms, but he rejected hypnosis, due to clinical reasons; in the long term hypnosis 'cures' faded (as Janet also admitted) and were ineffective, since they only treated symptoms and not the actual cause. Dreams and their interpretation became the more effective technique for Freud, as the 'royal road to the unconscious'.

37 Roudinesco, *Jacques Lacan and Co.*, p. 7. See also David Macey's 'Retrospective', in *Lacan in Contexts* (London: Verso, 1988).

38 Maurice Nadeau coins this term 'The Period of Trances' as the title of Chapter 5 in *The History of Surrealism*, trans. Richard Howard (London: Plantin, 1987).

39 See André Breton, *Conversations: The Autobiography of Surrealism* (New York: Paragon, 1993), p. 70. Also see Matthew Josephson, *Life Among the Surrealists* (New York: Holt, Rinehart and Winston, 1962), p. 221.

Rhetoric of the Unconscious

André Breton's own theorization of the automatic image was elaborated in the 1924 *Manifesto of Surrealism*. First, he said, the surreal image must come without volition 'spontaneously, despotically'.[40] Second, the '*value* of the image depends upon the beauty of the spark obtained; it is, consequently, a function of the difference of potential between the two conductors'.[41]

In Breton's electrical metaphor he is looking for something else than a poetic 'inspired' signification. He seems to be grasping for a way to say that the image should be triggered, 'sparked', by something outside conventional discourse and beyond the parameters of the conscious mind, as an image that has 'seized nothing consciously':[42]

> We are therefore obliged to admit that the two terms of the image are not deduced one from the other by the mind for the specific purpose of producing the spark, that they are the simultaneous products of the activity I call surrealist, reason's role being limited to taking notes of, and appreciating, the luminous phenomenon.[43]

The psychical image is to be produced without intention, it must come from 'somewhere else' while the conscious part of the subject's mind passively watches its eruption as a spectacle. If this 'spark' is produced by the disparity of the elements in the image, Breton nevertheless rejects certain types of image in explicitly rhetorical terms. Referring to rhetorical figures based in difference he claims that, in the figure of antithesis the 'spark is missing', whereas in comparison the difference is too slight, while the alternative ellipsis is a figure of subtraction that Breton 'deplores'. Avoiding the classification of surrealist images in rhetorical terms, the author of the *Manifesto* nevertheless claims that the common denominator and greatest virtue is given in the type of image

> that is arbitrary to the highest degree, the one that takes the longest time to translate into practical language, either because it contains an immense amount of seeming contradiction or because one of its terms is strangely concealed … or because it derives from itself

40 Breton, *Manifesto of Surrealism*, p. 36.
41 Ibid., p. 37.
42 Ibid.
43 Ibid.

a ridiculous formal justification, or because it is of a hallucinatory kind, or because it very naturally gives to the abstract the mask of the concrete, or the opposite or because it implies the negation of some elementary physical property, or because it provokes laughter.[44]

Breton gives an example. While falling asleep one evening, he notes 'a strange phrase which came to me' that had nothing to do with anything which he was conscious of. He does not remember it exactly, but the phrase was something like 'there is a man cut in two by the window'. This phrase insinuated itself, he says, accompanied by a 'faint visual image' of a man walking 'cut halfway up by a window perpendicular to the axis of his body'.[45] Breton produces an image which he is not able to reveal the origin of:

> Beyond the slightest shadow of a doubt, what I saw was the simple reconstruction in space of a man leaning out a window. But this window having shifted with the man, I realized that I was dealing with an image of a fairly rare sort, and all I could think of was to incorporate it into my material for poetic construction. No sooner had I granted it this capacity than it was in fact succeeded by a whole series of phrases, with only brief pauses between them, which surprised me with the impression of their being so gratuitous that the control I had then exercised upon myself seemed to me illusory and all I could think of was putting an end to the interminable quarrel raging within me.[46]

There are at least four points to be drawn from this example. First, its *form*: as Breton notes, the image itself takes the form of a 'phrase' as a set of words. The visual image produced is constructed through linguistic signs. In a footnote to his example, Breton comments on the relative strengths of auditory and visual types of phenomena, stating that it was his prior predisposition to auditory phenomena that gave them the emphasis over the visual. 'Were I a painter,' he wrote, 'this visual depiction would doubtless have become more important for me than the other.'[47] Second, the image produced is *cryptic*, a laconic picture. The scene depicted is a kind of rebus or hieroglyph, 'a model of writing irreducible to

44 Ibid., p. 38.
45 Ibid., pp. 21–2.
46 Ibid., p. 22.
47 Ibid., p. 21, note.

speech', as Jacques Derrida once described it.[48] Third, that for Breton at this time the *recording* of the image is itself simply enough; in so far as it gives rise to a surreal image, it is not subject to any analysis as in Freudian praxis. It is not the starting point for an interpretation. The image has a (designified) value in itself as the recognition of a 'psychical thought', as opaque and 'marvellous' (enigmatic). Fourth, the 'interminable quarrel raging within' which Breton notes demonstrates the relation of the image to an unresolved *psychical conflict*. That the image is one in a string of images which are in some sense disturbing for Breton is his stated reason for attempting to terminate their flow: 'all I could think of was putting an end to the interminable quarrel raging within me'. Breton tacitly admits to having invoked a psychical conflict; the image is far from 'gratuitous' or 'arbitrary' and supports the very psychical determinism the surrealist theory of the image was premised upon.

It is the radical disparity of signifying elements of the image that Breton insists upon as the definition of the value of the surrealist image in the 'spark obtained'. Thirty-three years later, Jacques Lacan will pay homage to this in his essay 'Agency of the Letter in the Unconscious', that 'modern poetry' (surrealism) had demonstrated the constitution of metaphor, which Lacan then also laconically critiques as a 'confused position based on a false doctrine'.[49] Lacan:

> The creative spark of the metaphor does not spring from the presentation of two images, that is, of two signifiers equally actualized. It flashes between two signifiers one of which has taken the place of the other in the signifying chain, the occulted signifier remaining present through its (metonymic) connexion with the rest of the chain.[50]

One sign stands in for another in metonymic and metaphoric (disrupted) chains of association. The 'creative spark' emerges in this substitutive activity between the metamorphosed elements and this is where the psychical conflict of the image potentially manifests itself. To take a visual example, in Man Ray's *Le Violon d'Ingres* the 'f-holes' in the picture are a metonymy (a part of the sign stands in) for a whole violin. This

48 Jacques Derrida, 'Freud and the Scene of Writing', *Writing and Difference* (London: Routledge and Kegan Paul, 1981), p. 209.

49 Jacques Lacan, 'Agency of the Letter in the Unconscious', *Ecrits, a Selection*, trans. Alan Sheridan (London: Tavistock, 1982), p. 157.

50 Ibid.

metonymy f-holes (= violin) also figures as a metaphor (one thing is substituted for another) of the female body (violin – female body). What Lacan refers to as the 'occulted signifier' (and Jean Laplanche proposes as the enigmatic signifier in his theoretical model) is the part of the sign that remains present throughout the rhetorical substitutions, but is nevertheless hidden from view. In Man Ray's picture this is the unresolved conflict in reading the picture as a violin or a woman's body (see Chapter 4 for analysis).

Lacan in fact links the surrealist image to the model of Freud's dream-work, where the dream-image produced is not the 'unconscious' itself, but rather a representative of an unconscious thought which has been subject to, worked over and shaped by repression and censorship. This is precisely the relation of manifest content (secondary conscious and preconscious processes) to latent dream thoughts (primary unconscious processes). The latent dream thought (unconscious) forces its way into consciousness as manifest content. That a dream-image typically arises during sleep, whereas the surrealists made efforts to invoke such surreal images while partially awake, should not divert our attention from the fact that we are just as susceptible to the efficacy of the unconscious in the waking state as when we are asleep. Freud's book, *The Psychopathology of Everyday Life*, is a veritable catalogue of examples of how any sign in all its manifestations (a gesture, an action, speech, writing, intention etc.) can be distorted, mutated, replaced, confused, forgotten, activated or obliterated through the presence of unconscious processes during the waking state.

As in dreams, the material is not intended to 'make sense' because the material is only permitted to emerge into consciousness as the failure of a censorship. Censorship does not entirely prevent the material emerging, but functions to distort the representative signifier, forcing a rhetorical mutation through the dream-work: condensation, displacement, means of dramatization and secondary revision (in whatever form, visual, verbal, motor etc.). Like the game of charades where syntax is lost and picture sign 'scenes' are used to replace linguistic phrases, the unconscious wish has to find substitute images to force its way into a preconscious content.

In the 'process of condensation' dream-thoughts, in varying degrees, are omitted and the ones that remain represented in the condensation are left because they are 'over-determined' by their content. An over-determined image is organized by several determinant factors, for example, the image of a man condenses, combining features of several individuals.[51] The second mechanism of displacement, or 'veering off', seeks to avoid censorship by 'translating' one thing into another. For example, clothing might be the displaced (metonymic) sign for an individual associated with it.[52] It is these mechanisms, condensation and displacement which account for the strangeness, the rebus puzzle-like quality of dream-images in surrealism, like Breton's 'man cut in two by a window'. Through condensation and displacement, an unconscious thought emerges disguised within the preconscious–consciousness system.

Freud's 1915 essay on 'The Unconscious' shows the compatibility of surrealism with, at least, his theoretical view of the production of thought processes close to the unconscious:

> In the last few pages of *The Interpretation of Dreams*, which was published in 1900, the view was developed that thought-processes, i.e. those acts of cathexis which are comparatively remote from perception, are in themselves without quality and unconscious, and that they attain their capacity to become conscious only through being linked with the residues of perceptions of *words*. But word-presentations, for their part too, are derived from sense-perceptions, in the same way as thing-presentations are; the question might therefore be raised why presentations of objects cannot become conscious through the medium of their own perceptual residues ... being linked with word-presentations is not yet the same thing as becoming conscious, but only makes it possible to become so ... [53]

Thus, properly speaking, the psychic automatism claimed by the surrealists (the stimulation of an enigmatic image) is a means to invoke unconscious 'ideational representatives', 'thing-presentations' with a successful image, as Breton puts it in the *Manifesto*, 'where its obscurity does not betray it'.[54]

51 Freud's example is the condensation of his Uncle Josef and his friend 'R'. See Chapter 4 in *The Interpretation of Dreams*.

52 I am drawing here on Ella F. Sharpe's account of dreams in her *Dream Analysis* (London: Hogarth Press, 1937), p. 24. She draws the analogy between figures of rhetorical speech and the mechanisms of the dream-work long before Jacques Lacan.

53 Sigmund Freud, 'The Unconscious', *On Metapsychology*, PFL 11, pp. 207–8.

54 Breton, *Manifesto of Surrealism*, p. 37.

The question of how unconscious material in what Freud calls the 'ideational representative' comes to be represented as a manifest content is also dependent upon the 'means of representation', that is, the available means of 'dramatization' for its *mise-en-scène*.[55] The mind 'borrows' from conscious scenes or conflictual events that have usually occurred in the days prior to the dream to stage the dream's scene. The manifest content of the dream is then subject to 'secondary revision' as the dreamer brings to bear conscious censorship when the dream-content is articulated within discourse by suppressing or deleting elements of the material found uncomfortable or unpleasant (discarded as 'irrelevant' etc.). The condensation, displacement, means of dramatization and secondary revision are component mechanisms of what must inevitably take place in the process of automatic writing or its equivalent means. By the time the image has been transcribed, it is subject to secondary revision (repression and censorship) in addition to the means of dramatization. Thus, theoretically speaking, psychic automatism would be something struggled for, with conscious censorship and repression as obstacles to be overcome and measured in terms of the realism of the unconscious. Jean Laplanche: 'That which comes from the unconscious intervenes as a reality (itself conflictual) in the midst of the conscious "text", which therefore appears much less coherent: sometimes lacunary, sometimes, on the contrary, with moments of unjustifiable intensity and insistence.'[56]

The 'unnatural image' of Breton's man cut in two by a window would appear to be electable to such a category of image; it also has a clear affinity with the 'visual' examples given by Freud at the beginning of 'The Dream-work' in *The Interpretation of Dreams*, where he gives rebus 'picture-puzzles' as illustrations of a dream-image. (A man with a comma for a head, a house with a boat on the roof, a letter of the alphabet with the figure of a man running away.)[57] For Freud, such images could not be read for their literal content as representations, but demanded a translation (dream-work analysis) of their distortion (chain of signifiers) effected by repression. Breton's image is not just an image of 'castration', a man cut in two by a window (paradoxically

55 In the English translation of Freud this is the 'means of representation'. I have substituted Ella Sharpe's term 'dramatization' here to emphasize the sense of staging that this gives.

56 Jean Laplanche, *Essays on Otherness* (London: Routledge, 1999), p. 88.

57 Sigmund Freud, Chapter 6 in *The Interpretation of Dreams*, PFL 4, 1980, p. 382.

by glass – something that 'cannot be seen'). It is also the image of a figure halfway through one place to another (interior/exterior), like the mirror in *Alice in Wonderland* that signifies the membrane between two worlds. In the image Breton is caught, trapped 'between' places in the position of a splitting.[58] It was precisely a splitting of the subject (a chiasmus) that surrealism demanded the subject occupy, as a spectator to their own thoughts. An act that simultaneously reasserts and thwarts the cogito of Descartes 'I think therefore I am'.[59] The surrealists' meditation on presence in the world tries to situate the subject where it is *not* thinking, within the productivity of the unconscious and its thing-presentations.

But with the automatic image produced in the mind, a means of concrete registration, of representation had to be found, deployed for its public signification. With the subject supposed to be the spectator (ex-centric) to their own thought production processes, the art was to 'capture' an image as it passed through the mind and find a form (rhetoric/means of dramatization) for its signification.

For the concept of 'psychic automatism' Breton knew and drew on distinctions previously made in French psychiatry by Jean Charcot. Charcot had synthesized nineteenth-century studies on '*endophasie*', the concept of 'inner speech', a *langage intérieur*. Charcot classified different categories of manifestation of interior images into *verbo-auditif* (heard voice), *verbo-moteur* (motor speech, body movements, hands etc.) and *verbo-visuel* (spoken images). Breton, aware of such categories, did not take for granted these definitions and borrowed from them for the idea of an automatic image in surrealism. These categories of inner speech were already in wider use, not only in discussions about psychology, but also about the status of these 'inner voices' in literature.[60] Jean Cazaux in his short study *Surréalisme et psychologie* (*Surrealism and Psychology*) (1938) catalogues the interest in interior speech in psychology and in relation to the simultaneous, but separate interest within literary circles. Cazaux notes the tendency of 'modern' literature to draw on the psychological domain of human activity and argued that the works of Marcel Proust, James Joyce and surrealists all show different types of interest in an

58 It might have been worth quoting Lacan here for a passage tailor-made to open up Breton's example for analysis: 'the interest the subject takes in his own split is bound up with that which determines it – namely, a privileged object, which has emerged from some primal separation, from some self-mutilation induced by the very approach of the real, whose name, in our algebra, is the *objet a*.' Jacques Lacan, *The Four Fundamentals of Psychoanalysis* (London: Hogarth Press, 1979), p. 83. This supports the thesis that uncanny images are derived from and rooted in the return of a primal/original fantasy.

59 Lacan famously plays with this formulation: 'What one ought to say is: I am not wherever I am the plaything of my thought; I think of what I am where I do not think to think' (*Ecrits*, p. 166).

60 See Jean Cazaux, *Surréalisme et psychologie* (Paris: Librarie José Corti, 1938), pp. 13–20. Freud also refers to Charcot's use of the inner speech categories in his essay 'Childhood and Screen Memories' (see Freud's *The Psychopathology of Everyday Life*).

'internal monologue'.[61] Cazaux posited a fundamental distinction between the poem and automatic writing, and makes a positive case for automatic images as psychic expressions of past experiences (their cause). In contrast, poetry in its general sense, he argues, also operates on the past, but the material of a poem is more often related to the desire to create something and present it. Poems are composed of signs which make words that figure as the substitute of a defined moment of a poet's experience. The signs are inseparable from the signifying intention to enable that moment of 'interior life' which the poet is intending to display to be refound by the reader.[62] In contrast, surrealism negated the intention of 'creation'. In surrealism, automatism remains, he argued, the inanimate content of an object, a non-knowledge where intentionality is not applicable. Proper surrealist automatic writing resembled a delirium or 'mental alienation' with no 'proper finality'. Thus for Cazaux, poetry and 'psychological' literature are linked in 'cognitive thought' whereas proper automatic writings produced by the surrealists were the products of 'psychical expression'.

To this end of achieving the material representation of psychical thought, the surrealists experimented with different methods and techniques of automatism, just like the psychiatrists. They modified and tried different means of achieving states of psychic automatism. What began as automatic writing in a state of distraction, turned to recording of verbal utterances in hypnotic trances, automatic drawing, dream recitals, chance encounters and the production of 'dream-objects', all so many means of making surrealist images. These various techniques, as part of an ongoing practice within 1920s surrealism, developed into an issue as to whether a 'psychical automatism' could occur with such a thing as 'visual' surrealism.

Visual Surrealism

Well known in the history of surrealism, one first key dispute around the new 1924 journal *La Révolution surréaliste* was the iconoclastic assertion of its first editor, Pierre Naville, that a 'surrealist painting' was a contradiction in terms: 'Everyone knows that there

61 Cazaux, *Surréalisme et psychologie*.
62 Ibid., p. 60.

is no *Surrealist painting*', he claimed.[63] Breton objected and took over editing of the journal and, going further, asserted in four separate issues of *La Révolution surréaliste*:'Le Surréalisme et la peinture' ('Surrealism and Painting').[64] These four articles were then collectively published as a separate book, *Le Surréalisme et la peinture* (*Surrealism and Painting*), in 1928 with photogravure plates of various works by ten artists, as illustrations to support the argument: Pablo Picasso, Georges Braque, Giorgio de Chirico, Francis Picabia, Max Ernst, Man Ray, André Masson, Joan Miró, Yves Tanguy and Jean Arp.[65] All this was not merely a power play between Naville and Breton, but also a theoretical dispute over what forms a surrealist image could take. Hitherto the automatic image had been primarily conceived in literary terms. Automatic writing, dream recitals and monologues under hypnosis all had understandable relations to states of psychic automation as the mode of producing images. But could a state of distraction be maintained with highly technological processes? How could the 'contrived' field of painting, for example, relay visually the automatic images of mental or 'psychical' images? This was Naville's objection.

In the first *Manifesto* the issue had been made quite clear:'psychic automatism' *is* surrealism, no matter what form of representation it takes: 'verbally, by means of the written word, or in any other manner'. Whatever Breton or Naville personally privileged as the means to surrealist images, the form of 'psychic automatism' was not dogmatically proscribed. Even in the later essay 'The Automatic Message' (1933) where André Breton claims auditory ('verbo–auditive') automatism to be the 'infinitely richer' source of 'visual meaning', he does so with a caution that lays down a gauntlet for artists:'This much having been said, the painters obviously are now the ones to speak, whether to contradict or not.'[66]

In the early episodes of *Surrealism and Painting* Breton railed, as he had in the *Manifesto*, against art based in mimetic realism. 'What does it matter to me whether trees are green, whether a piano is at this moment "nearer" to me than a carriage, whether a ball is cylindrical or round?'[67] And if Breton envisages a picture as 'a window' and poses the question 'to

63 Pierre Naville, 'Plus personne n'ignore qu'il n'y a pas de *peinture surréaliste*' (see his 'Beaux-Arts', in *La Révolution surréaliste*, no. 3, April 1925, p. 27).

64 Breton's views are recorded in his interviews with André Parinaud, *Conversations: The Autobiography of Surrealism*, p. 98. The essays by Breton, 'Le Surréalisme et la peinture', appeared in *La Révolution surréaliste*, no. 4 (July 1925), pp. 26–30; no. 6 (March 1926), pp. 30–2; nos 7 and 9–10 (October 1927), pp. 36–43. The 1928 book included additional written material.

65 André Breton, *Le Surréalisme et la peinture* (Paris: Gallimard, 1928). The cover is metallic green with black lettering. Breton's essay was printed in its entirety with the photogravure plates set at the back in sections by individual artists.

66 See André Breton, 'The Automatic Message', in Rosemont (ed.), *What is Surrealism?*, p. 108.

67 Breton, *Surrealism and Painting*, p. 2.

know what it *looks out* on', it is not in order to follow the 'beaten tracks' of the works of art in museums. As Breton sees it, painters had been far too content with using visual models of objects 'selected from the external world'. This 'inexcusable abdication' was, he now argues, in any case to be replaced: in 'a total revision of real values, the plastic work of art will either refer to a *purely internal model* or will cease to exist'.[68] By insulating and becoming (temporally) withdrawn from the external world the mind could become preoccupied with itself, 'with its own life, in which the attained and the desired no longer excluded one another'.

In *Surrealism and Painting* Breton acts like a critic, establishing the importance of various visual artists for surrealism. While today, all the artists he mentions are canonical, we should not forget that they were then quite marginal. Against the 'utter bankruptcy of art criticism' (so-called 'scandals' of Cézanne and neo-academicism), Breton elevates the stakes of his argument against the mundane 'grocer's assistants'-type criticism; that the critical significance of a work should not be defined by the formal choice of elements. (Breton is anti-modernist.) The trajectory of his paper flows from a rejection of external 'objective' realism to Picasso's break with tradition, a guiding light for models of visualizing 'internal thought' and through to 'dream-painting' by de Chirico, two- and three-dimensional collages and frottages by Ernst, 'dream-illusion' paintings (and 'objects'), photographs by Man Ray, paintings by Yves Tanguy and Joan Miró, automatic drawings and frenetic (including sand) paintings by André Masson, combined forms and bas relief sculptures from Jean Arp.

In Breton's view, the first artist to break with 'the facile connotations' of the visual image's 'everyday appearance' and challenge the external model was Pablo Picasso, the 'creator of tragic toys for adults'. Breton claimed Picasso as 'one of us', but nevertheless distanced him from the surrealists proper, because in the application of his methods, he was not entirely surrealist. Then against Matisse and Derain (Les Fauves), Giorgio de Chirico's earlier work is praised, but his work since 1917 is rejected because, Breton contests, de Chirico 'no longer has the slightest idea of what he is doing'.[69] Next

68 In French, a '*modèle purement intérior*', ibid., p. 4.
69 Ibid., p. 13.

Francis Picabia is approvingly noted as resisting the trap of money, refusing to be constrained by a commodified style of work, but whose 'total incomprehension of surrealism' remains an obstacle for Breton to praise him. Moving on to Max Ernst and his collages of reassembled 'disparate objects according to an order, which, while differing from their normal order, did not seem on the whole to do them any violence'.[70] Ernst's work is cited as having an exemplary surreality: 'to assert *by means of the image* other relationships than those generally or, indeed, provisionally established between human beings on the one hand and, on the other, things considered as accepted facts'.[71] For Breton, this is Ernst's 'dream of mediation'; his work points to images which revolutionize 'the relationship of objects'; their substance and shadows are all a 'jigsaw puzzle of creation'. Early collages (like absurd emblems), then paintings of (propainterly) dream or 'virtual' reality scenes and various frottages, showed for Breton the dynamic propensity for Ernst's 'positive' reflection and will for constant change.

Then Man Ray, praised as a painter and one who 'strips photography of its positive nature, of forcing it to abandon its arrogant air and pretentious claims'.[72] Breton regards it

> as 'fruitless' to attempt to divide Man Ray's artistic production into photographic portraits, photographs inappropriately called 'abstract', and pictorial works properly so called. I know only too well that these three kinds of expression, signed with his name and fulfilling the same spiritual mission are all bordered at their outer limits by the same conspicuous or inconspicuous halo.[73]

Abandoned to 'the delectation' and 'justice of the shadows', the objects in Man Ray's photographs 'live and die from the same trembling'. Breton quips, 'How can we distinguish the wax hand from the real hand?' thus highlighting the ambiguous status of the photograph in relation to its referent. Moving on to André Masson, Joan Miró ('perhaps the most surrealist of us all'), Yves Tanguy and Jean Arp, Breton legitimates the artists as positive evidence of surrealist activity in painting and

70 Ibid., p. 26.
71 Ibid.
72 Ibid., p. 32.
73 Ibid.

whose works are also published throughout the different issues of *La Révolution surréaliste* edited by Breton.

Is it surprising that Breton includes photographs, collages and bas relief in essays about 'Surrealism and Painting'? This shows that 'painting' was a general term to describe various processes of rendering surrealism visually across different forms (plastic arts, objects, wood, casting, painting, drawings and photographic), rather than as any specific set of techniques involving pigments. Breton develops an expansive view of painting across these artists and their works in the same way that automatic writing served as the name for multiple modes and forms of achieving 'psychical automatism'. Breton makes it clear in his comments on Man Ray that to divide works up between 'abstract' and 'pictorial' categories is 'inappropriate'. For Breton, so-called abstract and pictorial works are simply different means to achieve the same ends of psychic automatism.

As Max Ernst said, 'frottage was merely a technical means of augmenting the hallucinatory capacity of the mind'.[74] What Ernst meant was that a technique which had an automated process could allow a state of distraction to emerge. Through such automations, the mind could be allowed to drift and aid the 'hallucination' of images without conscious interference. In frottage the 'arbitrary' tracing of worn floorboards could evoke other scenes, a wild forest, not hitherto seen. With collages, the distracted state could lead to chance juxtapositions which might rarely occur while in a fully conscious state. Similarly, André Masson's automatic drawings were made as his hand 'doodled' automatically, while his mind (exhausted from lack of sleep, drugs or other means of narcosis) was in a state of distraction, 'elsewhere' as in daydreaming or as Janet's partial automatism.

Thus, automatic writing itself did not mean 'unmediated' thought. It should not be forgotten, for example, that in automatic writing (or drawing) a pencil is already a form of technology, just as the formation of acoustic sounds in the throat into auditive signifiers, 'speech', is already a symbolic grasp of the body as a technology for signification. Hence 'hysteria' could be regarded as a form of 'motor-automatism', of writing with the body, just as automatic techniques like 'frottage'

74 Max Ernst, in Werner Spies (ed.), *Max Ernst* (London: Tate Gallery, 1991), p. 353 quoted from 'Biographische Notizen (Wahrheitgewebe und Lügengewebe)', in Werner Spies (ed.), *Max Ernst, Retrospektive* (Munich: Haus der Kunst, 1979), p. 300.

10 A film still (photograph) from Man Ray's 'cinépoéme' *Emak-Bakia* (1926) published as a photograph in *La Révolution surréaliste*, in the centre of André Breton's essay, 'Le Surréalisme et la peinture' in *La Révolution surréaliste*, no. 9–10, October 1927.

(rubbing) as a mechanical 'automatism' invoked the distracted states of hysterics more than any 'mechanization' of the process of making an image.

In this respect distinctions between images produced as 'writing' or 'visual' were deeply obscured (or combined as in emblem theory) in surrealist theories of the image. Automatic writing could be 'visual', producing doodle-like 'abstract' images with no obvious meaning or, equally, create images with words, as in Breton's example, using conventional symbolic language. Likewise, photograms (Man Ray's eponymous Rayogram) written with light could be 'abstract' with no obvious meaning or used to produce 'pictorial' representations with imaginary referents. These could all be regarded as different yet equally valid modes for experimenting with 'psychic automatist' production, irrespective of the intelligibility of the results as having a message or meaning.

75 Breton, *Surrealism and Painting*, p. 32.

Photographic Modes

While Breton had privileged a rebus-type pictorial 'dream-image' for his own automatic image example in the *Surrealist Manifesto*, it was a different matter in the essay on *Surrealism and Painting*. Both 'abstract' and 'pictorial' ('dream')-type visual images shared the stage in his valorization and it was no different when it came to photography in *Surrealism and Painting*. André Breton gave clear praise to Man Ray:

> At a time when painting, far outdistanced by photography in the pure and simple imitation of actual things, was posing to itself the problem of its reason for existence and was resolving the problem in the manner we have described [the artist's cited above], it was most necessary for someone to come forward who should be not only an accomplished technician of photography, but also an outstanding painter; someone who should, on the one hand, assign to photography the exact limits of the role that it can legitimately claim to play, and on the other hand, guide it towards other ends than those for which it appears to have been created – in particular, the thorough exploration on its own behalf, within the limits of its resources, of that region which painting imagined it was going to be able to keep all to itself. It was the great fortune of Man Ray to be that man.[75]

The photograph that accompanies Breton's comments on Man Ray in *La Révolution surréaliste* is a conventional 'mimetic' picture – a film still – which although dark shows sculptural pencil-like objects standing upright, cast in shadow and light (see Figure 10). However, in the 1928 book version of *Surrealism and Painting*,

11 The three images by Man Ray published in André Breton's book *Surrealism and Painting* (1928). From left to right: two rayograms, *Pensée d'une femme* (1922), *Vers le Soleil* (1927) and a photograph, *Pièces de résistance* (1925).

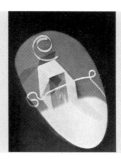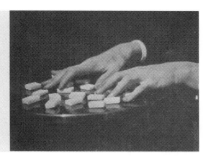

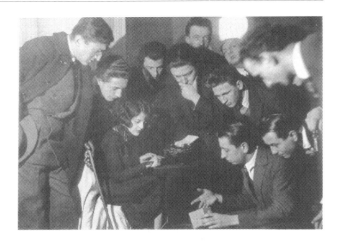

12 The surrealist group posed in a 'daydream' automatic writing seance at the Bureau of Research. Published on the cover of *La Révolution surréaliste*, no. 1, 1924: Max Morise, Roger Vitrac, Jacques-André Boiffard, André Breton, Paul Eluard, Pierre Naville, Giorgio de Chirico, Philippe Soupault, Simone Collinet-Breton, Robert Desnos, Jacques Baron. Photograph by Man Ray (see also Figure 4).

three completely different photographic images by Man Ray are published (see Figure 11). Two of these are photograms produced 'automatically' by the play of light projected on to objects placed directly on to photographic paper. The third is another mimetic-type photograph that depicts sugar cubes on a table, with a pair of hands placed above them as though 'about to be played' like piano keys, or 'about to be shuffled' like the dominoes of a gambler or (more mystically) as the objects 'moved by the hands of a spiritist'.

The different techniques used to produce the images demonstrate that photography is subject to the same gamut of images as other 'visual' forms like drawing and painting. The issue common to all these was how to mediate the psychical automatic image produced. When André Breton spoke of automatic writing as a 'veritable photography of thought', he was using photography as an analogy with the process of 'recording' something, as in the conventional belief that photography can 'capture' a moment.

If psychic automatism was the vital substance and source of the image appearing in thought by itself, the problem for photography, just as it was for painting, was that it was historically associated and linked with rendering (mimesis) of the exterior world rather than any psychological 'interior' world which the surrealist notion of psychic automatism was intended to draw out. Photographers associated with surrealism like Man Ray

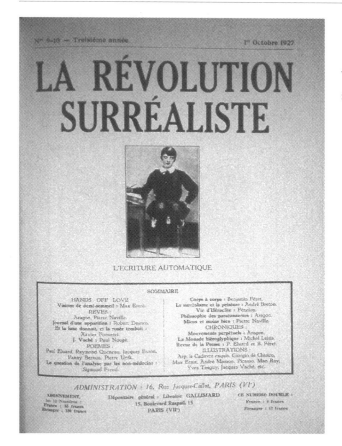

13 Cover of *La Révolution surréaliste*, no. 9–10, October 1927, with *Automatic Writing* as image caption.

were obviously aware of this issue at least as much as the painters were for their work. Mediation and means of invoking psychic automatism were common issues in the processes of making photographs and paintings. Certainly, in photography, processes like solarization left the image to 'chance': the unpredictability of the effects of light flashed directly at the developing image on the photographic paper. In photograms the image produced from the shadows of the objects held between the light source and photographic paper could produce 'unworldly' images. Then, photography could itself be seen as a type of 'automatic writing' or 'painting with light', after all, the etymological origin of 'photo-graph' already meant 'writing with light'. But the surrealist theory of the psychic image was predicated on the state of mind during the process (where the 'intuitive'

14 Paul Nougé, *The Harvests of Sleep*, 1929–1930. A photograph by the Belgian surrealist from his series *Subversion of Images*.

automatic image should emerge) not in the process of recording itself.

As argued in Chapter 1, photography was used to serve in different modes: mimetic, prophotographic and enigmatic. The first cover of *La Révolution surréaliste* (no. 1, 1924) shows the surrealists staged in a collective act of distracted 'automatic writing' (see Figure 12). The surrealists are gathered around a typist as 'automatic' writing machine, Simone (André Breton's wife) as the 'type-writer'. The photograph parodies images of scientists (as in *La Nature*), puzzling with their 'office' laboratory equipment over a 'psychical' experiment. (The secretary and her machine were, of course, ideologically the modern social 'equipment' for the function of writing in industry.) The men that surround Simone appear studied and 'thoughtful' as if engaged in the process of transcribing material. Another photograph, titled *L'Ecriture automatique* (*Automatic Writing*) appears on the double issue cover of *La Révolution surréaliste* (no. 9–10, October 1927) (see Figure 13). This picture shows a fashionable *garçonne* dressed woman, sitting like a school pupil on a chair at a desk. Her eyes stare off-frame while her hand seemingly 'autonomously' writes on the sheet of paper on the school desk. Her legs, strangely 'absent', appear to be replaced by the structure of the chair. The hand on hip echoes an impatient – cataleptic – stare, as though waiting impatiently for a psychical thought to emerge from the viewer. A later image by

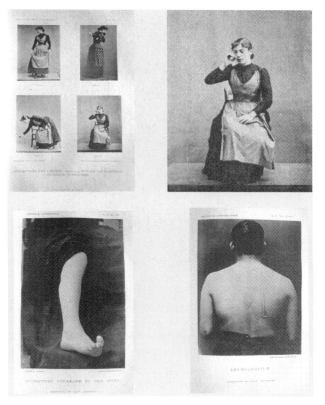

15 Photographs from Jean Charcot's famous *Nouvelle Iconographie de la Salpêtrière*, Paris, showing patients from top left to right: page of photographs of a patient under hypnotic suggestion, enlarged picture from page, the hysterical convulsion of a big toe and '*dermographie*', hysterical writing emerging on a patient's back.

the Belgian surrealist, Paul Nougé, also shows a figure, involved in the process of automatism, this time a man in a trance-like state. His eyes are closed; 'asleep', he is writing 'automatically' (in Figure 14). Titled *Les vendanges du sommeil* (*The Harvests of Sleep*), it is a 'realist' depiction of psychic automatism in practice. Like many of Nougé's pictures it has the property of signifying a rational contradiction (oxymoron) – 'writing with no pen' – to signify a 'writing in his mind'. As in the photographs of hysterics under hypnosis asked to simulate motor activities (which their hysterical symptoms prevented them from carrying out normally), Nougé stages his characters in states of dream-like somnambulism much like the hysterics of La Salpêtrière had been photographed under Charcot (see Figure 15). By refusing conventional realism (the *pro*photographic non-existence of a pen and closed eyes), the picture is made doubly strange, the uncanny spectacle of a process that is not optically visible and the

16 Paul Nougé, *The Birth of the Object*, 1929–30. A photograph by the Belgian surrealist from his series *Subversion of Images*.

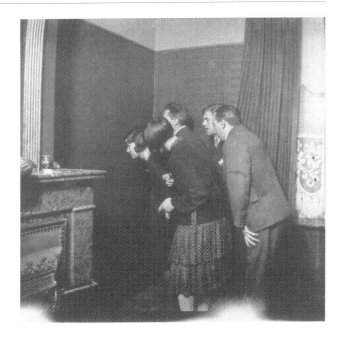

photographs' 'indifference to reality'.[76] In *La naissance de l'objet* Paul Nougé's picture undermines the illusion of photography's veracity with its own limitation (illusion), that these people are attentively looking at and seeing something which we cannot see. They are, the title tells us, witnesses to *The Birth of the Object* (see Figure 16).

In the work of Brassaï, perhaps the most mimetic (documentary) photographer involved with surrealism, photography was also used to represent objects of psychic automatism. In his 1930s series of *Les Sculptures involuntaires* (*Involuntary Sculptures*) Brassaï's photographs depict various bus and cinema tickets rolled into another shape or form: something done 'automatically' and 'without thinking' by the individual who rolled the ticket (see Figure 17). The photograph depicts *mimetically* a scene of 'motor automatism'; the object in the picture, the bus ticket, betrays a *prophotographic* psychic 'automatic' activity beyond conscious control. It was precisely such 'idle play' that Freud paid attention to in his sessions with patients: the way they fiddled with their clothes, played with objects or jingled money in their pocket, symptoms of what he called 'The Common Neurotic State'.[77] Why could not such 'evidence' in the

76 J. Laplanche and J.-B. Pontalis, *The Language of Psychoanalysis* (London: Karnac Books, 1988), p. 476.

77 See Lecture 24: 'The Common Neurotic State' in Freud's *Introductory Lectures on Psychoanalysis*, PFL 1.

17 Brassaï, *Rolled Bus Ticket*, 1932, first published in a page of his 'Involuntary Sculptures' photographs in *Minotaure*.

photogram or photograph be considered valid signs of psychological psychical states?

For Breton, the critical discussion about 'visual' automatism was not reducible to how processes as contrived as 'painting' could be given over to automatic (non-conscious) thought; if the means of production involved meticulous mapping of illusional (perspectival) space, layering of paint, shaping and depth, composition of pictorial elements (all attributes planned and executed within rational thought), then so be it. (Breton described painting as a 'lamentable expedient', weighed down with historical tradition and convention.) In conventional photography, the means of mediation were slightly different but the issues were more or less the same. Bearing in mind that one had to choose the scene, organize it into a composition, calculate a distance for focus and depth of field, position and measure lighting and so on to ensure the best negative, the process of producing an image presumed a complex of conscious procedures (or at best preconscious) to be undertaken. (At least photographers did not need to make decisions about colour in the earlier years.) The issue for Breton was more the duty of the surrealist painter 'to prevent the domination by the symbol of the thing signified'.[78] Breton argued, 'I reject categorically all initiatives in the field of painting, as in that of literature, that would inevitably lead to the narrow isolation of thought from life, or alternatively the strict domination of life by thought.'[79] The point here is that within this interstitial

78 Breton, *Surrealism and Painting*, p. 8.
79 Ibid., p. 46.

space between 'thought' (interior) and 'life' (exterior), any supposed dichotomy between interior and exterior was regarded as dissolved in the enigmatic photographs, paintings and literature that used pictorial techniques.

In surrealism, psychic automatism and the forms used to achieve it were all means to hear the psychic 'noise', first as post-Dada ('beautiful') babble and later more committed to releasing material from repression. For the surrealists this was already a kind of social revolt in the recognition of mental activity beyond consciousness. To depict this activity and to display it by any means possible characterized early surrealist activity. Advocating a social life which provoked Freudian slips, 'bungled actions', 'slips of the tongue' and 'chance' events etc. was a means of 'enjoying' their symptom in the name of 'reconciling' internal and external worlds. That surrealism founded itself on such a precarious psychological demand of attempting to overcome conscious censorship is what distinguishes it from Romanticism and Expressionism. But this drive to 'psychic automatism', the seeking of unconscious thoughts, also underpins the scepticism of critics towards this movement, both from within the movement and from without; attracting the same hostility as psychoanalysis towards the concept of the unconscious.

Whereas the rendering of opaque, enigmatic images was initially enough for the surrealists, in psychoanalysis work had yet to be done on the images to find, through the sliding of the signified and word associations to analytic interpretation. By the time of the *Second Manifesto of Surrealism* in 1929 the 'marvellous' value of the automatic image for the surrealists as enigmatic signifier was only the beginning of the work for discovering the unconscious desire that was to be found in social action.

Lacan's insistence on defining the unconscious through a semiotic algorithm of S/s,[80] as the sliding of the signified under the signifier, thus provides a key to the thinking of the surrealists:

> Between the enigmatic signifier of the sexual trauma and the term that is substituted for it in an actual signifying chain there passes the spark that fixes in a symptom the signification inaccessible to the conscious

80 Lacan, 'Agency of the Letter', p. 163.

subject in which that symptom may be resolved – a symptom being a metaphor in which flesh or function is taken as a signifying element.[81]

For Lacan the dream-image and its dramatized rhetorical forms that the surrealists preoccupied themselves with are signifiers without a signified. Just as certain figures of speech in everyday language, puns, metaphor, metonymy, similes and so on function through a slippage of language, so too does the surrealist rhetoric of the image; enunciating a disruptive flow into common discourse, like a rhetoric of the unconscious. It is not a question of revealing the unconscious of the 'artist'; rather, the surrealists introduced and exhibited psychical dramas 'translated' into material forms for public scrutiny outside of the medical world. (They also introduced Freudian psychoanalysis to the non-specialist in France.) The various forms of inaccessible rebus-type visual or written puzzles were cloaked through the distortions of the dream-work and secondary revision, coded in the culture of that time: 'the surreal' is the enigmatic form in which the memory of a trauma, in whose name the image was made, nevertheless has *some* message or meaning present, but 'designified'.

81 Ibid., p. 166.

3 · Sadness and sanity

I am the other. *Gérard de Nerval*

André Breton famously begins his book *Nadja* (1928) with the question: 'Who am I?'[1] By the end of the story he knows who he is and Nadja, the woman encountered in it, is left 'mad' and committed to a mental asylum. Breton retains his sanity while Nadja plunges into madness. The fact that such a distinction between sanity and madness is one which surrealism intended to collapse is here apparently contradicted. But the twists and turns of Breton's text make this initial observation a somewhat more convoluted tragedy.

Breton qualifies the question of 'Who am I?' by noting that it is really a question of 'knowing whom I "haunt"'. Breton is not referring to the presence of some other being, but simply drawing on the vocabulary available to him from 'psychics' and clairvoyants. The haunting other in the self, as Breton puts it, is about 'learning a mere fraction of what I have forgotten'.[2] Thus, *Nadja* will, he claims, reveal to the reader 'the most decisive episodes of my life … and only in so far as it is at the mercy of chance'. Breton stumbles from scene to scene with 'chance encounters' structuring his path. Memory and its 'chance' return is of course what Freud dubbed the 'return of the repressed', one of the fundamental conditions for the uncanny to emerge.

The Story

In *Nadja* Breton meets an unknown woman in the street in Paris, whom he continues to see almost every day in a short, torrid affair of nine days and one night. The book appears in three unannounced sections, the first, a prologue of chance encounters before he meets Nadja, second the encounter with Nadja and, last, a section which is retrospective, an afterwards that looks back at what happened.

Wandering 'aimlessly' one afternoon (4 October 1926) after visiting the communist bookshop L'Humanité, Breton notes a 'poorly dressed woman' walking towards

1 André Breton, *Nadja* (Paris: Gallimard [1928] 1963). Breton revised the book when it was republished in the 1960s. All page citations are from the English edition of *Nadja*, trans. Richard Howard (New York: Grove Press, 1960), p. 11.

2 Ibid., p. 12.

him. They exchange glances. Breton speaks to her and they begin to converse. Stopping in a café by the Gare du Nord, they engage in animated conversation. He is transfixed and puzzled by her eyes: 'What was so extraordinary about what was happening in those eyes? What was it they reflected — some *obscure distress* and at the same time some *luminous pride*?'[3] Breton is entranced. She talks about her life to Breton and he listens attentively, until she speaks of the evening commuters on the Metro that she likes to observe and describes them as 'good people'. Breton interrupts and begins an impassioned monologue on his attitudes to work, showing his contempt for lives of servitude being valued. She does not contradict him. The conversation becomes more intimate, she speaks of her delicate health and attempts to find employment to pay for the cure she needs. Finally, as they prepare to depart, Breton asks her, 'Who are you?' Nadja replies, 'I am the soul in limbo.' They arrange to meet the next day (corner of rue Lafayette and rue du Faubourg Poissonièrie) and then part.

Meeting again the next day, Breton notes that her appearance is now 'elegant', dressed 'in black and red'. They continue their conversation and talk about Breton's books (*Manifeste du surréalisme* and *Les Pas perdu*), which she had asked him to bring. When on the next (third) day they finally meet again, it seems Nadja has become wary of Breton and was not going to meet him. However, later in a taxi and supposedly on their way home, she closes her eyes and offers her lips to him, confessing his 'power over her'. In the same passage Breton recounts that Nadja tells him of his 'faculty for making her think and do' whatever he desires and Nadja begs him 'to do nothing against her'.[4] Later, Breton will acknowledge her dependency on his 'presence', but notes, 'I strongly doubt the influence I can have had over her.'[5] They end up in a restaurant at Place Dauphine and it is here that he first experiences one of Nadja's 'clairvoyant' hallucinations.

By the fourth day of their encounter, Nadja has become the object of an anxious obsession for Breton and his literary text displays the characteristics of a neurotic lover, wretched with guilt and racked by doubt:

3 Ibid., p. 64.
4 Ibid., p. 79.
5 Ibid., p. 115.

it was a mistake not having made a date with her today. I am annoyed. I suppose I observe her too much, but how can I help it? How does she regard me, how does she judge me? It is unforgivable of me to go on seeing her if I do not love her. Don't I love her? When I am near her I am nearer things which are near to her …
It would be unforgivable if I were not to reassure her about the kind of interest I feel in her behalf, persuade her that she could not be an object of mere curiosity for me – how could she think so – a whim. What should I do? And to have to wait until tomorrow night – no, that is impossible. What can I do in the meantime, if I don't see her? And if I never see her again?[6]

Then, eight days after they first meet, while walking in her company (12 October) Breton declares to us 'I am bored'.[7] The following night they spend in a hotel together for the first and last time, and the subsequent tone of the book changes. Breton writes, 'Can it be that this desperate pursuit comes to an end here? Pursuit of what I do not know, but pursuit, in order to set working all the artifices of intellectual seduction.'[8] From the curiosity and inspirational excitement at what Nadja says and does (her history, her being and her hallucinations) at the beginning of their encounter, Breton's commentary becomes reflective, pensive, almost psychiatric, as in a post-coital *triste*. In the ensuing pages their relationship, such as it is, falls apart, as Nadja, it appears, was increasingly suffering from delusions.

Nadja thinks of Breton as the sun, the light in her world. In a drawing reproduced in the book, she depicts him as someone in flames. While, for Breton, what had been her 'charm', her vulnerability and fragile existence, he now finds irritating. His curiosity is over. But unlike the explicit disgust that Charles Baudelaire had for his lovers after copulation in his literary accounts of them, Breton is semi-conscious of his own neurotic subjectivity. When Nadja recounts how she had been hit in the face by a would-be lover (she had refused him because he was 'low') Breton confesses to us that he reacts 'with terrible violence'. He notes, the story 'almost managed to alienate me from her for ever'.[9] This sends him into tears:

6 Ibid., p. 90.
7 Ibid., p. 105.
8 Ibid., p. 108.
9 Ibid., p. 113

I wept a long time after hearing it, cried as though
I could no longer cry. I wept at the notion that I
shouldn't see Nadja again, not that I couldn't. Not that
I was angry at her for not concealing what was now
distressing me, indeed I was grateful for that, but that
she might one day reach this point, that – who knows
– such days might dawn again for her, I didn't have the
heart to imagine.[10]

Although they meet again, at this point their 'affair' is
over when they part, despite Breton's increasing sadness.
From here, Breton's book begins to filter the memories
of what had been (for *him* of course), discussing the
drawings she had produced and the enigma of their
relationship which he himself seemed unable to solve.

How does the use of photographs in *Nadja* relate
to this story? Between the pages of the writing, black-
and-white photographs accompany the unfolding of
the book's drama, as *mise-en-scène* of the places of their
'chance encounters'. The photographs in *Nadja* show
buildings, places, people and objects, and the drawings
made by Nadja and discussed in the story.

Seeing Things

The use of photography in *Nadja* is a self-fulfilling
prophecy of what Breton had proposed shortly before
in *Surrealism and Painting*: 'The photographic print,
considered in isolation, is certainly permeated with
an emotive value that makes it a supremely precious
article of exchange (and when will all the books that
are worth anything stop being illustrated with drawings
and appear only with photographs?)'[11]

Often cited, it may be thought that Breton is saying
that photographs save tedious and boring literary des-
criptions, what he called 'the realist attitude, inspired by
positivism' common among his contemporary writers
– condemned in the 1924 *Manifesto of Surrealism*.[12] But
that realist issue does not reflect Breton's concern with
photography here, as he goes on to say, 'it is not in the
final analysis the *faithful* image that we aim to retain of
something'.[13] The interest here, in relation to *Nadja*, is
the 'something retained' and the 'emotive value' Breton
ascribes to photographs. This is important for *Nadja*

10 Ibid., p. 114.
11 André Breton, *Surrealism
and Painting*, trans. Simon Watson
Taylor (London: Macdonald,
1972), p. 32.
12 André Breton, Richard
Seaver and Helen Lane (eds and
trans.) *Manifestos of Surrealism*
(Ann Arbor: University of Michi-
gan Press, 1997), p. 6.
13 *Surrealism and Painting*, p. 32.

because the photographs in it are so often said to be 'ordinary', with 'nothing to see' in them, characterized as 'boring'. Certainly, for one reader, Rosalind Krauss, the photographs are 'banal': 'the presence of the photographs strikes one as extremely eccentric – an appendage to the text that is as mysterious in its motivation as the images themselves are banal'.[14]

But the photographs in *Nadja* are far from banal. In a celebrated reading of surrealism, Walter Benjamin commented on the photographs in *Nadja* just one year after the book was first published:

> photography intervenes in a very strange way. It makes the streets, gates, squares of the city into illustrations of a trashy novel, draws off the banal obviousness of this ancient architecture to inject it with the most pristine intensity toward the events described, to which, as in old chambermaids' books, word-for-word quotations with page numbers refer. And all the parts of Paris that appear here are places where what is between these people turns like a revolving door.[15]

Benjamin, far from regarding the photographs as themselves banal, or as rendering Parisian architecture 'banal', argues that the pictures in *Nadja* 'inject [the architecture of Paris] with the most pristine intensity towards the events described'. It would certainly be reductive to regard Breton's book as a 'trashy novel', as a love story dressed up in surrealist style, with pictures merely 'illustrating' locations. The photographs do describe some scenes where events in *Nadja* take place, but the fact that the reader of the book knows so little about the precise relation of the photographs to the story opens up a space between the story and the pictures. It is as if, in a filmic analogy, the story is narrated over visual images which represent, not actions of characters, but places and spaces which characters in the story once 'inhabited' and the objects they have seen.

The first photograph in *Nadja* by Jacques-André Boiffard is of the 'seedy' Hôtel des Grands Hommes (see Figure 18). This is itself an ironic sign of the times, the decaying (Hotel of) Great Men. The 'caption' to this photograph, as with all the texts accompanying the pictures in the book, is culled from the lines of

14 Rosalind Krauss, 'The Photographic Conditions of Surrealism', *October*, no. 19 (1981), p. 14. Michel Beaujour also argues that 'nothing is suggested in these banal photographs', 'Qu'est-ce que "Nadja"?', published in *Nouvelle revue française* (vol. 15, no. 172) in 1967. This is taken up by Jane Livingston in her essay 'Photography and the Surrealist Text', in Dawn Ades, Rosalind Krauss and Jane Livingston (eds), *L'Amour Fou* (New York: Abbeville/Cross River Press, 1985), p. 163.

15 Walter Benjamin, 'Surrealism: The Last Snapshot of the European Intelligentsia', in *One Way Street and Other Writings*, trans. Edmund Jephcott and Kingsley Shorter (London: Verso, 1985), p. 231.

18 The caption reads: 'My point of departure will be the Hôtel des Grands Hommes...' Jacques-André Boiffard, *Hôtel des Grands Hommes*, from André Breton's story *Nadja*, 1928.

Nadja. With this image Breton announces, 'My point of departure will be the Hôtel des Grands Hommes.'[16] Situated at the Place du Panthéon, this hotel was indeed a place where Breton had lived when he came to Paris around 1918. The once grand hotel in fact stands opposite the Panthéon and is photographed by Boiffard with a horse and cart facing in the opposite direction from the Jean-Jacques Rousseau statue in the foreground. The only human figure in the picture is in the far right-hand window just beneath the sign of the hotel. This figure, who could be André Breton, is shown with arms crossed and facing the same direction as the statue of Rousseau. Such juxtapositions are far from arbitrary or 'accidental'. Breton had specially commissioned the photographs for *Nadja* and there is certainly signification, whatever Breton says about 'objective chance' structuring the book. For example, not only is this image a point of departure for the book, but Jean-Jacques Rousseau was a formative figure, a 'point of departure' for Breton's thinking; he cites especially the revolutionary texts *A Discourse on Inequality* and *The Social Contract*.[17] The

16 Breton, *Nadja*, p. 23.

17 Breton says that Rousseau was key to his own formation in *Conversations: The Autobiography of Surrealism*, trans. Mark Polizzotti (New York: Paragon, 1993), p. 14.

figure in the Hotel of Great Men looks in the direction of Rousseau. The viewer is separated from this by the railings in the foreground, placing us in the Panthéon. The Panthéon, which had originally been a church, was converted in 1791 by the Constituent Assembly of the French Revolution to become a resting place for 'great men' where, to this day, their remains lie. We are given semiotic clues in the picture to the starting point of Breton's story, a decaying (once grand) hotel in which a figure from within stands in the same direction as Rousseau, thus starting with a revolutionary figure, one who argued, much like Breton, that civilization corrupts man's 'natural happiness' and freedom. More than a mere description or 'document' of the place, the elements of the photograph and their associations also imbue the place with a 'feeling', an enigmatic affect of emptiness.

Place Dauphine

In the photograph of Place Dauphine (see Figure 19), also by Boiffard, a figure lurks beneath the awning of the shop, seen between the tree and the lamp post on the left, while the restaurant tables under the awnings on the right appear vacant, except for a dog. Breton gives us the caption: 'We have our dinner served outside by the wine seller.' Instead of seeing a picture of Breton and Nadja dining at the restaurant, we are given a bleak and melancholy 'empty' scene.

What I would insist as reading across the photographs in *Nadja*, like 'Place Dauphine', is not an aesthetic coding of banality, but rather the signifiers of 'emptiness'. This is not to say that the photographs are unpeopled or have 'nothing' in them. In most of the other pictures of places there are figures who stand about, as though waiting for something to happen. It might seem to the reader that, perhaps, these figures are in anticipation of the events in the story 'about to happen': an arrival or departure of Breton with Nadja. In other words, the signified feelings of emptiness across these pictures are in contrast with the fullness of the story described. The pictures that might be expected by a reader to accompany a story set in Paris would be of a busy and thriving metropolis. This crucial structure of anticipation (our conventional assumptions about correspondence)

19 The caption reads: 'We have our dinner served outside by the wine seller … ' Jacques-André Boiffard, *Place Dauphine*, from André Breton's story *Nadja*, 1928.

is 'let down' by the images conjured by photographs in *Nadja* and what invokes a melancholy sense of loss or even sadness. It is precisely the *absence* of the events that are described in the book that give these 'ordinary' photographs their strangeness. The emptiness of the spaces in the photographs jars with the events we are told happen there, as Benjamin puts it, the events that 'turn' between Breton and Nadja. It is also here at Place Dauphine, in Breton's account, that Nadja's 'clairvoyant' hallucinations are first experienced.

Already Breton imbues this place that he and Nadja are in with a disquieting strangeness for the reader:

> Place Dauphine is certainly one of the most profoundly secluded places I know of, one of the worst wastelands in Paris. Whenever I happen to be there, I feel the

desire to go somewhere else gradually ebbing out of me, I have to struggle against myself to get free from a gentle, over-insistent, and, finally crushing embrace.[18]

Breton might well be speaking of his feelings towards Nadja here, but we shall never know. As they eat, Nadja's mood changes and during the dessert a 'disturbance' begins. Convinced that an underground tunnel is under their feet, she is agitated by what has happened in this square previously and 'in the future'. She sees a crowd, 'And the dead, the dead!', Breton reports her crying out.[19] Turning to the houses opposite, Nadja shows Breton:

'Do you see that window up there? It's black, like all the rest. Look hard. In a minute it will light up. It will be red.' The minute passes. The window lights up. There are, as a matter of fact, red curtains … I confess that this place frightens me, as it is beginning to frighten Nadja too. 'How terrible! Can you see what's going on in the trees? The blue and the wind, the blue wind. I've seen that blue wind pass through these same trees only once before.[20]

Breton tries to take Nadja away as the hallucinations about the past wash over her: 'Listen, tell me why you have to go to prison? What is it you're going to do? I've been to prison too. Who was I? It was ages ago. And you, then, who were you?' Then: 'She wonders what she might have been, in Marie-Antoinette's circle.'[21] They stop by the River Seine and Nadja says,

That hand, that hand on the Seine, why is that hand flaming over the water? It's true that fire and water are the same thing. But what does that hand mean? How do you interpret it? Let me look at that hand! Why do you want to go away now? What are you afraid of? You think I'm very sick, don't you? I'm not sick. But what do you think that means: fire and water, a hand of fire over the water?[22]

Once again an uncanny theme emerges across these 'surreal images', from the previous quote, where a dark room suddenly illuminates 'red', to Place Dauphine with a ghostly presence of people who had lived there before

18 Breton, *Nadja*, p. 80.
19 Ibid., p. 83.
20 Ibid., pp. 83–4.
21 Ibid., p. 85.
22 Ibid., pp. 85–6.

and, above the River Seine, the vision of a flaming 'severed' hand; all voiced in Nadja's utterings – as narrated by Breton. In the story Breton does not have any of these hallucinations, but he is clearly fascinated and troubled by the ones that Nadja has. It becomes clear in the text that while Breton feels disturbed by some of those places visited, he does not really know their cause, it remains enigmatic for him, whereas Nadja hallucinates the ghostly presence that is its cause and we can see here a clear structure in the book: Nadja sees things that André Breton cannot.

Historical Visions

It turns out, Margaret Cohen argues, that the places visited in the story which are troubling to Nadja are sites predominantly associated with historical uprising, revolution or insurrection in Paris.[23] Tracing the path of Breton's wanderings with Nadja, Cohen discovers that not only do these places have long turbulent histories connected with insurrection and violence, but also these histories were part of a popular knowledge of those places for the contemporary reader of *Nadja* via, for example, the guides of Paris.[24] Place Dauphine where they had eaten in the restaurant, for example, is described in the contemporary tourist guides as having a 'melancholy' ambience that contrasts with its 'lively' past history of events.[25] It was where Jacques de Molay, a Knight Templar, had been publicly burnt in 1314. As Cohen notes, 'ghosts of revolutionary violence moreover descend on the Place Dauphine from all sides' associated with the 1789 French Revolution including the condemned Marie-Antoinette.[26]

Breton's description of the place is consistent with the common view of it in guides at the time. Nadja's hallucinations, far from arbitrary, have a historical accuracy and we can begin to sense that Breton's playful writing is more of a 'docu-drama' than at first imagined. The hallucinations and historical themes of places in Paris belong to a literary tradition that Breton was acutely aware of through, for example, the *flâneur* of Charles Baudelaire. Cohen suggests that Nadja's vision of a flaming hand over the River Seine alludes to a novel by Gérard de Nerval, an author favoured by

23 See 'The Ghosts of Paris', Margaret Cohen, *Profane Illumination, Walter Benjamin and the Paris of Surrealist Revolution* (London: University of California Press, 1993), pp. 77–119.

24 Cohen does a trawl of texts and tourist guides to Paris. She also quotes a letter by Freud describing his experience of Paris while studying under Charcot there which seems to condense Charcot's clinic with Paris: 'I am under the full impact of Paris and, waxing very poetical, could compare it to a vast overdressed Sphinx who gobbles up every foreigner unable to solve her riddles … Suffice it to say that the city and its inhabitants strike me as uncanny; the people seem to me of a different species from ourselves; I feel they are all possessed of a thousand demons … They are a people given to psychical epidemics, historical mass convulsions, and they haven't changed since Victor Hugo wrote *Notre-Dame*.' Cited from Sigmund Freud, *Letters of Sigmund Freud*, pp. 187–8, in Cohen, *Profane Illuminations*, p. 83.

25 Cohen, *Profane Illuminations*, pp. 100–3.

26 Ibid., pp. 100–1.

the surrealists; one who had suffered his own bouts of 'madness' before committing suicide. 'Nadja evokes Gérard de Nerval's post-Revolutionary fantastic tale of long-ago bohemian life set on the Place Dauphine, *La Main enchantée*, which takes a demonic dismembered hand as its central conceit.'[27]

Nerval's writings were historically set fictions in the genre of the fantastic. His early works like *La Main enchantée* (*The Enchanted Hand*) were derivative of E. T. A. Hoffmann's fantastic stories (the author studied in Freud's 'The "Uncanny"'). Nerval actually translated some of Hoffmann's work into French from the German. Both authors evoked 'realist' scenes and descriptions as the setting for marvellous 'fantasy' events. More than the surrealists, Nerval had been interested in the occult and 'Asian theology'.[28]

La Main enchantée, Nerval's first fantastic tale (published in 1852) was set in Paris at the beginning of the 1600s.[29] The first chapter, 'La place dauphine', describes both the hero character, Eustache, who lives there, and the place itself. It is characterized, much as it is by Breton, by 'a cruel displeasure which invades this place' – a premonition of events to come.[30] Most of the story takes place there and the locality around it, including the Pont Neuf (New Bridge) that was the principal new monument during the Paris of Henri IV's reign before he was assassinated in 1610.[31] In brief, Eustache, finding himself challenged to a duel by a soldier who is certain to beat him, seeks help from a gypsy who rubs a magic ('oriental') lotion on his sword hand. During the duel the next day, his hand takes on a life of its own and, out of character, he decisively – brutally – kills his opponent. Eustache is eventually convicted and hanged for committing murder while duelling, a quasi-illegal activity. The location of the hanging is set near the Pont Neuf and Place Dauphine, a frequent actual site for executions during that period. Eustache is hanged, but the hand remains alive, wriggling. When the executioner cuts it off, hoping to kill it, the hand falls into the crowd and scuttles off back to the bohemian gypsy who owned it. Dabbling in 'Eastern magic' and 'cheating' is punished by the law in death and amputation, but the hand lives on (an uncanny theme of *Un Chien andalou*).

27 Ibid., p. 103. The surrealists were very familiar with Nerval's work. Breton had discussed Gérard de Nerval's 'supernaturalism' as a word they considered using to name the movement instead of 'surrealism'. See the 'Manifesto of Surrealism' in *Manifestos of Surrealism*, pp. 24–5.

28 See 'The Fantastic Tale: Nerval and Hoffmann' in Alfred Dubruck, *Gérard de Nerval and the German Heritage* (London: Mouton and Co., 1965), p. 53.

29 An earlier different version was published as *La Main de gloire*.

30 Gérard de Nerval, *Oeuvres complètes*, vol. 3 (Paris: Gallimard, 1993), p. 335.

31 Ibid., vol. 3, p. 1118.

32 See Jean-Paul Webster,

20 'The Humanité bookshop' in Paris. Jacques-André Boiffard, *L'Humanité bookshop*, photograph from André Breton's story *Nadja*, 1928.

Commentators on Nerval's literature note that the themes of fire and flaming red persist across all his writings; they always appear as signs of that 'which destroys and consumes'.[32] These same motifs reappear in Nadja's hallucinations, for example, her appearance in black and red on their second meeting and the black window that turns red, 'as a metaphor of revolt, of insurrectional fire'.[33] Margaret Cohen points out that this window is on the site where Madame Roland, a victim of the Terror of the Revolution, had lived.[34] The Pont Neuf, where Nadja hallucinates the flaming hand over the river, is near where the hand is cut free from Eustache in Nerval's fantastic tale. Cohen concludes, 'Repeatedly experiencing hallucinations that recall Parisian revolution, Nadja usually identifies herself and Breton with forces across the political spectrum that lost out.'[35]

'Nerval et les mains pleines de feux', *La table ronde*, no. 135, 1959, pp. 97–107.

33 Julia Kristeva, 'Nerval, the Disinherited Poet', in *Black Sun: Depression and Melancholia* (Oxford: Columbia University Press, 1989), p. 158.

34 Cohen, *Profane Illuminations*, p. 101.

35 Ibid., p. 103. The observation by Cohen about figures who 'lose out' could be taken further, Julia Kristeva writes of Nerval as 'The Disinherited Poet', after the title of his poem, *The Disinherited*, written after his fit of madness in May 1853. Paul Eluard owned the manuscript. Kristeva's book title *Black Sun* is from a line of Nerval's poem: 'Bears the *Black Sun* of *Melancholia*', cited p. 141.

One suspects that in such instances in the story Nadja is not really Nadja, but Breton's signifying vehicle for Paris. In his preliminary question of 'whom I haunt' the answer turns out to be literary and revolutionary figures, mediated through the tragic figure of Nadja.[36] It is, after all, immediately following Breton's purchase of 'Trotsky's latest work' at L'Humanité bookshop, a place important enough for him to make it the subject of a photograph in the book, that he first meets Nadja[37] (see Figure 20). Thus the 'historical' hallucinations of Nadja are literary concoctions by Breton, a fact dissimulated by the craft of his writing and the apparatus of first person biographic description. Far from arbitrary, Breton's work of 'fiction' combines a kind of psycho-geography of his encounter with Nadja with references to historical uprisings of Paris. Paris is a city haunted by its history. This is what Walter Benjamin takes up as constituting Breton's more historical than political view of Paris in *Nadja*, an attitude that Benjamin endorses and takes up in his own work.[38] What is 'revolutionary' in Nadja's hallucinations is the recovery of scenes from historical Paris; her life is not subjugated to dreary work, rather to the work of dreaming impressions of Paris. It is this bringing of history to fleeting metropolitan life in *Nadja* that Benjamin enthusiastically notes:

> Breton and Nadja are the lovers who convert everything that we have experienced on mournful railway journeys (railways are beginning to age), on Godforsaken Sunday afternoons in the proletarian quarters of the great cities, in the first glance through the rain-blurred window of a new apartment, into revolutionary experience, if not action. They bring the immense force of 'atmosphere' concealed in these things to the point of explosion.[39]

Breton's world is illuminated by Nadja. The work of love? Breton's wanderings around the streets of Paris, waiting for 'images' to appear, treats the manifest world as a psychical space. *Nadja* is less the path of a *derivé* (drifting) than the *mise-en-scène* for desire. With *Nadja* Breton welds psychiatry and literary history to Baudelaire's city *flâneur* in a 'science' of an everyday practice: historical day-dreaming on the asphalt of

36 Hélène Smith, the renowned medium (see Chapter 2), had thought of herself as Marie Antoinette in a former life. Breton had read Hélène Smith and was well aware of the notion of haunting from the work of the spiritualists and analysis of it, for example, Theodore Flournoy, *Des Indes à la Planète Mars* (Paris: Fischbacher, 1899).

37 Breton does not say which book by Trotsky he bought (see *Nadja*, p. 63).

38 Walter Benjamin speaks of 'the substitution of a political for a historical view of the past' (Walter Benjamin, 'Surrealism: The Last Snapshot of the European Intelligentsia', in *One Way Street and Other Writings*, p. 230).

39 Ibid., p. 229.

Paris. Breton's Paris is his psychical reality. Neither poet nor psychiatrist, Breton is a chronicler of modern urban pathologies; the chance encounter on the street becomes an allegory of revolutionary freedom and its failure, their (hopeless) relationship that burns out in the irreconcilable difference of 'who they are'. The violence of the revolution against an existing social order manifests itself as Nadja's increasing madness. The answers to Breton's question of 'whom I haunt' only becomes illuminated by Nadja's cryptic visions as Paris becomes the site of uncanny 'memories', of events once familiar, 'forgotten material from a collective past that has now been surmounted'.[40] However, the 'identification' with those that 'lost out' mentioned by Cohen is also a sense that the reader has of Nadja, as her hallucinations run wild in the story.

Memory of Madness

In a temporal shift, Breton suddenly announces, 'I was told, several months ago, that Nadja was mad.'[41] After 'eccentricities' in the hallway of her hotel, Nadja 'had to be committed to the Vacluse sanitarium'. Breton anticipates a reader's interpretation of this, which some 'will inevitably interpret as the fatal result of all that has gone before'. 'The more enlightened', he says, will attribute it to 'the ideas already frenzied' and 'perhaps set a terribly decisive value to my role in her life, a role favourable, in practice, to the development of such ideas'.[42] Breton takes this as an opportunity to condemn the psychiatric asylum and its practices for making madness through the treatment of people, adding that 'people have been committed for life who have never had any reason, or who have no further reason, to be in institutions at all'.[43] He blames the institution, saying that the fact that she was poor meant that she could not receive the proper attention and care that she needed for a recovery, that would lead to her return to 'an acceptable sense of reality'.

Breton tells us that 'Nadja' is the name she had chosen for herself 'because in Russian it's the beginning of the word hope, and because it is only the beginning'.[44] We know from information outside Breton's book that the woman called Nadja that Breton met on 4 October

40 Cohen, *Profane Illuminations*, p. 86.

41 Breton, *Nadja*, p. 136.

42 Ibid.

43 Breton is right about institutions producing illnesses. Lacan notes, 'The fact that an analysis can, right from its first stages, trigger a psychosis is well known' (*The Psychoses*, p. 15).

44 Breton, *Nadja*, p. 66.

1926 had changed her name from Léona D——, was born in Lille and had been a mother at eighteen. Breton mentions that Nadja (Léona) had a daughter in the story.[45] Nadja was twenty-four when Breton met her and he was thirty. It is clear from letters that Breton did initially try to support Nadja, who was otherwise dependent on the street and whomever she met there. Breton also certainly told his wife Simone about Nadja and he introduced her to other surrealists at their gallery; their relationship was far from secret. Breton, in a rare act of generosity, sold one of his own paintings to raise money for her.[46] Pierre Naville appeared to share Breton's fascination with Nadja and he wrote of her in a manner that is blunt: 'this woman is really strange' and comments that she resembled Gala '(the same beauty and ugliness); fantastic eyes which change form'.[47] In a private letter to Simone dated 8 November, Breton confessed he did not know what to do. Nadja was taken with him in a serious and desperate manner, but he was clear that he did not love her nor would he ever.[48] In a letter to Breton dated 1 December 1926, Nadja complained of being forgotten by him. She was terribly alone. By 15 December she had not seen him for ten days and by the end of January had seen him only once. Writing to him again on 30 January 1927 that, 'I am lost if you abandon me', a poem follows:

> It's raining again
> My room is sombre
> The heart in an abyss
> My reason is dying.[49]

Later, after Breton had returned all her letters, a hand-delivered note appeared under his door, acknowledging receipt of them. Thanking him, she wrote, 'I do not want to make you waste your time that you need for more important things.'[50] She says that everything Breton does will be well done and hopes that nothing stops him, recognizing that it is sensible not to weigh on 'the impossible'. A few weeks later, on 29 March 1927, Nadja, suffering from visual and verbal hallucinations and crying with fear, called for help. The hotel staff where she was staying called the police and she was committed at Saint-Anne by her parents. She was

45 Pierre Daix, *La Vie quotidienne des surréalistes, 1917–1932* (Paris: Hachette, 1993), p. 311, cited from Marguerite Bonnet, *Oeuvres complètes.*

46 Breton's partners complained that he would rather live in absolute poverty than sell any paintings from his collection.

47 Cited in Daix, *La Vie quotidienne*, p. 325.

48 Ibid., p. 324.

49 My translation:
Il pleut encore
Ma chambre est sombre
Le coeur dans l'abîme
Ma raison se meurte.
Cited in Daix, *La Vie quotidienne*, p. 322 (from Marguerite Bonnet, *Oeuvres complètes*, no pagination).

50 Cited in Daix, *La Vie quotidienne*, p. 323 (my translation).

later transferred to a psychiatric hospital nearer to them, where she apparently stayed until her death, 15 January 1941.[51]

Reflecting on Nadja in the story, Breton notes that everyone should strive for some emancipation from the 'jail of logic', but that he had not seen or 'become conscious of' the actual 'danger she ran'. He claimed: 'I never supposed she could lose or might have already lost that minimal common sense which permits my friends and myself, for instance, to *stand up* when a flag goes past, confining ourselves to not saluting it.'[52] In defence of his role in Nadja's 'madness', Breton remarks: 'The well-known lack of frontiers between non-madness and madness does not induce me to accord a different value to the perceptions and ideas which are the result of one or the other.'[53]

Psychosis and Sadness

The common notion of 'madness' is clinically described as psychosis.[54] Verbal and visual hallucinations, the most common psychotic phenomena, have the characteristic stamp of a subject identifying with that of which they speak, in a way that the 'normal' subject cannot. Jacques Lacan likens delusional speech to that of automata, an uncanny motif: 'those sophisticated dolls that open and close their eyes, drink liquid etc.'.[55] In the psychotic, 'the unconscious is at the surface, conscious'. Yet, as Lacan puts it, 'the psychotic subject is ignorant of the language [s] he speaks'.[56] In this respect psychotic delusions are of a completely different origin from the common neurotic hallucinations we call dreams. In the neurotic, a daydream fantasy, something repressed or 'forgotten', returns through the dream sequence with the aim of satisfying that wish. A psychotic fantasy does not do this, it is not simply a hunger to be 'satisfied' by hallucinating food.[57] The 'neurotic inhabits language, the psychotic is inhabited, possessed, by language'.[58]

In the prologue to *Nadja*, Breton is able to intimate the things about places in Paris where something troubles him, but in the story Nadja experiences the hallucination of what troubles her directly. Whereas Breton recognizes the signifier of something disturbing (for example, Place Dauphine) whose signified meaning is obscure to him,

51 Ibid., p. 323.
52 Breton, *Nadja*, p. 143.
53 Ibid., p. 144.
54 Jacques Lacan, *The Psychoses, Book III 1955–1956*, trans. Russell Grigg (London: Routledge, 1993), p. 4.
55 Ibid., p. 34.
56 Ibid., p. 12.
57 Ibid., p.106.
58 Ibid., p. 250. Here at least, Lacan and Michel Foucault agree. Foucault remarks: 'Language is the first and last structure of madness, its constituent form' (*Madness and Civilization* [London: Tavistock, 1987], p. 100).

103

Nadja experiences the signified meaning without going through a signifier. The signified is taken for reality. This is more or less the distinction between neurosis and psychosis.

Whereas neurosis is conditioned by repression, psychosis according to Lacan is 'where there has been a hole, a rent, a gap, with respect to external reality'.[59] It is this hole which is 'patched over by psychotic fantasy'.[60] Rather than explain this hole in reality as something that is filled through the mechanism of 'projection' (nothing there in the first place to be projected), Lacan, following Freud, posits the term of 'foreclosure' (or rejection), a translation of Freud's *Verwerfung* to designate the refusal of the symbolic and the 'reappearance in the real of what the subject has refused'.[61] The element that is foreclosed becomes unavailable for representation and is instead ejected, refused and 'expelled' from symbolization. It can thus only appear as though 'from without' in the provocation of a psychotic episode. Lacan argues that what is always foreclosed in the real, what creates the hole, or 'point of rupture, in the structure of the external world' in reality, is the absence of the paternal metaphor, the 'name-of-the-father'. The signifiers that are subsequently 'unleashed' revolve around castration and stem from the subject's relation to paternity and patriarchal law.

There are at least two Nadjas in Breton's book, one that hallucinates violent histories of Paris, another that Breton comes to interrogate through her drawings. (It is in the contiguity of these two Nadjas that the text gains its 'marvellous' un-real-ism.) For the second Nadja, Breton was a flame, the sun, a God and in one of her drawing he is a bird too. Breton describes Nadja's attempt at a drawing of him: 'Several times she has tried to draw my portrait with my hair standing on end – as though sucked up by a high wind – like long flames. These flames also formed the belly of an eagle whose heavy wings fell on either side of my head.'[62]

The similarity of these signifiers to those in the famous psychosis, the delusions of Judge Schreber analysed by Freud, is remarkable. They have similar scenarios of the sun and eagle, albeit from different reference points. Judge Schreber's hallucinations led him to believe

59 Lacan, *Psychoses*, p. 45.
60 Ibid.
61 See ibid., p, 13. Lacan's distinction comes from Freud's Wolf-Man case study where *Verwerfung* (foreclosure) is opposed to *Verdrängung* (repression) (see Anika Lemaire, *Jacques Lacan* [London: Routledge and Kegan Paul, 1982], p. 230).
62 Breton, *Nadja*, pp. 116 and 121.

he was the wife of God. He found himself spoken to by the sun, which Freud analyses as a 'sublimated "father-symbol"'.[63] Schreber had a father complex. When the sun revealed itself to Schreber, he shouted at it and he claimed that he could look into it without being more than 'slightly dazzled by it'. Freud reports that being able to look at the sun is in antique mythology a power attributed 'to the eagle alone, who, as a dweller in the highest regions of the air, was brought into especially intimate relation with the heavens, with the sun, and with lightning'.[64] In Freud's reading, looking at the sun is an '*ordeal*, a test of lineage'. By looking back at the 'divine rays' of the sun, Schreber submitted himself to this test, thus 'expressing his filial relation to the sun as his father'.

We know not what exact psychical drama or event was organizing Nadja's delusions and psychosis historically speaking, but it is certainly structured around a paternal function in the discourse of the real. Nadja's drawings of Breton 'represent' him as a paternal figure, as one who flies close to the sun ('God' the father) and, indeed, becomes the sun with his hair in burning flames. The 'severed' flaming hand that Nadja supposedly hallucinates over the River Seine conjoins the drawing of Breton as flaming head. A flaming phallus. In another scene she 'tells' Breton 'to follow a line slowly traced across the sky by a hand'.[65] Then seeing the image of a hand on a poster, she slaps her own hand against it, exclaiming: 'The hand of fire, it's all you, you know, it's you.'[66] Nadja's insistent hallucinated image of Breton as a flaming hand is a 'phallic view' of flames and fire – as known in Freud's work.[67] Fire, flames and 'heat' are common metaphors in the language of 'love' and passion. Love is a 'raging fire' or 'burning (or burnt-out) heat', etc. In examples given by Freud, associations between fire and filial love are frequently evident as a central problem, for example, in the dream of the dead son's plea to his father, 'Father can't you see I'm burning' cited in *The Interpretation of Dreams*,[68] and Dora's recurring dream about fire (house burning) with anxiety about the proximity of her father to her bed.[69] In Nadja's hallucinations, the image of fire is always associated with a single hand, the 'severed' hand flaming above

63 Sigmund Freud, 'Psychoanalytic Notes on an Autobiographical Account of a Case of Paranoia (*Dementia Paranoides*) (Schreber)' ([1910] 1911), PFL 9 (Harmondsworth: Penguin, 1981), p. 220.

64 Freud's source is S. Reinach, *Cultes, mythes et religions* (4 vols, Paris, p. 221), in 'Psychoanalytic Notes on an Autobiographical Account of a Case of Paranoia (*Dementia Paranoides*) (Schreber)', p. 221.

65 Breton, *Nadja*, p. 100.

66 Ibid.

67 Freud explores fire in 'Character and Anal Eroticism' (1908) PFL 7 and 'The Acquisition and Control of Fire' (1932), PFL 13; also in 'Civilization and Its Discontents', PFL 12, note 3, pp. 278–9.

68 Freud discusses the dream in Chapter VII, 'The Psychology of the Dream-Processes' (*The Interpretation of Dreams*), PFL 4, pp. 652–5. Jacques Lacan takes up the same dream in *The Four Fundamentals of PsychoAnalysis*, see pp. 56–60 and 67–70.

69 Sigmund Freud, see 'The First Dream' in 'Fragment of an Analysis of a Case of Hysteria ("Dora")', *Case Histories I*, PFL 8 (Harmondsworth: Penguin, 1980), pp. 99–132.

the water and, later, the 'hand of fire' in the sky image.[70] A dismembered limb, as a bit of the human body, the hand is repeatedly burning, 'in flames', waving in the sky. Such images are typically uncanny for a reader, Freud insists: 'this kind of uncanniness springs from its proximity to the castration complex'.[71] In psychosis, what has been foreclosed (the name-of-the-father) within, returns from without. The symbolic world increasingly becomes replaced, filled by a 'regression' to the imaginary.

Lacan claims that what provokes a psychotic outbreak is an encounter with a paternal figure, a stand-in or his metaphor.[72] The origin of this outbreak is in the individual's personal history. The 'name-of-the-father' is the name of what disrupts and comes into conflict with the infant's initial dyadic and blissful relation with its mother. The conflict is crucial for the infant's formative identification as an 'I', as separate and distinct from its (m)other. Recognition (not necessarily acceptance) of the paternal representation is what propels the infant into language and the symbolic order. Thus in psychotics this event is not dealt with in the same way as in neurotics. Rather than the drama of paternal authority being repressed, as in neurosis, with psychosis the paternal is repudiated, not dealt with. The consequent 'hole' produced in the symbolic order where this conflict is missing has to be dealt with (filled) when the subject is confronted by the paternal function. In Schreber's case, it was his expectation (and failure) to become a father at the same time that he is appointed to an eminent social position, as a chief judge – by men twenty years his senior. With Nadja, it appears to be her encounter with Breton who – knowingly or not – becomes a paternal figure for Nadja.

Here, Lacan's own model of the mirror stage can serve as an analogy. As is often described, in the mirror stage, the six- to eighteen-month-old infant is formed as a subject in its splitting through a (mis-)recognition of the idealized other in the mirror as 'itself'.[73] This mirror image, which the subject has to live up to in its cogency (the motor co-ordination and 'unity' of the limbs in the mirror 'image' are greater than those of the actual immature infant), is formative of the aggressive

70 The 'severed hand' theme of course also appeared the following year in the famous 1929 surrealist film *Un Chien andalou* directed by Luis Buñuel.

71 Freud, 'The "Uncanny"', S.E., Vol. XVII, p. 244. We could add the motif of the glove in *Nadja* as a version of the severed-hand theme. The sky-blue bronze glove that a woman visitor leaves at the surrealist gallery fascinates Breton, a 'chance encounter' that anticipates meeting Nadja and her hallucinations. See Hal Foster's discussion in *Compulsive Beauty* (MIT Press, 1993), p. 33–5. Foster describes Nadja as an 'obsessional neurotic', but this ignores the disturbance of language and lack of differentiation between internal and external worlds so typical of psychosis in Nadja's discourse.

72 See Lacan, *Psychoses*, especially p. 320.

73 See Jacques Lacan, 'The Mirror Stage as Formative of the Function of the I', in *Ecrits* (London: Tavistock, 1982).

tension (contradiction) that the infant has towards its own image. The image is foreign, other, 'over there'. In psychosis, this image ('the other') fragments, falls to pieces, as happens in the verbal images invoked by Nadja. Despite the disturbances of language, what can be detected is the way in which Nadja (in the story) empties out the image of herself for the presence of Breton. He quotes her as saying: '"With the end of my breath, which is the beginning of yours"' and '"If you desired it, for you I would be nothing or merely a footprint."' Or more explicitly: '"You are my master. I am only an atom respiring at the corner of your lips or expiring. I want to touch serenity with a finger wet with tears."'[74] Fragmentation and annihilation, Breton is her other.

The lack of a signifier for the name-of-the-father makes itself heard in the images of Breton. In relation to each another, Nadja's emptying mirror image is filled by a Breton who is signified, in metaphorical fragments, by a burning dismembered hand, a part eagle, flaming hair, the sun etc. Breton is a flaming 'phallus', but it is not a metaphor to say that when Breton leaves her, Nadja goes to pieces. As the image which animates Nadja, and as her struggle for mastery of it, collapses and disintegrates, so does she. The hole that is patched over by hallucinations around Breton fragments and disappears. Nadja, living near destitution and prostitution, found in her encounter with Breton a troubling sign of the foreclosed signifier. Deep in sadness and alone in her psychotic conflicts, she is lost with Breton's departure.

The photographs in *Nadja* echo this structure of loss through their emptiness. As the reader views the photographs in relation to the text, the pictures are disturbingly empty, 'lacking' in actual events. Looking into these photographic spaces where any decisive moment has 'disappeared', we wonder what is the other there. Just as Nadja loses her image of identification, so the reader of *Nadja* is deprived of a reflected identification in the photographs. Most of the photographs, even the portraits, have a mute and mournful look, there is a 'dinginess' in these pictures, rarely noted by commentators as such, through which their 'mood' of emptiness invades the book. Expecting to find photographs 'full'

74 Breton, *Nadja*, pp. 115–16.

107

of the events in their captions, the reader finds them lacking and it is in this way that an enigma emerges. Yet this sense of loss characterizes the whole book: the proud starting point of Breton with Rousseau and the Great Men as a fading ideal gives way to Breton's loss of his passion for Nadja, then Nadja 'loses her mind' to her hallucinations and, eventually, loses the street for the asylum. Even Breton's view of the photographs involves a sense of loss.

Towards the end of *Nadja*, Breton says that he wanted some of the photographic images of the places and people to be taken 'at the special angle from which I myself had looked at them'.[75] This proved impossible; the places 'resisted' this and thus, for Breton, 'as I see it, with some exceptions the illustrated parts of *Nadja* are inadequate'.[76]

Breton mythologizes these places, as having something in them which resists representation. This only makes those places gain in enigma. There is little or no attempt to show things as literally *from* Breton's point-of-view in the photographs. In the photograph of Place Dauphine, the view is outside, looking in. One would have to be a disembodied voyeur to be able to 'see' what cannot be seen in these photographs. Whatever Breton says himself in the book, the photographs make crucial contributions and their presence gives a distinct feeling to the book. Can it be that this is what Breton meant when he described the photograph as 'permeated with an emotive value'?

Moods

Can photographs have moods? 'Moods', Adam Phillips says, 'are points-of-view.'[77] Whether it is possible to inscribe moods in photographs is not a question that has ever really been asked in such terms. Certainly photographs have 'points of view' and codings of that view, including the scene it represents, always take place. The point-of-view of the camera is bestowed on to the viewer and connotative conventions of rhetoric teach us that photographs certainly have effects on a viewer. Writing on depression and melancholia, Julia Kristeva comments: 'Let us say that representations germane to affects, notably sadness, are *fluctuating* energy cathexes:

75 Ibid., pp. 151–2.
76 Ibid., p. 152.
77 Adam Phillips, *On Kissing, Tickling and Being Bored* (London: Faber and Faber, 1993), p. 71.

insufficiently stabilized to coalesce as verbal or other
signs, acted upon by primary processes of displacement
and condensation ... Thus moods are *inscriptions*, energy
disruptions, and not simply raw energies ... '[78] Yet
the mechanisms and status of such structures remain
imprecise, as Kristeva notes, accounts of the 'enigma of
mood' are conceptually 'very vague'.[79] So is it possible
to inscribe a mood in a photograph? How to describe
the mood of the photographs in *Nadja*?

'Sadness', says Julia Kristeva, 'is the fundamental mood
of depression.'[80] Certainly the photographs in *Nadja* are
not joyous, they resonate with solitude. The ghosts of
'whom I haunt' appear through their absence; as in the
solitude of the child at the primal scene, with the parents
'away' enjoying themselves. In this paradoxical signifying
structure the signs are empty but never 'empty', they
still signify. The enigmatic message of emptiness draws
us back to those feelings and affects in the story of
Nadja, where madness and sanity are combined in
the mood of melancholy sadness. This mood is based
on an identification with the lost object, where the
depressing and depressed feelings hide an aggression
against that object. Or it is perhaps that other form of
sadness which Kristeva challenges us with, the sadness
of a subject 'wounded, incomplete, empty', where it is
not an object being mourned, but 'the "Thing"', that
'unnameable narcissistic wound' of 'the real that does
not lend itself to signification'.[81] Kristeva could well be
speaking of Breton's *Nadja* when she says:

> Knowingly disinherited of the Thing, the depressed
> person wanders in pursuit of continuously
> disappointing adventures and loves; or else retreats,
> disconsolate and aphasic, alone with the unnamed
> Thing. The 'primary identification' with the 'father in
> individual prehistory' would be the means, the link that
> might enable one to become reconciled with the loss
> of the Thing.[82]

The 'whom do I haunt?' posed by Breton at the begin-
ning of the book is revealed as Breton's melancholic
trawl of the patchwork of paternal literary figures
(Rousseau, Nerval, Baudelaire etc.) emerging in *Nadja*
as the 'primordial' signifiers that make up his Paris.

78 Julia Kristeva asks 'Is Mood
a Language?', in *Black Sun*,
pp. 21–2.

79 Ibid., p. 21.

80 Ibid.

81 Ibid., p. 13.

82 Ibid.

21 Photomontage of Nadja's eyes added to the 1964 revised edition of *Nadja* by Breton.

Breton buries himself in relations to these signifiers as he delves into a bit of Nadja's psychosis. His fleeting interest in Nadja is as link to that lost literary history. *Nadja* is a story in which Breton nevertheless undoes himself a little. He is clearly haunted by Nadja's 'madness' and the experience of their encounter – even if, as a trained psychiatric nurse, he can still say: 'You are not an enigma for me.'[83] Meanwhile, the eyes of Nadja, repeated insistently in Man Ray's montage of them in *Nadja*, place Breton and the reader under her surveillance (an image added by the author in 1964; see Figure 21). Both Nadja and Breton are haunted, Nadja by psychotic hallucinations and Breton by the loss of their relationship and the ghostly enigmatic signs she conjures up of revolutionary figures. *Nadja* as a book is both a process of his mourning for the literary figures of Paris that preceded him and a recovery of lost fragments of 'whom he haunts' in his own literary 'staging of affects'.[84] The role of his choice to use photographs in this is crucial and is what lends the book its melancholy.

The book ends famously with the seemingly impromptu and rushed conclusion: 'Beauty will be CON-VULSIVE or will not be.'[85] The 'beauty' here for Breton is the hysteric in convulsion, but in the end, Breton remains on this side of the symbolic order, he is the neurotic witness to his own unconscious conflicts, while Nadja is given to signify the unconscious and can no longer bear witness to her own thoughts. Nadja transgresses the symbolic order and pays the price of incarceration. As Simone de Beauvoir wryly notes: 'She is so wonderfully liberated from regard for appearances that she scorns reason and the laws: she winds up in an asylum.'[86]

That psychiatrists took the book seriously, or were perhaps forced to, since *Nadja* was being passed around and read avidly by inmates of asylums, surely delighted the surrealists. The section in *Nadja* where Breton denounced the 'retarded infancy' of psychiatry and expressed his contempt for the psychiatrist (Breton said he would physically assault them if he was incarcerated)[87] had apparently been underlined in blue by a patient who presented it to his doctor to read (a patient described by his doctor, Paul Abély, as an especially dangerous and

83 Breton, *Nadja*, p. 158.
84 Kristeva, *Black Sun*, p. 179.
85 Breton, *Nadja*, p. 160. Pierre Daix suggests the conclusion to *Nadja* was written hastily (see his *La Vie quotidienne*, p. 331).
86 Simone de Beauvoir, *The Second Sex*, trans. H. M. Parshley (London: David Campbell, 1993), p. 245.
87 Breton, *Nadja*, p. 139.

demanding madman). The doctor subsequently wanted to set up a committee to 'deal with these matters' as an issue of a professional 'right to be protected'.[88]

The paths of the sexual question 'Who am I?' are different for the man and the woman in *Nadja*. The different trajectories relate to the different relations to a paternal image. If beauty is hysteria, it is in the opening up of an identification with the other. In patriarchal law, as Lacan points out, the question of 'woman' is of an 'identification with the paternal object' through the Oedipus complex.[89] It is surely this relation that Breton explores in *Nadja* and is perhaps why the photographs he chooses are so emptied of such potential identifications, except one photograph: of himself.

88 This incident, written up in the *Annales Medico-Psychologiques Journal*, is reprinted as a preface to the 'Second Manifesto of Surrealism'. See *Manifestos of Surrealism*, pp. 119–21; and discussed in Breton's 1930 essay 'Surrealism and the Treatment of Mental Illness', see André Breton, in Frank Rosemont (ed.), *What is Surrealism?* (London: Pluto, 1989), pp. 62–6.

89 Lacan, *Psychoses*, p. 172.

4 · The Oriental signifier

> Oriental laughter: sensible and leading to the void …
>
> *Julia Kristeva*

When Man Ray left for Paris in July 1921 he was following in the path of Marcel Duchamp, whom he already knew from New York. According to Man Ray in his autobiography, when he arrived in Paris, it was his friend Marcel Duchamp who introduced him to the surrealists for the first time in a café. There he met André Breton, Jacques Rigout, Louis Aragon, Paul and Gala Eluard and Philippe Soupault, along with 'the young medical student Fraenkel', who 'with his slanted eyes and high cheekbones looked impassively Oriental'. Man Ray recalls: 'We left the café together and went to a little Hindu restaurant for dinner. My friends ate the various dishes of curry and rice with a certain disdain, as if nothing could replace French cooking, but made up for it by ordering innumerable bottles of red wine, becoming very gay and loquacious.'[1]

Whether Man Ray's first impression of the dining surrealists is accurate or not, his anecdote certainly conjures up, in a set of now well-worn cultural stereotypes, a surrealist encounter with cultural difference: the enduring *image fixe* of the impassive 'Oriental', a discerning culinary and flamboyant image of 'Frenchness' and the 'little Hindu restaurant'. It is precisely in the articulation of such scenes that the terms of an encounter with cultural difference, 'the foreign', is constructed. Even the very possibility of this scene is marked by the history of colonial dislocations and migrations: Emanuel Redensky,[2] or Man Ray, an American of Russian-Jewish parents who had migrated to the USA from Kiev, had just arrived from New York and was now in a 'Hindu' restaurant in Paris with a mixture of Europeans. In the paths trodden by migrants are the traces and residues of complex political, cultural and colonial histories that helped form the new 'modern' metropolitan cultures that the surrealists were living in. Given that the surrealists were already hostile and restless around the cultural fron-

1 Man Ray, *Self Portrait* (London: André Deutsch, 1963), p. 108.

2 Man Ray's original name was Emanuel Redensky or Radnitsky or Rabinovitch, depending on which source you use. He was born in Philadelphia in 1890 and died in Paris in 1976.

tiers they were being given by their European 'heritage', it is perhaps not surprising that they eked out spaces to encounter the other (object *a*) of their desire. What I want to consider here is the way that, for a moment in the mid-1920s, the surrealists appealed to 'the Orient' as a means to critique European culture and society. The extent to which Orientalism and active interest in colonial and anti-colonial politics were part of surrealism is a neglected area. This path of study is, here at least, not straight. It means going in and around surrealism and out and across the histories that intersect with it, so as to return to surrealism all the richer for it.

The Orient was 'almost a European invention', Edward Said argues, turning Orientalism into a critical discourse through his 1978 book *Orientalism*.[3] There he opened up notions of 'the Orient' to interrogation as a complex discursive field of knowledge, to show that Orientalist representations were enmeshed in the politics of colonial power. Said argues that Orientalism is 'the discipline by which the Orient was (and is) approached systematically, as a topic of learning, discovery, and practice' and as a 'collection of dreams, images, and vocabularies available to anyone who has tried to talk about what lies east of the dividing line'.[4] The Orient, defined as a geographic entity with a set of beliefs and values about its social cultural characteristics, is constituted, along with its inhabitants – 'Orientals' – as different, other and emphatically inferior to the West. As a set of 'academic' and 'imaginative' representations, he suggests, the Orient served as a site for the projection of ideas that served to legitimate Western colonial power.

In this context, the surrealist interest in the Orient demands an examination along with, in particular, how one famous surrealist photograph resonates within a politics of Orientalist representations. Man Ray's *Le Violon d'Ingres* (1924) has an evident relation to Orientalist representations of 'the East', even though it has never been explicitly discussed in such terms (see Figure 22). Indeed, what is striking about the criticism of *Le Violon d'Ingres* is the obvious lack of writing upon it at all, let alone any issue of Orientalism. Despite being one of the most famous and widely known photographs in the whole canon of surrealism, a veritable icon of surreal-

3 Homi Bhabha acknowledges 'the pioneering oeuvre of Edward Said' for post-colonial criticism (Homi Bhabha, *The Location of Culture* [Routledge, 1994], p. ix). Edward Said, *Orientalism* (London: Routledge and Kegan Paul, 1978).

4 Said, *Orientalism*, p. 73.

113

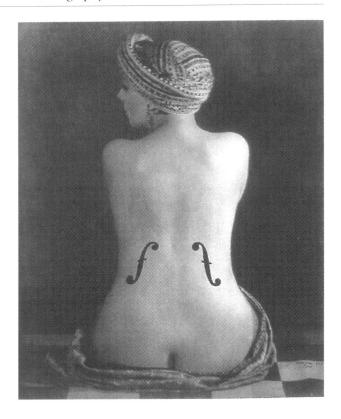

22 Man Ray, *Le Violon d'Ingres*, 1924. First published in the surrealist magazine *Littérature*, no. 13 in June 1924.

ism, frequently reproduced in picture books, calendars, postcards and monographs on Man Ray, any critical discussion of it is extremely rare. Critics and enthusiasts alike appear to have virtually ignored the task of writing about it, all the more surprising because it is so easily vilified. *Le Violon d'Ingres* is strikingly absent even in: *L'Amour fou*, the major Anglo-American exhibition book on photography and surrealism (1986); the earlier French *Les Mystères de la chambre noir* by Eduard Jaguer (1982) and Hal Foster's *Compulsive Beauty* (1993).[5] It is certainly puzzling that such a canonical image has attracted so little critical attention at all in recent years, when photographs from surrealism have increasingly been re-evaluated. To what source can this quietism be attributed?

The conventional standard account of the image is the one given by Man Ray's friend, Roland Penrose, in 1975:

5 More texts which neglect it are: Dickran Tashjian, *A Boatload of Madmen* (London: Thames and Hudson, 1995); David Batchelor, Bryony Fer and Paul Wood, *Realism, Rationalism, Surrealism* (London: Open University Press, 1993) Mary Ann Caws et al., *Surrealism and Women* (London: MIT Press, 1991), Mary Ann Caws, *The Surrealist Look* (London: MIT Press, 1997).

With Kiki as his model, Man made drawings with classical precision and photographs that had the serene beauty of the odalisques of Ingres. In particular, there is a photograph of Kiki crowned with a turban, seated in a position similar to one of the beauties in the *Bain turc* of Ingres; on her back, however, are superimposed the two sound-holes of a violin evoking neatly the ancient metaphor of a woman's body being like a musical instrument. Man Ray gave this photo-collage the title *Violon d'Ingres*, which in French is the poetic term for a hobby or a captivating pastime, and which also reminds us that Ingres was a violinist before he was a painter.[6]

Here Penrose's commentary points to basic signifying elements of the picture, but gives an account which, consciously or not, effectively represses the historical significance of the picture for surrealism, or any potential critical readings of it. In a more recent monograph on Man Ray, Roger Shattuck has a short passage on the image:

> *Violon d'Ingres* sets off an inexhaustible series of associations that combines mystery, humour, and the erotic. I cannot help wondering which (presumably French) collaborator helped him find the multiple visual-aural pun that rhymes violin shape with woman's torso, with the French expression for hobby, with a famous composition by Ingres – and more.[7]

Shattuck at least recognizes that the image has associations even if he does not explore them.

In the context of this critical lacuna, it is by turning to the avenues of associated meaning that analysis of Man Ray's picture will emerge. That is to say, the historical and semiotic 'enigma' of this image is to be glimpsed by first, turning to a reading of the image, then to the historical discourses in which it was made and finally to how the image resonates within and across those discourses as an intervention within them from the position of the surrealists and their attitudes to Orientalism.

The Obvious and Obtuse

It is 'obvious' that the photograph is composed of a conventional pictorial referent, 'the nude', with two black

6 Roland Penrose, *Man Ray* (London: Thames and Hudson, 1989), p. 92.

7 Roger Shattuck, 'Candour and Perversion in No-Man's Land', in his *Perpetual Motif; The Art of Man Ray* (London: Abbeville Press, 1988), p. 318.

23 Ingres, *Baigneuse de Valpinçon*, 1808, the Louvre, Paris.

'f-holes' montaged on it to make her body double as a violin or cello body. Showing the back of the woman, her head is turned towards the left shoulder, with her arms almost completely hidden in front of her. She sits 'naked', a robe around her buttocks as though lowered to reveal her back as the code of *un*dressed, 'revealed'.[8] The two f-holes on her back make her body appear hollow and against the dark background it can be seen that she is sitting on a chequered tiled surface, which, because the lines are not straight, are associated with a soft texture, something like a sofa or bedspread. The turban and matching earring along with the particular back-view pose refer to the figure in the perhaps even more famous paintings by Ingres of the *Valpinçon Bather*

8 Man Ray frequently used this device of the 'lowered robe' in his photographs of women.

24 Ingres, *Turkish Bath*, 1863, the Louvre, Paris.

(1808) and the central figure in *Le Bain turc* (1863), both now in the Louvre (see Figures 23 and 24).[9]

Rhetorically, Man Ray's photograph is premised on a visual pun (*paronomasia*) where an image makes a connection between two elements (woman and violin), which have no logical relation (a false homology).[10] What the photograph does is to hold in tension 'violin' and 'woman'. To understand one of these means ignoring or mis-recognizing the other one, to put them together is not 'realistic'. In semiotic terms, a pun is a signifier repeated (in two similar but distinct forms) with two separate, different, signifieds. One signified ('woman') is constantly undermined by the co-presence of the other signified ('violin'). As signified 'objects', a violin and a woman or 'female body' are in antithesis; one is hard, inanimate and 'wooden', the other is fleshy, animate and 'human'.[11] To combine these makes no apparent 'sense' and violates the *representation* of woman.

But this enigraphic image has to be regarded as, not so much a signifier *of* something, as a signifier *to* someone to grasp the meaning. Moving from the level of what a classic semiotics called *denotation* to the discursive field of *connotation* (the trail of cultural associations), the pun

9 Other versions of these paintings exist in other collections, *Bather* (1807) at Bayonne, Musée Bonnat, and *Bain turc* (1864) in Cambridge, Mass., Fogg Art Museum (see Wendy Leeks, *The 'Family Romance' and Repeated Themes in the Work of J.A.D. Ingres*, Ph.D. thesis, University of Leeds, March 1990).

10 On visual puns see Paul Hammond and Patrick Hughes, *Upon the Pun* (London: W. H. Allen, 1978).

11 These opposites can be 'deconstructed', for example, someone might be described as wooden, but this is a metaphorical term not 'literal'.

works by the vague, crude similitude of form proposed between female body and violin. The joke meaning: a woman is an object to be played like a violin. The violin, an inanimate object, is brought to life by being 'played'. The sliding signifier, 'woman-violin' (denotation), connotes 'play', 'playing', 'played'.[12] The 'instrument' to be played *is* her body and the music heard is 'love'. In this associative field, it is preconscious popular ideas like 'making music', 'If music be the food of love … ',[13] 'making love' and other such figures of speech which associate the image of 'play' back to *sexual* play and 'playing with the body'. This common-sense figurative language is available to anyone, without any specific interest in, familiarity with, or knowledge of surrealism and perhaps explains the durable public fascination that this image has had. Even verbalization of this linguistic meaning is not required for someone to arrive at the meaning. Indeed, to do so, to verbalize a description of the joke would be to labour the elements beyond its humour, as my text no doubt demonstrates. Preconscious reverie with the appropriate cultural knowledge is all that is required to 'get the joke'. It is in this respect that Man Ray's image can be said successfully to have 'avoided' critical analysis, that a meaning is not quite utterable and is only a joke. As precisely 'only a joke', it is as though there is nothing further to be said, since it is in the very nature of a joke to circumvent conscious criticism. As Freud has taught us, a joke is a way of avoiding social restrictions and censorship, effectively short-circuiting in advance any attempts at critical or, in this case, a historical analysis.[14]

The reader of the 1924 surrealist journal, *Littérature*, in which this image first appeared, would have, by turning the page, found the picture anchored by the title printed there as *Le Violon d'Ingres*. Obviously at one level, the phrase *violon d'Ingres* refers to the violin of Ingres; taken literally, it anchors the picture as 'this is the violin of Ingres': a female body. As an idiom in figurative speech, *le violon d'Ingres* makes this female body a hobby or 'second skill'. Putting these two meanings together with the image in a syntactical sense means: 'this is the violin that Ingres played'. His profession was an artist, he played *her* like a violin. For the French-speaking viewer the idea

12 Puns are regarded as 'cheap' and 'base' jokes because of the low economy of expenditure required in making them (see Jonathan Culler [ed.], *On Puns* [Oxford: Basil Blackwell, 1988]).

13 Extrapolated from Shakespeare's *Twelfth Night*, this phrase has become a platitude of the first order, but signifies none the less for it.

14 See Sigmund Freud, *Jokes and Their Relation to the Unconscious*, PFL 6 (Harmondsworth: Penguin, 1986), p. 147.

of play, *jeu*, is already in a chain of linguistic associations, to *jouir* (enjoy) and *jouissance*, which of course also has a sexual meaning. As the translator of Lacan's *Ecrits* points out, in French, '*Jouir* is slang for "to come".'[15] A hobby, or 'creative' pastime is where activities like music and painting are carried out for love, not money, and this is what the image proposes that Ingres loved: playing his women like a violin. Ingres is imputed as 'playing the woman's body', making music with her body (like a violin), having sex. Such associations come readily to the fore when Man Ray makes the joke in relation to Ingres.

Why does Man Ray make a vulgar joke at the expense of Ingres? It is certainly not justified, in that Ingres was known for not having sexual relations with his models, even if his representations of them clearly are 'erotic'.[16] This was simply not part of the 'myth' of Ingres. So what reason is there for Man Ray's slur on Ingres's professional conduct as an artist and why did the surrealists choose to publish this photograph, only one of four, in their magazine in 1924; what was the cultural currency of such a joke in surrealism?

Angry at Ingres

The status and position of Ingres in French culture was being elevated at the beginning of the twentieth century, as more than just another nineteenth-century French Academy painter who had studied in the studio of Jacques-Louis David. The work of Jean-Auguste-Dominique Ingres was being re-evaluated and most notably advanced by Henry Lapauze, a tireless advocate, writer and curator of Ingres's work. Born in Montauban, the same town as Ingres, Lapauze was instrumental in organizing at least three key exhibitions of the works of Ingres and wrote numerous articles and reviews to support them (1901, 1911, 1921).[17] For an 'Ingriste' like Lapauze, Ingres was the undisputed (and insufficiently recognized) 'grand master of l'Ecole Française'.[18] The violin playing of Ingres was part of his myth and the title phrase of Man Ray's photograph, *Le Violon d'Ingres*, is attributed an origin in the life of Ingres.[19] The story goes that at the age of seventeen, Ingres left his home town of Montauban with a friend for Paris on foot, paying their way as they went by playing the violin.[20]

15 Alan Sheridan in Jacques Lacan, *Ecrits* (London: Tavistock, 1982), p. x.

16 In recent literature on Ingres some (male) critics seem to reject his odalisques as 'erotic', Richard Wollheim, for example, describes them as 'chaste pictures' in *Painting as an Art* (London: Thames and Hudson, 1987), p. 285.

17 Henry Lapauze, *Les Dessins de J.A.D. Ingres du Musée de Montauban* (Paris: I. E. Bulloz, 1901); *Ingres, sa vie et son oeuvre (1789–1867)* (Paris: Georges Petit, 1911); *La Renaissance*, May 1921.

18 Henry Lapauze, 'Les Faux Ingres', in Lapauze (ed.), *La Renaissance de l'art Française et des industries de luxe*, November 1918, p. 341.

19 Apollinaire claims: 'Ingres's violin has given us a proverb', Leroy C. Breunig (ed.), *Apollinaire on Art: Essays and Reviews, 1902–1918*, trans. Susan Suleiman (New York: Da Capo Press, 1988), p. 340.

20 See L. Frolich-Bume, *Ingres, His Life and Art*, trans. Maude Valerie White (London: Heinemann, 1926), p. 4.

In the 1911 exhibition, Ingres's paintings and drawings were grouped around his actual palette and violin, exhibited like cult relics, symbols of his first profession and second talent: painting and music.[21]

A review of the July 1921 Ingres Exhibition in the English *Burlington Magazine*, in the same month that Man Ray arrived in Paris, reflected that it was more important than the previous 1911 exhibition.[22] The 1921 exhibition included the *Valpinçon baigneuse*, *La Source*, *Grande Odalisque* and *Bain turc*, Ingres's major Oriental odalisque, nude pictures. The last of these, *Bain turc*, adorned the front cover of *La Renaissance* journal with all the others reproduced inside and the *Grande Odalisque* printed on special paper as a detachable 'hors texte' (see Figure 25). Directed by Henry Lapauze, the special issue of the magazine was dedicated to Ingres with written essays supporting the centrality of Ingres, not only to France, but for all modern art.[23]

Kenneth Silver argues in his book *Esprit de Corps* that the reason for this popularity of Ingres after the 'Great War' is because Ingres came to serve an ideology of patriotic 'Frenchness', represented as 'the most public, confident, conservative, and quintessentially French of artists'.[24] Silver suggests that Ingres was held up as the guiding light of a 'Great French Tradition' in a nation still recovering from war. 'Ingres was not only the symbol of sanctioned French art but was also seen as an antidote to everything that deviated from the path of France.'[25] Silver notes, for example, that the 1921 exhibition of Ingres paintings was held as a benefit for disfigured war veterans, signifying Ingres's work as appropriately 'patriotic'. The neo-classical Roman garb adopted in some of Ingres's 'historical' paintings lent itself to the representation of a glorious imperial tradition of France with its iconography serving its contemporary notion of a certain French colonial self-image whose geographic identity became a compulsory component in the school curriculum. 'Textbooks began to portray France as "the heir to Rome", reviving the Roman Empire around the Mediterranean Sea,' now modified by 'adding to it an African hinterland stretching southward to the Congo'.[26] Ingres was made to signify Imperial France, with the 'classical' realism of his paintings promoting

21 G. Apollinaire, Review of *The Ingres Exhibition* (27 April 1911), reprinted in *Apollinaire on Art*, p. 155.

22 Despite declaring this Ingres exhibition more important than the 1911 one at Georges Petit Gallery, Paris, the reviewer heavily criticizes Ingres, 'the obvious stage management of its emotion' ... 'the inadequacy of Ingres to conceive of Christian themes'. He misses Ingres's new (French) credentials as source reference for modern art. C. H. Collins Baker, 'Reflections on the Ingres Exhibition', *Burlington Magazine*, July 1921, pp. 36–42.

23 'La Nouvelle leçon de Ingres' by Henry Lapauze, 'Comprendre Ingres, c'est comprendre la Grèce et la France' by Arsène Alexandre, in Lapauze (ed.), *La Renaissance de l'art française et des industries de luxe*, May 1921.

24 See Kenneth Silver, *Esprit de Corps, Art of the Parisian Avant Garde and the First World War, 1914–1925* (Princeton, NJ: Princeton University Press, 1989), p. 71.

25 Ibid., pp. 139–40.

26 C. M. Andrews and A. S. Kanya-Forstner, *France Overseas, the Great War and the Climax of French Imperial Expansion* (London: Thames and Hudson, 1981), p. 249.

25 Cover of *La Renaissance de l'art français et des industries de luxe*, May 1921 with Ingres's *Turkish Bath* in the centre.

(more than that of a Delacroix) a 'truthfulness' about the past, just as his paintings of the Orient constituted the 'truth' about the East.

Thus, when Man Ray arrived in Paris, interest in Ingres was a contemporary one. Legitimated as the figure of a French 'tradition', Ingres had become a significant cultural reference point of origin for modern art in France. The paths of modernist art were read back into the so-called 'disciplined' but 'eclectic' work of Ingres.[27] A compressed diachronic history of this particular view can be quickly glimpsed through the key critics.

Mentor to the surrealists, Guillaume Apollinaire in his review of the 1911 Ingres exhibition quotes the same point made more than fifty years earlier by Charles Baudelaire. Baudelaire, the influential critic, had claimed that Ingres was 'a revolutionary in his own way'.[28] And no more so than in his eroticizing of the depiction of woman. Baudelaire argued, 'One of the things in our opinion that particularly distinguishes M. Ingres's talent is his love of women. His libertinism is serious and convinced. M. Ingres is never so happy nor so powerful as when his genius finds itself at grips with the charms of a young beauty.'[29]

27 Jean Cassou and Geoffrey Grigson, *The Female Form in Painting* (London: Thames and Hudson, 1953), p. 46.

28 Charles Baudelaire, quoted in 'The Ingres Exhibition' review by Guillaume Apollinaire, 27 April 1911, reprinted in *Apollinaire on Art*.

29 Charles Baudelaire, reprinted in *Art in Paris: 1845–1862, Salons and Other Exhibitions Reviewed by Charles Baudelaire*, ed. and trans. Jonathan Mayne (Oxford: Phaidon, 1981), p. 38.

Reviewing the 'radical' nudes of Ingres in the 'French Art' section of the 1855 Universal Exhibition, Baudelaire associated them with paintings by Gustave Courbet (who had been excluded): 'their passive solidity and unabashed indelicacy – have just the same peculiarity, in that they also reveal a dissenting spirit, a massacrer of faculties'.[30] Despite Ingres's 'taste for the antique' and different motives, Baudelaire's effective conflation of a romantic appeal to 'nature' in Ingres with Courbet's 'realism', provided a model for later critics to organize the litany of artists indebted to Ingres. These included Degas (the famous 'Impressionist' who owned nineteen paintings and thirty-three drawings by Ingres),[31] Cézanne and the Cubists. By the 1920s the reopened post-war Louvre museum had explicitly linked Manet to Ingres by hanging his *Olympia* painting opposite Ingres's *Grand Odalisque*, relating – mirroring – the sexual economy of the Orient to the 'modern' (nineteenth-century Western) prostitute.[32] With a similar clashing rhetoric of juxtaposition, Man Ray's *Le Violon d'Ingres* brings together the distinct 'high'-culture academic iconography of Ingres's Oriental painting with the then (usually regarded as) 'low' modern vulgar form of 'nude photography'. Yet *Le Violon d'Ingres* is obviously different from Ingres's *Valpinçon baigneuse* painting in which the odalisque figure appears.

Made more than a hundred years apart, the differences are not only between painting and photography, colour and black-and-white, the slightly different poses, the different shoulder that she looks over, in other words, the *forms* of the images, but also their treatments of the 'theme' of the odalisque nude. Ingres is credited with its nineteenth-century innovation; Man Ray's photograph makes a twentieth-century renovation of it in a parodic play. *Le Violon d'Ingres* does not represent the details of the Oriental background decor which help to constitute the 'realism' of the Eastern setting of Ingres's paintings. Whereas Ingres's painting shows a 'naturalistic' depth, signified through the layering of space, from the foreground drapes to the tiny water fountain by the sole of the odalisque's foot, Man Ray strips out this Orientalist decor for an anonymous, dark space. No Oriental drapes, linen, or distant water fountain as in the *Valpinçon*

30 Ibid., p. 131.
31 Jean Alazard, *Ingres et l'Ingrisme* (Paris: Albin Michel, 1950), p. 153, note 1.
32 See Frolich-Bume, *Ingres, His Life and Art*, p. 62.

baigneuse nor the 'harem scene' of women idly, erotically, passing their time in *Bain turc*. Man Ray's figure is 'flat' in contrast with Ingres's corpulent and rounded figure, just as it flattens the perspective of the image. In effect, *Le Violon d'Ingres* can be regarded as post-'cubist'. Man Ray brings to photography both the formal punning of cubism and its collapsing into the same space of different objects (violin and woman are typical motifs in cubism) as a sign of its modernity. Man Ray had already been familiar with modern currents in French art, culture and its history in New York prior to his arrival in Paris. His encounters with Alfred Stieglitz and the exhibitions which introduced modern European art at 291 Gallery on Fifth Avenue; his French wife, 'Donna' (Adon Lacroix), a poet, mother and former art historian, and his one-time tutor Robert Henri who had been in Paris for years before, had all given him tuition in the modern art and literature by which he was to be surrounded when he finally went to Paris.[33]

If Ingres was the reference point against which avant-garde artists marked their difference in the twenties, Man Ray was certainly not alone in quoting from Ingres's iconography. Picasso, Matisse and many others were also quoting and drawing on the work of Ingres.[34] By 1921 it was a common view that the Cubists had taken their principles from Ingres. Critics as different as Lapauze (who was hostile to Cubism and modern art) and Apollinaire (who had critically launched Cubism) could both nevertheless agree their essential relation to Ingres. Lapauze, by then an eminent 'Ingriste', suggested that every artist 'wants to be able to claim Ingres for himself', including Picasso – his so-called Ingres phase, where he parodied his drawings. Much later Herbert Read (in 1959), borrowing from Alfred Barr, still cited the 1915–21 'phase' of Picasso as 'Classical realism, mostly pencil drawings in the style of Ingres'.[35] In 1912, Apollinaire had supported such a view, writing, 'the Cubists can claim to be descendants of Ingres: for them, as for Ingres *line is the probity of art*'.[36] In 1923, a short article called 'Académisme' was published in *Littérature* (no. 9), ridiculing the institutional adulation of Ingres in ironic and laconic terms. Addressed to André Breton, the article is signed 'F. P.' (probably Francis Picabia) who wrote:

33 For his encounters with Stieglitz see Man Ray, *Self Portrait*, p. 18. Man Ray attended classes at Feffer Modern School and met Sammuel Halpert who had returned from ten years in France and studied at l'Ecole des Beaux Arts in Paris under Léon Bonnat. See Neil Baldwin, *Man Ray* (London: Hamish Hamilton, 1988), pp. 17–21. Man Ray married Adon Lacroix in 1914 but they separated before he went to Paris. In an interview he claims that she read to him out loud French books, translating verbally Balzac, Rimbaud and Lautréamont's *Chants de Maldoror* (Pierre Bourgeade, *Bonsoir, Man Ray* [Paris: Editions Pierre Belfond, 1971], pp. 43 and 78).

34 'The transformation of revolutionaries into classicists, by way of the art of Ingres, was in fact taking place in ateliers all over Paris' (Silver, *Esprit de Corps*, p. 249).

35 Herbert Read, *A Concise History of Modern Painting* (London: Thames and Hudson, 1991), p. 149.

36 Apollinaire, 'Cubism', 1912, *Apollinaire on Art*, p. 257.

When Ingres wrote 'Drawing is the probity of art', he thought that drawing and painting were purely arts of imitation.

The carpenter-constructors raise a scaffolding around a cathedral built by Ingres. They regard this cathedral, the neon signs and the machines just as the frog looked at the ox ... What they call to build is to manufacture, their art is a cancer feeding on the foolish jabbering of credulous amateurs; one man is seldom interesting, a gang of workers always smells bad.

As for the little journals, allegedly modern in the style of '*Feuilles libres*', they exist thanks to the subsidy of two or three dealers or gigolos, the first ones hope for fortune, the others for intelligence.

All this, my dear friends, is artificial; what will remain of our epoch lies beyond dealers and editors; above the idiotic mud of critics and regular visitors of sales rooms.[37]

Just over a year after this attack on the critical and salesroom industry around Ingres, Man Ray's *Le Violon d'Ingres* was published in *Littérature*. André Breton, the editor of *Littérature*, also certainly knew what status Ingres had at the time, employed as he was, until the end of 1924, as an art adviser (and librarian) to help Jacques Doucet, the famous couturier, to collect modern art. It was through Breton that Doucet acquired what were to become canonical works in the history of modern art: Pablo Picasso's *Demoiselles d'Avignon*, Giorgio de Chirico's *The Disquieting Muses* and Marcel Duchamp's *Glider* and *Rotary Glass Plate*, among others.[38] Breton was certainly antithetical to the conservative *beaux-arts* 'return to tradition' and promotion of Ingres advocated by Lapauze.

In this context, the joke about Ingres 'playing the violin' (in English, 'fiddling') with his models can be read as an attempt to bring 'down to earth' the supposed 'high-minded contemplation of form' of the academic tradition, a critique of its imagery and an attack on the 'anachronistic' virtues propounded by the likes of Henry Lapauze by implicating Ingres in a 'base' sexual interest. Whereas pre-war critics like Apollinaire had critically 'legitimated' Cubism by sympathetic reference

37 *Littérature*, no. 9 (1 February–1 March 1923), p. 5.
38 André Breton, *Conversations: The Autobiography of Surrealism*, trans. Mark Polizzotti (New York: Paragon, 1993).

back to Ingres, now new post-war groups like the sur-
realists were putting some distance between themselves
and Ingres as a founding reference point of any 'new'
classicist tradition.

Historically, then, Man Ray's picture is an affront
to a high art tradition of the academy, combining
an appeal to the popular – modern – form of photo-
graphy: a vulgar picture, disguised as an elegant joke?
Man Ray's photograph establishes his historical avant-
garde credentials, insulting bourgeois artistic culture in
the form of a joke. Is this all there is to be said about
it? Is it merely incidental that the painting referred
to the Orient? What other signification or historical
associations did it have?

All jokes enunciate a point of view. They issue from
some position, aimed at something or someone. Man
Ray's sexual joke, aimed at Ingres, is carried by the
model, Man Ray's lover 'Kiki', whose female body is
'quoted', coded, as an odalisque nude. Combining East
and West, Orient and Occident in a structural contra-
diction, this doubled play of the Oriental signifier has
another chain of meanings.

Oriental Fashion

Quite simply, in terms of twenties design, *Le Violon
d'Ingres* is a statement of 1920s fashion accessories, with
the hat and earring.[39] 'Turbans' were part of Parisian fash-
ion, initiated before the First World War by Paul Poiret,
the Parisian couturier famous for his Oriental-'inspired'
designs which became deeply popular in the twenties.
Man Ray was important in this; he had met Paul Poiret
(introduced by Gabrielle Picabia) in 1921 when he began
photographing Poiret's fashion collections until Poiret's
later demise. Man Ray recalls the 'Orientally influenced
fashions: silk crêpe, and lamé designs that were heavily
decorated with satin, panther fur, beads, gilt, and tassels;
and his scarlet, flowing tunic like hand-painted gowns
reminiscent of decadent harem life.'[40]

Poiret, like Erté, promoted an exotic, erotic 'volup-
tuous' look in contrast with the childlike cylindrical
garçonne dress trend.[41] Man Ray dresses Kiki with a fash-
ionable hat, a lookalike 'Orient' turban, to help secure
'reference' to the iconography of Ingres's 'voluptuous'

39 The hat is a Western hat
stitched as an approximation of a
turban so that, unlike a turban, it
would not have to be retied each
time it is put on. By the 1920s,
such hats were produced by
Parisian milliners. Although Man
Ray worked for Paul Poiret it is
difficult to confirm whether the
hat was one of his. (Thanks to
Susan North at the V & A.)

Paul Poiret visited the South
Kensington Museum (V & A) to
see their collection of turbans (see
Florence Müller and Lydia
Kamitsis, *Les Chapeaux: Une
Histoire de tête* [Paris: Syros-
Alternatives, 1993], p. 53).

40 Baldwin, *Man Ray*, p. 87.

41 On 'Women and Fashion'
in the twenties, see Anne Hol-
lander, in Kenneth W. Wheeler
and Virginia Lee Lussier (eds),
*Women, the Arts and the 1920s in
Paris and New York* (London:
Transaction, 1982).

odalisque figure. That the turbans are completely different only helps the parody. It is through these differences that the picture establishes both sufficient reference to Ingres's Oriental figure and a semiotic distance from it in the photograph. In Ingres the odalesque is denoted, in Man Ray the 'odalesque' is connoted and Man Ray participates in what Griselda Pollock has called an 'avant-garde gambit', a play of reference, deference and difference. The homage to Ingres's picture as *reference*, shows a *deference* to it as the authority of tradition, yet by asserting a *difference* from it establishes his own position.[42] Condensing the iconography of Ingres's odalisque with the modern photographic nude produces a parodic relation between past and present, between Ingres as the nineteenth-century source of 'French tradition' and a 'modern' Parisian culture of the twenties. A play between the Oriental odalisque 'over there' and a new Orientalism 'over here'. This effectively enlists the spectator in a contradiction, an ideological instability between the two Orientalisms without them ever being finally resolved or closed. In Said's terms the image is Orientalist, yet it makes a parody, which undermines that status. In this respect the image draws attention to a historical contradiction, if not mutation, in the concept of the Orient in the period that Man Ray made the picture.

Discussions about the Orient in the visual arts and literature have tended to be dominated by the nineteenth century, no doubt because this is the period in which it seems ascendant,[43] but what happens in the early twentieth century at the 'high point' of European colonialism is no less significant. A discourse on 'the Oriental' increasingly suffused metropolitan Western culture at the beginning of the twentieth century in a quite different way. For nineteenth-century inhabitants of Europe, the experience of the colonies had been primarily in the use and abuse of their raw materials (ivory, gold, humans, tea, coffee, sugar, textiles, rubber etc.) for Western consumption. Representations of colonial existence and inhabitants were fabricated through the spectacle of its natives (displayed at various World Fairs and international exhibitions) and the various descriptions, images and 'experiences' repeatedly produced by writers, tourists and a panoply of image-makers. Through such

42 See Griselda Pollock, *Avant-Garde Gambits, 1888–1893* (London: Thames and Hudson, 1992), p. 14.

43 Edward Said's *Orientalism* and Linda Nochlin's 'The Imaginary Orient' in her *The Politics of Vision* (London: Thames and Hudson, 1991) are seminal texts in the discussion of nineteenth-century culture, Said for literature and Nochlin for the visual arts.

images the Orient was predominantly signified as a set of exotic, erotic or terrible experiences to be had, that were emphatically 'over there'. What increasingly appears in the early decades of the twentieth century is a fascination with 'the Orient' as a set of cultural practices located within and as part of Western culture 'over here'. These sets of social practices which took the forms of an *imaginary* Orient were in no way required to be tested against any ostensible 'real' Eastern culture. Thus this imaginary Oriental culture was readily embraced as the form for leisure, art, culture and erotic pleasure in European metropoles.

Peter Wollen notes the upsurge in this new particularly French Orientalism following the new translation of *The One Thousand and One Nights* in 1899 by Dr J. C. Marsru published as a series in the avant-garde symbolist journal *Revue Blanche*.[44] As Wollen puts it: 'The Russian Ballet launched the new Orientalism, Poiret popularized it, Matisse channelled it into painting and fine art.'[45]

By 1925 the International Exposition (Art Deco)rative, partially sponsored by the department stores of Paris, had popularized the 'Oriental' as a 'fashion accessory'.[46] The Orient had indeed come home to roost in the West, not only as an ideology of the East (myths, images and concepts used to legitimate a colonial politics) but also as a type of cultural practice 'internalized' paradoxically as modern forms for pleasure, eroticism and leisure. It is as though, at the high point of European colonialism, the colonizing culture had absorbed its own myths and fantasies of otherness. Here, in a suitably displaced discourse, was a frame in which sexuality could be spoken and the Western body eroticized. This is intimately linked with the historical process of colonialism, as an allegorical reading of Ingres's painting implies.

Colonial Sense

Ingres, who never went further south than Italy, had painted *Valpinçon baigneuse* during the period when he stayed in Rome, then under French occupation and after French troops, led by Napoleon, had invaded Egypt and travelled up the edge of the Nile to Syria (1798–1801).[47] According to Edward Said in *Orientalism*, Napoleon was the first European colonial invader to employ 'savants',

44 Peter Wollen, *Raiding the Icebox* (London: Verso, 1993), p. 1.

45 Ibid., p. 3. The first Henri Matisse painting to be bought by the French state was his *Odalisque with Red Trousers* in 1922, a painting which referred directly to one by Ingres (see Silver, *Esprit de Corps*, p. 264).

46 Even orthodox accounts of the exposition acknowledge this: 'the [1925] Exhibition was not just for the rich, for the main sponsors were the departmental stores of Paris who had found it profitable to embrace these new expressions of modernism albeit overlaid with influences from Africa, the Orient, tribal subjects and the Ballets Russes (Charles Moreau, *Authentic Art Deco Interiors* [Woodbridge: Antique Collectors Club, 1989]).

47 See Jules Momméja, 'Le "Bain Turc" d'Ingres', *Gazette des Beaux-Arts*, III (1906), p. 180.

Oriental scholars who were used to negotiate with indigenous Muslims and to collect, record and write, in twenty-three volumes, *Description de l'Egypte* (1809–28). Said notes: 'After Napoleon, then, the very language of Orientalism changed radically. Its descriptive realism was upgraded and became not merely a style of representation but a language, indeed a means of *creation*.'[48]

While stories of Napoleon's invasion were popularized at the time in France with picturesque views of the Orient, Ingres's *Valpinçon baigneuse* combined this with an 'eroticism': the Orient was a woman ready to be seduced. The hidden harem figure was revealed and vulnerable to scrutiny by the West. If such images of a 'morally inferior' culture over there – flushed out by Ingres's sensuality with paint – could serve to legitimate a nineteenth-century colonialism, by the twenties, the apparent sexual liberty of the East became a mythical form for the invasion of a raw sexuality, an emergent liberty in sexual relations that swathed Parisian art and fashion as a 'new Orientalism'. In the absence of any other discourse in which Western sexuality could be articulated, still trapped as it was in rationalist function, the fantasized Orient, with stories like *The One Thousand and One Nights*, pictures of harem scenes and 'liberated' clothing, could be understood as a ready-made repertoire for an erotic, sexual and primal otherness.

At the same time that European colonial activity was rampant, the discourse of Orientalism which had helped that very activity was now, in a form alienated and split away from colonial administrators, 'integrated' as part of its metropolitan culture. Such ambivalent mutations in the apparently once clear oppositions between Orient and Occident, East and West formed the basis of a European cultural formation founded on anxiety and fear of a 'hybridity'. Homi Bhabha notes: 'Hybridity is a problematic of colonial representation and individuation that reverses the effects of the colonialist disavowal, so that other "denied" knowledges enter upon the dominant discourse and estrange the basis of its authority – its rules of recognition.'[49] For the surrealists, of course, breaching a divide and disrupting the discourses in which it signified were precisely the interventions they dreamt up.

48 Said, *Orientalism*, p. 87.
49 Bhabha, *The Location of Culture*, p. 114.

Discourses of Division

In the third issue of *La Révolution surréaliste* (April, 1925) the surrealists appealed explicitly to the Orient as a means to critique the West. In contrast to the condemned intellectual poverty of Western culture an open letter to the Dalai Lama (and another to Buddhist schools) appealed to the Eastern values of elevated spirituality to save the West. Editorially anonymous 'letters' (written by Antonin Artaud) were addressed to the rectors of European universities, the Pope and other public figures condemning the impoverished and debased material values of European education and the 'falseness' of Christianity. Robert Desnos protested at the Westernization of the world (and the rise of Jewish nationalism – he was himself Jewish). Articles in this and other issues of *La Révolution surréaliste* also showed a consciousness and active political interest in the situations of colonies. In one essay Paul Eluard characterizes colonial Africa as where 'in Africa man is more beaten than a dog'; Indo-China where the white man 'is a corpse which throws its waste under the nose of the yellow'; and on the suppression of slavery, 'The taste of liberty comes with the fight for it.'[50]

Already implicit in Dada, anti-colonial politics became more explicit in surrealism towards the end of 1925 in their position on the Riff rebellion in Morocco.[51] As the French were drawn into the war on the side of the Spanish against Abd-el-Krim and his highly organized army and followers, the surrealists declared their support for the fighting Riffs as co-signatories of a manifesto printed in the communist paper *L'Humanité*. While many French intellectuals had declared their support for the government in a document called 'Intellectuels aux côtés de la patrie' (Intellectuals on the side of Patriotism) the surrealists wrote a manifesto in conjunction with the *Clarté* journal, *Philosophies* group and *Correspondance* journal, called 'La Révolution d'abord et toujours' (The Revolution First and Always).[52] Published in the fifth issue of *La Révolution surréaliste* (October 1925) the manifesto condemned the Moroccan war, and rejected the colonial values and laws that underpinned it:

It is our rejection of all accepted law, our hope in new,

50 *La Révolution surréaliste*, no. 3 'en Afrique l'homme est plus battu qu'un chien', p. 19.

51 For an account of the Riff war see David S. Woolman, *Rebels in the Riff: Abd-el-Krim and the Riff Rebellion* (London: Oxford University Press, 1969).

52 Other co-signatories included the *Philosophies* group (Henri Lefebvre, Georges Politzer, Norman Guterman, Georges Friedmann, Paul Nizan) and contributors from the Belgian surrealists of *Correspondance* (ed. Paul Nougé and Camille Goemans) (see Helena Lewis, *The Politics of Surrealism* [New York: Paragon, 1988], pp. 32–6).

subterranean forces, capable of overthrowing history, which make us turn our eyes toward Asia … Time is up for the contemporary world. The stereotyped gestures, acts and lies of Europe have gone through their whole disgusting cycle. Spinoza, Kant, Blake, Hegel, Schelling, Proudhon, Marx, Stirner, Baudelaire, Lautréamont, Nietzsche – this list alone is the beginning of your downfall. It is the turn of the Mongols to bivouac in our squares.[53]

The very idea of non-Western cultures 'pitching their tents' in the centres of Europe was an image designed to invoke a threat, an invitation, that from a reverse view was a deep source of anxiety.

Another French journal, *Les Cahiers du mois*, carried out a survey of established Orientalists (Sylvain Lévi, Emile Senart) and literary men (André Gide, Edmond Jaloux, Paul Valéry) the same year (1925), on views about relations between East and West. Paul Valéry had replied:

… the real question in such matters is to *digest*. But that has always been, just as precisely, the great speciality of the European mind through the ages. Our role is therefore to maintain this power of choice, of universal comprehension, of the transformation of everything into our own substance, powers which have made us what we are. The Greeks and the Romans showed us how to deal with the monsters of Asia … [54]

In an image of cannibalism, Valéry proposes that the East be *digested* by Western culture. Another contributor, Henri Massis, a right-wing writer, had already expounded more fully his views in his book *La Défense de l'Occident* (translated as *Defence of the West* in 1927).[55] The book begins: 'The future of Western civilization, indeed the future of mankind, is today in jeopardy.'[56] The source of this jeopardy is spelled out across the book. Written in a tone of panic, the impending crisis of Western civilization is, he relentlessly asserts, caused by the 'danger of Asiaticism', a dreadful 'awakening of the nations of Asia and Africa, united by Bolshevism against Western civilization.'[57] The 1914–18 war, he argues, broke the 'European unity' and 'weakened our prestige

53 From Franklin Rosemont (ed.), *What is Surrealism?* (London: Pluto, 1989), p. 319.

54 Paul Valéry (*Oeuvres*, Jean Hytier [ed.] [Paris: Gallimard, 1960], 2: 1556–7), quoted in Said, *Orientalism*, pp. 250–1.

55 The English preface by G. K. Chesterton in the book is no less racist: 'We have taught Asiatics to dress in European clothes, at the very moment when those clothes are uglier than they ever were before or, let us hope, ever will be again. But so far from giving them the best European ideas, we have allowed them to give us the very worst Asiatic ideas. Fatalism, pessimism, the paralysis of the fighting spirit, the contempt for individual justice, all these things have been allowed to creep into our culture until they are practically the negative religion of our time. We have conquered the body of the East and let it conquer the soul of the West.' Henri Massis, *Defence of the West*, trans. F. S. Flint (London: Faber and Gwyer, 1927), p. 1.

56 Ibid.

57 Ibid., pp. 2–3.

as "civilized peoples" in the eyes of the Asiatics'.[58] He blames the Germans for turning to 'Asiatic mysticism' and importing it to Europe where it was now spreading like a disease, encroaching on the West through 'Asiatic Russia' – the newly formed Soviet Union. Frankly xenophobic, blatantly racist, the paranoid text indicts everything to which the author is opposed, Dostoevsky is 'Slav Asiaticism' and one passage sounds like a thinly veiled attack on the surrealists as much as the work of the intellectual figures they drew upon:

> how is it possible to give a name to this dreadful mixture of Kantian idealism, Bergsonism and Freudism, that seeks to empty the mind of any objective content, exalts the primacy of the psychic and the individual, reduces truth to affective efficiency, sanctifies the ecstasy of the flesh, and lets loose vital forces on the pretext of spiritualizing them?[59]

The proto-nationalist, fearful, obnoxious argument put by Massis finds a solution to these problems in Catholicism, which for him is 'the only possible assimilator of the Asiatic genius'.[60] The fear of European cultural contamination is purified by religious fervour. For Massis, Eastern ideas were to be fought and (contradictorily) 'assimilated' into Catholic religion; for Valéry, the East was to be 'digested'. In both arguments the Orient had to be consumed, by a Catholic mind and a Western body. In the discourse of colonial administration, 'assimilation' was 'a subject frequently discussed', but was 'too much at variance with the doctrine of authority ever to be seriously implemented'.[61] Official policy was called 'the policy of association, as opposed to assimilation'.[62] This meant that relations were to be established with the colonized, but not identification; 'cultures' were to be kept separate. Officially, colonies and their cultures were to be kept in check at a proper distance and not absorbed by the West.

Such arguments seem futile. The impact of colonialism and 'Eastern' values on the West in the 1920s shows the changing cultural climate; a slow 'hybridity' was in process. So although in an 'official' discourse on the East, Orientalism was a body of knowledge associated with colonialism, it was also a set of values, ideas and

58 Ibid., p. 8.

59 Ibid., p. 31. Massis takes issue with Romain Rolland for introducing to France 'the propaganda of Hindu Nationalists'. Rolland wrote an Introduction to *Gandhi. La Jeune Inde* by Mohandas Gandhi (trans. H. Hart; Paris: Stock, 1924).

60 Massis, *Defence of the West*, p. 203.

61 Henri Grimal, *Decolonization* (Routledge and Kegan Paul, 1978), p. 60.

62 'The only possible solution … from 1910 onwards and adopted in practical policy up to 1939, consisted of not treating coloured [*sic*] French people as *citoyens*, but as subjects of the Republic' (Franz Ansprenger, *The Dissolution of the Colonial Empires* [London: Routledge, 1989], p. 79).

fantasies now 'inhabited' and enjoyed as Western culture. Not so much an assimilation of the East but transformation in cultural meanings of East and West. More than a cultural stereotype of the East, the Orient was part of the fabricated image of a Western modern culture. What did this signify? For Massis, the intimation of this Orient and the cultural values of 'Asiaticism' were now the destruction of the West by the East. Even the Great War is *caused* by an Orientalism or 'Asiaticism' leaking into the West from Germany and 'Russia'. For the surrealists, however, the West could be saved from its contemptible bourgeois and capitalist colonial values by listening, appealing to the ancient knowledge, virtues and philosophy of the Orient.

From any of these points of view, the Orient and its synonyms had become constituent components of the West's discourse upon itself. As Germanic imperialism in the First World War and the Russian revolution reconfigured Europe, legitimate questions were raised about the political and cultural authority of Western culture, particularly in the colonies ruled by them. But it was more than doubt that produced the anti-imperialist resistance and anti-colonial struggles by indigenous populations and communities which were certainly building up in European colonized territories. Those struggles at the beginning of the twentieth century exploded after the First World War into open revolt in the twenties and eventually consolidated as independence movements following World War Two.[63] Commenting on the inter-war period colonial relations, Edward Said argues:

> The Orient now appeared to constitute a challenge, not just to the West in general, but to the West's spirit, knowledge, and imperium. After a good century of constant intervention in (and study of) the Orient, the West's role in an East itself responding to the crises of modernity seemed considerably more delicate.[64]

Dialectic Sign

While the surrealists' appeal to the Orient was intended to challenge positively the hegemonic authority of Western culture, they also found themselves attacked for using the 'Orient myth' by Pierre Naville. Naville

63 See Said, *Culture and Imperialism*, p. 265.
64 Said, *Orientalism*, p. 248.

was a surrealist member and, until then, editor of *La Révolution surréaliste*.[65] In 1926 he published a pamphlet 'La Révolution et les intellectuels' and, demonstrating a clear shift of allegiance to the politics of the French Communist Party, questioned what the surrealists meant by the title of their journal, *La Révolution surréaliste*: 'Do the surrealists believe in liberation of the mind *before* the abolition of bourgeois conditions of material life, or do they comprehend that a revolutionary spirit can be created only after the Revolution is accomplished?'[66]

Naville denounced the surrealists for their crude opposition of an Orient to an Occident, both 'mythical' terms.[67] For Naville, taking the surrealists somewhat literally and at their word, to 'want to see the Mongols camping in our squares, rather than the bourgeoisie and the police, means nothing; it only indicates a sentimental vision of the Revolution'.[68]

Having been challenged to make a choice between anarchy or Marxism, a revolution 'of the mind a priori' or that of the world, the surrealists in the voice of André Breton replied in his own pamphlet published later that year as 'Légitime défense'.[69] On behalf of the surrealists Breton rejected the very grounds of the debate by noting Naville's own binary opposition: 'the entirely artificial opposition' between 'the mind a priori' and 'the world of facts'. Breton then replies to the question of the Orient:

> This word [the Orient] which plays, in fact, like many others, on various double meanings, has been uttered more and more in recent years. It must correspond to a special anxiety of this period, to its most secret hope, to an unconscious foreboding; it cannot recur with such insistence for no reason. It constitutes of itself an argument which is as good as another, and today's reactionaries know this well, losing no occasion to put the Orient in question.[70]

With Henri Massis and Maurras given as examples of 'today's reactionaries', Breton rounds on Paul Valéry's comments in *Les Cahiers du mois*, the survey on East/West relations: 'Valéry insinuates that "the Greeks and the Romans have shown us how to handle the monsters of

65 See 'The Naville Crisis', in Nadeau's *The History of Surrealism*; and 'The Surrealists Join the Communist Party', in Lewis, *The Politics of Surrealism*.

66 Quoted in Lewis, *The Politics of Surrealism*, p. 57.

67 'la grossière opposition d'un Orient et d'un Occident passablement mythiques', Pierre Naville, 'La révolution et les intellectuals', in *La Révolution et les intellectuels* (Paris: Gallimard, 1975), p. 96.

68 Cited in Lewis, *The Politics of Surrealism*, p. 57.

69 'Légitime défense' was published as a pamphlet in September 1926 and also published in *La Révolution surréaliste*, no. 8, 1 December 1926. Also reprinted in Nadeau, *The History of Surrealism*. *Légitime défense* was adopted as a title for the short-lived anti-colonial journal initiated in Paris, 1931. See Chapter 7 and Michael Richardson (ed.), *Refusal of the Shadow* (London: Verso, 1996).

70 Quoted in Nadeau, *History of Surrealism*, pp. 252–3.

Asia." It is a belly which speaks: "moreover, the question, in these matters, is only one of digestion".[71]

Fifty years later, Edward Said also cites Valéry's views and comments: 'If European culture generally had digested the Orient, certainly Valéry was aware that one specific agency of doing the job has been Orientalism.'[72] André Breton's response differs from Edward Said's. 'Why under these conditions', Breton asks, 'should we not continue to claim our inspiration from the Orient, even from the "pseudo-Orient" to which surrealism consents to be merely an homage, as the eye hovers over the pearl?'[73] For Breton the appeal to the Orient by surrealism is justified as an intervention into the discourse on 'Orientalism' and its political and social currency in French culture by the aim of undermining it. Breton goes on to demonstrate this point, quoting from the Indian philosopher and poet, Rabindranath Tagore, to attack French Communist Party politics:

> Tagore, that wicked Oriental mind, believes that 'Western civilization will not perish, if it seeks now the harmony which has been broken to the advantage of its material nature' ... What we cannot tolerate, I say, and this is the entire subject of this article, is that the equilibrium of man, broken it is true, in the West, for the sake of its material nature, should hope to recover itself in the world by consenting to new sacrifices to its material nature. Yet this is what certain revolutionaries believe in good faith, notably within the French Communist Party ... It is not by 'mechanism' that the Western peoples can be saved – the watchword 'electrification' may be the order of the day, but it is not thereby that they will escape the moral disease of which they are dying.[74]

The use of the 'Orient myth' by surrealism is conceived by Breton as a kind of counter-hegemonic intervention, to invoke those 'other "denied" knowledges' that Bhabha claims disrupt the authority of Western culture. For Pierre Naville, this world of surrealism was in 'the mind' as opposed to revolutionary action in the 'world of facts'. Breton's counter-argument to this is that surrealism dissolves – collapses – the dualistic opposition of an 'interior reality' versus the 'world of facts'.

71 Ibid.
72 Said, *Orientalism*, p. 251.
73 Ibid., p. 253.
74 Nadeau, *History of Surrealism*, p. 253.

In the realm of facts, as we see it, no ambiguity is pos-
sible: all of us seek to shift power from the hands of
the bourgeoisie to those of the proletariat. Meanwhile,
it is nonetheless necessary that the experiments of
the inner life continue, and do so, of course, without
external or even Marxist control. Surrealism, moreover,
tends at its limit to posit these two states as one and
the same, making short work of their so-called practi-
cal irreconcilability by every means, starting with the
most primitive of all whose use it would be difficult to
justify if this were not the case: I refer to the appeal to
the marvellous.[75]

In effect, Breton refuses to constrain surrealist activity to
the discursive horizon of the Communist Party. Instead
of attempting to abandon 'idealism' by making an appeal
to the external object, 'the world of facts', Breton turns
the duality either/or of Naville into a single discursive
space in which both terms (the world of facts and the
mind) are dissolved into one marvellous state.[76] Surreal-
ism and its discourse of the marvellous offered a world
in which opposed terms were not situated as either the
cause or supplement of each other. In a footnote he
asserts the need to

> revise certain purely formal oppositions, such as the
> opposition of act to speech, of dream to reality, of
> present to past and future. The basis of these distinc-
> tions, in the deplorable conditions of European exist-
> ence at the beginning of the twentieth century, even
> from the practical point of view, cannot be defended
> for a moment.[77]

Having claimed the surrealists' use of the Orient as an
instance of the marvellous, it is from this discursive logic,
the 'revision' of Western dualisms, that Breton wishes
the surrealist use of the Orient to be judged.

Here, then, can be seen the surrealist justification for
Le Violon d'Ingres. Printed as a full-page image in the
last issue of *Littérature* (a 'Numéro démoralisant'),[78] Man
Ray's picture combines such formal oppositions, which
Breton claims surrealism needs to 'revise': past/present,
Orient/Occident, woman/violin (painting/photograph)
and animate/inanimate. These oppositions figure in the

75 Ibid., p. 252.

76 To pursue the *political* aspect
of Breton's argument with Naville
would mean dealing with the
theoretical Hegelianism which
Breton reveals here in the vein
that Ernesto Laclau and Chantal
Mouffe comment on Hegel's
'dialectic of unity and fragmenta-
tion' where Hegel 'represents the
highest point of rationalism: the
moment when it attempts to
embrace within the field of
reason, without dualisms, the
totality of the universe of differ-
ences. History and society, there-
fore, have a rational and
intelligible structure. But in a
second sense, this synthesis con-
tains all the seeds of its dissolu-
tion, as the rationality of history
can be affirmed only at the price
of introducing contradiction into
the field of reason.' *Hegemony and
Socialist Strategy* (London: Verso,
1989), p. 95.

77 Nadeau, *History of Surreal-
ism*, p. 252, note 6.

78 The 'Numéro démoralisant'
title is presumably due to André
Breton losing his job with Jacques
Doucet. Breton and Aragon were
sacked by him after they pub-
lished the pamphlet 'Un Cadavre'
which attacked the just deceased
Anatole France. The pamphlet is
reprinted in Nadeau's *The History
of Surrealism*, pp. 233–7.

reference to a tradition and difference from it. Yet the desire to wave away binary oppositions is not so easily achieved. Certainly the photograph 'revalues' the Oriental image, an identity is made impossible and identification is ridiculed in its very articulation as Western fashion. If, as Bhabha claims, hybridity 'reverses the *formal* process of disavowal', then the hybrid sign is marked (unlike the fetish) by 'a strange metonymy of presence', of two contradictory knowledges.[79] In terms of the 'marvellous' re-visioning of Western dualisms proposed by Breton, an 'ideal fusion' is not resolved in *Le Violon d'Ingres*. It rather reproduces oppositions and contradictions which cannot be resolved; oppositions in the pun of human figure and violin (flesh and wood, animate and inanimate), Orient and Occident and so on. In this respect, the image sets up what psychoanalysis describes as a 'psychical conflict'. Freud argued: 'Any psycho-analytic attempt to elucidate the question of conflict in depth must inevitably open on to what is the nuclear conflict for the human subject – the Oedipus complex ... as a dialectical and primal conjunction of desire and prohibition.'[80]

From a political and cultural economy to a psychical economy, the 'non-sense' that still shrouds this image – despite the presence of the historical discourses within which it resonates – exceeds the process of its signification, which is still obscure and enigmatic. What exactly is communicated or being understood is still not clear, a fact of special interest, since circulation and interest in Man Ray's photograph are sustained without any specified historical knowledge: how might this still more obtuse other meaning be clarified?

Economy of a Joke

Little or no work has been carried out on photographic jokes, but discussion of photographs in analogy with a dream-logic is already familiar.[81] Freud noted that it was sometimes hard to distinguish a joke from a dream.[82] The similarity is due to the fact that jokes are subject to the same processes as the 'dream-work': condensation, displacement and dramatization and secondary revision. Although subject to these processes (the 'joke-work'), the function and topological place

79 See Homi Bhabha's discussion in *The Location of Culture*, especially pp. 114–15.

80 See Jean Laplanche and Jean-Bertrand Pontalis, *The Language of Psycho-analysis* (London: Karnac Books, 1988), p. 362.

81 See, for example, Victor Burgin, 'Seeing Sense', in *The End of Art Theory* (London: Macmillan, 1986).

82 Sigmund Freud, *Introductory Lectures on Psychoanalysis*, PFL 1 (1979), pp. 273–4.

of dreams and jokes are different. The dream is an eminently private affair. The dream-work attempts to disguise, censor, distort and hide latent thoughts. In contrast, the 'joke-work' is dependent on retaining a certain legibility in order for it to fulfil its social function as a 'joke'. Freud notes, a joke 'is the most social of all the mental functions that aim at a yield of pleasure … A dream remains a wish, even though one that has been made unrecognisable; a joke is developed play.'[83]

In common-sense pictorial terms, Man Ray's picture is an 'illogical' puzzle and the photograph does not represent something that we know to be possible in material reality; it is not 'realistic'. In psychical reality, however, an illogical puzzle-picture is often found in dream images, like a rebus.[84] In terms of the dream-work, Man Ray's image condenses the violin and the woman's body (already condensing photographic nude and odalisque) and masks the once logical connections between each of the elements of psychical thoughts. In jokes where condensation is an evident mechanism, Freud notes 'we must suppose that the determinants for such condensations, which are absent in the preconscious, are present in the unconscious thought-process'.[85] Topographically for Freud, in a joke, *a preconscious thought is given over for a moment to unconscious revision and the outcome of this is at once grasped by conscious perception*.[86]

There is, obviously, no question of returning to the unconscious thoughts of Man Ray, no attempt to analyse him here, and anyway the purpose is not to find out how the joke was produced, but rather what governs its effects on spectators, the issue of: what is its enigmatic message? This effect of the image-joke, the unconscious of the *Le Violon d'Ingres* joke, is a reading which can be derived by following the associations of the image which are now available to us.

Intimate Scene

Let's go back to the odalisque 'back view' that was noted in at least two of Ingres's famous odalisque paintings: *Valpinçon baigneuse* (1807) and *Bain turc* (1862). Harem life is the theme of the paintings. Precisely which of the two paintings is claimed as a source for *Le Violon d'Ingres* is almost irrelevant since the quoted back view

83 Sigmund Freud, *Jokes and Their Relation to the Unconscious*, PFL 6 (1980), p. 238.

84 Freud: 'Dreams, then, think predominantly in visual images – but not exclusively … what are truly characteristic of dreams are only those elements of their content which behave like images, which are more like perceptions, that is, than they are like mnemic presentations.' Freud, *Interpretation of Dreams*, PFL 4 (1980), p. 114.

85 Freud, *Jokes and Their Relation to the Unconscious*, p. 226.

86 Ibid., p. 223, italics in original.

137

of the figure is the same in both paintings. Although painted more than fifty years apart, it is exactly the same fleshy nineteenth-century back, not at all aged, that is repeated in both paintings. The major difference between the two figures is not this fetishized position of their bodies but the context in which they are seen. In the later *Bain turc* painting, the figure is holding, presumably playing, a musical instrument, an oud. Her 'high-minded' musical interest is the one thing that differentiates her from the other women in the orgiastic harem scene of the 'Turkish bath'.[87] In *Valpinçon Bather* the isolated figure is shown 'caught' between bath and bed. The viewer is offered a look at these women which is coded as 'illicit', signified in *Valpinçon baigneuse* by the pulled-back curtain in the foreground, a painterly convention for 'revealing'. (In May Ray's picture it is a lowered robe.) In *Bain turc* this 'revealing' is signified through the rotunda framing, the circular logic of a spy-glass lens and its implied distant hidden viewer. But in the discursive logic of Ingres's Orientalist imaginary, the points of view which these pictures reproduced were already 'illicit' because the original, 'proper' viewer of these harem scenes was not just anyone, but an imagined despot or 'sultan'.[88] Depicting 'his possessions', the fantasy is of an intrusion into the point of view of this imaginary 'despot', ogling, with his polymorphous monopoly, these harem women in the service of his sexual and scopic pleasure. It is investing in this point of view of the imaginary absent despot that gives the nineteenth-century Western spectator a frisson of identity with the intruding glance at the harem property of an other, a sight that was so preciously hidden from Western eyes.[89]

This notion of 'doing something wrong' or 'illicit' is also connected with Man Ray's photograph as '*le violon*', which in twenties French slang also meant a 'prison cell' in a police station.[90] '*La nuit "au violon"*' means: to spend the night locked up in a police cell, which is (normally) to have done something forbidden, to have committed a crime. The woman's body *is* a violin, in Man Ray's picture, illicit and taboo. The illicit of Ingres in the pun is his purported hobby, of 'playing', to *jouir*, as 'coming' with women. Sexual intercourse is equated with being thrown in prison. Why? In what sense should this be

87 *Bain turc*, according to Richard Wollheim, was based on the first-hand description of life in a Turkish harem by Lady Mary Wortley Montagu. Ingres had apparently copied out passages from her description of a bath with two hundred bathers (*Painting as an Art* [London: Thames and Hudson, 1987], pp. 260–1). Lady Mary Wortley Montagu's descriptive text has been questioned by more than one author. Wendy Leeks, for example, argues that in such descriptions 'the West has coloured its Eastern fantasies' (see her 'Ingres Other-Wise', *Oxford Art Journal*, 9:1 [1986], p. 32). Rana Kabbani argues: 'The allure of *Les Mille et une nuits* led many Europeans to confuse the real East with the East of the stories' (*Europe's Myths of Orient* [London: Pandora, 1986], p. 29).

88 *Valpinçon baigneuse* was in fact commissioned for a sultan, the Khabl Bay.

89 Wollheim reports that in Ingres's notebook was written: 'Nothing short of death awaits any man who might be found in one of these women's baths.'

90 Thanks to Adrian Rifkin for drawing this to my attention. Other slang uses are: '*pissais dans un violon*' as 'a waste of time' and '*boîte à violon*' is a 'wooden overcoat', a coffin, to be dead (see 'violon' in *Dictionary of Modern Colloquial French* [London: Routledge and Kegan Paul, 1984], p. 322).

138

taken? In what context is sexual intercourse an illicit, forbidden, activity, something to be 'slapped in jail' for? What is this law transgressed?

Hearing and Seeing

Looking again at the photograph, the woman Kiki is shown sitting on the edge of what might be a bed, her arms folded in front of her. Like the odalisque in Ingres's *Valpinçon baigneuse* her head is turned sideways, only a little more so in *Le Violon d'Ingres* (and in the opposite direction). Her head is turned as though she has sensed something over her shoulder or behind her. What has she heard? Norman Bryson notes that Ingres's *Valpinçon baigneuse* figure is

> less an erotic presence than an intimation of its possibility. The figure is placed in a hushed interior whose silence is interrupted only by a splashing font; she turns from the spectator and covers her body with a sheet: we cannot see her face. Our attention is directed instead to a different personal feature: the bather's ear, as it experiences the liquid acoustic of her private world. The sensuality of the image is unquestionable, but the *Valpinçon baigneuse* cannot be appropriated by the viewer's desirous gaze: the bather's senses, perfectly attuned to her environment, attend to silences and sounds our senses cannot share.[91]

Bryson draws attention to the aural aspect of the image which it has in common with *Bain turc*: the oud player. Even though we cannot 'hear' what these figures in the paintings are hearing, the image signifies sound. Yet for Bryson, because the odalisque in *Valpinçon baigneuse* is turned away from the viewer, he argues that she is oblivious to everything but 'the liquid acoustic of her private world'. What this description elides is the sonorous capacity of hearing beyond a presumed narcissistic contemplation.[92] Although there is nothing to confirm or refute these readings, the bather's head is turned as though looking, listening or hearing some acute presence. Why might not the aural in the painting be something which *disrupts* the odalisque from being 'perfectly attuned to her environment'? What if she has heard something outside herself, the noise of someone

91 Norman Bryson, *Tradition and Desire* (Cambridge: Cambridge University Press, 1984), p. 130.

92 Richard Wollheim argues that Ingres's harem bather pictures 'should be seen primarily as portrayals of women temporarily released from the demands of men, and, as such they depict them taking innocent pleasure in a new-found idyllic freedom' (*Painting as an Art*, p. 285). This works only if the viewer and the discourse of Orientalist painting are disavowed and the woman's 'glance over her shoulder' in *Valpinçon baigneuse* is ignored.

approaching; the auditory clatter of the artist's painterly paraphernalia, a noise made by the viewer or, returning to Man Ray's photograph, the noise of his camera apparatus? Whatever the fantasy, this attentive 'listening' of the figure in the picture functions to signify another's presence. In Ingres's paintings, the spectator is put in the position of the despot looking at the odalisque who has heard him (us) approaching and we are 'positioned' as intruders in a scene of seduction.

Readers of Freud will no doubt recall the paper in which he first mentions the primal scene, the case where there is the *sound* of a camera in it. In this 1915 essay, 'A Case of Paranoia Running Counter to the Psychoanalytic Theory of the Disease', the woman patient was lying with her lover in his bedroom and heard a 'click'. She became convinced afterwards that she had been photographed in a compromising position by a hidden camera behind a curtain in the room. The appearance of two men with a box in their hands (she imagined a camera) as she was on her way out of the building further convinced her that she had been photographed. The man had tried to reassure her that this was not the case, but the woman was not convinced and took the case to a lawyer, who having doubts about it, sought the advice of Freud, since the man had made no attempt to blackmail her and expressed his regret at the 'unfortunate morbid idea' which had terminated their relationship. Freud's interpretation is that the woman had produced the displaced version of a primal fantasy: 'The accidental noise [the supposed camera click] was thus merely playing the part of a provoking factor which activated the typical phantasy of over-hearing which is a component of the parental complex.'[93] The aural element appears central to the fantasy: 'Behind this delirium', Laplanche and Pontalis write in their seminal essay 'Fantasy and the Origins of Sexuality', 'Freud saw the primal scene: the sound is the noise of the parents who awaken the child; it is also the sound the child is afraid to make lest it betray her listening.'[94]

In her liaison with the man, Freud notes, the woman had identified herself with the position of her mother (as her father's lover). Thus, taking her male lover as 'still her father', the projection of the click (which for

93 Sigmund Freud, 'A Case of Paranoia Running Counter to the Psychoanalytic Theory of the Disease' (*On Psychopathology*, PFL 10 [1981], p. 154).

94 Jean Laplanche and Jean-Bertrand Pontalis, 'Fantasy and the Origins of Sexuality', in Victor Burgin et al. (eds), *Formations of Fantasy* (London: Methuen, 1986), p. 18.

Freud is no 'accidental noise') had enabled the woman to *'advance from a female to a male object'*.[95] The woman had psychically identified, switched places, with her mother. From a position as a child surreptitiously watching, to taking the place of her mother in a scene with her father, the hostile mother was now watching *her*, signified by the 'click' of the camera, while she (the daughter) was with her lover (associated as father). The woman's own internal 'noise' (according to Freud, the beat of her clitoris) is guiltily projected out on to an accidental noise as 'being watched', the camera click as metonymical presence of this external judging and accusing figure – her still overbearing mother. In this scenario, the camera came to represent her judging mother figure (thus demonstrating how 'identification' is mobile in an image of fantasy and not necessarily simply the position given by the camera).

There are two 'sounds' signified in Man Ray's picture. One is the figure in the picture *hearing* something, the other is the violin (woman) being played (to *jouir*) by Ingres, the sound of 'sexual intercourse'. Jean Laplanche and Jean–Bertrand Pontalis pose the question as to why, in primal fantasies, a privileged position is given to hearing:

> We suggest there are two reasons. One relates to the *sensorium* in question: hearing, when it occurs breaks the continuity of an undifferentiated perceptual field and at the same time is a sign (the noise waited for and heard in the night) which puts the subject in the position of having to answer to something. To this extent the prototype of the signifier lies in the aural sphere, even if there are no correspondences in the other perceptual registers. But hearing is also – and this is the second reason to which Freud alludes explicitly in the passage – the history or the legends of parents, grandparents and the ancestors: the family *sounds* or *sayings*, this spoken or secret discourse, going on prior to the subject's arrival, within which he must find his way.[96]

No need for a phylogenic explanation of the source of primal fantasies; they are already there, structured in the world in which the infant finds itself. Man Ray's picture draws on, 'responds to' a primal scene 'already

95 Ibid., p. 156 (italics in original).
96 Ibid., p. 18.

141

there' in the mythical cultural prehistory of the pictured scenario. A scenario already found before and beyond Ingres's Oriental paintings in a litany of Western depictions of naked women's backs painted in intimate spaces by generations of men.

Primal Fantasy

But it is exactly in this reference to forebears that Man Ray's image also *attacks* the father's tradition. The paternal image of Ingres as the 'father of French art' in the 1920s is the cultural tradition that Man Ray's picture challenges. The avant-garde artist is caught up in an Oedipal story; Man Ray's 'insult' on Ingres is an attack on the law of the father, on his position in art and his omnipotent – despotic – 'mastery' in the bedroom, in the erotic depictions of women. Given that the model in Man Ray's picture is his lover, the picture is an extra-ordinary attack on Ingres, a secret knowingness that she is already 'mine'. Yet in the 'joke' she is the lover of Ingres and we can begin to understand why this picture has an ambivalent love and hate in readings of it: the parody is a history of parracide.

In *Le Violon d'Ingres*, the (m)other's body is represented as the site of an erotic prohibition who, with the turn of the head, signifies hearing the sound of someone approaching. In a preliminary identification with the position of the camera, the viewer is 'in' this room as an infant (male or female) looking. In the imagined primal scene the child 'sees' its parents copulate but without the knowledge to register what it is, and it remains traumatically untranslatable, as enigmatic signifier. That such a scene is the unconscious fantasy, the *enigma* of *Le Violon d'Ingres* is intimated across the material gathered so far and can be summarized as follows.

Man Ray pokes fun at Ingres, his painting of the odalisque and hobby of violin playing. The 'funny' f-holes render the woman's body 'uncanny' and it is 'surreal' [*sic*] to think of her body as a *void*. The *sound* of this body being *played* by Ingres is associated with 'illicit', even 'breaking the law' and prison. The viewing subject – put in the same position as Man Ray's camera – is 'caught out', *heard* by the woman in the picture. In the picture this woman is Ingres's nineteenth-century

odalisque lover, yet she is also contemporary to Man Ray, his actual lover: Kiki. She, a doubled woman (let's say as mother and mistress), hears the camera/Man Ray/us. This is the moment we are given as depicted in the scene: she hears the approach of someone. In the joke she is in the act of lovemaking with Ingres. What she hears is the arrival of Man Ray and we are given the elements of a classic Oedipal mother, father and son triangle, the copulating adults and the prying voyeuristic male child looking on, unable to comprehend the scene (enigmatic signifier) and left out of the excitement. The f-holes (as prison image) say 'no!', an interdiction to the viewing child. This, in an enigmatic form, is the structure of an unconscious primal scene, as 'witness' to copulation.

But this primal scene is also overlaid by a cultural scene, the Orient as a historical stage for the fantasy. What Linda Nochlin calls Ingres's innovation of the '*original* Oriental back view' overlaps the feminine back view as an originary *primal* scene.[97] The specific scenarios of an Oriental odalisque in the harem, offered a cultur-ally legitimate space for a Western imaginary possession of the despot's place – we find here the same psychical fantasy played out at a cultural level. As a cultural fantasy of origins, female bodies are depicted as always already preparing for seduction, 'over there' and far away. Man Ray's image brings this fantasy image closer, the brazen photographic nude, disguised by the f-holes and the turban making it 'acceptably' non-Western. Laplanche and Pontalis note that primal fantasies

> are all related to the origins. Like collective myths, they
> claim to provide a representation of and a 'solution'
> to whatever constitutes a major enigma for the child.
> Whatever appears to the subject as a reality of such a
> type as to require an explanation or theory, these phan-
> tasies dramatise into the primal moment or original
> point of departure of a history. In the 'primal scene' it is
> the origin of the subject that is represented; in seduc-
> tion phantasies, it is the origin or emergence of sexual-
> ity; in castration phantasies, the origin of the distinction
> between the sexes.[98]

What is striking about Man Ray's photograph is that it involves all three fantasies: in the primal scene, the

97 My italics. Nochlin, *The Politics of Vision*, p. 47.

98 Jean Laplanche and Jean-Bertrand Pontalis, *The Language of Psycho-analysis* (London: Karnac Books, 1988), p. 332.

'origin of the subject' is given in the body of the woman, doubled in the contemporary and a 'history' as the Orient. 'Seduction' is signified in the aural aspects of the picture: the noise heard by the woman is of the desiring child approaching figure and the noise of the 'playing violin'. 'Castration' is implicit: as a violin, it empties her body, it is 'hollowed' out and something is 'missing' from her, a 'void'. Also as illicit, a prison cell signifies interdiction of the law. The infant's incestuous desire for the mother is forbidden and the photograph 'speaks' of these fantasies, of desire and prohibition, as an enigma. This is not to suggest that these were the intentions of Man Ray; as Jean Laplanche notes, an 'enigma is defined by the fact that it is an enigma even for the one who sends the enigma'.[99]

But read literally, the f-holes in the woman's back as 'branding' appear as another signification of crime. In a scene in the Marquis de Sade's novel *Justine*, she is marked on the shoulder with an 'f'-shaped branding iron. Under the *ancien régime* an 'impression *f* au fer chaud' on her back is the conventional sign of 'criminality'. In *Justine* it is the unjust punishment for her attempting to set free the daughter of her keeper Rodin (who with a fellow surgeon was about to dissect his daughter for 'medical research' on female genital anatomy). Here and in Orientalist scenes, sadism is the theme. Stephen Heath reminds us: 'Sade's comment that, for the true libertine, it is "the sensations communicated by the organ of hearing which are the keenest" (thus his libertines listen to long narratives, construct machines to amplify sound, achieve orgasm on hearing cries).'[100] The sounds of 'seduction' become the screams of an assault.

Yet might there not be another way to imagine the Man Ray photograph, as otherwise, as the scene of a woman who has the 'play of the violin', a feminine *jouissance* which goes, precisely, *beyond* Man's imagination?

99 Jean Laplanche, *Seduction, Translation, Drives* (London: Institute of Contemporary Arts, 1992), p. 57. Jean Laplanche credits the term 'enigmatic signifier' to Jacques Lacan: 'Between the enigmatic signifier of the sexual trauma and the term that is substituted for it in an actual signifying chain there passes the spark that fixes in a symptom the signification inaccessible to the conscious subject in which that symptom may be resolved – a symptom being a metaphor in which flesh or function is taken as a signifying element.' Jacques Lacan, *Écrits*, p. 166.

100 Stephen Heath, *Questions of Cinema* (Basingstoke: Macmillan, 1981), p. 176.

5 · The Sadean eye

It is strange that the true source of cruelty should be desire.

Novalis

'Sade is surrealist in sadism' announces the first *Manifesto of Surrealism* in 1924. True to their word, the interest in Sade and sadism figures across surrealism by both men and women surrealists.[1] André Breton and Louis Aragon were already familiar with Sade and some of his writings through the days when they made visits to Guillaume Apollinaire. Apollinaire had discovered and read rare manuscripts by Sade buried in the Bibliothèque Nationale in Paris. He published a selection of Sade's writings in 1909, introducing the Marquis de Sade as 'the freest spirit that ever lived', a statement that must be taken to refer primarily to Sade's thinking rather than his actual life, since much of it was spent in prisons and asylums for various 'minor crimes'.[2]

Celebrations of Sade can be found across the periodicals, for example, in *Le Révolution surréaliste* (no. 8, 1 December, 1926) where Paul Eluard wrote about the Marquis de Sade as a 'fantastique' and 'revolutionary', but it was at the end of the 1920s that surrealist references to Sade really began to accelerate. One explanation for this sudden surge of their interest in Sade might be accounted for by the rediscovery of actual Sade manuscripts, but this is not entirely convincing since they had some familiarity with Sade's work since the early part of the twenties. Other factors cannot be ruled out. Nevertheless, Man Ray lived next to Maurice Heine (in rue Campagne-Première, Montparnasse), who for fifteen years had been sifting and piecing together parts of Sade's manuscripts from libraries and museums in Europe.[3] It was due to Heine that numerous texts by Sade were published between 1926 and 1935, including *120 Days of Sodom* and *Les Infortunes de la Vertu*, the original draft of *Justine*, extracts of which were published in issues of *Le Surréalisme au service de la révolution*.[4]

According to Man Ray, Heine visited his studio, bringing the original 1785 manuscript of *120 Days of*

1 Penelope Rosemont lists Nora Mitrani and Annie Le Brun among these. See Penelope Rosemont, *Surrealist Women: An International Anthology* (London: Athlone, 1998), pp. xxiv–xl. Their interest in de Sade is of course long before Angela Carter's discussion of 'the problems his writings raise about the culturally determined nature of women and of the relations between men and women that result from it', in *The Sadeian Woman* (London: Virago, 1979), p. 1.

2 The Marquis de Sade's actual life was extraordinary. A well-read Provençal nobleman, at seventeen he fought in the 1750s war against Prussia. In 1763 at the age of twenty-three he married Renée-Pélagie Cordier de Launay de Montreuil, but was imprisoned in Vincennes prison shortly after their wedding by order of the King for 'excesses' in a brothel. Released a few weeks later, Sade continued his adulterous life and the incidents escalated until *in absentia*, he was tried for attempted poisoning and sodomy along with his servant in 1772. Sentenced to death by decapitation (the noble death) with his ashes to be scattered to the winds, he fled to Italy and despite various attempted arrests, escaped the threat of capture, but returned home four years later in 1776. Two years later, after a trail of seductions of female servants and complex events, he was brought to trial where the previous death sentence was overturned, but he was found guilty of 'acts of debauch and excessive libertinage' (see *Marquis de Sade* [London: Arrow Books,

1991], p. 93). Despite attempted escapes he was imprisoned in Vincennes, Paris, in September 1778, where he wrote for ten years until moved to the Bastille in 1784. Five years later in 1789 and ten days (4 July) before the French Revolution storming of the Bastille, Sade was moved to Charenton Asylum, ostensibly because of his complaints. The following spring (1790) he was visited by his two sons (he also had a daughter) and like all prison inmates held under Royal Orders, was released by the new 'Revolutionary Council' a few weeks later. Now separated from his wife, under the new Republic he became first a Citizen and playwright, then a Republican soldier and three years later (1793) was appointed as a magistrate, three months after King Louis had been guillotined. But again Sade was imprisoned in the Bastille, this time apparently for the 'anti-revolutionary' contents of a letter he had written to an aristocrat two years earlier. Condemned to death again, he narrowly escaped execution, unlike Robespierre and twenty-two others before him on the same 'terrorist' list. After a perhaps feigned illness, Sade was released and he tried to survive as a writer, mostly living in poverty until 1801 when he was again imprisoned as the alleged author of *Justine* and *Juliette*, but Sade's publisher was put to death instead. Returned to Charenton Asylum in 1803, Sade was under Napoleon's orders and kept there until his death in December 1814 at the age of seventy-four.

Sade's remarkable survival of Royalist, Republican and Napoleonic Nationalist regimes is only surpassed by the strange survival of his writings. It is these writings the surrealists were aquainted with through Apollinaire and Maurice Heine, writings that were disseminated through surrealism.

Sodom with him to be photographed. Sade had written the famous text while in the Bastille prison in minuscule writing on a twelve-metre-long roll of (toilet) paper.[5] Man Ray became interested in Sade and visited his family chateau at Vaucluse along with André Breton, Paul Eluard, Jean Hugo, René Clair and others. Letters, extracts of writing and material by Sade and homages to him by surrealists were published in *Le Surréalisme au service de la révolution* in issues no. 2, no. 4 and no. 5 (respectively October 1930, December 1931, May 1933). Man Ray's photograph in *Le Surréalisme au service de la révolution* shows what appears to be the decapitated head of a woman resting on a book and encased in a glass bell jar, as though it were a trophy (see Figure 26). Three years later another image by Man Ray titled *Monument à D.A. F. de Sade* (see Figure 27) appeared in *Le Surréalisme au service de la révolution* (no. 5), located between Max Ernst's image of *Oedipus* and before and after (anonymous) photographs of the Papin sisters who had suddenly brutally murdered their domestic service employers in Le Mans, in what became a high-profile public case.[6] (That case at least showed that the surrealists were not just interested in men who committed sadistic acts – in fantasy or actuality – as 'liberation'.) A number of other visual representations appeared at the same time with Sadean elements, for example, the two famous surrealist films of the period by Luis Buñuel *Un Chien andalou* and *L'Age d'or*, the former (written with Salvador Dali) known for its notorious eye-slitting scene and the latter with an explicit citation of Sade's *120 Days of Sodom*.[7]

3 Man Ray in interview with Pierre Bourgeade, *Bonsoir, Man Ray* (Paris: Editions Pierre Belfond, 1971), pp. 74–5.

4 Extracts of Sade's *Justine* were published in the second issue of *Le Surréalisme au service de la révolution* to celebrate ninety years since his birth (1740). An essay by René Clair in the same issue shared its title with a photograph by Man Ray, *Hommage à D.A.F. Sade*.

5 See publisher's preface in *Marquis de Sade* (London: Arrow Books, 1991), p. xix.

6 The Papin Sisters are much neglected in standard literature on surrealism. For useful discussions see: Elisabeth Roudinescou in her *Jacques Lacan and Co.; A History of Psychoanalysis in France 1925–1985*, trans. Jeffrey Mehlman (London: Free Association, 1990), pp. 124–8; and Catherine Clément, *The Lives and Legends of Jacques Lacan*, trans. Arthur Goldhammer (New York: Columbia University Press, 1983), pp. 69–77.

7 The fame of this film and its subsequent banning came from the first showing of Luis Buñuel's

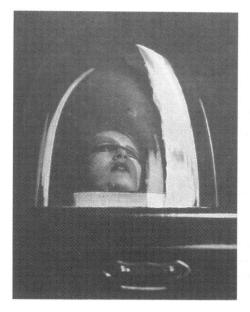 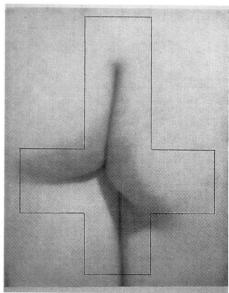

The photograph by Man Ray, *Monument à D.A.F. de Sade*, shows the softly lit skin of a bottom, framed by the graphic marks of an upside-down Christian cross. Not only did this upside-down sign signify a devilish anti-clerical inversion of the Christian good and identify an equivalence between the anal zone with the 'devilish' sign; it also, in a literal sense, places the imaginary object in a position in which it can be thrust into the anus, an act perpetrated by a monk in Sade's story of *Justine*. The symbol of Christian religion is turned into a sadistic weapon; as a sign of Christian love (the crucifix, itself founded on a violent event) is inverted, resignified as sign of 'perverse' sexuality and sadistic power. Clearly the surrealists were interested in sadism itself as a form of dissent and liberation beyond any 'literary' passion.

To begin a discussion of such sadism, then, is to embark on what must seem like a treacherous path. Surrealism has brought with it a flood of protest, accusing its male members of phallocentrism, misogyny and outright sexist attitudes towards women.[8] Whether such arguments are justified or not, the question of why sadism or misogyny are component parts of surrealism and what role they play in it still remains to be answered and raises a number of other related problems in relation

26 Man Ray, *Homage to D.A.F. de Sade*, photograph published as a full-page image in *Le Surréalisme au service de la révolution*, no. 2, 1930.

27 Man Ray, *Monument to D.A.F. de Sade*, published as a full-page image in *Le Surréalisme au service de la révolution*, no. 5, May 1933.

film *L'Age d'or* at the Studio 28 cinema in December 1930. Two right-wing protest groups, the 'Patriot's League', and the 'Anti-Jewish League' turned up at the showing, creating a riot which was quelled only when the police arrived. The film, subsequently banned because of this event, is about love and desire, and satirizes 'bourgeois' and religious morals.

to images and desire. This chapter seeks to discuss why these issues emerge in surrealism, rather than short-cut any discussion by simply condemning or somehow resolving them. For example, the common definition of sadism is pleasure in inflicting pain and suffering. Misogyny is defined as 'a hatred of women'. It is immediately important to distinguish between these two things, not in order to justify them but to make distinctions for the purpose of analysis. Sadism is not the same as misogyny just as it also needs to be made clear whether such issues are being discussed at the level of individual lives of the surrealists or in terms of the representations made by them. To abolish that distinction, between sadism and misogyny and between actual events and sadistic fantasy, would be to redefine the world in psychotic terms, collapsing symbolic and imaginary registers together. Yet nor should these distinctions be an excuse to deny connections across these territories, especially when the question of what 'woman' or a feminine subjectivity signifies in surrealism and the relations of men to that signification remains a central problematic in the issue of sadism.

None of this is made easier by the fact that the celebration of Sade and Sadean fantasy is intertwined with other preoccupations and issues in surrealism which are not easily reconciled or easily separated except as apparent contradictions. Most notable, for example, is what appears as an antithesis to sadism, that is, the surrealist quest for idealized love. Such contradictions need to be examined.

Allegory of Love

One place to start is in 1929, the year of a so-called crisis in surrealism and the publication of the following visual image in *La Révolution surréaliste* (no. 12, December 1929) (see Figure 28). The image, a scripto-visual photomontage, shows the figure of a nude woman surrounded by 16 'photomat' photographs of men, all with their eyes shut. The central image, a painting by René Magritte who also made the montage, is based mimetically on his wife Georgette, but is nevertheless connoted as Venus, the goddess of love. The pose of the woman alludes to Botticelli's famous renaissance

8 See Mary Ann Caws (ed.), *Surrealism and Women* (London: MIT Press, 1991). For example, Rudolf Kuenzli's essay 'Surrealism and Misogyny' denounces surrealist imagery made by men for their 'misogyny' and various discussions of them by critics for ignoring this misogyny. This stance can be used to open up a space for discussion of other surrealist work made by women involved in surrealism (which he does not, in fact, do). Yet this does little to confront the offence of misogyny alleged in the canonic imagery of 'male' surrealism. Any discussion of surrealism, sadism and misogyny needs to unpack the assumptions that are all too quickly jumped to as emotive and *moral* arguments to close down what are inevitably difficult discussions (see Penelope Rosemont for her criticism of the failures of 'conventional criticism' in *Surrealist Women*, p. xxxix).

9 The famous Hellenic statue of *Venus de Milo* stood in the Louvre, though the pose of Botticelli's *Birth of Venus* is more

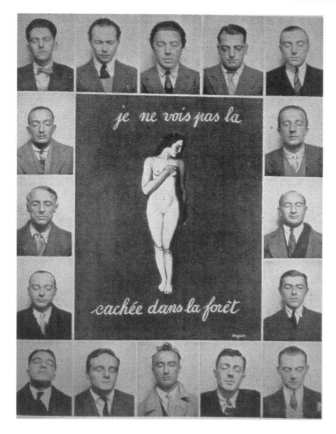

28 An allegory to love? Rene Magritte's photomontage of the surrealists with automated photographs taken when they visited Brussels in 1929 with his own painting *Je ne vois pas la femme* at the centre of the image. Published as a full-page image in the last issue of *La Révolution surréaliste*, no 12, 1929.

painting, *The Birth of Venus*, itself already based on the statues of antiquity and a familiar figurative convention in the history of art.[9] In all this tradition, Venus is the allegorical figure for love. To read Magritte's montage as an allegory of 'love' is supported by the fact that it appears in the middle of an 'Inquiry into Love' in that same issue of *La Revolution surréaliste* no. 12, December 1929. The Inquiry into the 'drama of love' had been initiated with a set of questions sent to surrealists and other individuals:

I What kind of hope do you have for love?

II How do you envisage the passage from the *idea of love to the act of loving*? Would you, willingly or not, sacrifice your freedom for love? Have you already? If such a step seemed necessary, in order not to be

directly linked to the first century B.C. *Venus de Medici* now in the Uffizi, Florence. For discussion of Botticelli see Ernst Gombrich, 'Botticelli's Mythologies', *Symbolic Images* (Oxford: Phaidon, 1985). On the tradition of this figure see: Patricia Rubin, 'The Seductions of Antiquity', in Caroline Arscott and Katie Scott (eds), *Manifestations of Venus; Art and Sexuality* (Manchester: Manchester University Press, 2000); Geraldine A. Johnson, 'Idol or Idea', in *Picturing Women in Renaissance and Baroque Italy* (Cambridge: Cambridge University Press, 1997); and Hubert Damish, *The Judgement of Paris*, trans. John Goodman (London: University of Chicago Press, 1996).

unworthy of love, would you sacrifice a cause that up until then you considered it your duty to defend? Would you accept not becoming the person you might have been if this were the price you had to pay for fully enjoying the certainty of loving? How would you judge someone who would even betray his convictions in order to please the woman he loved? Can such a token be asked for? Can it be obtained?

III Do you recognize the right to deprive yourself of the presence of the being that you love, to test the point of exaltation of love, yet realize the mediocrity of such a calculation?

IV Do you believe in the victory of a wonderful love over sordid life or of a sordid life over wonderful love?[10]

Replies to these questions were published in the journal as a survey of attitudes, including responses from six newspapers and magazines as well as the many individual responses.[11] But it is the photomontage by Magritte which represents the *collective* response of the surrealists to the Inquiry; pictured are: Maxime Alexandre, Louis Aragon, André Breton, Luis Buñuel, Jean Caupenne, Salvador Dali, Paul Eluard, Max Ernst and Marcel Fournier, Camille Goemans, Magritte, Paul Nougé, Georges Sadoul, Yves Tanguy, André Thirion and Albert Valentin.[12] In comparison to the – often compared – Germaine Berton montage in the first issue of *La Révolution surréaliste* (no. 1, 1924; see Figure 8 in Chapter 1) this photomontage signals a shift in the 'object' of surrealism. The surrealists had collectively chosen love. From the passion for death (murder and suicide) in that 1924 montage to the 'worship' of love in this image in 1929.[13]

The questions that were asked in the Inquiry (basically: what are the meaning and limits of my desire) were certainly pertinent to the lives of the surrealists. At that time André Breton, having gone through the encounter with Nadja, was in the process of divorce with his wife Simone. Paul Eluard had met Nusch (Maria Benz) and left Gala, who became Salvador Dali's lover (and eventual wife). Louis Aragon, recovering from his attempted suicide over Nancy Cunard leaving him the year before (1928), had just met Elsa Triolet after a brief

10 *La Révolution surréaliste*, no. 12 (12 December 1929), p. 65 (my translation). See also Appendix II in José Pierre (ed.), *Investigating Sex; Surrealist Discussions 1928–1932*, trans. Malcolm Imrie (London: Verso, 1992), p. 158.

11 Respondents were all men but for two women who were already involved in surrealism, Valentine Penrose (then married to the English Roland Penrose) and Suzanne Muzard (with whom Breton had an affair and identified his response as the same). The responses of these women are translated in Rosemont's *Surrealist Women*, pp. 33 and 36.

12 These surrealists in the picture were all contributors to that issue of *La Révolution surréaliste*.

13 Of course to represent love and death as 'constructive or destructive' would go against the aim of surrealism of reaching a point where these would no longer be contradictions (see the 'Second Manifesto of Surrealism', in Richard Seaver and Helen Lane [eds], *Manifestos of Surrealism* [Ann Arbor: University of Michigan Press], pp. 124–5).

affair with the dancer Lena Amsel. So the questions proposed in the Inquiry were certainly pertinent to the experiences of these men and the women around them. Issues of 'unique' or 'successive love' and 'reciprocity of love' were just as central in their own personal relationships as they were of others.

Questions about loyalty and love were also appropriate to quite other spheres preoccupying the surrealists at that time. In February 1929 Georges Bataille, never an actual member of the surrealists, published the work of several surrealists in the first issue of his new journal *Documents*. Breton took the opportunity to 'expel' those individuals from surrealism and all the others who also did not show more than mere verbal commitment to surrealism. The following month André Breton and Louis Aragon confronted, attacked and expelled those surrealists, including Michel Leiris, Jacques Prévert and Robert Desnos, who had all contributed to Bataille's journal. Also excluded for deviations, defections and abandonment of surrealist ideals were Antonin Artaud, Philippe Soupault, Roger Vitrac and André Masson. For Breton, these were all individuals who were paying lip service to surrealism while developing careers on the back of it in other fields like acting or journalism, art, politics and commerce. As the publication of the orange-covered *La Révolution surréaliste* journal ceased in 1929 and was replaced the following year with *Le Surréalisme au service de la révolution*, a change that is typically remarked as a move towards putting surrealism at the service of the 'revolution' of the Communist Party, questions of loyalty were tested even further by that party which Breton and other surrealists were trying to be loyal to as well: the Communist Party. Not that the idea of 'love' was considered a valid question or problem worthy of discussion within the Communist Party, unlike in surrealism. Such issues as 'love' were far removed from, and totally subordinated to, the grander political and economic revolutionary schemes of the Internationale-minded Party. None of the communists participated in the surrealist Inquiry into Love. Indeed, in the *Second Manifesto of Surrealism*, Breton felt moved to defend the surrealists' interest in love against a counter-revolutionary charge:

Yes, I believe, I have always believed, that to give up
love, whether or not it be done under some ideological
pretext, is one of the few unatonable crimes that a man
possessed of some degree of intelligence can commit in
the course of his life. A certain man, who sees himself
as a revolutionary, would like to convince us that
love is impossible in a bourgeois society; some other
pretends to devote himself to a cause more jealous
than love itself; the truth is that almost no one has the
courage to affront with open eyes the bright daylight
of love in which the obsessive ideas of salvation and
the damnation of the spirit blend and merge, for the
supreme edification of man.[14]

For Breton, love was not something that should be
escaped, or given up for any revolutionary project, since
it burns by itself as a passion – this is the central motif
of Magritte's picture.

Of course, at one level, an orthodox interpretation of
the Magritte montage can speak of the easily observable
division of labour in the picture. Like Manet's painting
before it, *Le Déjeuner sur l'herbe* (1863), the juxtaposition
of naked/clothed reminds the viewer of the rude dif-
ference in relations between men and women in art.
But why do the surrealists have their eyes closed when
faced with this female figure read as either a personified
allegory of love or simply as a nude? Why do they not
look at her? The text, far from giving us a clue, repeats
the visual structure in a linguistic relay of image to text:
Je ne vois pas la (picture: 'femme') *cachée dans la forêt.*
('I [the surrealists] do not see the [picture: 'woman']
hidden in the forest.)

As in the emblem or *impresa*, the (impressed) viewer
has a device (picture and motto or poem) which re-
ciprocates with one another in dialogue to represent a
wish or purpose; it might be supposed that the wish of
the surrealists with their eyes closed is that they fantasize
the object of their desire and this object is the woman
depicted. But if we accept that the image of the woman
signifies not simply 'femme' but (allegory) 'love', then
the text reads allegorically: *Je ne vois pas ...* (love) *cachée
dans la forêt.* Here the text/image relation suggests that
they – and we – have yet to see/find the object of their

14 Breton, 'Second Manifesto
of Surrealism', ibid., p. 180.

desire, their eyes have yet to be 'opened to love'. In other words, what *they* 'see' with their eyes closed is not the specific woman that the *spectator* looks at, so much as the otherwise abstract concept that she personifies of *love*. (That love and woman can appear as interchangeable signs is, of course, still a key issue.)[15] 'Woman' as such is not represented in language in this montage, she is seen only as a visual image and is quite literally absent from language and their vision. Thus, in the montage, love remains *beyond* sight and 'in the imagination'. All this can be read with the common prejudice – not shared by the surrealists – about men and women and language and images: that women and images are closer to the senses, 'more intuitive' than language or men.[16] But what we are in fact being offered in Magritte's photomontage is a lesson, a demonstration in the problem – idealization – of love as exaltation and sublimation. In the manner of a medieval emblem, we are shown a model of the surrealists involved in 'elective' or courtly love.

Courtly Love and Sublimation

Courtly love refers to the Provençal poetry of the twelfth century, written by the troubadours of Langue-doc and spoken in Provençal across southern Europe. The single and dominating theme of the poetry is love dedicated to 'the Lady', a love that is perpetually unsatis-fied, 'unhappy love'. Deeply rhetorical, the lyric poetry of courtly love is the means through which a 'Lady' is to be won, but where the fulfilment of erotic love, of desire is constantly delayed by obstacles. Perpetually un-satisfied in a sublimated devotion, the loved and longed-for Lady becomes an abstract ideal, exalted beyond any actual woman.

The historical conditions of this discourse, with which Breton was certainly familiar, is that the troubadours who wrote and sang such poetry did so in the context of the Cathars' religion, also known as the 'Church of Love'. The troubadours adopted the rhetoric of this Catharist religion.[17] The central Cathar doctrine was founded in the dualistic logic of Good and Evil: 'God is Love, but the world is Evil.'[18] The Cathars dedicated themselves to God and renounced the world – refusing to kill or eat animals and abstaining from sexual relations

15 The notion that woman is reduced to love and sexuality in surrealism remains a key debate. The two poles of arguments around whether and how this constitutes a reduction are most clearly represented in Xavière Gauthier's *Surréalisme et sexualité* (Paris: Gallimard, 1971) and Rosemont's *Women in Surrealism*. See also Susan R. Suleiman's *Subversive Intent: Gender, Politics, and the Avant-Garde* (London: Harvard University Press, 1990); and my contribution to this debate via Claude Cahun in *Mise-en-Scène* (London: Institute of Contemporary Arts, 1994).

16 This might otherwise be read in the sense that Jacques Lacan made later, of putting the concept of '*The* Woman' under erasure (see 'God and the *Jouis-sance* of *The Woman*', in Juliet Mitchell and Jacqueline Rose, *Feminine Sexuality* (London: Macmillan, 1982).

17 See Denis de Rougemont, *Passion and Society*, trans. Mont-gomery Belgion (London: Faber and Faber, 1956). Also published as *Love in the Western World* (see note 63 below). The book was first published in French as *L'Amour et l'Occident*, 1938. Lacan cites it in his discussion of courtly love.

18 de Rougemont, *Passion and Society*, p. 79.

153

even in marriage.[19] Woman was the 'Devil's lure', but 'Maria' pre-existed the material creation and was thus pure.[20] Hence, the Cathar religion, which spread like wild-fire in Europe, worshipped the Blessed Virgin. The troubadours of Provençal worked in Cathar castles and towns, wrote and sang songs and lyric poetry dedicated to idealized love of an allegorical woman.[21]

What is key in the literary conventions of courtly love and taken up in surrealism is the virtue of devotion to an unobtainable object, literally idealized beyond actual existence and into the form of language. Courtly love, as a set of codes and rules for relations between the sexes, is a mode of discourse that Jacques Lacan uses to exemplify the form of satisfaction called sublimation *par excellence*.[22] As Lacan notes:

> The object involved, the feminine object, is introduced oddly enough through the door of privation or of inaccessibility. Whatever the social position of him who functions in the role, the inaccessibility of the object is posited as a point of departure …
>
> Furthermore, that object or *Domnei*, as she is called – she is also frequently referred to with the masculine term, *Mi Dom*, or my Lord – this Lady is presented with depersonalized characteristics. As a result, writers have noted that all the poets seem to be addressing the same person.[23]

And further, he comments,

> The poetry of courtly love, in effect, tends to locate in the place of the Thing certain discontents of the culture. And it does so at a time when the historical circumstances bear witness to a disparity between the especially harsh conditions of reality and certain fundamental demands. By means of a form of sublimation specific to art, poetic creation consists in positing an object I can only describe as terrifying, an inhuman partner.[24]

Magritte's montage shines like a beacon for this model of love adopted by the surrealists. The single iconic female figure painted into a pose of partial modesty, her head cast down sideways and her hand covering her heart, represents the 'Thing' that drives them; their

19 According to de Rougement, the Cathars had two categories, the 'Perfects' or 'Goodmen' and the 'Believers'; only the latter were allowed to marry and 'go on living in the world which the Pure condemned'(p. 81).

20 'Cathar' is from the Greek for 'spotless'.

21 The songs praised the virtue of devotion in its own right to Catharist audiences who already found sexual relations to be 'ugly and low'. This extremely popular Catharist religion was seen as a heresy by the Catholic Church, partly due to their vows of chastity and anti-natal beliefs. As a consequence, the cult was ruthlessly stamped out, believers were burnt and destroyed by the Inquisition.

22 Jacques Lacan, 'The Problem of Sublimation', in *The Ethics of Psychoanalysis*, 1959–60, Book VII trans. Dennis Porter (London: Routledge, 1992), p. 128.

23 Ibid., p. 149.

24 Ibid., p. 150.

own desire taunts them and remains inaccessible in the 'forest of signs'. In this courtly discourse of fidelity and allegiance dedicated to an absent other, the surrealists found a thing they could worship, 'the cause of his desire' whose obscurity was also paradoxically the necessary condition of surrealist discourse.

The virtue of this model of love and sublimation for the surrealists was as a basis for 'inspiration'. In Breton's 1929 call to order of surrealism to its principles in the *Second Manifesto* he makes the demand that surrealists, through acts of self-observation, bring 'a new *awareness*' of the mechanism of 'inspiration' and the 'concern to create, to destroy' through the 'phenomenon of sublimation'.[25] Breton asserted the need to pay more attention to investigating the *substance* of dreams and automatic texts, and not to be complacent in simply reproducing them. The forms of dreams and automatism had now to be concerned with their contents too. Breton wanted the surrealists to pursue the enigma that eluded them, the cause of their desire – and their sexuality. It is with such a model of love and sublimation that the surrealists use the feminine object 'woman' as a point of imaginary fixation for (not object *of*) 'inspiration'.

The female nude stands in for the image of the idealizing of love. She is love personified, the unattainable thing they crave in their 'imagination'. In the discourse of Breton: 'The problem of woman ["the Lady"] is the most wonderful and disturbing problem there is in the world. And this is so precisely to the extent that the faith a non corrupted man must be able to place, not only in the Revolution, *but also in love*, brings us back to it.'[26]

In Breton's discourse the aim appears to be the 'problem of woman' but the discourse makes a detour around love. 'Faith' in love, its idealization will bring him closer to the 'problem of woman'. It is in the obstacles to love – as addressed in the Inquiry into Love – *and* their productivity in the realm of sublimation as inspiration that for Breton lie the means by which the discourse of surrealism itself functions. Sublimation is the means of inspiration, and the unobtainable object (due to the obstacles in attaining it) of 'ideal love', the thing that cannot be *seen* or reached, is what drives them on.

In Lacan's account of sublimation, following Freud,

25 Breton refers to sublimation as a Freudian concept and offers a definition in a footnote of the 'Second Manifesto of Surrealism' in *Manifestos of Surrealism*, p. 160. 'Sublimation' was a contemporary problematic within psychoanalytic circles too.

26 *Second Manifesto*, footnote, p. 180.

'sublimation involves a certain form of satisfaction of the *Trieb*' (*drive*, not 'instinct') in which the drive is deflected from its aim without a change of object. The drive (the pressure that directs an organism towards an aim) is sublimated when the aim (goal) is not the one it appears to be: 'It is a paradoxical fact that the drive is able to find its aim elsewhere than in that which is its aim.'[27] For surrealism, love is celebrated as passion, an abstract structure represented by the image of woman but where the aim is elsewhere than in the woman (as object). The aim in sublimated desire is not what it seems. In this courtly model of unhappy love – the unattainable object drives to despair the yearning lover – the wish to fulfil the aim in love is directed via a sublimated satisfaction as signifiers, e.g. in the literary form of poetry.

The satisfaction derived from a sublimated aim, Lacan claims, 'is precisely that which reveals the true nature of the *Trieb*' (the drive) … and 'has a relationship to *das Ding*' (the Thing). What Lacan names as 'the Thing' is a type of value ascribed to an object characterized as its emptiness: 'this Thing will always be represented by emptiness, precisely because it cannot be represented by anything else – or, more exactly, because it can only be represented by something else'.[28] In courtly love the Lady is, as Lacan puts it, the feminine object 'raised to the dignity of a Thing' and he likens this structure to the distortions involved in an anamorphic image. The anamorphic image seen from another angle throws up the shape of its proper meaning, and sublimation similarly involves a reversal of the illusion of space, 'that is to transform it into the support of the hidden reality'. Such a 'distortion' is at work in Magritte's montage.

Out of the black space of nothingness in Magritte's painting is conjured up Venus, woman as phallus. The image of Venus is a veil for emptiness. In mythology it is told that Venus, the goddess of love, was born out of a certain absence, of castration: 'Saturn castrated Heaven and threw the testicles into the sea, out of the agitated foam of which Venus was born.'[29] With this mythical origin of love produced out of an unspeakable violence, we can also begin to note that this enigmatic structure of emptiness is also foregrounded in other surrealist images

27 *The Ethics of Psychoanalysis*, p. 110.

28 Ibid., pp. 129–30.

29 Quoted in Gombrich, *Symbolic Images* (Oxford: Phaidon, 1985), from Marsilio Ficino, *Opera Omnia* (Basle, 1576).

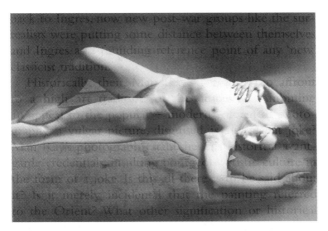

29 Man Ray, *Primat de la matière sur la pensée*, solarized nude of Meret Oppenheim as a full-page image published in *Le Surréalisme au service de la révolution*, no. 3, December 1931.

of the female nude too, as a part of their organization. Consider, for example, the treatment of the female figure in Man Ray's 1929 photograph titled *Primat de la matière sur la pensée* (primal/primacy of material over thought) reproduced in *Le Surréalisme au service de la révolution*, no. 3, 1931 (see Figure 29). The figure, as in Magritte's painting, also has her hand on her breast and floats in a pictorial space which hides as much as it reveals. The matter of this woman's body, her 'objectness', is distorted within an emptiness; she is quite literally *posited* and *negated* in the floating 'presence and absence' of solarized contrasts. We find here that, just as with the female nude in Magritte's image, she is an exalted signifier invoked as the enigmatic support of an emptiness, a 'feminine object raised to the dignity of the Thing'. But what is more, these characteristics can be seen to pervade the more obviously sadistic images of woman in surrealism.

Consider what is perhaps the most famous example of a violent image in surrealism, the cutting of the woman's eye scene in Luis Buñuel and Salvador Dali's 1929 film *Un Chien andalou* (see Figure 30). Again made the same year as Magritte's and Man Ray's images, not only does this scene show the symbolic castration of the woman's right to see while raising the same threat and possibility of damage to the very organ with which viewers are themselves perceiving the scene, it also signifies the woman as quite literally a Thing of emptiness. The sadistic experience of the scene is all the more exacerbated by the fact that the woman character

30 (above) The famous eye slitting scene from Luis Buñuel's *Un Chien andalou*, 1928 (for which Salvador Dali co-wrote the script). Buñuel's image inflicts damage to the facial narcissism proposed in the 'bourgeois' feminine beauty of cosmetics advertising imagery in this period. The viewer does not have to be a sadist to read masochism in the cosmetics imagery.

31 (right) The Belgian surrealist Paul Nougé also addressed this theme in his image *Cils coupé*, from his photographic series of the same period: *Subversion of Images*, 1929–30.

30 For analysis of the film see Phil Drummond, 'Textual Space in *Un Chien andalou*', *Screen*, Vol. 18, no. 3, Autumn 1977.

is looking at us while it happens and makes no move to stop it; she (masochistically) accepts without resistance, for all we know, wants it to happen. In this surrealist fantasy – we are not talking about a reality – it is not the woman who suffers from a hysterical attack, but the man (Buñuel himself) who sadistically blinds the woman with a razor, even though she returns in the following scenes of the film with both eyes intact and is the object of affection – lust – that drives the 'story'.[30] It might be said that her blinding, the punishment that Oedipus inflicted upon himself, is a defence on the part of the surrealist against his own desire being *seen* and that the object of love is mutilated as the sign of her difference from him; as in an infantile explanation of difference in genitals between the sexes. Such images are certainly at odds with the claims to idealization in courtly love

and exaltation of the Lady, of *la femme*. Unlike many conventional 'nudes' in the history of art, most of the surrealist scenes of a female nude foreground a structure of emptiness as enigma. What is invoked in these signs of 'emptiness' with their contradictory inverted schemes of sadism and love can begin to be understood as part of the complex vicissitudes of desire, something hinted at when Lacan speaks of the Lady in courtly love as a 'terrifying' inhuman partner.

Sexuality and Sadism

Lacan seems to give differing interpretations to the function of the 'detour in the psychic economy' of sublimation. In a 1956 reading he takes sublimation as akin to techniques of foreplay, that is, a certain delay and lingering in the arts of seduction, the 'preliminary stages of the act of love': drinking, speaking, looking and touching.[31] In this erotic phenomenon Freud called '*Vorlust*', the sexual act is deferred to increase its pleasure by paradoxically maintaining a state of (un)pleasurable tension. Nothing could be more appropriate to the discussion of the role of vision and in particular the pleasure involved in photography, since the scopophilia in voyeurism absolutely depends upon keeping the object looked at, at a distance (no matter how close it is in the picture). This is unlike the oral, anal and genital zones, where actual contact is normally part of the pleasure. In contrast, the precarious balance of pleasure in looking at a photograph rests on the edge of an economy dependent on a distance where the lingering pleasure (the amount of time spent looking) is also in ratio to the value of the (unfathomable) enigmatic meaning of the image for the viewing subject.

The second account of sublimation by Lacan is in a 1972 essay on female sexuality. Here he relates sublimation to courtly love as a mode of fidelity that is, in fact, a kind of justification as 'the only way of coming off elegantly from the absence of sexual relation' … 'pretending that it is we who put an obstacle to it'.[32] (It is the surrealists who close their eyes in the Magritte montage.) Here the function of looking and image-making (painting, film, drawing, photography etc.) as sublimatory activities serve as the investment of sexual

31 *The Ethics of Psychoanalysis*, pp. 152–3.

32 Lacan, 'God and the *Jouissance* of The Woman', in J. Rose and J. Mitchell (eds), *Feminine Sexuality* (London: Macmillan, 1982), p. 141.

energy in 'non-sexual' activities. This reading by Lacan coincides with the first published use of sublimation in Freud's work too, where it is in connection with looking and touching that he raises it:

> Visual impressions remain the most frequent pathway along which libidinal excitation is aroused ... The progressive concealment of the body which goes along with civilization keeps sexual curiosity awake. This curiosity seeks to complete the sexual object by revealing its hidden parts. It can, however, be diverted ('sublimated') in the direction of art, if its interest can be shifted away from the genitals on to the shape of the body as a whole.[33]

Looking – at pictures – is to maintain a distance between the viewing subject and the desired object. This distance, whether metaphorical or literal, is also a requirement of the condition for (courtly) loving; the self-inflicted obstacles are what sustains sublimation.

While such readings are appropriate to sublimation in surrealism, for André Breton sublimation was what would lead to the creative impulse and was valued as a means for creative productivity. It would be a mistake, however, to think that sublimation is somehow devoid of sex or sexuality, or that sublimation is not within sexuality. Breton was certainly not proposing this; for example, it is most obvious that the surrealist promotion of courtly love did not mean abstaining from sexual activity.[34] Indeed, Breton claimed that surrealism had made efforts to 'lift the taboos that bar us from freely treating the sexual world'. This was certainly true, within limits. The frank discussions that the surrealists conducted into 'sexual research' between 1928 and 1932, and published in their journals, were extraordinary for the period, approaching topics that were simply taboo elsewhere (i.e. medical and psychiatric fields).

Early in the first session of 'Research into Sexuality', published in *La Révolution surréaliste* (no. 11, March 1928) the surrealist group discussion about heterosexual intercourse shifts to a questioning of homosexuality.[35] Provoked by Benjamin Péret, the topic of love between women quickly moves on to the question of love between men. Raymond Queneau and Jacques Prévert

33 Sigmund Freud, *Three Essays on Sexuality*, PFL 7 (Harmondsworth: Penguin, 1979), p. 69.

34 As Lacan prosaically puts it with reference to medieval courtly love, 'This phenomenon is all the more striking since we see it develop at a period of uninhibited fucking' (*Ethics*, p. 136).

35 Pierre (ed.), *Investigating Sex*.

have no moral objections to homosexuality if the men love each other. Pierre Unik is disgusted and objects violently. Prévert complains of this prejudice against homosexuality among the surrealists. André Breton abruptly – not for the last time in these discussions – tries to close the topic altogether, accusing homosexuals of 'moral and mental deficiency' – despite the fact that his close friend Louis Aragon had gay episodes and others in surrealism were openly gay, René Crevel and Georges Malkine, for example – though Breton certainly made an exception for Sade.[36] Other topics ranged from relations with, numbers of and attitudes to partners, masturbation, types and positions in lovemaking, postcoital and other habits.

So many eulogies to love, repeated discussions of sexuality and images that lingered over parts of the body connected with, more or less, acts of love are nevertheless themselves a form of sublimation. All these '*delays*' in the field of sexual activity belong to the structures of sublimation outlined by Freud and Lacan, and have their origins in the detours of the sexual drive. Sublimation is the satisfaction of the drive 'without repression'[37] – the whole problem of love and its relation to sexuality which preoccupied the surrealists at that time.

When André Breton is asked in an interview recorded in 1951[38] about the fact that the surrealist admiration for someone like Sade seems to fly in the face of their aspirations for 'elective love' he answers, somewhat elliptically:

> though the surrealists elevated to the zenith the meaning of that 'courtly' love that is generally thought to derive from the Cathari tradition, just as often they anxiously studied its nadir, and it's this dialectical process that made Sade's genius shine for them like a black sun ...
>
> Were it to remain in the very elevated spheres where poems such as Baudelaire's 'Hymn', Germain Nouveau's 'Aimez', Eluard's 'Amoureuses' [Women in Love], and almost the entirety of Péret's collection *Je Sublime* place it, this love, which such works bring to the point of incandescence, would soon become rarefied.

36 See Rosemont, *Surrealist Women*, p. xlv.

37 See Jacques Lacan, *The Four Fundamental Concepts of Psycho-Analysis*, trans. Alan Sheridan (Harmondsworth: Penguin, 1979), p. 165. Lacan's sentence draws directly on Freud's: 'sublimation is a way out, a way by which those demands can be met *without* involving repression' (Sigmund Freud, 'On Narcissism: An Introduction', *On Metapsychology*, PFL 11, p. 89).

38 André Breton interview, *Conversations: The Autobiography of Surrealism*, pp. 108–11.

Such a flame's admirable blinding light must not be allowed to conceal what it feeds on, the deep mine shafts criss-crossed by hellish currents, which nonetheless permit us to extract its substance – a substance that must continue to fuel this flame if we don't want it to go out.[39]

Breton's response hardly constitutes a critical analysis, but it does posit a relationship between elements, a recognition of the 'plasticity' of the drive and the way that one can find compensation in another or be reorganized in another way – a recognition that Lacan credits Breton with, at work in his book *Communicating Vases*.[40] For Breton, courtly love and sadism were parts of a 'dialectical process'. In this 'dialectic of desire' the flame of love, 'passion', feeds on sadism and it is these raging 'hellish currents' which underpin the exalted idealization of courtly love. The account of such a dialectic can be found in psychoanalysis, even though Breton complained (wrongly) that it was lacking there (in Freud's account of the dream).[41] It is certainly worth the detour in order to return to the images in surrealism with a better light, that is, to reconsider the particular structure – dialectic – between courtly love idealization and sadism with respect to the image of woman and the purported emptiness of the Thing.

Courtly love initiates a structure, not reducible to gender, as a particular organization of desire. In this 'desexualized' reality, the object 'the Lady' is there as the name for the cause of desire. In that sublimation of courtly love, the inaccessibility of the object introduces into love the idea of passion as suffering. In suffering the object as inaccessible, lovers put themselves in a masochistic position. This is why for Lacan the position of the Lady in the structure is allocated as one of 'cruelty', but returns in surrealism as images of cruelty to her. What is this structure in which love is rewarded with cruelty?

Love and Libido

For Freud and Lacan the origin of love is in self-love (i.e. it is fundamentally narcissistic) and, in terms of the libido, is an auto-erotic pleasure in the service

39 Ibid., p. 111.
40 Lacan, *Ethics*, p. 91. Others translate Breton's book title as *Communicating Vessels* (see below).
41 The 'almost complete lack in Freud and himself [Havelock Ellis] of any dialectical conception' (André Breton, *Communicating Vessels*, trans. Mary Ann Caws and Geoffrey T. Harris [London: University of Nebraska, 1990], p. 14).

of the ego.[42] In the first stage, or elementary process of primary narcissism, the human infant is organized into a 'gestalt' image as 'itself', the *ideal* ego. This stage has the body of the infant (actually in pieces) as the object of its own scopophilic interest; and libidinally mapped through the oral, anal and genital erotogenic zones sensitized in the processes of nurturing. It is such a structure for which Jacques Lacan developed the metaphor of 'The Mirror Stage' (first proposed in 1936 as 'The Looking Glass Phase') where the mirrored image of the six- to eighteen-month infant is 'itself', the fascinating (alienated) object of scrutiny whose apparent coherence enables the infant to establish itself and function as an 'I'. Thus the identification of the subject is alienated from the start by its identity with an object 'over there' in the mirror, a 'self-image' which is actually a 'mis-recognition'.[43]

In secondary narcissism, the subject develops and structures this image of itself in relation to 'the other', the *ego* ideal (or super-ego). Here the object of curiosity is not the subject's own body, but that of another, typically its parents and their ways of being in the world. (With the Oedipus complex the relations to those objects are 'desexualized', diverted from 'direct sexual aims').[44]

It is across these structures of primary and secondary narcissism that the subject's libido is organized in terms of its social appearance and, depending upon the particular vicissitudes of desire established in that subject, is where the pattern of love object-choice is made. The ego is thus a structure that is split in conflict because it is established on the subject's identification (mis-recognition) as 'itself' *and* the others it has incorporated as ego ideal in the 'desire of the other'. With respect to this, then, the situation is that the subject is '*loving oneself through the other*',[45] a point which Breton does appear to grasp in *Communicating Vessels*: 'I persist in considering the workings of love as the most serious of all. I am careful not to forget that, always from the same materialistic point of view, "it is their own essence that people seek in the other" [Engels].'[46]

According to Freud, the love object that is chosen is determined and can be classified by two categories of relation: *anaclitic* and *narcissistic*.[47] The anaclitic type

42 See Lacan, 'From Love to the Libido', in *The Four Fundamentals*, p. 193.

43 See Lacan, 'The Mirror Stage as Formative of the Function of the I as Revealed in Psychoanalytic Experience', *Écrits, a Selection*, trans. Alan Sheridan (London: Tavistock, 1982).

44 See Sigmund Freud, 'The Economic Problem of Masochism', *On Metapsychology*, PFL 11 (1986), p. 422.

45 Lacan, *The Four Fundamentals*, p. 194.

46 Breton, *Communicating Vessels*, p. 69.

47 See Sigmund Freud, 'On Narcissism: An Introduction', *On Metapsychology*, pp. 75–85.

of love object can be traced in a chain to the original carer for the infant with whom it first develops an 'attachment'. This type of parental 'caring' affection is contrasted to the narcissistic type object-choice which is one that satisfies the sensual currents of the subject. In either type, whatever object fulfils these conditions is open to becoming idealized as object-choice. In so-called 'normal' love, Freud argues, both types are combined and the subject's narcissism is transferred to the love object when 'falling in love'. Moreover, even without the exposition of their polarities it is possible to see how idealization in courtly love and overvaluation of the sexual object belong to the same structure. Freud sums up the situation:

> with this 'devotion' of the ego to the object, which is no longer to be distinguished from a sublimated devotion to an abstract idea, the functions allotted to the ego ideal entirely cease to operate. The criticism exercised by that agency is silent; everything that the object does and asks for is right and blameless. Conscience has no application to anything that is done for the sake of the object; in the blindness of love remorselessness is carried to the pitch of crime. The whole situation can be completely summarized in a formula: *The object has been put in the place of the ego ideal.*[48]

In this *amour fou*, the subject finds itself vacated to the idealization of the object. The narcissism of the ego risks a complete alienation for the love of the object. The price of this sexual overvaluation (if it is not reciprocated) is that the ego (itself an object) is now subjected to the sadism of that ego ideal(ized love object). This sadism of the super-ego/love object satisfies the already existent 'masochistic trend of the ego', which finds an unconscious gratification – pleasure – in mental punishment or physical suffering.[49] In other words, subjects who idealize an object, as in courtly love, are putting themselves into a masochistic position, as in Leopold von Sacher-Masoch's story *Venus in Furs*, where it is his Venus, 'the Lady', who determines his punishment, how much he should beg and plead with her for *merci*. In servitude, her cold and punishing narcissism fuels his constant sense of doubt

48 Italics in original. Sigmund Freud, 'Group Psychology and the Analysis of the Ego' [1921], *Civilization, Society and Religion*, PFL 12 (1985), pp. 143–4.

49 In 'The Economic Problem of Masochism' Freud highlights that a moral masochism derived from the sadism of the super-ego 'falls on the ego's own masochism' (*On Metapsychology*, p. 424). Also discussed in Jean Laplanche, 'Aggressiveness and Sadomasochism', in *Life and Death in Psychoanalysis* (London: Johns Hopkins University Press, 1985).

about her love and 'complaints of her enigmatic nature'. To prove his love, the would-be lover of courtly romance is implicitly engaged in a sado-masochistic structure of libidinal relations far from the idealized 'reciprocal love' demanded by the surrealists, but closer to the notion of a 'dialectical process' noted by Breton.

We can begin to see that the drama of love and the enigma that surrounds it with the surrealist interest in sadism can be understood within a structure where narcissism and sexuality overlap in a conflictual dynamic.

Idealization is to do with the object, sublimation is to do with the drive. In courtly love the Lady is the object and in sublimation we see a detour in the aim of the drive; the subject's own punishment at the hands of 'the Lady' is the hidden satisfaction. Love (narcissism) and libido go out to an object, but return in a masochistic form. In surrealism the passive pleasure of masochism is turned around to its active form as sadism (a defence of the ego); masochism is now directed not against 'me', but her.

Freud remarks:

we have every reason to believe that sensations of pain, like other unpleasurable sensations, trench upon sexual excitation and produce a pleasurable condition, for the sake of which the subject will even willingly experience the unpleasure of pain. When once feeling pains has become a masochistic aim, the sadistic aim of *causing* pains can arise also, retrogressively; for while these pains are being inflicted on other people, they are enjoyed masochistically by the subject through his identification of himself with the suffering object ... of course, it is not the pain itself which is enjoyed, but the accompanying sexual excitation – so that this can be done especially conveniently from the sadistic position.[50]

Sadism is masochism turned around from the subject's own body, with the aim changed from the passive to the active; *feeling* pain is reinvested to *making* pain in the other. Masochism, the desire to be treated as a 'naughty child', is reversed in surrealism and the object of woman is subjected to sadistic fantasies. The love object enables

50 Freud, 'Instincts and Their Vicissitudes', *On Metapsychology*, p. 126.

a circuit for the object(ive) of desire. As Lacan summarizes it:

> It is in so far as the subject makes himself the object of another that the sado-masochistic drive not only closes up, but constitutes itself.
>
> ... you will see that the sadist himself occupies the place of the object, but without knowing it, to the benefit of another, for whose *jouissance* he exercises his action as sadistic pervert.
>
> ... In this sense, sadism is merely the disavowal of masochism ...
>
> But the object of desire, in the usual sense, is either a phantasy that in reality is the *support* of desire, or a lure.[51]

When it comes to sadistic fantasy, then, the surrealist images of woman are 'the support of desire'. She is the empty fantasy to support their desire. In this respect what appears across those images in surrealism as *her* masochism is his fantasy – his fantasy of the passive receipt of suffering or humiliation. Such images, which are sprinkled across surrealism and appear as chaotic and random, anarchic even, can and do show that they are the speech of a language whose rules are governed by the pleasure principle and demonstrate a link of the drives with the erogenous zones.

The source of 'primary masochism' is as a leftover product from the infant's development of its libido, from auto-eroticism to the formation of the ego, following the lines of the erotogenic zones (and the oral, anal, scopic, invocatory and [separately][52] genital drive) that are mapped in/as the infant's body as the product of its rearing. If it is the unconscious or its 'ideational representatives' that the surrealists sought to figure in their images of the other, it is not surprising that the images of '*la femme*' constitute a set of fantasies in which the trajectory of sadism follows the paths of the 'pleasures' of masochism already established in the subject's own body. That is to say, those images which trouble our conscience follow the experienced paths of the erotogenic zones and bodily functions of the subject's body. The surrealist images, in fact, focus on parts of the body that preoccupy an infant in its pre-Oedipal

51 Lacan, *The Four Fundamentals*, pp. 185–6.
52 Lacan: 'the genital drive, if it exists at all, is not at all articulated like the other drives', *The Four Fundamentals*, p. 189.

relation with its mother: the oral object of the breast (as in the historical image of Venus in her maternal function, her hand on her breast), Man Ray's images around the anal zone (see Figure 32), his fascination with control and interdiction (the hands and Catholicism) and barely disguised fantasies of beating, the captured female head (a reversal of the story of Judith and the head of Holofernes)[53] whose preservation in the bell jar is a thing that he can now 'possess' (see Figure 26). All these 'treasures' are the things scotomized in the sadistic eye as it roams over the body and its orifices; captured by fantasies of violence done to them implied in the field of vision.

Strikingly, Freud also classifies scopophilia as a drive that is auto-erotic in origin, narcissistic, but he notes that active scopophilia (voyeurism) 'develops from this, by leaving narcissism behind'. An auto-erotic narcissistic 'love of the self' activity of looking is exchanged, or rather, overlaid and developed into a pleasure in looking at 'an analogous part of someone else's body'.[54] Passive scopophilia (exhibitionism) 'on the contrary, holds fast to the narcissistic object'.[55] We see combined in the active poles of such drives in sadism and voyeurism the dependency on the narcissism of the ego, its projection outwards on to objects and its return, as parallel with

32 Man Ray, *Prière (Prayer)*, 1930. The nude woman 'praying' relates to Man Ray's *Monument to D. A. F. de Sade* photograph made three years later. Man Ray read de Sade.

33 May Ray, *Imaginary Portrait of D. A. F. de Sade*, 1938. The Marquis de Sade is pictured as a castle, while, in the background, the prison in which he spent a good deal of his life, the Bastille, is shown burning.

53 'Beheading is well known to us as a symbolic substitute for castrating' (Sigmund Freud, 'The Taboo of Virginity', *Three Essays on Sexuality*, PFL 7 [1979], p. 281).
54 Freud, 'Instincts and Their Vicissitudes', *On Metapsychology*, p. 127. Freud uses the word 'exchange', but a page later says the metaphor of 'successive layers of lava', suggesting that one is laid over the other, rather than actually replacing one another *per se*.
55 Ibid., p. 129.

the vicissitudes of loving/being loved, respectively. In scopophilia too, then, is found the same situation, the pleasure in the *act* of looking (or, like masochism, being looked at) as itself a source of enjoyment and pleasure, one which Freud regards as parallel to that of sadism and love in 'Instincts and Their Vicissitudes':

> ... loving-being loved, corresponds exactly to the transformation from activity to passivity and may be traced to an underlying situation in the same way as in the case of the scopophilic instinct. This situation is that of *loving oneself*, which we regard as the characteristic feature of narcissism. Then, according as the object or the subject is replaced by an extraneous one, what results is the active aim of loving or the passive one of being loved – the latter remaining near to narcissism.[56]

In the drive to mastery so characteristic of looking and sadism, the object is kept at a distance from the source, from the eye itself and protected from masochism. What is it that the sadist wants to see? Certainly not his masochism. What does the voyeurist want to see? Lacan:

> What he is trying to see, make no mistake, is the object as absence. What the voyeur is looking for and finds is merely a shadow, a shadow behind the curtain. There he will phantasize any magic of presence, the most graceful of girls, for example, even if on the other side there is only a hairy athlete. What he is looking for is not, as one says, the phallus – but precisely its absence, hence the pre-eminence of certain forms as objects of his search.[57]

The pre-eminent form in surrealism of this object is *la femme*, upon which loving, sadism and voyeurism line up as the active aims in the same way across the three different poles; the scopophilic images of sadistic fantasy recalling the 'sympathetic excitation' in which are alloyed narcissism and the libido. It is the 'emptiness' that Lacan speaks of and its phallic other which is visually mutilated and revered, shown for its 'emptiness'; to *see* the absence of the phallus is the compulsion of the sadistic images of women in surrealism. But it is accompanied by a self-love that is protective, yet colonized by the drive – her enigma is the mapping of his own sexuality.

56 Ibid., p. 131.
57 Lacan, *The Four Fundamentals*, p. 182.

Man Ray in particular seems to have been pre-
occupied by Sade. In his *Self Portrait* Man Ray claims
his motives for art as 'the pursuit of liberty, and the
pursuit of happiness', precisely the slogans of Sade.[58]
Man Ray even made a fantasy drawing of him (see
Figure 33). In the drawing Sade has the aged face of a
libertine (from the Latin *liber* for liberty), a man in his
later years whose body bears the trace of its debauchery
and is itself a kind of island. The libertine's body is a
castle of isolation and Man Ray's drawing shows that
the sadist is mounting a defence against the destruction
of his own body. Maurice Blanchot in his essay 'Sade'
identifies this sort of isolation as the basic principle of
Sade's philosophy:

> This philosophy is one of self-interest, of absolute
> egoism. Each of us must do exactly as he pleases,
> each of us is bound by one law alone, that of his own
> pleasure. This morality is based upon the primary fact
> of absolute solitude. Sade has stated it, and repeated
> it, in every conceivable form: Nature wills that we
> be born alone, there is no real contact or relationship
> possible between one person and another. The only
> rule of conduct for me to follow, therefore, is to prefer
> whatever affects me pleasurably and conversely, to hold
> as naught anything which, as a result of my preferences,
> may cause harm to others. The greatest pain inflicted
> on others is of less account than my own pleasure.
> Little do I care if the price I have to pay for my least
> delight is an awesome accumulation of atrocious
> crimes, for pleasure flatters me, it is within, while the
> effects of crime, being outside me, do not affect me.[59]

In Sade's fantasy world – it is primarily as a discourse of
fantasy that his world exists, locked up as he was in prison
for twenty-five years (without ever having committed
a 'serious crime') – is the world of the libertine who
takes pleasure in absolute pleasure, pursuing it to its
limits at whatever cost to the other. In Blanchot's
conception, despite Sade's concern for liberty, despotic
power is linked to an 'absolute egoism' manifested as
'the urgent need for sovereignty to assert itself by an
enormous negation'.[60] A rampant narcissistic drive for
pleasure and mastery. The 'transgression of desire' turns

58 Man Ray, *Self Portrait*
(London: André Deutsch, 1963),
p. 340.
59 Maurice Blanchot, 'Sade',
in *Marquis de Sade* (London:
Arrow Books, 1991), p. 40.
60 Ibid., p. 56.

169

out in the end to be a satisfaction for the benefit of the ego (socially and psychically) and is informed by the structure of the love object in narcissism and what it provides for the drives.

Within the polarities of loving/being loved, sadism/masochism and voyeurism/exhibitionism we can, finally, begin to see the vicissitudes of desire, which propelled the surrealists, in their turmoil, to their 'Inquiry into Love', to that eternal dialogue of lovers, as Lacan puts it, of the question 'What value has my desire for you?'[61]

The response to the 'Inquiry into Love' by Suzanne Muzard, with whom Breton was, apparently, in complete agreement, was love is 'about the discovery of an object, the only one I deem indispensable ... There is a great mystery in the fact of *finding*. Nothing can be compared to the fact of loving.'[62] Here was not love of the family, religion, nation or one's neighbour, but passion itself to be found only in the '*finding*' and 'loving' of an object. But she adds, 'The idea of love is weak, and its representations lead to errors.'

In a sweeping analogy, Denis de Rougemont in his 1938 book *Love in the Western World* draws together changing social attitudes to passion and war.[63] By the end of the 1914–18 war, he argues, 'we have stopped making formal declarations of love at the very time we have allowed war to begin without any declaration either'. Noting a changing attitude towards love, Rougemont argues that 'modern love' is represented as something above the established order. Love triumphs over the odds to win the heart and where its actors thrive on a simplistic notion of *happiness*. 'Passion', Rougemont argues, 'means suffering', but modern conceptions of love have discarded this. American films of the 1920s insisted on happy endings and resolved social contradictions and other obstacles magically, as in mystical fairy tale fulfilments.[64] In contrast the courtly love of troubadours and its revival by the surrealists places greater emphasis on the *instinct*, or *drive*, by 'denying it' in the loss of the object. This is the 'trauma of the libido's investment in an object'.

The surrealists introduced courtly love as suffering – sublimation – in opposition to a facile popular notion of 'happiness in love'. For Rougemont, the revival of

61 Lacan, *The Four Fundamentals*, p. 192.
62 Printed in Rosemont, *Surrealist Women*, p. 33.
63 Denis de Rougemont, *Love in the Western World* (Princeton, NJ: Princeton University Press, 1983). (The 1956 Faber and Faber English edition was called *Passion and Society*.)
64 Ibid., pp. 234–5.

such 'Catharism' in avant-garde movements like surreal-
ism were indications of the profound and deeper trans-
formations in the modern psyche about conceptions of
love in the twentieth century:

> When marriage was established on social conventions,
> and hence, from the individual standpoint, on chance, it
> had as much likelihood of success as marriage based on
> 'love' alone. But the whole of Western evolution goes
> from tribal wisdom to individual risk; it is irreversible,
> and *it* must be approved to the extent it tends to
> make collective and native decision *depend on personal*
> *decision.*[65]

One might say, then, that the surrealists were attempting
to think the structure in which the social contradic-
tions of love and passion experienced at the level of
the individual could be explored or resolved. The visual
sadism in surrealism is testament to this inquiry into the
complex structure of suffering in love. For the female
figure, surrealism offers a discourse in which sexuality is
represented as beyond, or outside of, a bourgeois femi-
ninity. But if the idealization of love and the Woman
as representative of this is the goal in surrealism, how
is such a view to be reconciled with the desire *of* the
other? Where is her desire to be articulated beyond
and against those images that are more sadistic than
'idealistic'?

65 Ibid., my italics.

6 · Black object, white subject[1]

The finding of an object is in fact a refinding of it.
Sigmund Freud, Three Essays on Sexuality

The finding of an object serves … exactly the same purpose
as the dream. *André Breton*, L'Amour fou

1 An early version of this argument was presented at the Association of Art Historians' Annual Conference, *Objects, Histories and Interpretations*, London, April 1995.

2 The original: 'Visage de la femme, doux oeuf transparent tendant à se débarrasser de la toison par où il tenait encore à une nature primitive! C'est par les femmes que s'accomplira l'évolution qui portera à son suprême degré l'espace au passé plein de mystère. Dolente parfois, elle revient avec un sentiment de curiosité et d'effroi à l'un des stades par où passa, peut-être, avant de parvenir jusqu'à nous, la blanche créature evoluée.' (French) *Vogue*, May 1926.

3 Sigmund Freud, 'The Question of Lay Analysis' (1926), *Historical and Expository Works on Psychoanalysis*, PFL 15 (1986), p. 313. Parts of Freud's essay were published in *La Révolution surréaliste*, no. 9/10 (1 October 1927), a year after Man Ray's photograph in *Vogue*. The phrase 'dark continent' is attributed to Stanley, see Leo Frobenius, *The Voice of Africa* (London: Hutchinson, 1913), p. xiii.

The analogy between female sexuality and colonialism as 'dark continents' is addressed by several authors. See, for example, Mary Ann Doane, 'Dark Continents: Epistemologies of Racial and Sexual Difference in Psychoanalysis and the Cinema', in her *Femmes Fatales: Feminism, Film Theory, Psychoanalysis* (London:

One of the pictures on a wall of the Institut Français café in London is a reproduction of Man Ray's 1926 photograph *Noire et blanche*. The apparent 'removal' of this image from a context of surrealism to the wall of a popular meeting place could not be more justified since the photograph was in the first instance published in *Vogue* magazine (May 1926) (see Figure 34). It appeared across a page with the title *Visage de Nacre et Masque d'Ebene* (*Mother of Pearl Face and Ebony Mask*) underneath, accompanied by the following caption:

> The face of a woman, soft, transparent tending to throw off the hair through which it was still clinging to a primitive nature! The evolution which will bring to its highest degree the space with a past full of mystery will be accomplished by woman. Sometimes mournful, the evolved white creature returns, before reaching, with a feeling of curiosity and fright, to one of the stages through which it might have gone.[2]

Even without a context of surrealism or psychoanalysis, *Vogue*'s commentary nevertheless hints at Freud's famous *analogy*, written that same year, that 'the sexual life of adult women is a "dark continent" for psychology'.[3] Since in colonial culture the 'dark continent' was a metaphor for Africa and lack of European knowledge about it, the comparison between female psychology and Africa appeared justified. Both were territories considered rich for exploration, exploitation and mastery, but the difference between the aims of a psychology of female sexuality and colonialism was their respective ends. The late attention to female sexuality and the 'riddle of femininity' in Freud's work is well known and the subject of debate as an issue at the time and ever since he wrote those words.[4] Yet Freud's analogy

34 Man Ray's *Noire et blanche* photograph as it appeared in *Vogue* (Paris), May 1926. Kiki of Montparnasse posed for the picture and the Baule mask is credited as owned by Georges Sakier. The photograph was commissioned as part of an article and review of an exhibition about 'exotic' cultures.

is not a temporal one, it does not impute, like *Vogue*'s commentary, a modern white femininity within an evolutionary scheme of development: an archaic past 'evolved' to the present 'white creature', *primitive* yet *modern*. While Freud's work questioned assumptions about the biological 'innateness' of male and female characteristics in culture and the inevitability of established social relations between the sexes, colonialist discourses asserted innate superiority and inferiority (setting out a hierarchy) of particular 'races'. It is between the space of these different discourses that a discussion of Man Ray's image must be taken up, precisely because the photograph clashes them together to establish a relationship between them. Man Ray's image makes an explicit *prophotographic* juxtaposition between two 'objects', a white woman's 'pearl' face and the African black mask. The *Vogue* commentary gives

Routledge, 1991); and David Macey, 'The Dark Continent', in his *Lacan in Contexts* (London: Verso, 1988).

4 See Jacqueline Rose, 'Femininity and Its Discontents', in her *Sexuality in the Field of Vision* (London: Verso, 1986); and for a general introduction, Juliet Mitchell's *Psychoanalysis and Feminism* (Harmondsworth: Penguin, 1979).

the image a particular reading, inflecting the image in a way which it is not pinned down to elsewhere. Two years later the image was reproduced in the Belgian review sympathetic to surrealism, *Variétés* (no. 3, 15 July 1928). It appears again in a short article reviewing Man Ray's photographic work in the Parisian magazine *Art et decoration* (no. 54) in November 1928. The photograph floats around the culture, sliding its signification from context to context, and shows the problematic in which all images associated with surrealism are placed with regard to any final meaning.

The title of this chapter, 'Black object, white subject', may give the impression that a 'black' object is 'objectified' by a white viewing subject in Man Ray's photograph, but the photograph also treats a white *subject* (woman) as an object. If all signs are in some sense 'objects' (e.g. objects of knowledge) then there has to be some basis for establishing whether an object has been 'objectified' or not. This distinction between object and objectification is a part problematic of this chapter, i.e. what do we as viewers do with the objects in the picture? It is a question that Man Ray's photograph invites about the historical relations between fashion and signification of colonial culture in *Vogue*.

Art and Fashion

'Vogue', the name of a magazine, is also a term that describes its function: a prevailing or popular fashion. *Vogue* magazine was one of the vital forums for the meeting and intersection of avant-garde culture with fashion, art and industry in the early twentieth century.[5] In this respect both objects in Man Ray's photograph were fashionable, but in different ways. To put them together is to make a manifest comparison between them. What are the latent trains of thoughts, preconscious signifying chains, which put them together? What gave an emotive currency to this juxtaposition in 1926, one that still endures? One common currency between them is art deco.

'Art deco' as a name was an abbreviation of *Exposition Internationale des [Arts Déco]ratifs et Industriels Modernes* held in Paris, 1925. This Arts Déco Exposition was heavily sponsored by Parisian department stores whose own

5 In 1925 André Breton, Sigmund Freud, Bertrand Russell, Le Corbusier and the American poet Marianne Moore were all nominated by *Vogue* for their 'Hall of Fame' (see Carolyn Hall, *The Twenties in Vogue* [London: Octopus, 1983], pp. 106–7).

fashion design houses had pavilions with new designs for furniture, carpets, ceramics, ornaments and the modern concept of a room as an 'ensemble'.[6] The Exposition was intended to promote 'new' modern decorative arts, designs intended as utilitarian *and* decorative. Various designers and artists veered towards one or the other, utility or decoration. On one side were Paul Poiret's extravagant decorative fashion displays, with Oriental and baroque designs. Man Ray had photographed them. He recalls Poiret 'had installed three ornate barges on the river: a theatre, a night club, and a modern home which included a perfume organ. With his lavish ideas he was ruining himself, or rather his backers.'[7]

In contrast Le Corbusier's modern pavilion, called 'l'Esprit Nouveau' was marginalized, considered so severe that the Exposition organizers had a six-metre fence erected round it.[8] 'Modern decorative art', the Swiss architect had said, 'has no décor.'[9] Even so, his pavilion had Cubist paintings hanging in it. Somewhere between these two poles of 'decorative' and 'utility' the attributes and characteristics of 'art deco' as a style were hewn. Symmetrical geometric curves, oval, hex- and octagonal shapes with hardened lines and edges were combined with the rediscovery of 'colour' to produce schematized images, repeated in motifs that celebrated the elements (fire, sun, sky, earth and water) with animals, outlines of nude females and other worldly things.

Design history speaks insistently of 'influence' in its account of art deco as a stylistic category: the 'influence' of 'Egyptology, the Orient, tribal Africa and the Ballets Russes'.[10] Mexico and Aztec references might also be included, but the notion of 'influence' is unable to live up to the pressures which bear on it as an explanatory category. The emergence of art deco is less an issue of influence than it is a question of how these motifs and characteristics, its 'attributes', became available and why they were taken up. Paul Greenhalgh tries to give an account:

Despite its basic intentions, art deco was both eclectic and historicist ... The exotic and ancient inspiration behind art deco at first appears to contradict its

6 Major department stores of Paris, Printemps, Galeries Lafayette, Bon Marché and Les Grands Magazins du Louvre, all financed their own design houses, respectively: Primavera, La Maîtrise, Pomone, Studium-Louvre (Malcolm Haslam, *Art Deco* [London: Macdonald, 1987], p. 8).

7 Man Ray was commissioned to photograph the couture section of the Exposition, including Poiret's displays. By this time he knew Poiret, who introduced him to the fashion crowd and magazine editors (see his *Self Portrait* [London: André Deutsch, 1963], p. 133).

8 See Haslam, *Art Deco*, p. 11.

9 Ibid., p. 10.

10 Alistair Duncan, *Art Deco* (London: Thames and Hudson, 1988), p. 8.

struggle for modernity, as does its persistence with neo-classical and baroque profiles ... There were three basic reasons for the fashionability of the ancient and exotic: first, modern artists since Gauguin had made use of primitive and ancient art. They had been a vital ingredient in avant-garde movements up to and including 1925. Thus, in order to modernise their own practice, designers followed what they believed were the methods of the acknowledged progressives in the fine arts. Second, these sources were popular because of their distance from everyday experience; their 'otherness' made them new and unexpected ... Finally, the ability of all these forms to be abstracted and subjected to geometry made them suitable for furniture, architecture and product-casings. They could be adapted easily to mass-production processes.[11]

While the simplified and stylized block motifs of art deco suited the emergent (electrical) industrialized forms of mass production, the very availability of these forms as 'motifs' was due to the importation of materials, images and objects from colonial territories. Ivory, which was imported virtually for free in the early years of colonialism, and the many imported hard woods, like ebony, were used in figure sculptures, jewellery and furnishing which became popular.[12] Although eclectic, art deco was premised on industrial production supplied by colonial materials and culture. In Greenhalgh's account, industrial designers followed artists' reference to and use of 'primitive and ancient art'. In this respect art deco was less a resolution of an older (nineteenth-century) dichotomy between art and industry, of *fine* art versus *applied* arts.[13] Rather, it was a modernization of design for mass production through use of colonial cultural materials.[14] Greenhalgh also suggests what was to become in the twentieth century the relation between avant-garde art and industry, the hegemony of the former by the latter. 'Art' was simply where things happened first (the entrepreneurial origins for industrial capitalist production).

Man Ray was one figure who moved easily between these respective discourses of art and commerce, in particular, the avant-garde domain of surrealism and

11 Paul Greenhalgh, *Ephemeral Vistas* (Manchester: Manchester University Press, 1988), p. 165.

12 On the opposition of Le Corbusier's functionalism to neo-classical decorative tendencies at the Exposition, see Florence Camard, *Ruhlmann, Master of Art Deco*, trans. David Macey (London: Thames and Hudson, 1984). On art deco sculptures see Haslam, *Art Deco*, pp. 155–8.

13 See Bevis Hillier, *Art Deco of the 20s and 30s* (London: Studio Vista, 1968), p. 136.

14 Malcolm Haslam notes that when Carter discovered Tut-ankhamun's tomb (1922) a syndicate of Parisian couturiers offered £20,000 for the rights to copy the clothing and ornaments in it (*Art Deco*, p. 13).

the consumer industry of fashion. Since his arrival in Paris, Man Ray had earned his living through providing a photographic service, his 'commercial' work, making photographic reproductions of paintings for artists and even portraits of the artists themselves. From these activities, Man Ray established the connections that enabled him to enter the more lucrative field of 'society portraits' and, quite quickly, fashion work.[15] The high commercial fees he commanded for such jobbing commissions paid for his experiments and aspirations as an artist, a convenient relationship that he nevertheless appeared always to tire of.[16] Man Ray seemed familiar with the respective values and expectations of both and was often able to move the images he produced across them; for example, reusing a fashion photograph of Poiret's art deco dressed mannequin 'ascending a staircase' for the cover of La Révolution surréaliste (no. 4, July 1925). The context and caption of the image 'The Surrealist Revolution and War at Work' renders it strange.[17] Conversely it was the fashion designer Paul Poiret who was the first to buy Man Ray's experimental 'rayographs', 'abstract' photograms subsequently published in Vanity Fair as well as in surrealism.[18] Noire et blanche seems different from this traffic of photographic experimental images between institutions of art and fashion commerce, in that it makes a juxtaposition between objects-signs from both discourses within the picture. One reading of Noire et blanche, then, would be that it juxtaposes 'art' (African mask) to 'deco' (the modern feminine 'deco') fashion. Two fashionable and exotic commodities, then, objects which are elevated through their mutual juxtaposition because of how Man Ray photographed them.

Composition

The mode of picturing that Man Ray uses here was also fashionable. In Lucia Moholy's account of photography in this period of 'abstract artists', she notes the 'great numbers of still-life and "pattern" photographs between 1920–1930, with a minimum of object and a maximum of lights and shades, rhythm and balance in them'.[19]

Photographers were interested in the formal proper-

15 Man Ray photographed many public figures in Paris: Jean Cocteau, Brancusi, Gertrude Stein, James Joyce, Josephine Baker, etc. (see his Self Portrait).

16 Man Ray always seems disappointed with his painting career; in contrast, Neil Baldwin notes that Man Ray was able to command upwards of $500 for a Vogue commission (see Man Ray [London: Hamish Hamilton, 1988], p. 131).

17 See Tag Gronberg's fascinating discussion of these new mannequins at the Art Deco Exposition and the new 'publicité' industry. Her remarks about use of mannequins by surrealists is unusually positive. That surrealists used mannequins to parody 'applied arts' display only goes to show the circular relation between art and commodity culture – anticipating 'postmodernism' critiques of mass commodity objects in avant-garde art (Tag Gronberg, 'Beware Beautiful Women: The 1920s Shop Window Mannequin and a Physiognomy of Effacement', Art History, Vol. 20, no. 3 [September 1997]).

18 The separation of art from commerce in the writing of the history of photography is a general problem. For a rare account of Man Ray's art and commercial activities, see John Esten et al., Man Ray in Fashion (New York: International Centre of Photography, 1990). Man Ray published work and commissions in many magazines: Vu, Bazaar, L'Art Vivant, Transitions, Jazz, Paris Magazine, as well as Vogue.

19 Lucia Moholy, A Hundred Years of Photography (Harmondsworth: Penguin, 1939), p. 163.

ties of the medium; the object(s) in it were seemingly 'overlooked'. She continues:

> At the same time, however, contrary to the primary aesthetic intention, the object, by being isolated from its natural surroundings, was endowed with a much greater importance than it originally possessed.
>
> This was the beginning of a counter movement: photographers, after having been made over-conscious of tone values and balance, began to be more object-conscious than ever before. The object in the picture became self-assertive; and so did the details of the object.[20]

So, whatever the object, whether it was a light bulb, glove or matchstick, because it was isolated from its usual context it becomes elevated as more important in the picture. This 'still-life' strategy was obviously useful to the demands of an emergent 'advertising photography'. 'Ordinary' commodities could be elevated into something exotic and larger in symbolic importance too, because there was no context, no scale to measure the object by, due to the close-up. Through these formal devices of the medium an object could be idealized, a standard rhetoric of commodity photography to this day (this rhetoric, of 'elevation' through objectness, can also be used *against* a dominant or prevailing set of commodity values).[21] Lucia Moholy also suggests that the 'revival' of this 'object-consciousness' in photography had already taken place in the arts, citing the work of Picasso and 'leading Cubist painters'.[22] This also recalls the similar emergence of 'object-consciousness' in the cinema, in the use of the 'close-up' shot in film. Writing about the face of Greta Garbo, formed in the 1920s, Roland Barthes notes: 'Garbo still belongs to that moment in cinema when capturing the human face still plunged audiences into the deepest ecstasy, when one literally lost oneself in a human image as one would a philtre.'[23] Describing her face in one film, Barthes says, 'It is indeed an admirable face-object ... the make-up has the snowy thickness of a mask: it is not a painted face but one set in plaster ... In spite of its extreme beauty, this face, not drawn but sculpted in something smooth and friable, that is, at once perfect and ephemeral.'[24]

20 Ibid., p. 164.
21 See Roland Barthes, 'Rhetoric of the Image', *Image–Music–Text* (London: Fontana, 1980).
22 Moholy says this 'object-consciousness' is the beginnings of 'straight' photography (*A Hundred Years of Photography*, p. 164).
23 Roland Barthes, 'The Face of Garbo', in *Mythologies* (London: Paladin, 1980), p. 56.
24 Ibid.

In Barthes's eulogy, the 'face-object' of Garbo is 'a mask' detached from her body, seemingly sculpted in plaster. Speaking of this same early cinema, Laura Mulvey draws attention to the function of the 'close-up' of female stars:

> On the one hand, the cinema was developing the conventions of continuity editing that gave the Hollywood product its movement and excitement, on the other hand, the star close-up would hold the story in stasis, cutting her image out from the general flow of the narrative, emphasising her function as spectacle in its own right.[25]

This 'function as spectacle' of the woman, with the camera dwelling on her image, was linked to a contradiction, her image as 'liberated', yet 'constraining'. Mulvey notes, 'The 1920s saw the emergence of the "new woman", who cut her hair, shortened her skirt, went to work, earned money, began to take control over her own sexuality, and finally had to be taken into account at the movie box-office.'[26]

In effect, the close-up shot of a woman's face as a 'face-object' became a commodified signifier of desire. The 'face-object' was offered to the female *for* her desire and at the same time for whoever desired her. In France, after the 1919 '"strike of the wombs" against forced maternity and natalist propaganda of post-war government', the sale of contraceptives was banned in 1920.[27] Yet the images of female Hollywood stars which circulated in Europe after the First World War were part of a wider economy of 'classical' and 'sculpted' visual images of femininity associated with the 'ancient and exotic', such that the juxtaposition of the African mask and white pearly face in Man Ray's picture was not an isolated example.

In 1925 at the Théâtre de Champs-Elysées the highly successful 'black' jazz show, the '*Revue nègre*', was led by Josephine Baker's popular success. Looking at the spectacle from the other side, Phyllis Rose notes Josephine Baker's amusement at the reviews of her show: '"Primitive instinct? Madness of the flesh? Tumult of the senses?" The white imagination sure is something," she said, "when it comes to blacks." They thought she

25 Laura Mulvey, 'Close-up and Commodities', in her *Fetishism and Curiosity* (London: BFI, 1996), p. 41.

26 Ibid., pp. 41–2.

27 Elaine Marks and Isabelle de Courtivron (eds), *New French Feminisms* (Brighton: Harvester Press, 1981), p. 22.

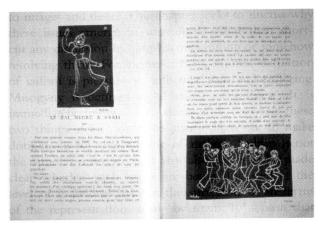

35 From left to right: Man Ray's photograph, *Noire et blanche*, reproduced in *Variétés*, no 3, July 1928; article on the black dance culture of Paris in *Variétés* with illustrations by Halika, June 1928.

28 Phyllis Rose, *Jazz Cleopatra* (London: Vintage, 1991), p. 81.

29 André Levinson, 'Danses Nègres', *L'Art vivant* (February 1925), pp. 115–16, quoted in Jon Kear, 'Vénus noire: Josephine Baker and the Parisian Music Hall', in Michael Sheringham (ed.), *Parisian Fields* (London: Reaktion Books, 1996), pp. 53–4.

30 In ibid.

was from the jungle. She knew very well she was from St Louis [Missouri, USA].'[28]

Paris was undoubtedly a haven from the racially segregated communities that black Americans knew, but to be black and in Paris was also to be a sign of the 'primitive', as exotic and erotic. That Josephine Baker's 'African' image was seen as highly sexualized is blatantly evident in reviews of her performance. For one critic: 'There seemed to emanate from her violently shuddering body, her bold dislocations, her springing movements, a gushing stream of rhythm.'[29] Adding to this, the critic André Levinson draws this sexualized image together with the discourse of '*l'art nègre*' by linking her movements to what was perceived as the 'plastic' objectness of African sculptures. 'Certain of Miss Baker's poses, back arched, haunches protruding, arms entwined and uplifted in a phallic symbol, had the compelling potency of the finest examples of Negro sculpture. The plastic sense of a race of sculptors came to life and the frenzy of African Eros swept over the audience.'[30] A wave of 'African Eros' had also swept Paris in the name of 'negrophilia', including Western metropolitan art in its popularization of 'African art' as '*l'art nègre*'.

An emergent discourse of so-called negrophilia was made up of various different components, not only dance and music, but also cultural 'translations' of literature, poetry, theatre, various eclectic ethnographic exhibitions and various museum displays of non-European artefacts.

In 1923, '*La création du monde*', a 'cosmogonic "ritual"' performed at the Ballet Suédois' had combined the music of Brazil and New York jazz, the iconographic motifs of Africa and masks in the sets, costumes and decor, and dance from everywhere.[31] Negrophilia, still the rage five years on in Paris, was reported on in the Brussels-based *Variétés* (June 1928). A short journalistic article by Georgette Camille describes the experience of going, as the title of the piece explains, to 'Le Bal Nègre à Paris'. In a poor street, 'like in films' lots of cars begin to pull up alongside the kerb. On entering into a space that appears to be the back room of a small café, she finds a dance hall filled with the weekly gathering of '*les nègres de Paris*' upon whose sight the writer is excitedly surprised at their dancing: 'legs thrown in all corners of the room, hands waving at the ceiling, and arms unrolling almost everywhere'.[32]

These observations are supported by the black-and-white illustrations of Halika (see Figure 35). Among the pulsating throng the writer notes the numerous whites who have gathered there, who have come, she says, to take a 'lesson in health'. In the mimicry of a colonial scene, the 'whites' looked down from the balcony at the spectacle of the natives doing their thing, dressed in false diamonds, pink scarves and 'disguised in tinsel from the bazaar'. The spectacle was 'free'. Writers and artists are named; this was obviously the place to be: she spots Max Jacob the poet, Marcoussis, Mauriac (who appeared 'somewhat anxious') and Zadkine the painter. Ossip Zadkine and 'friends' appear sitting at a restaurant or bistro table in a photograph beneath Man Ray's *Noire et blanche* in the following issue of *Variétés* (See Figure 35). It was in the proximity of these black 'entertainers' and the intertextual spaces of the 'Africanized' (modern yet archaic, African/American) exotic that artists, fashion and literary figures of the Parisian milieu met and mingled. 'Le Boeuf sur le Toit' was one hub for such mixing, a nightclub 'famed for its deafening Negro band' (1923)[33] promoted by Jean Cocteau. This was where Gaby Picabia (Francis Picabia's wife) had introduced people like Tristan Tzara and Man Ray to the new Africanism and negrophilia. Man Ray went there accompanied by his 'friend and

31 See James Clifford, 'Negrophilia', Denis Hollier (ed.), *A History of French Literature* (London: Harvard University Press, 1989), p. 902.
32 *Variétés*, June 1928, p. 79.
33 Hall, *The Twenties in Vogue*, p. 83.

companion' Elsa Schiaparelli, the fashion designer. It was also frequented by Picasso, Nancy Cunard, Coco Chanel, Maurice Chevalier, André Gide, the Prince of Wales (Edward VIII) and Igor Stravinsky among others.[34] None of this explains Man Ray's particular use of the African mask, but it shows the historical cultural context in which such an object could end up with Man Ray in his studio.

African Art

According to Michel Leiris and Jacqueline Delange it is Maurice de Vlaminck and André Derain who launched the European vogue for African art in the early 1900s. They cultivated an interest in statuettes and masks which were subsequently seen by artists like Picasso and Matisse.[35] Although interest by Europeans and exhibitions of African culture pre-dated this, it is the German, Leo Frobenius who, at the end of the nineteenth century is credited as the first European to 'render the proper homage due to African civilizations'.[36] As the number of African object exhibitions in Europe increased, Paul Guillaume the collector, gallery owner and dealer had launched 'African Art' on the transatlantic art market near the end of the First World War in 1917.[37]

When Man Ray moved from New York to Paris in July 1921, he was himself going in the opposite direction to many art objects. While in New York he had exhibited his own paintings there since 1912 and had seen the exhibitions of art objects unshipped from Europe. One of these included the exhibition called *Statutary in Wood by African Savages: The Root of Modern Art* arranged by Marius de Zayas at Alfred Stieglitz's small but important 291 Gallery on Fifth Avenue in 1914.[38] Stieglitz showed the exhibition installation in a photograph published in his *Camera Work* magazine.[39] The eighteen African objects had been exported from Paris, lent by Paul Guillaume who had the respect and support of Apollinaire. It was through Apollinaire, one of the great paternal figures of the surrealists, that they became acquainted with African objects and developed an ethnographic interest in them. Apollinaire had already shown his interest in African culture (evidenced in

34 Palmer White, *Elsa Schiaparelli: Empress of Paris Fashion* (London: Aurum Press, 1986), p. 45.
35 Michel Leiris and Jacqueline Delange, *African Art*, trans. Michael Ross (London: Thames and Hudson, 1968), p. 8.
36 Ibid., p. 5.
37 Ibid., p. 14.
38 According to Neil Baldwin, Man Ray had begun to frequent the 15-foot-square gallery in 1911 when he met Alfred Stieglitz and went to Edward Steichen's 'round table' lunches, *Man Ray*, p. 14.
39 *Camera Work*, no. 48 (1916). The image is reproduced in Simone Philippi (ed.), *Alfred Stieglitz, Camera Work, the Complete Illustrations, 1903–1917* (London: Taschen, 1997), p. 763.

his 1912 *Zone* poem) and had accumulated a private collection of non-European objects. Like Apollinaire, the surrealists, André Breton and Paul Eluard in particular, had adopted this fascination and not only collected such cultural objects for themselves, but included them in surrealist exhibitions.[40] For example, in the inaugural exhibition of the Galérie surréaliste in March 1926, Pacific Island sculptures were shown alongside paintings by Man Ray.[41] Man Ray was certainly familiar with the growing art, cultural and commercial interest and value of these objects from other cultures, since he had been employed to photograph them.

The same year as the Galérie surréaliste exhibition (1926) Man Ray takes this photograph of a white woman's head on a table-top-like surface juxtaposed with an African mask. Both objects have a history. Man Ray's model is his lover with whom he lived, Kiki of Montparnasse, who had worked as a model for artists and later as a singer and dancer. Her face is made up, 'whitened' except for lipstick and eyebrow lines pencilled in. (Man Ray often did her make-up before they went out.)[42] The African mask is similar to one in an exhibition, where African objects were exhibited in their own right as art, at Galérie Levesque in Paris, 1913. That particular mask was the only one photographically represented in the catalogue. It is a Baule mask from the Ivory Coast in Western Africa.[43] The Baule peoples (or baoulé) are an 'important group of the Akan'.[44] The mask in Man Ray's *Noire et blanche* photograph is a Baule mask, recognizable by the distinctive iconic features, hairstyle and smooth carved ebony finish, and was owned by Georges Sakier.

Such Ivory Coast objects were already present in Paris, in the Trocadero's (very bric-a-brac) 'collection', the 'first museum dedicated to the arts and crafts of non-European cultures'.[45] Leiris and Delange trace European interest in African objects back to 1470 with a bill of sale from Charles the Bold.[46] The Portuguese, who first coined the term *fetisso* to name the African 'small wares' and 'magic charms' used for barter, had collected ivories from the Congo in 1486 and had traded with Western Africans.[47] Thus Baule trading with Europeans had been established prior to French colonial military activity in

40 Elizabeth Cowling argues that surrealists were more interested in the less well-known South Pacific Oceanic, 'Eskimo' and North American Indian arts than 'African art' and made concerted efforts to collect it (see 'The Eskimos, the American Indians and the Surrealists', *Art History* [Vol. 1, no. 4, December, 1978]).

41 Ibid., p. 486.

42 See Baldwin, *Man Ray*, p. 107.

43 The exhibition, with its 'primitive' title *Art nègre*, listed twenty-one African objects. The same mask was also in Carl Einstein's *Negerplastik* (1915) (see Jean Paudrat, 'From Africa' in William Rubin [ed.], *'Primitivism' in 20th Century Art*, Vol. 1 [New York: MOMA, 1985], p. 152).

44 Leiris and Delange, *African Art*, p. 49.

45 Ibid., p. 7.

46 Ibid., p. 2.

47 See Emily Apter and William Pietz (eds), *Fetishism as Cultural Discourse* (London: Cornell University Press, 1993), p. 5.

the region in the nineteenth century. Trading had been based on the 'classic commodities': gold, ivory, cloth and slaves.[48] Despite sustained local resistance, by the time the French installed Customs posts and imposed tax tariffs on African traders in 1889 the Ivory Coast was 'officially annexed' as a colony. The transformation was hardly tranquil. The so-called 'pacification' atrocities which occurred in the region escalated around 1910. Those who refused to pay the rapidly increased taxes wrought violent responses. A report at the time shows the grim reality, that tax was 'incompletely gathered at the cost of villages burnt down, chiefs and natives killed in large numbers, heads of chiefs put up on poles, the imposition of fines'.[49] When 'natives' began to attack the railway that was being built through their land a military 'crackdown' insisted on disarmament, arrest of chiefs and witchdoctors, and payment of retroactive taxes and fines. The threat of punishment was visibly displayed with 'severed heads put up on poles by the railway stations or in front of the huts in the villages'.[50] Barbarism was the province of primitive colonialists. In 1912, Charles Régismanset, a senior official in the French Ministry for the Colonies, asserted in his book *Questions Coloniales* what he thought should be the proper colonial relation:

Poor black humanity! Let us at least have the frankness to admit that if we take good care of you, it is because you seem to us to constitute an inexhaustible reserve of labour ...

We want to get as much as we can out of the African races; we want bales of unlimited rubber and ivory at our quays of Bordeaux and Le Havre, we want the groundnuts to grow, palm oil to fill the ships to the brim. That's all we want. There's no need here for science, justice, goodness and especially progress.[51]

The economy was brutally clear. Baule traders were transformed from gold and cotton producers to suppliers of oil to turn the wheels of the industrial revolution with groundnut and palm oil. Africans had become 'peasant producers for the world commodity markets'.[52]

In contrast, to this colonialist economy, '*l'art nègre*' was becoming part of the more general cultural economy

48 Timothy C. Weiskel, *French Colonial Rule and the Baule Peoples* (Oxford: Clarendon Press, 1980), p. 11.

49 Jean la Bruère, 'Les événements de Côte d'Ivoire' (*Revue indigne*, no. 46, February 1910, p. 104), quoted in Jean Suret-Canale, *French Colonialism in Tropical Africa, 1900–1945*, trans. Till Gottheiner (London: C. Hurst, 1971), p. 99.

50 Ibid., p. 100.

51 Ibid., p. 85.

52 Ibid., p. 4.

of 'negrophilia' in France. It had 'acquired positive connotations', it had come to stand for 'liberation and spontaneity'.[53] Whether the supposed 'simple' and 'refined' features of the mask in Man Ray's *Noire et blanche* can be attributed to it being an object made for commodity exchange rather than an 'authentic' mask would seem to miss that point.[54]

Cultural Value

In an exhibition catalogue of *Sculptures nègres* held by Paul Guillaume in Paris, in 1917, the introduction by Apollinaire, 'A propos de l'art de Noirs' notes the lack of a proper 'critical apparatus' in which to discuss these objects.[55] The discourse on '*l'art nègre*' that did subsequently develop was a rigorously reductive formal one, emphasizing 'aesthetic' obsession with the objects. In the 1920 London Chelsea Book Club's exhibition of 'Negro Sculpture', reviewed in *Athenaeum* by Roger Fry and reprinted in his book *Vision and Design*, Fry finds himself surprised at the special qualities of the objects, their 'complete plastic freedom'.[56] This is a view then reiterated fifteen years later by James Johnson Sweeney in the Museum of Modern Art catalogue of '*African Negro Art*' shown in New York, in 1935. Sweeney says, 'In the end, [however,] it is not the tribal characteristics of Negro art nor its strangeness that are interesting. It is its plastic qualities.'[57] The persistent, repeated emphasis on plasticity, an aesthetic question which is constantly deferred by an endless description of details, 'the curves', etc. effectively represses the social question of what these 'sculptural objects' might have been produced for. It is this formalist discourse that the conventions of photographing non-Western objects also began to supply and support.

Shaping 'l'Art Nègre'

It is a banal fact that the distribution of photographs of non-Western objects through reproduction in catalogues, books and reviews also contributes to Western discourses upon those objects. However, this does not mean that the banality of how they are photographed is not important. Indeed, one reason for this apparent banality is that there is a tendency to overlook the

53 James Clifford, 'Negrophilia', *A New History of French Literature*, p. 901.

54 Evan Maurer suggests that the object is 'a Baule style mask with the overrefined proportions and highly polished surface that would seem to indicate its being one of the many commercially produced African objects popular at the time' (*Primitivism*, Vol. 2, p. 539). That the mask is commercially produced *because* it is 'overrefined' seems a strange argument, implying that Baule carvings are usually 'less refined' than this one. Commercial production invariably simplifies, but anyway, masks had been made for exchange for at least two hundred years prior to this, so who knows what is 'authentic' in that context.

55 Guillaume Apollinaire, 'A propos de l'art de Noirs' in Paul Guillaume, *Sculptures nègres: Paul Guillaume* (Paris 1917) (my translation). The catalogue has twenty-four photographs.

56 Roger Fry, *Vision and Design* (London: Chatto and Windus, 1920), p. 66.

57 James Johnson Sweeney, *African Negro Art* (New York: Museum of Modern Art, 1935), p. 21.

manner in which those objects are photographed. In early art catalogues (pre-First World War) photographs included not only the object, but something by which to judge the scale of it. Somewhere in the image would be a corner of a room, the edging on a desktop or a background wall against which the object could be sized. Consciously or not, there was generally something within the frame which enabled the viewer to 'place' the object in relation to other things, to fathom its size. But the 'style' or convention of photographing the various objects as 'art objects' quite quickly became one which isolated the particular item from everything possible, including its support and background. The object was left to float in a 'pure space" (See Figure 36). This increasingly became the fixed mode of visibility of representing these objects as *objets d'art* in photographic reproductions. It rendered them as 'floating' in space, not located in any specific spatial, cultural related context as they are in, for example, 'ethnographic' exhibitions.[58] To this extent the photograph of these artefacts itself supports their signification as elevated art objects, as in the 'object-conscious' photography described by Lucia Moholy. Subsequently, the question of any other i.e. ethnographic function of such masks was sharply silenced in the words of the worst and most offensive colonialist assumptions:

> following a discussion of the principles of negro art, or the analysis of a statue, the reader may be inclined to wonder what relation it all has to the thought of the primitive negroes themselves. Surely they did not work out these elaborate theories of aesthetics, or proceed in this systematic fashion to construct a design. Are we perhaps attributing a great deal of imaginary significance to what was really the mere fumbling and whittling of half-animal savages?[59]

I repeat this utterance here not to celebrate the primitivizing assumptions of the colonial tongue or its bogus objectivity, but to indicate and remember the sort of ambivalent and fetishistic discourse that it was deemed necessary for critics to engage in when discussing these objects. *Ambivalent* (as love *and* hate) because the objects were given a positive value, their 'complete

58 See Clifford, 'Negrophilia'.
59 Paul Guillaume and Thomas Munro, *Primitive Negro Sculpture* (London: Jonathan Cape, 1926), p. 53.

plastic freedom', while at the same time denigrating the cultures that the objects came from. Love of the objects and hatred of their cultural origin separated the object from its culture, a separation repeated in the photographs of these objects. 'Archaic' and belonging to 'the past' (*sic*), the indigenous cultures could not possibly understand these higher aesthetic formal values. This view is also repeated in the writings of the influential English critic Roger Fry in his chapter on 'Negro Sculpture' in *Vision and Design*. Having admired the sculptures for their 'complete plastic freedom'[60] he goes on to comment, 'It is curious that a people who produced such great artists did not produce also a culture in our sense of the word.'[61] Fry locates culture as 'the power of conscious critical appreciation and comparison'.[62] In other words, they might make some good art, his logic argues, but it needs someone 'cultured' like me to validate and name it so. Fry, of course, is known for having equally applied such arrogant snobbery to his own culture. It was only from within his own social elite that the application and judgement of formalist aesthetic value could save civilization from the popular, the philistine and the barbaric.[63] The emphatic formalism of plasticity – a displaced, sublimated eroticism – in the discourse on *l'art nègre* represses another culture and another history. Any cultural history of the objects is precisely what *this* Western 'appreciation' of them avoided. The 'critical apparatus' that Apollinaire had called for was not developed at all, except this discourse of disavowal of black 'plasticity' as a fetish of the *fetish*. Yet, this discourse of '*l'art nègre*' grew out of an opposite connotation, their negative status as objects. The statuettes, objects and masks were being dragged out of their nineteenth-century European status as curiosities, as 'barbarous fetishes', objects which some missionaries had found it necessary to burn. But this twentieth-century discourse of Western formalism, what we call modernism, eulogized the *fetish* object as sign of *primitivism*. The term 'primitivism' was the compromise formation of the ambivalent relation to these objects which the critical discourse of formalism produced and determined as a modern Western art fetish. That discourse, itself fetishistic and full of disavowal, was inhibited and repeated the

60 Fry, *Vision and Design*, p. 66.
61 Ibid., p. 67.
62 Ibid.
63 See Simon Watney, 'The Connoisseur as Gourmet', in Tony Bennett et al. (eds), *Formations of Pleasure* (London: Routledge and Kegan Paul, 1983).

very blocking that a fetishistic structure purportedly describes. As though, 'I know very well this object has other meanings and values, nevertheless, I believe it to be a fetish'. In calling objects 'fetishes', by naming and evaluating their qualities as 'plastic' (as signifier of 'primitivism'), Western modernism is enunciated through the obsessional repetition of formal 'aesthetic' attributes of the object, a kind of intellectual defence (fetish) against any discussion or analysis of the object as a cultural thing. To invoke fetishism, then, as a means of critical analysis seems to block the very possibility of moving beyond the fetishism of that discourse. We simply end up denouncing this discourse as 'fetishistic'. It is possible here, as one way of moving beyond or around the symptomatic blocking of fetishism, to consider the relation to the object itself as a 'thing'. After all, what characterized the growing interest in the artefacts of other cultures was a specifically European fantasy of Africa, an African*ism*, indeed a generalized 'tropicalism' as a 'thing'. Perhaps these discourses (and their nominative terms: *primitivism*, *l'art nègre* and *negrophilia*) appear as variations of something that can be described as an even more general *type* of European fantasy, as *exoticism* (tinged or not with eroticism).

Exotic Looking

Tzvetan Todorov describes exoticism as 'a form of relativism' in opposition to nationalism: 'If I am a nationalist, I proclaim that the values of my own country, whatever they may be, are superior to all others. No, the exoticist replies, the country with superior values is a country whose only relevant characteristic is that it is not my own.'[64]

In exoticism 'otherness' is more highly valued than sameness, whereas for nationalism, 'sameness' is more highly valued than otherness. The fact that both of these categories may be imaginary constructions, in that they are based on attributes which are only partial, contradictory or fantasized, should alert us to the fact that exoticism and nationalism are two sides of the same coin. Or rather, two relations to the same object. Exoticism is an attribute given (signified to) an object by a human subject, exoticism is not an

64 Tzvetan Todorov, *On Human Diversity*, trans. Catherine Porter (London: Harvard University Press, 1993), p. 264.

intrinsic property of any object. Exoticism is 'praise without knowledge', a structure which Todorov calls 'its constitutive paradox'.[65] The object is praised without knowledge of – at least – one of its signifying chains. However, to explore this paradox means returning to the question of the object.

'In analysis,' says Jacques Lacan, 'the object is a point of imaginary fixation which gives satisfaction to a drive in any register whatsoever.'[66] What is the relation of a spectator to an object? In the register of sight and the organ of the eye, Freud reminds us: 'The mouth serves for kissing as well as for eating and communication by speech; the eyes perceive not only alterations in the external world which are important for the preservation of life, but also characteristics of objects which lead to their being chosen as objects of love – their "charms".'[67] Furthermore, he says, 'The saying that it is not easy for anyone to serve two masters is thus confirmed. The closer the relation into which an organ with a dual function of this kind enters with one of the major instincts, the more it withholds itself from the other.'[68]

Thus, the activity of seeing, 'mapping' objects in space, is potentially subject to interference and even domination by the sexual aim in scopophilia. It is this latter aim that would appear to be referred to in a non-psychoanalytic notion of 'objectification', that something has been fixed upon 'sexually', *scotomized*. In this process a thing has been turned into an object of (for) desire. Otto Fenichel takes up this aspect of scopophilic pleasure to suggest that it is characterized by the equation: 'to look at = to devour'.[69] He notes that 'When someone gazes intently at an object, we say that he "devours it with his eyes" … and the "eye or glance" becomes "a sadistic weapon".'[70] The eye here has become an aggressive 'oral' organ that devours. This turns out to be partially something to do with a primary, or rather primitive, form of identification: 'all identification takes place through an act of introjection'.[71] Fenichel formulates this as 'I wish what I see to enter into me'. In other words, a desire to incorporate the object is a primitive form of narcissism (the structure of the 'self'), just as a child introjects aspects of its parents. Consider, in a colonial context,

65 Ibid., p. 265.

66 Jacques Lacan, *The Ethics of Psychoanalysis, 1959–1960* (London: Tavistock/Routledge, 1992), p. 113.

67 Sigmund Freud, 'The Psychoanalytic View of Psychogenic Disturbance of Vision' (1910), *On Psychopathology*, PFL 10 (1981), p. 111.

68 Ibid., pp. 111–12.

69 Otto Fenichel, 'The Scoptophilic Instinct and Identification', in *The Collected Papers of Otto Fenichel*, Vol. 1, ed. and trans. Hanna Fenichel and David Rapaport (London: Routledge and Kegan Paul, 1954), p. 373.

70 Ibid., pp. 373 and 374.

71 Ibid., p. 378.

the greedy scopophilia at stake in the removal of artefacts from colonized cultures by collectors. Otto Fenichel in a paper called 'Trophy and Triumph' argues that

> The relation between the collector and his objects ought some day to be studied to see how frequently it reflects the feeling 'I have acquired something by force or fraud that originally belonged to someone more powerful, but which is now a talisman for me, or which connects me magically with the previous possessor'.[72]

This 'talisman' object embodies a kind of power as trophy-object, but is also something 'incorporated'. The colonial collector is no better than the cannibal who devours his enemy to incorporate their strength when it comes to the taking of trophies: 'The ambivalence toward those from whom trophies are taken is important. They are held in honour, since part of them is made part of one's self.'[73]

The so-called 'barbaric negro fetishes', nineteenth-century anthropologists often called them, were revalorized in the 1920s as '*l'art nègre*'. The trophy resignified is raised to an idealized form of object. African art became an idealized sign in Western culture. 'Idealization of an object', Freud comments in his essay, 'Group Psychology and the Analysis of the Ego', is 'the tendency which falsifies judgement':

> We see that the object is being treated in the same way as our own ego, so that when we are in love a considerable amount of narcissistic libido overflows onto the object. It is even obvious in many forms of object-choice that the object serves as a substitute for some unattained ego ideal of our own. We love it on account of the perfection which we have striven to reach for our own ego and we would now like to procure in this roundabout way.[74]

From this we can begin to see what a critic, collector, artist and photographer might have in common in their position as viewers of objects, albeit often with different specialized materials, discourses and sometimes places. Appropriation of an object is a triumph, the taking of a trophy as idealization and in its idealization, an act of love. Loving or idealizing an exotic object-thing is

72 Fenichel, 'Trophy and Triumph', p. 149.

73 Ibid., p. 151.

74 Sigmund Freud, 'Group Psychology and the Analysis of the Ego', *Civilization, Society and Religion*, PFL 12 (1985), p. 143.

not a means to any real thing for itself, so much as a means of satisfying narcissism. While such a model can help think about the circulation of non-European objects in early twentieth-century colonial discourse (as 'devoured', incorporated, present, but silenced and atrophied), how might this be located in terms of Man Ray's photograph and affiliation to surrealism?

The Surrealist Object

The '*objet surréaliste*' is mostly associated with surrealism of the 1930s and the emphasis that Salvador Dali is claimed to have brought to it (before his expulsion in 1938).[75] In André Breton's (1934) essay 'What is Surrealism?' he notes,

> It is essentially on the object that surrealism has
> thrown most light in recent years. Only the very close
> examination of the many recent speculations to which
> the object has publicly given rise (the oneiric object,
> the object functioning symbolically, the real and virtual
> object, the moving but silent object, the phantom ob-
> ject, the found object, etc.) can give one a proper
> grasp of the experiments that surrealism is engaged in
> now. To continue to understand the movement, it is
> indispensable to focus one's attention on this point.[76]

In fact, much earlier, in 1924, Breton had discussed the potential of a surrealist object in his essay 'Introduction to the Discourse on the Paucity of Reality'. There he had formed the idea that an 'oneiric' dream-image could and should be used as the basis for the production of an actual object, which would be

> no more useful than enjoyable. Thus recently, while I
> was asleep, I came across a rather curious book in an
> open-air market near St Malo. The back of the book
> was formed by a wooden gnome whose white beard,
> clipped in the Assyrian manner, reached to his feet. The
> statue was of ordinary thickness, but did not prevent
> me from turning the pages which were of heavy black
> cloth. I was anxious to buy it and, upon waking was
> sorry not to find it near me … I would like to put into
> circulation certain objects of this kind, which appear
> eminently problematical and intriguing.[77]

75 Dali claimed to have an affection for Adolf Hitler. On Dali's politics see Helena Lewis, *The Politics of Surrealism* (New York: Paragon, 1988), pp. 151–2. For an introduction to his conception of the object in surrealism see Dawn Ades, *Dalí* (London: Thames and Hudson, 1992), pp. 151–72; and a general introduction to the surrealist object in Sarane Alexandrian, *Surrealist Art* (London: Thames and Hudson, 1993).

76 André Breton, 'What is Surrealism?' in *What is Surrealism?*, F. Rosemont (ed.) (London: Pluto, 1989), p. 138.

77 Ibid., p. 26. Introducing this essay, Franklin Rosemont claims that it is 'one of the pivotal reference points, one of the central sources, of surrealist theory', p. 17.

In his text, Breton qualifies this surrealist image 'dream-object' as different from those trophy objects of the 'explorer': 'Human fetishism, which must try on the white helmet, or caress the fur bonnet, listens with an entirely different ear to the recital of our expeditions.'[78] In effect, Breton makes an explicit distinction between a ('white helmet') anthropological-colonial explorer's fetishized trophy object and the ('caress the fur bonnet') sexual fetishist's object from the surrealist 'dream-object'. The surrealist dream-object, his example of the 'book-gnome' is something he clearly wishes to be put at a distance from and, indeed, sees as a contribution to the destruction of fetishism: 'Perhaps in that way I should help to demolish these concrete trophies which are so odious, to throw further discredit on those creatures and things of "reason".'[79]

Breton's category of surrealist object, with its marvellous psychical contradiction, is pitched against 'reason' and classical fetishism.[80] As often noted in the frequently discussed type of surrealist object, the 'found object', the surrealist economy of the object functions to resignify things that had been 'discarded', finding them by chance, rummaging in flea markets and so on. For Breton, the surrealist object, whether found, 'ethnographic', oneiric, etc. is not to be reduced to any art category as sculpture or as a cultural 'fetish'. For Breton, as made blatantly clear in his later essay 'Crisis of the Object' (1936), the surrealist 'quest for objectification' in the making concrete of a dream-image and the 'unprecedented *desire to objectify*' is what corresponds to a 'non-Euclidian geometry' and 'non-Newtonian gravity', a break with the co-ordinates of a Cartesian *cogito* and rationalist 'hegemony'.[81] The actual surrealist object produced is 'the objectification of the very act of dreaming'.

Elizabeth Cowling has pointed out that the surrealists' own 'ethnographic' object collections were primarily based in Oceanic, Alaskan and North West American Indian objects more than African cultures, even though materials from Africa were more abundantly available in France.[82] The list of items in the total sale of Breton's and Eluard's collections in July 1931 (at the Hôtel Drouot, Paris) confirms this. The sale catalogue lists thirty items from Africa, a hundred and thirty-

78 Breton, 'What is Surrealism?', p. 26.

79 Ibid.

80 Emily Apter and William Pietz (eds), *Fetishism as Cultural Discourse* (London: Cornell University Press, 1993).

81 André Breton, 'Crisis of the Object' (1936), in *Surrealism and Painting*, trans. Simon Watson Taylor (London: Macdonald, 1972), p. 275.

82 Elizabeth Cowling gives an account of the sources of the surrealists' collections (see her 'The Eskimos, the American Indians and the Surrealists', *Art History* [Vol. 1, no. 4, December, 1978]).

four from Oceana', a hundred and twenty-four from America(s), fourteen from Malaysia and seven 'others'.[83] According to Cowling, the surrealists had gone to some effort to find and discover not only the objects themselves, but specifically about the original uses of the objects in their indigenous culture. In particular, Breton, Eluard and Aragon all made trips to London, using the *British Museum Handbook to the Ethnographial Collections* (and buying articles from W. O. Oldman, 'the famous Clapham dealer'). They also visited the Musée d'Histoire Naturelle in Boulogne (which had a much larger collection of Alaskan art than the Trocadero)[84] to find out more information, for example, about North American native tribes. The surrealists were interested in a 'critical apparatus' for these objects that Apollinaire had called for much earlier.

It is here that a distinction should be drawn between the object as signifier and the discourse in which its signified is constituted. Although the word 'primitive' as a noun does appear in the writings of Breton and other surrealists, it is certainly a mistake and reductive to conflate this surrealist interest and use of those objects in their discourse with the appropriation of those objects to a modernist primitivizing art discourse. In surrealism non-European objects were valued in their own right and placed alongside objects made by the surrealists. In modernism such objects were another iconographic source to appropriate and devour.

Breton's 'dream-object' of the book-gnome juxtaposition might here stand as a kind of allegory for the relation between an object and a discourse, how the object and discourse upon it are welded together. A book (with its temporal function of narrative description) and the gnome statue (as spatial-object) are in Breton's dream condensed together as a hybrid thing, a dream-object and its interpretation. Surrealist objects provided another means to the marvellous, as 'poem-objects', as a social critique of commodity culture. (The implicit ecology, for example, of revaluing that which had already been discarded in the flea market.) In effect, if there was any equivalence between various types of objects in surrealism they were all as so many preconscious residues of previous mental activity. The surrealist object

83 Evan Maurer, in Rubin (ed.), *'Primitivism' in 20th Century Art*, Vol. 2, p. 546. Maurer and Cowling explain the sale of Breton and Eluard's collections as the 'extremely hard financial times'. The sale also coincides with the surrealists' participation in the 'Anti-colonial Exhibition' (see Chapter 7).

84 Cowling, *Art History*, pp. 486–7.

is a *déjà vu*, an already seen thing. If non-European objects evoked for the surrealists, in some way, a sense of the 'primitive', it was in the same way as any of the other objects that they had made or found. The surrealists tried to produce a space for objects which was not involved in either the sexual fetishism market economy of the commodity or the colonial fetishism of 'art' objects, despite the obvious tensions that this attempt could cause.[85]

Louis Aragon, André Breton, Paul Eluard and others, owned and collected colonial objects while being politically anti-colonial.[86] To be consciously anti-colonial is not the same as the 'primitivism' of the unconscious. Yet the surrealists posited a difference between the trophy hunter, an art collector of colonial objects in a colonizing culture and their own use of those objects in surrealism. For the surrealists this difference was not only in a consciousness about the cultural use of objects (their social functions), but as an issue as unconscious object of desire.

Object of Desire

For Freud, 'The finding of an object is in fact a refinding of it.'[87] This object in psychoanalysis is the (love) object of desire. Freud indicates that there are two methods of finding this object, 'anaclitic' and 'narcissistic'.[88] The anaclitic, or 'propping'-type method is 'based on attachment to early infantile prototypes', that is, the seeking of a love object based on someone, 'a thing' which will care or look after them as their parent figure(s), mother/father did. The second, 'narcissistic' type of object-choice 'seeks for the subject's own ego and finds it again in other people'.[89] Here the 'ego' develops through identification with the other, but an other already 'based' on the ego. Without going through a full account of the early stages of sexuality in childhood here (oral, anal and genital), it is still important to note that for Freud, 'There are … good reasons why a child sucking at his mother's breast has become the prototype of every relation of love.'[90] This first (oral) object is sexual in that it gives the infant its first experience of satisfaction and frustration. It is in frustration of achieving a repeated satisfaction that the

85 See Dennis Duerden, *The Invisible Present* (London: Harper and Row, 1975) for a discussion of the importance of location, context and language in relation to African art and culture. Thanks to Dr Griselda Pollock for drawing this book to my attention.

86 Breton's speech in Haiti in December 1945 is reputed to have been 'instrumental' in bringing down the Lescot dictatorship there. Breton's support for the black poet Aimé Césaire is well known.

87 Sigmund Freud, *Three Essays on the Theory of Sexuality* (1905), PFL 7 (1979), p. 145. Hal Foster addresses this Freudian concept in relation to surrealist objects (*Compulsive Beauty* [MIT, 1993]). My argument here is concerned with distinctions between discourses of 'avant-garde' criticism and 'modernist primitivism'.

88 Freud, *Three Essays on the Theory of Sexuality*, p. 145, note 1 (see also Jean Laplanche and Jean-Bertrand Pontalis, *The Language of Psycho-analysis* [trans. Donald Nicholson-Smith] [London: Karnac Books, 1988], p. 33).

89 Freud, *Three Essays on the Theory of Sexuality*, p. 145.

90 Ibid., pp. 144–5.

infant is propelled into the structure of fantasy – to hallucinate the object of desire. If the oral object is the prototype for 'a refinding of it' in the guise of a love object, then it might be considered how the different methods of anaclitic and narcissistic structure relations to an object as a question of *being* or *having*.

In the anaclitic relation there is an attempt to find the same (parental carer) object. In the narcissistic relation there is an openness to difference (the other in the 'self') in so far as it aims to find the same (ego) object. There is a parallel to this anaclitic and narcissistic distinction in Todorov's (non-psychoanalytic) distinction between the nationalist and the exoticist, between desire in the same and desire in difference. Would it then be possible to suggest that for the nationalist, the object must be anaclitic, as the same, and that for the exoticist, the narcissistic object must be different, other idealized (introjected as the same)?

Freud notes in 'On Narcissism' (1914) that anaclitic and narcissistic 'kinds of object-choice are open to each individual'. But he points to a cultural tendency of men towards the former attachment anaclitic type of object and women towards the latter narcissistic object-choice.[91] Generalizations are of course problematic and Freud is careful to comment that this description is 'non-essential'; the reverse can also be true. But it is striking to note that the fervour for nationalism – no less 'erotic' than in the desire for the exotic – has been mostly a man's thing. Can the same be said of exoticism? Is 'negrophilia', in which can be seen the traits of exoticism and eroticism (sometimes sublimated) akin to the overvaluation of 'being in love', enacted in the name of a transferential narcissism? Or are the surrealists identifying with a 'feminine' attachment to narcissism through the exotic? Are all the objects of exoticism to do with, in this sense, 'woman'? Or is there both an anaclitic and narcissistic relation in the dynamics of the discovery of the colonial object as exotic, and in such a context how are we to read Man Ray's image?

Feminine Object?

Although Man Ray's photograph *Noire et blanche* has an established place in the oeuvre of Man Ray, there is

91 Sigmund Freud, 'On Narcissism', PFL 11, p. 81.

no consistent view of it in existing critical texts. What to one author is, apparently, 'one of the photographs Man Ray valued most highly'[92] is for another 'worked self-consciously',[93] 'lacking in mystery', or his 'least successful'.[94] A reading by Evan Maurer suggests: 'Man Ray's photograph *Noire et blanche*, 1926 is an elegant yet eerie comment on Art Deco's use of "*l'art nègre*".'[95] The writer does not add more about this 'eeriness' in 'art deco's use of "*l'art nègre*".'

The 'rediscovery' of non-Western objects as art through European artists at the beginning of the twentieth century is often told as an anecdotal *event*, the visits that Picasso paid to the Trocadero Museum in Paris which 'inspired', 'influenced', his famous 'Cubist' painting *Les Demoiselles d'Avignon* (1907), where the faces of the two figures (prostitutes) on the right are 'appropriated' from African and Iberian masks.[96] Phyllis Rose suggests this was not a tribute to the sculpture of these cultures, but rather they were 'painted in for their emotional impact − to express the terrifying aspects of female sexuality'.[97] Thus, 'Female sexuality and the black were for Picasso visual analogies.'[98] Man Ray's photograph juxtaposes two cultural things in a different way. *Noire et blanche* and Picasso's *Les Demoiselles d'Avignon* stand as opposite versions of the positive and negative connotations given to the fashionable European exoticism of the 'dark continent'. Man Ray's juxtaposition is a classically elegant and melancholic image compared with Picasso's visually abrasive condensation of white female *as* primitive mask. Man Ray's image puts together in the same space objects from different taxonomies; it does not, as Picasso's painting does, condense them into *the same*. Picasso's painting, then, brings together things as the same, where the image of the other is 'terrifying', a sort of anaclitic alienation (in its odour the other is faecal, 'shit').[99] What has been found is the bad mother.

In Man Ray's picture different things are juxtaposed as the same, but they are never reducible to the same; the image elides this reduction in their very distinct 'objectness', as different things. The *Noire et blanche* objects remain obstinately different objects even if it *implicitly* suggests by their very comparison that they

92 *Man Ray: Photographs*, trans. Carolyn Breakspear (London: Thames and Hudson, 1981), p. 88.

93 Jane Livingston, 'Man Ray and Surrealist Photography', in Dawn Edes et al. (eds), *L'Amour fou* (Paris: Gallimard, 1990), p. 145.

94 Ibid., p. 135.

95 Maurer, 'Dada and Surrealism', in Rubins (ed.), *'Primitivism' in 20th Century Art*, Vol. 2, p. 539.

96 Picasso undoubtedly learnt from Cézanne. For an orthodox account see William Rubin, 'Picasso', in *'Primitivism' in 20th Century Art*, Vol. 1. On Rubin's general thesis of 'Primitivism' see James Clifford, 'Histories of the 'Tribal and the Modern', in his *The Predicament of Culture* (London: Harvard University Press, 1988), pp. 189–214. Clifford's complaint is that the 'affinity' supposed between the 'Tribal and the Modern' in Rubin's argument and exhibition displays is only expressed within a Western, modernist discourse. Also on Cézanne see Griselda Pollock, *Avant-Garde Gambits, 1888–1893* (London: Thames and Hudson, 1992).

97 Rose, *Jazz Cleopatra*, p. 42.

98 Ibid., p. 43.

99 Picasso's description of the Trocadero Museum is emphatic in recalling what he found to be its most striking attribute, its 'putrid smell'.

might be related as the same. But if art deco 'appropriated' '*l'art nègre*', then is not art deco in the process implicitly '*primitivized*' as the African mask in the picture? Yet in doing so is not '*l'art nègre*' also elevated, at one level, to the dignity of *art deco*, precisely as modern style itself, as a fashionable mode of objectness in vogue?

In a process of reciprocal resignification, the white European woman is connotated as archaic, primitivized, and the mask is modernized, feminized in a timeless youthfulness. Each 'object' displaces the meaning of the other, each becomes doubly *significant*, neither is totally graspable without the other; or able to signify in its own economy without the other contaminating its semiotic structure. In a rhetoric of chiasmas (argument made through a relation between two signs repeated but inverted) the iconic features of the two objects invite a formal comparison as similar, but at the level of content, all similarity is converted to differences, a series of oppositions: white/black, art deco/African, woman/mask, animate/inanimate, horizontal/vertical. The two heads are 'like one another', yet 'different'. It is this tension between similarity and difference which the photograph maintains as its fundamental, complex status. Any reading will therefore be an ambivalent inflexion of this basic rhetorical matrix. The invitation to make a comparison, a visual 'affinity' between connotations of sameness, is also countered by their irreducible difference.[100] On the side of sameness there are chains of connotation. In *Variétés* magazine where

36 From left to right: African mask on cover of *Variétés*, November 1928; cosmetics advertisement from 1928, featuring mask as revealing/re-invigorating beauty; and a coiffeur advertisement with art deco mask like Kiki's face in Man Ray's *Noire et blanche*.

100 The issue of 'affinity' is dominant in the discussion of 'modernist primitivizing'. Both William Rubin's '*Primitivism*' and James Clifford's critique centre around the legitimacy of 'affinity'. Claude Lévi-Strauss receives short shrift in Clifford's argument, but Lévi-Strauss deals head on with the question of cultural 'affinity' in his essay on 'Split Representation in the art of Asia and America' (see his *Structural Anthropology*, trans. Claire Jacobson and Brooke Grundfest Scoepf [Harmondsworth: Penguin, 1993], Vol. 1, p. 248).

Man Ray's photograph was published in 1928, a full-page advertisement for 'Maison Jean' shows a graphic depiction of the features of an 'Art deco woman' like in Man Ray's photograph[101] (see Figure 36). As the advertisement makes clear, the art deco image is about the status of a fashionable European woman and her cultural idealization in modern feminine beauty. In another advertisement the feminine image is valorized as a mask, just as it is in the African mask depicted in Man Ray's photograph. Michel Leiris and Jacqueline Delange report that the Baule sculptor is a 'highly esteemed dignitary', one whose opinion carries great weight. The Baule mask with its 'classic style' epitomizes 'feminine beauty' and as a mask of the 'mbolo' category was, in usage, painted red, the 'colour of life' and a symbolization of 'the renewal of power'.[102] The mask serves as a 'condensation of occult forces' for which the bearer of the mask is a temporary agent.[103] Thus both African and European cultures have produced imagery, 'feminine masks', in overlapping representations of beauty (see Figure 36). Unwittingly perhaps – we can but guess at Man Ray's knowledge about Ivory Coast Baule culture – he has juxtaposed two different cultural icons, both masks of feminine beauty, somehow different, yet the same. Both are to do with 'the renewal of power', feminine values as image of eternal youth. Even in the negative (reversed) version of the photograph that Man Ray used, the same 'difference', with the black and white inverted, is produced. We are returned to the issue of feminine sexuality and the face reified as a 'mask' in two cultural traditions: the pearly mask of Kiki's face and the Baule mask from the 'dark continent'. Commenting on Jean-Luc Godard's remarks around the cinematic close-up and femininity, Laura Mulvey notes how Godard also associates

> both the image and femininity with secrets, with something that lies 'darkly' behind the mask. And the spectacle of female sexuality becomes one of 'topography', one of surface and secret. The celluloid image thus acquires an 'unconscious' that has its source in male anxiety and desire projected onto an uncertainty about femininity.[104]

101 The photograph was published in the Belgian review *Variétés*, July 1928. Edited by E. L. T. Mesens (poet, painter, musician and key figure in Belgian surrealism), *Variétés* was popular in orientation, but surrealist in spirit. A special issue was published on surrealism in 1929. *Variétés* used a lot of photography as images in their own right. Man Ray's *Noire et blanche* simply appears as one of several of his photographs scattered across that issue.

102 See B. Holas, *Masques Ivoiriens* (Paris: Geuthner, 1969), p. 78.

103 Ibid., p. 11. Vincent Guerry notes that the highest 'fetish' or 'Amoin' (mysterious force) in Baule culture is the excised woman's vagina. The men have fetishes which are not their sex (their penises), but another object which represents it. The woman must not make fun of his penis and he will die if he looks at his fetish (*La Vie quotidienne dans une village baoulé* [Côte d'Ivoire: Inades, 1970]).

104 Mulvey, *Fetishism and Curiosity*, p. 46.

We find the same 'dark secret' of anxiety and desire involved in all masks. In *Noire et blanche* the masks of femininity are literal. It is the 'mysteriousness' of these faces as objects, 'beyond' the surface which eludes the spectator's look. Yet the objectness of Kiki's head makes it 'graspable' like the African mask. But as Mulvey indicates, there is also in such images of femininity a sense of something lurking 'behind' the mask, which shows another 'darker' thing.

The photograph obviously differentiates itself from the mode of art exhibit photograph that isolates, disembodies, non-European 'ethnographic' objects from the space in which they are photographed; Man Ray's photograph explicitly puts the mask with another object. It is clear from other photographs by Man Ray that he tried a variety of poses with Kiki holding the mask in different positions. What is it that made the one in *Vogue* 'right'? *Noire et blanche*, sometimes called simply 'Composition',[105] does achieve a kind of balance, a visual harmony between the two elements in the picture. Kiki does not hold the object like an object; it is treated as rather an 'equivalent'. The juxtaposition, literally, elevates the African mask above her face and in this respect Kiki lays down her gaze with her head and becomes like the African mask, an inert 'object'.

Petrified

Importantly, Kiki's eyes are closed in the photograph; she does not return our look with her gaze.[106] Closed eyes in surrealism are commonly used to evoke an image of someone dreaming or asleep – or dead. The top light in the image casts a highlight on to her hair and flattens her head in space. It appears as in a 'plastic freedom', floating, as like a mask. The hard-edged oval shadow cast by her head from the top lighting looms forward, a dark pool of liquid space that merges into the darkness of her hair. It is as though her head is frozen, fixed by the camera and petrified like the wooden object she holds in her left hand. In the given plane of vision her head is visually separated from her body by the African mask. Fantasmatically, metaphorically, the mask object 'cuts' her head, as the blade of a guillotine would from her body, her head fallen, 'lifeless' as an object, like one

105 Janus, *Man Ray, the Photographic Image*, trans. Murther Baca (London: Gordon Fraser, 1980), p. 193.

106 A woman with her eyes closed is a familiar surrealist trope, seen on many covers of books on surrealism.

199

of Brancusi's sculpted heads as an autonomous object.[107] It might seem ridiculous to propose Man Ray's image as a fantasy of decapitation, but Freud notes that the dreaming (or 'nightmare') of the death of a loved one is a 'typical dream'. Despite the horror with which such an idea might be received, Freud suggests that this is exactly what it means: 'There is no wish that seems more remote from us than this one: "we couldn't even *dream*" – so we believe – of wishing such a thing.'[108] The loved feminine object returns unconsciously as the sign of an anxious male threat, castration, death. The darkness that is behind the surface reveals its content as, precisely, nothing, an emptiness. We are returned to the ambivalence of the anaclitic/narcissistic object relations. In exoticism an object-trophy is introjected, an unconscious incorporation of the object. Otto Fenichel notes: ' ... man's mechanical ingenuity had actually created a "devouring eye", which looks at and incorporates the external world and later projects it outward again. I refer, of course, to the camera.'[109] Here the 'devouring eye' that Fenichel speaks of has been rendered a service by the photographic apparatus. The exotic object is devoured by the camera (without any material digestion). In the photograph what is projected outwards is the narcissism of the woman as *being*. Her face is compared with an exotic object. We could say, as Lévi-Strauss does, that the display of the mask is 'at the expense of the individual wearing it' and that, in both masks, the decorative arts are used to project an individual 'on to the social scene' by their dress, as *having* a masquerade.[110]

In *Kiki's Memoirs* published in 1930 she speaks of her time with Man Ray during the 1920s. At the end of one chapter she says, 'What drives Man Ray to despair is that I have a nigger's tastes: I'm too fond of flashy colours! ... And yet,' she adds, 'he loves the black race.'[111] For Man Ray's image, Kiki is 'like' the black woman, exotic, erotic and Other.[112] But an idealization of the love object entails some renunciation of the subject's own narcissism, just as Freud notes: 'The charm of a child lies to a great extent in his narcissism, his self-contentment and inaccessibility', which can precipitate a 'childish' absorption of the parents' wishes in it.[113]

107 Brancusi asked Man Ray to teach him photography, because he thought that only he could photograph his work properly.

108 Freud, *Interpretation of Dreams*, p. 369.

109 Fenichel, 'The Scoptophilic Instinct and Identification', p. 395.

110 Lévi-Strauss, *Structural Anthropology*, Vol. 1, pp. 262–3.

111 Kiki (Alice Prin), *Kiki's Memoirs*, trans. Samuel Putnam, introduced by E. Hemingway (Paris: Edward Fitus/Black Manikin Press, 1930), unpaginated.

112 One of Man Ray's later lovers, Adrienne, was from Martinique.

113 Freud, 'On Narcissism', PFL 14 (1986), p. 82.

So Claude Lévi-Strauss melancholically concludes his anthropological 'autobiography', *Tristes Tropiques*, by speaking of the farewell '*unhitching*' of identification required, as in 'the brief glance, heavy with patience, serenity and mutual forgiveness, that, through some involuntary understanding, one can sometimes exchange with a cat'.[114] What comes across here is the ambivalence between the (imagined) self, the objects of desire as same and difference, and the final recognition of their irreconcilable differences. In the end, it is the difference of the exotic (or any other) object which also dissatisfies the exoticist, it is the difference which cannot be 'devoured' in the look of the narcissistic love object type. The objectification of the object is not satisfying, it incites desire again.

Experienced from the other side this look of objectification was not always received as benign. Frantz Fanon speaks of the act of naming the '*nègre*', the 'Negro' as the traumatic moment of becoming an object in his colonial 'recognition':

'Look, a Negro!'
 I came into the world imbued with the will to find a meaning in things, my spirit filled with the desire to attain to the source of the world, and then I found that I was an object in the midst of other objects.[115]

Pursued by this 'look', he reports:

I was responsible at the same time for my body, for my race, for my ancestors. I subjected myself to an objective examination, I discovered my blackness, my ethnic characteristics; and I was battered down by tom-toms, cannibalism, intellectual deficiency, fetishism, racial defects, slave-ships, and above all else, above all: 'Sho' good eatin'.'[116]

It was precisely against such negative stereotypes that Aimé Césaire's 'négritude' movement was to emerge, critically as a point of positive identification, a 'black consciousness' for oppositional black writers in the thirties. With the short-lived journal *Légitime défense*, which took its title from André Breton's 1926 pamphlet 'Legitimate Defence' (see Chapter 4), a group of young Martiniquan men studying at the Sorbonne in Paris

114 Claude Lévi-Strauss, *Tristes Tropiques*, trans. John and Doreen Weightman (Harmondsworth: Penguin, 1984), p. 544.
115 Frantz Fanon, *Black Skins, White Masks* (London: Pluto, 1990), p. 109.
116 Ibid., p. 112.

117 *Légitime défense* (1932), reprint (Paris: Editions Jean-Michel Place, 1979). See also Michael Richardson (ed.), *Refusal of the Shadow* (London: Verso, 1996) for translated texts from *Légitime défense*.

in 1932 produced a first anti-colonial French cultural journal by 'colonized blacks'. The journals, *Légitime défense*, *L'Etudient noir* and *Tropiques*, independently of European surrealists established a voice for a 'collective consciousness' of '*negritude*' within capital culture. It was a beginning of the black subject and the white object.[117]

7 · The truth of the colonies

How does it feel to be a problem? *W. E. B. Du Bois,*
The Souls of Black Folk

Edward Said in *Culture and Imperialism* is pessimistic about 'the inability of the Western *humanistic* conscience' to 'confront the political challenge of the imperial domains'.[1] More specifically, he is critical of European anti-colonialism for only criticizing the 'mis-uses' of imperialism, not the *ideology* of colonialism itself, the actual principles of imperialism (its 'hegemony').[2] Said argues: '[But] as in England, the French reaction to Asian and African nationalism scarcely amounted to a lifted eyebrow, except when the Communist Party, in line with the Third International, supported anti-colonial revolution and resistance against empire.'[3] There is only one other reference to communism in his book, indexed to the Soviet Union, where Said notes: ' … nearly every successful Third World liberation movement after World War Two was helped by the Soviet Union's counter-balancing influence against the United States, Britain, France, Portugal, and Holland.'[4]

Although importance is attributed to the Soviet Union and communism, this is not pursued as a historical question, why it was there, in 'the Communist Party, in line with the Third International' that anti-colonialism emerged in Europe. But his historical observation, the failure of humanist thinking to support anti-colonialism, also raises a theoretical problem: why did the conscience of humanism not support anti-colonialism?

It might be supposed, then, that those who did support anti-colonialism (Communist Party and Third International) had a stronger judicial, moral and political conscience (what Freud termed the '*super-ego*')[5] than those with a 'Western humanistic conscience'. If that is the case, it is perhaps surprising to find the surrealists, so apparently lacking in morality, decorum and any supposed interest in consciousness, among those with a strong anti-colonial conscience.[6] This is a question which is certainly worth exploring.

1 Edward Said, *Culture and Imperialism* (London: Vintage, 1993), p. 251 (my italics).

2 Said cites André Mallard's *La Voie royale*, 1930 as an example, the story of a European's deathly journey into French Indochina. Said, *Culture and Imperialism*, pp. 250–1.

3 Ibid., p. 250.

4 Ibid., p. 292.

5 A standard definition by Freud is given as follows: 'The super-ego is in fact the heir to the Oedipus complex and is only established after that complex has been disposed of. For that reason its excessive severity does not follow a real model but corresponds to the strength of the defence used against the temptation of the Oedipus complex. Some suspicion of this state of things lies, no doubt, at the bottom of the assertion made by philosophers and believers that the moral sense is not instilled into men [*sic*] by education or acquired by them in their social life but is implanted in them from a higher source.' Sigmund Freud, 'An Outline of Psychoanalysis' (1940 [1938]), *Historical and Expository Works*, PFL 15, p. 442. Also Catherine Millot, 'The Feminine Super-Ego', in Parveen Adams and Elizabeth Cowie (eds), *The Woman in Question* (London: Verso, 1990).

6 Edward Said does not mention surrealism at all, but they were active anti-colonialists from their early days.

It is not self-evident that the surrealists should have, as they did, worked in collaboration with the Communist Party jointly to produce an explicitly anti-colonial exhibition. This exhibition was a direct response to the huge government-organized *International Colonial Exposition* (*Exposition coloniale*) held in Paris in 1931. In opposition to this *Colonial Exposition*, the surrealists and communists claimed to show, as the title argued: *The Truth of the Colonies* (*La Vérité sur les colonies*). The title had a good pedigree; it echoed an address to the Revolutionary Assemblée Nationale in 1789. The speech, titled 'Enfin, la vérité sous les colonies', given by Monsieur Leborgne, chief administrator for the colonies, led a debate about what to do with those colonies that had declared their separate independence from the new revolutionary France.[7] Since then, of course, most European states had vastly increased their colonial territories, including France, just as European debates about the value of the colonies persisted as a question of viability and profit.

Edward Said's surprise and sadness at the failure of humanism is also because he declares himself to be a humanist.[8] The fact that it has so often historically failed to engage in struggles of liberation, not only in relation to colonialism but the rights of women, children, racial equality and so on, demands that the humanistic conscience be brought to court.[9]

Humanism and Ideology

Louis Althusser (the Marxist philosopher) attacked humanism, not for its lack of conscience, but its theoretical weakness.[10] For Althusser, humanism does not provide, as the 'essence of man', a theory of knowledge and action in history, since it presupposes, or rather negates, the 'problematic of *human nature*'. The idealist 'essence of man' does not account for why man does or does not act, so the concept of humanism is an 'ideological' one, it is not theoretical.[11] Althusser's rejection of humanism is a '*theoretical* anti-humanism' not a political one.[12]

The fact that humanism can be named as an ideology does not stop people believing in it, as Althusser points out. Marxists, like liberals or conservatives (Althusser

7 P. J. Leborgne, 'Enfin, la vérité sur les colonies', 24 Vendemiaire, l'an III (1794). Leborgne, chef de l'Administration de la Marine et des Colonies, ci-devant employé aux îles françaises, reported back from his visit to colonies. In Paris the declaration of independence by any of its colonies was seen scornfully as a ploy of the English to undermine the French Revolution, encouraging a 'counter-revolution' in their colonies. A pamphlet of the period also expressed 'Le danger de la liberté des nègres'.

8 Said, *Orientalism*, p. 26.

9 See Raymond Williams, 'Humanism', in his *Keywords* (London: Fontana, 1981), p. 123.

10 Louis Althusser, 'Marxism and Humanism', in his *For Marx* (London: NLB/Verso, 1986).

11 Ibid., p. 223.

12 Paul Hirst and Penny Woolley's account of Althusser's 'anti-humanism' in 'Theories of Personality', in their *Social Relations and Human Attributes* (London: Tavistock, 1982).

discusses 'socialist humanism' in his essay) may recognize a need for humanism as 'a conditional necessity' because 'ideology' is necessary, it is what is lived in.[13] Althusser gives his now famous definition of ideology as: 'a system (with its own logic and rigour) of representations (images, myths, ideas or concepts depending on the case) endowed with a historical existence and role within a given society'.[14]

Ideology is the name given to the system of representations through which the 'lived' relation between men (each other) and 'the world' (only known through its representations) is acted out, 'experienced' and practised. This concept of ideology is one of Althusser's three 'instances' in his schematic description of the social totality of any society: economy, politics and ideology. Ideology should not be confused with politics. No doing away with ideology in a revolution, at most it is the transformation of an ideology which occurs. It is in this sense that Althusser is often quoted as claiming that ideology is 'eternal' and has no history. It is also here that Althusser argues, scandalously at the time (1965), that ideology is not as it is usually conceived to be, something which belongs to the faculty of 'consciousness', but 'profoundly *unconscious*':

> Ideology is indeed a system of representations, but it is in the majority of cases these representations have nothing to do with 'consciousness': they are usually images and occasionally concepts, but it is above all as *structures* that they impose on the vast majority of men [*sic*], not via their 'consciousness'.[15]

Rejecting a 'philosophy of consciousness', Althusser's '*theoretical* anti-humanism' tries to show how human subjects and their actions are rooted (and 'over-determined') in their subject position as socially constituted agents, not in some abstract idealist 'essence'.[16] Ideology is not 'false consciousness', but the means through which 'the world' is lived. Rather than dismiss or 'wave away' ideology as the cynical plot of a scheming class, duplicitous administration or advertising company (to cite common targets), Althusser argues that ideology is a necessary – unconscious – condition for the functioning of any set of social relations:

13 Althusser, *For Marx*, p. 231.
14 Ibid.
15 Ibid., p. 233. Althusser's Marxism and psychoanalysis debate is only a summary point of a long-standing historical argument (see, for example, V. N. Volosinov, *Freudianism, A Critical Sketch* [Indianapolis: Indiana University/Academic Press, 1987]). Jacqueline Rose argues that once the unconscious and psychoanalysis were introduced into Marxist theory it was rejected (*Sexuality in the Field of Vision* [London: Verso, 1986], pp. 85–9).
16 See the critique of Althusser in Ernesto Laclau and Chantal Mouffe's *Hegemony and Socialist Strategy* (London: Verso, 1989), especially pp. 97–105.

In ideology men do indeed express, not the relation
between them and their conditions of existence, but
the way they live the relation between them and their
conditions of existence: this presupposes both a real
relation and an '*imaginary*', '*lived*' relation … In ideology
the real relation is inevitably invested in the imaginary
relation, a relation that *expresses* a *will* (conservative,
conformist, reformist or revolutionary), a hope or a
nostalgia, rather than describing a reality.[17]

Here Althusser uses the terms 'imaginary' and 'real' to
describe a binary, dialectical relation or conflict between
them, a process which gives rise to the product of
'ideology'. Both imaginary and real might seem to
belong to the psychoanalytic theory of Jacques Lacan.
I say 'might seem' because as Lacanian terms they do
not exactly fit.[18] In fact, the relation of Althusser's work
to psychoanalytic theory is problematic, even though
this was also the source of an interest in his work,
the introduction of the unconscious as a concept into
the workings of a theory of ideology and (political)
'consciousness'.

Ideology and the Unconscious

There are two main uses of the term 'unconscious' in
psychoanalysis, one *topographic* and the other *descriptive*.[19]
In the topographical sense, the unconscious refers to
those aspects of the psychical apparatus, meanings and
motives that are denied access to the conscious system
by repression and censorship. In the descriptive sense,
the unconscious refers to contents which are accessible
to consciousness, but not necessarily present at any
particular moment. Since this material *is* available to
consciousness it is not strictly speaking 'unconscious' as
defined by its content (the topographic sense) and should
thus properly be called '*preconscious*'. Jacques Lacan, for
example, locates syntax in the preconscious.[20] But which
of these is Althusser's meaning of the unconscious?

If Althusser's notion of the unconscious is analo-
gous to the topographic definition in psychoanalysis,
as subject to 'repression', then things like colonialism,
imperialism, racism etc. would be radically 'unknowable'
except through their failings (dreams, slips of the tongue,

17 Althusser, *For Marx*,
pp. 233–4.
18 See Colin McCabe's 'On
Discourse', in McCabe (ed.), *The
Talking Cure* (Basingstoke: Mac-
millan, 1981) especially pp. 210–13.
19 See Jean Laplanche and
Jean-Bertrand Pontalis, *The
Language of Psycho-analysis*
(London: Karnac Books, 1988),
pp. 474–6.
20 'Syntax, of course, is
preconscious' (Jacques Lacan, *The
Four Fundamental Concepts of
Psycho-analysis* [Harmondsworth:
Penguin, 1979], p. 68).

bungled actions and so on). On the other hand, it might seem more 'logical' to understand Althusser's ideological unconscious as closer to the Freudian concept of the 'preconscious', since ideology is theoretically accessible to consciousness (hence 'consciousness raising') *as* ideology? This would still raise other theoretical problems, for example, that a critique of colonialism is somehow 'immanent' in the subject. If, in the end, Althusser's ideological subject and the psychoanalytic subject are *theoretically* incompatible (only analogies), the dream of a *fully conscious rational* subject had nevertheless been shattered for ever by the discovery of the unconscious. Even if Althusser's analogy of ideology and the (psychoanalytic) unconscious has been theoretically critiqued (or more often, *ignored*), the sense of his argument, that ideology is not conscious, is not actually 'thought about' or theorized, still makes an important *practical* point.

Returning to Said's comments, then, it can be said that anti-colonialism was not 'conscious' in humanism, not represented as a *social* thought, since the ideology of imperialism was itself 'unconscious'. If it is not conscious, then it cannot be acted upon – even though *as unconscious* it acts on you. This is one sense in which Althusser's theory can be understood. Thus, it is perhaps not that Europeans failed to be good humanists, rather that humanism *per se* failed to make or *enable* them to act outside the imperialism in which they were entangled. Belief in humanism is just not effective when it comes to issues of colonialism. So one reason, perhaps, that communism and surrealism made efforts to be consciously active in anti-colonialism was because they were also ideologically 'unconscious' anti-humanists. Put the other way around, the reason why communism had an (unconscious) ideology of anti-humanism is because of its conscious identification with anti-colonialism. Given the eventual history of the Soviet Union, this obviously ignores the issue of Soviet 'imperialism'.[21] (Although consideration of this would at least show that no ideology is implicitly in and of itself 'morally correct'; 'anti-humanism' might even help to explain why the Soviet Union became so inhuman in its 'socialist humanism'.) However, communism did have a political consciousness of colonialism as part

21 Althusser's essay on 'Marxism and Humanism' also engages with the Soviet Union's turn to 'socialist humanism' as a political issue.

of its ('Marxist') *theory* of capitalism (even if a theory of the process of anti-colonialism was not resolved, i.e. the problematic theory of 'stages' of revolution and development/underdevelopment, laid down like a mathematical rule of inexorable 'historical' logic). Surrealism, too, had a political consciousness of anti-colonialism as part of its theory. Thus, returning to Said's observations that Western humanism failed to respond to the call of anti-imperialism, he is right: humanism did not recognize imperialism as such; it was not 'conscious'. Humanism *is* an ideology. It is interesting to note that historically many of those involved in *anti*-colonialism were anti-humanists too.[22]

Humanism and Photography

One famous anti-humanist criticism is Roland Barthes's essay on the even more famous post-World War Two humanist photography exhibition, *The Family of Man* in 1955.[23] Organized by Edward Steichen at the Museum of Modern Art, New York, this massive exhibition, 'Five hundred and three photographs from sixty-eight countries' by 'two hundred and seventy-three men and women' toured the world globally.[24] When Barthes saw *The Family of Man* exhibition in Paris, he condemned its underlying 'classic humanism' for making universalizing assumptions and reducing historical and cultural differences to 'Nature'. For example, in the completely unprogressive way the exhibition 'naturalized' the notion of 'work':

> And what can be said about work, which the Exhibition places among great universal facts, putting it on the same plane as birth and death, as if it was quite evident that it belongs to the same order of fate? That work is an age-old fact does not in the least prevent it from remaining a perfectly historical fact. Firstly, and evidently, because of its modes, its motivations, its ends and its benefits, which matter to such an extent that it will never be fair to confuse in a purely gestural identity the colonial and the Western worker (let us also ask the North African workers of the Goutte d'Or district in Paris what they think of *The Great Family of Man*).[25]

22 See Robert Young, *White Mythologies* (London: Routledge, 1990), especially pp. 119–29.

23 Roland Barthes, *Mythologies* (London: Paladin, 1981), pp. 100–2; Edward Steichen, *The Family of Man* (New York: Museum of Modern Art, 1955 [1986 reprint]).

24 Steichen, *The Family of Man*, p. 3.

25 Barthes, *Mythologies*, p. 102.

Humanism simply cannot 'see' imperialism, colonialism or its consequences, because 'human nature' is the ideological positivity in which work is the same everywhere – if we extrapolate the differences (colonial relations, 'surplus' money from wages etc.). Barthes rejects humanism because it universalizes what is historical and contingent; the conditions in which people work are not universal or fixed. What Barthes dismisses, in his phrase 'to confuse in a purely gestural identity' is precisely the form in which humanism constructs and succeeds *as* an identification with an imaginary relation to real imperialism. *The Family of Man*, with its universalizing tendencies, offers a space for imagined 'fullness', precisely a gestural identity sustained by a discourse, a set of photographic representations. Why this attraction for a discourse which offers fullness? The constitution of one identity (e.g. 'we all live, we all die' etc.) is the repression of an identification with any 'other'. To put this another way, humanism was the form in which *what we now mean by* 'colonialism' was repressed. Commenting on Barthes and French *anti*-humanist criticism, Robert Young notes:

> … the French critique of humanism was conducted from the first as a part of a political critique of colonialism. Colonial discourse analysis therefore shows why 'anti-humanism' was not merely a philosophical project. The anti-humanists charged that the category of the human, however exalted in its conception, was too often invoked only in order to put the male before the female, or to classify other 'races' as sub-human, and therefore not subject to the ethical prescriptions applicable to 'humanity' at large.[26]

If ideology is somehow a set of 'common-sense' (preconscious) assumptions appearing as a taken-for-granted 'natural' knowledge, then it is perhaps difficult to see how someone can lift themselves outside it (what Michel Pêcheux alludes to as the 'Münchhausen effect' after the Baron von Münchhausen character who could remove himself from a situation by pulling himself up out of it by his own hair).[27] This might more productively be theorized via the human subject's entry (identification) into the 'symbolic' of language, into 'representation'

26 Young, *White Mythologies*, p. 123.

27 Michel Pêcheux, *Language, Semantics and Ideology*, trans. Harbans Nagpul (Basingstoke: Macmillan, 1986).

209

28 I refer here, without rehearsing the argument, to Jacques Lacan's 'The Mirror Stage as Formative of the Function of the I', *Ecrits, a Selection* (London: Tavistock, 1982). In 'Freud and Lacan', Althusser refers to the 'imaginary misrecognition of the "ego", i.e. in the ideological formations in which it "recognizes" itself'. He concludes: 'It must be clear that this has opened up one of the ways which may perhaps lead us some day to a better understanding of this *structure of misrecognition*, which is of particular concern for all investigations into ideology' (Louis Althusser, *Lenin and Philosophy* [New York: Monthly Review Press, 1987], p. 219).

Homi Bhabha avoids the binarism of the 'conscious/ unconscious' model via Foucault's 'material repeatability of the statement' (See 'doublethink', in his *The Location of Culture* [London: Routledge, 1994], pp. 129–31.

29 See Sylvie Palà et al., *Documents, Exposition coloniale, 1931* (Paris: Bibliothèque de la Ville de Paris, 1981).

30 The British exhibition turned their otherwise significant absence into a minor but medically 'clean', respectable presence at Vincennes. With the British Empire's motto, 'the first wealth is health', a display listed nineteen 'Diseases of Importance to British Colonialism'. It was organized for the Department of Overseas Trade by the Wellcome Museum of Medical Science, London with the exception of the 'syphilis' exhibition display which was arranged by the Social Hygiene Council of Great Britain. Despite the 'scientific' materials, the catalogue takes the opportunity to contrast the British 'Health is Wealth' policy with the 'primitive' ideas of 'medical treatment' by witch doctors: the 'continued struggle against ignorance and

(images, concepts) and signification in which the subject (and his or her unconscious) is constituted, in Lacan's account through the structure of a ('mis-recognized') 'identification' (Althusser's *interpellation*).[28] In these terms, the *Colonial Exposition* and the anti-colonial exhibition organized by the communists and surrealists can be understood as struggle over identificatory positions being offered in respect of colonialism. It is also where the role of humanism itself will be seen as an important element.

The *Colonial Exposition*

The International *Colonial Exposition* of 1931 was organized by the French Ministry of Colonies as an unashamed celebration and promotion of the activity of colonialism, bringing a supposed experience of colonial life to Western populations. Held at Vincennes in Paris, May to November 1931, it was opened by the President of France (Third Republic), Gaston Doumergue.

Originally planned for 1925 as a follow-up to the *French Colonial Exposition* of 1922 in Marseilles, it was postponed several times until 1931. By this time it had become an international event, with French colonialism located in wider colonial culture.[29] It was intended to have a 'modern concept', unlike the 'Oriental bazaar' and chaotic 'bric-a-brac' of the 1922 Marseilles exposition. This Paris exhibition used modern methods of display, statistics, photographs, films, first-hand reports and above all, experience of actual native villages imported and rebuilt, complete with native inhabitants. Advertised as 'a tour of the world in a day' to show the 'formidable richness' of colonies, the *Colonial Exposition* was meant to be a total experience, where a spectator could sample a 'global village' of colonial life in the major empires of France, Denmark, Belgium, Italy, Holland and Portugal, all in one visit. (British territories were present as a small medical exhibit.)[30] Despite (or because of?) the weak economic state of the French colonies, they were represented to a metropolitan France as the source of a richness which would be a security knot against the global effects of the 1929 New York market 'crash'.[31] Employing all the technological means available, the exposition was a phenomenal attempt to recruit its

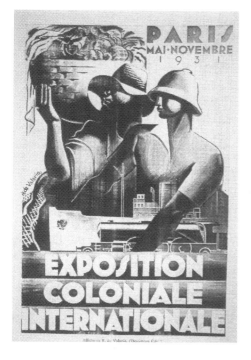

37 Poster for the 1931 *Colonial Exposition* in Paris.

audience to a sympathetic view of colonialism as a humanist project.[32] This is evident in many of the materials from the *Colonial Exposition*. The posters to advertise it, for example, showed colonialists standing shoulder to shoulder with natives, arms around them in an imagined fraternal humanism (or as might be read now, as a paternal superiority; see Figure 37).

In official terms, such indigenous populations under colonial rule were subject to the laws of France, but as French 'subjects' not as citizens.[33] Some Senegalese who fought for France in the First World War were made into citizens in 1916, but then those citizen–soldiers were used against other communes who were still subjects, effectively creating distinct ranks.[34] After the First World War the official policy of 'assimilation' as the appropriate relationship to 'colonized peoples' was replaced by one of 'association', although it is not exactly clear how either of these related to the concept of a 'Greater France', to which all official colonies were supposed to belong. 'Assimilation' could mean giving up, ignoring, your own culture and replacing it with a colonial one,

superstition' (see the Exhibition Guide catalogue, document of the British display, *Section Britannique cite des Informations, exposition coloniale internationale*, Paris, 1931).

31 Sylvie Palà et al., *Documents, Exposition coloniale*.

32 Herman Lebovics, *True France, the Wars over Cultural Identity, 1900–1945* (London: Cornell University Press, 1992) discusses the *Colonial Exposition* in terms of an 'ideology' and the 'politics of identity'. Broadly speaking his discussion follows a 'semioclasm' as in Roland Barthes, *Mythologies* (see the 1971 preface by Roland Barthes to *Mythologies* for his own criticism of this approach).

33 Jean Suret-Canale, *French Colonialism in Tropical Africa, 1900–1945*, trans. Till Gottheiner (London: C. Hurst, 1971), p. 83.

34 Ibid., p. 84.

211

which anyway tended to denigrate 'local habits'. In this sense, assimilation had a negative meaning. Affiliation or association suggested a looser 'fraternal'-type 'respect for customs, manners and religions'.[35] These debates about assimilation versus affiliation seem to have been a preoccupation in colonial administration at the turn of the nineteenth and twentieth century. In many ways they were futile, since local interpretations would anyway be made. In another respect they are extremely important, because as discursive statements they constitute the rules of colonial discourse. Such 'details' of *how* one should relate to an unfamiliar culture are in some sense constitutive for 'lived' colonial relations. To be 'a colonial' demands a certain identity, a set of discursive practices and rules, a way of 'being', that certain thing which constitutes someone's social identity.

The *Colonial Exposition* gave its audience a position of spectatorial authority. The colonial scenes displayed there were as things to be *consumed*. The collection of different colonial villages made 'local', cafés and restaurants with indigenous foods, 'native' clothes in fake souks, dancer troupes, displays of 'rituals', African orchestras, camel rides, shops and souvenirs all connected by roads; the viewer had nothing to do but sample a colonialist life as one of pleasure and leisure.[36] As if a metaphor for this, a cinema was constructed out of earth, a huge anthill, where audiences could *watch* 'documentary' films on colonies.[37] These images were supported in the 'City of Information' with a vast array of postcards, posters, guidebooks, press presentations and guided tours. Volumes of illustrated books on the different colonies were also published with photographs, drawings and written accounts, showing 'normal' colonial life in picturesque scenarios and a humanist vision of harmony. The aim was to make colonies seem familiar and attractive, to encourage a 'colonial career'. According to Sylvia Palà, in each pavilion a contrast of the situation in that country prior to the arrival of the French and its subsequent 'colonial peace' was stated. Whereas earlier exhibitions had left the impression of confusion, she argues, 'They didn't make the same mistake in 1931.'[38]

As a massive spectacle with its accumulated mass media publicity it was an authoritative and formidable

35 Ibid., p. 84

36 See also Charles-Robert Ageron, 'L'Exposition coloniale', in Pierre Nora (ed.), *Les Lieux de Memoire*, Vol. 1 (Paris: Gallimard, 1984), p. 574.

37 On French colonial film see David H. Slavin, 'French Cinema's Other First Wave: Political and Radical Economies of *Cinéma colonial*, 1918–1934', *Cinema Journal*, 37, no. 1 (1997). He argues that documentaries gave way to narrative films in the 1920s with 'the stunning box office success of *L'Atlantide* (1921)'.

38 Palà et al., *Documents, Exposition coloniale*, pp. 10–13.

discursive statement about colonialism. Every day for six months, thousands trooped around the exposition daily; eight million visitors in total (four million from Paris and its suburbs, three from the provinces and one from other parts of Europe and abroad) visited it.[39] Major publications, newspapers and magazines ran articles and stories on it, with dozens of others focusing on whatever aspect suited the interests of the magazine and its readership. The large weekly *L'Illustration*[40] dedicated a special issue (23 May 1931), as did other magazines, like *Vu* (3 June 1931) and *Paris Soir*, who all ran special photographic picture stories on it.

Reviews of the exposition, except for the 'resolutely hostile' communist *L'Humanité* and the satirical *Le Canard enchaîné*, were generally thought to be favourable.[41] Yet what people made of it cannot be certain: one commentator is reported as writing coyly, 'We found the characteristics of colonialisers expressed as much as, if not better than the characteristics of colonised races.'[42] People with cameras, whose curiosity got the better of them, caused disturbances (fights) when they tried to photograph indigenous peoples (brought to Paris to fill the native villages and stroll around as 'actors') during their time off.[43] As an exhibitionary event it was a staggering spectacle of colonialist culture. The 'global colony' of the Vincennes exhibition displayed different cultures as together in the same colonial world, a simulacrum in which their diversity and the actuality of imperialism were waved away in the same gesture. Even if the reality of the *Exposition coloniale* did not quite live up to the fantasy of it (i.e. problems encountered with the 'natives' while in Paris), this could reinforce a colonialist's view of the need to complete the project of colonialism 'properly' ... by getting rid of those awkward natives who were ruining it, etc.

Here, Althusser's conception of ideology as the *resolution* of a conflict between imaginary and real in favour of the imaginary relation to the conditions of existence shows us that humanism (the progress of mankind [*sic*]) is the fantasy structure (imaginary relation to the real) in which real differences and conflicts in colonialism are settled. In this respect, the *Exposition coloniale* and its representations of colonial life was like a big

39 These do not include forged ticket entries. Catherine Hödeir and Michel Pierre, *L'Exposition coloniale* (Brussels: Editions Complexe, 1991), p. 101.

40 *L'Illustration* had a circulation of 154,000 in 1926. Carlton J. H. Haynes, *France, a Nation of Patriots* (New York: Columbia University Press, 1930), p. 130.

41 Hödeir and Pierre, *L'Exposition coloniale*, p. 102.

42 See Palà et al., *Documents Exposition coloniale*.

43 Ageron, 'L'Exposition coloniale', in Nora (ed.), *Les Lieux de Memoire*, p. 579.

advertisement, offering a spectator a *position* from which to 'see' and imagine an identification as a colonialist. Thus the organizers, like the visitors to the *Exposition coloniale,* had to tread a fine line between satisfying the 'correct distance' of a picturesque and exotic view of colonies (an image already present in European representations) and a sufficient *effet réel (reality effect)* to satisfy a visitor's curiosity about 'what it is really like over there'. A little too much realism might drive people away; not enough and they will not know 'what it is really like'. The musicians, dancers, camel rides, information and documentary films were all attempts to show, give a frisson of, 'actual' colonial life. The real conflictual battle of one culture imposing its will on another was resolved in the exhibitionist staging of colonialism as a big imagined community.[44] The *Exposition coloniale* offered the opportunity in time and space for the identification of European populations with the humanist fantasy of this colonial community. It was in order to dispute precisely this fantasy that anti-colonialists drew together to propose an oppositional exhibition to the 1931 *International Colonial Exposition.*

Organizing Opposition

The Truth of the Colonies exhibition (*La Vérité sur les Colonies*) was organized by the French Communist Party (PCF), the surrealists and the Anti-Imperialist League [AIL]. Started in 1927, the Anti-Imperialist League (League of Anti-Imperialism or League against Imperialism) was an international affiliation of anti-colonialists with nationals from around the world as members. The first congress was held in Brussels in late 1928,[45] with delegates from Africa (Messali Hadj-Ahmed and the North African Star freedom movement); India (including Jawaharlal Nehru); Indonesia and the Americas (Nicaragua, which had been occupied by the USA in February 1927).[46] According to Babette Gross the Anti-Imperialist League was supported financially by the Mexican government, who were themselves trying to push (USA) Standard Oil out of their country.[47] The facilitators for the Anti-Imperialist League were people associated with the Comintern (*Com*[munism] *intern*[ational]) and whether or not the League was a

44 Some colonialists themselves concluded, with concern, that the spectacle had won out; the zoo and Western art (Delacroix to Gauguin) in the Permanent Pavilion were the popular parts of the exposition.

45 One hundred and seventy-four delegates from thirty-four organizations in thirty-seven countries met a hundred and four of those delegates coming from colonies and twenty-five from China (see Babette Gross, *Willi Münzenberg: A Political Biography* [Michigan: Michigan University Press, 1974], p. 189).

46 Ibid., p. 188.

47 Ibid.

'front organization' for the Communist Party, it worked to network anti-colonial activities. Delegates active in their own countries met and discussed as a collective to share information on issues, strategies and so on. (Babette Gross argues in her book on her husband, Willi Münzenberg, who was heavily involved in the League and a member of the Communist Party, that the Communist Party did not fund the League.)[48] Honorary members of the League included figures like Romain Rolland, Henri Barbusse, Upton Sinclair, George Lansbury, Maxim Gorki, Madame Sun Yat-Sen and Albert Einstein.[49]

Who exactly initiated *The Truth of the Colonies* exhibition is not clear, though it is suggested that Alfred Kurella (head of the Anti-Imperialist League) approached the surrealists through André Thirion.[50] All three, Thirion, Aragon and Sadoul, were then surrealist members, though Aragon and Sadoul were wavering about becoming communists after their joint trip to the Soviet Union at the end of 1930. According to André Breton it was Elsa Triolet (an alleged Kremlin spy)[51] who had just met Louis Aragon and encouraged him to go to Moscow with her.[52] Even before Aragon returned he acted like a fully paid-up Communist Party member. Despite going to Russia to defend surrealism, he signed a letter there addressed to the International Writers' Union denouncing surrealism (along with idealism, Freudianism and Trotskyism). Then he penned an enthusiastic Soviet-styled 'revolutionary' poem, 'Front Rouge', and published it in *Littérature de la Révolution mondiale*, the International Writers' Union magazine.[53] But Aragon was imprisoned for this poem. 'Front Rouge' had the line 'Kill the police' so he was prosecuted by the French government for 'inciting soldiers to disobey orders' and 'incitement to murder'.[54] Despite Aragon's betrayal of the surrealists in Moscow, Breton and the surrealists supported him and campaigned for literary freedom from the judiciary until he was released from prison. Aragon then left the surrealists (accused by them of 'political opportunism') entirely for the Communist Party. Such tensions are important to note here: the relations between surrealism and communism were far from easy. It is actually at this highly tense conflictual

48 Ibid., p. 192.

49 The British section published a journal, *The Anti-Imperialist Review*, in English, German and French. *The Times* published a leader on the congress, but delegates of the League were often arrested. Mohammed Hatta was locked up in Holland and Lamine Senghor was arrested in Paris, imprisoned and died of tuberculosis (Gross, *Willi Münzenberg*, p. 189).

50 'Thirion asked Louis Aragon to present the cultural issues and Georges Sadoul to do the propaganda and publicity' (Lebovics, *True France*, p. 106). The author does not indicate his source for this.

51 Elsa Triolet was the sister of Lily Brik, whose partner was Mayakovsky (Stephen Koch, *Double Lives* [London: Harper-Collins, 1994], p. 22).

52 André Breton, *Conversations: The Autobiography of Surrealism*, trans. Mark Polizzotti (New York: Paragon, 1993), p. 128.

53 See Maurice Nadeau, *The History of Surrealism*, trans. Richard Howard (London: Plantin, 1987), pp. 176–82.

54 Aragon, reprinted in Nadeau, *History of Surrealism*, pp. 285–95.

moment that Louis Aragon, Paul Eluard and Yves Tanguy co-operated with the Communist Party and the Anti-Imperial League to organize *La Vérité sur les Colonies* as an anti-colonial protest against the *Colonial Exposition* in Paris. The anti-colonial exhibition itself shows how these issues of identification are crucial in any critique of culture.

The Truth of the Colonies opened on 19 September 1931, several months after the opening of the *Colonial Exposition.*[55] It was located in what had been the constructivist Soviet pavilion of the 1925 international *Exposition des arts décoratifs et industries modernes*, a large wooden construction with vast windows. Moved from its original site, the building was now the premises of the French Communist Party and trade unions on rue Mathurin-Moreau (near Place du Fabien), nineteenth arrondissement, Paris. (The *Colonial Exposition* was located to the south of this in the twelfth arrondissement at Vincennes.) Information on *The Truth of the Colonies* is dependent on written reports more than on original documents. Marcel Cachin, the editor of *L'Humanite*, described his visit to the exhibition in a review, 'Une visite à "Exposition Anti-Colonialist"' (A visit to the 'Anti-Colonial Exhibition'). The exhibition had three sections over two floors. Each section appears to have been arranged by one of the participating groups, the Anti-Imperial League, the Communist Party and the surrealists respectively. At the entrance, visitors were met by a banner quoting Lenin: *L'imperialisme est la derniere étape du capitalisme* (Imperialism is the last stage of capitalism). Underneath it were statements from well-known figures supporting the exhibition, Henri Barbusse (author of the 1916 anti-war novel *Le Feu*), Romain Rolland and other members of the Anti-Imperialist League. Caricatures and photographs ridiculed Marshal Lyautey (responsible for the *Colonial Exposition*), shown sitting on a throne amid piles of media celebrations of the colonial event. This Anti-Imperialist League's section addressed 'Conquests', 'Exploitation of Indigenous Peoples' and 'Revolutionary Movements and Their Repression'. Maps, statistics and graphic displays compared colonizing nations to the size of their colonies: the British Empire one hundred and ten times larger

55 This is from information available in the French Communist Party archives. According to the librarian, the Party library records were sent to Moscow in the 1950s and microfilm copies of documents were sent back to Paris. A copy of a confidential report (no. 5163) on the exhibition, 'Note sur L'Exposition Anticoloniale', dated 23 September 1931, is on microfilm, Institut Maurice Thorez (Paris), microfilm bob 69, séries 461.

than Britain; French, twenty-one times larger than France; Belgian colonies, seventy-seven times larger than itself and so on. The colonialism of Africa, its partition and territorial fights between Europeans over it, was documented. The atrocious massacres at Dahomey, using the famous illustrations from *L'Illustration* magazine which had then (1891) condemned them as 'crimes committed in the name of civilization' were used. (Now, in 1931, the periodical supported the *Exposition coloniale* with their special issue on it and were regarded as apologists for colonialism.)

Contemporary photographs were used to make the case about repressions: images of machine-guns in Morocco and a Moroccan attached to the wheels of a canon with a description of how his head had been plastered in honey so that flies and insects would sting it; the effects of bombardments in Syria and nationalists hanging in a square in Damas; and a French army officer pictured with two decapitated heads of Moroccans. Alongside these were older engravings of the English Boer War as proof of the long-standing barbarism by colonizers. Photographs showed the employment and massacres of indigenous troops, placed around a central portrait of Général Mangin, who had the nickname 'black crusher' during the 1914–18 war. In contrast to these scenes of colonial violence were more 'positive' images, showing indigenous cultural activities like weaving, basket making, artisans, hunting and families. In 'Exploitation of Indigenous Peoples' the forced labour of 'black Africa' was shown, the construction of roads by African men and women with texts from journalist reporters and writers (André Gide and Albert Londres) recounting the terrible conditions there. The tragic history of the Congo–Océan railway construction told how seventeen thousand perished in the construction of one hundred and seventy kilometres of railway between Brazzaville and Point Noire in Equatorial Africa.

Panels on Indochina also described revolutionary movements and their actions there to combat famine, low wages, crushing taxes, opium, absence of basic liberties and national oppression alongside exploitation in rice, tobacco, sugar plantations and mines. Revolutions (China, India, the Kémaliste movement in Turkey,

Syrian nationalists) and repressions in the colonial world (punishments and torture in China, executions in Annan, flogging in Morocco, lynching of blacks in the USA) were represented. A map showed the trips made by barristers, organized by the Secours Rouge (the communist equivalent of the Red Cross) to defend indigenous militants being prosecuted in Madagascar, Syria and Indochina. In total, this first section of the exhibition had 350 square metres of panels, information, photographs, drawings, maps and texts.

The second section, dedicated to the Soviet Union, declared 'above all to oppose imperial colonialism with the example of the "nationalist politics" applied by the Soviets'. A poster showed the 'constructors of socialism', workers in numerous photographs of heroic achievements (the rejection of the veil by women, pictures of crèches) in the style of socialist realism. Another panel juxtaposed contrasting photographs with the slogan: 'In France the most valued are the bourgeois. In the USSR the most valued are workers.' A map of the Soviet Republic had a motto from Lenin: 'Talk to unite'. Illustrations showed the economic and cultural 'progress' of the Kurdists, Tartars and Bachkirs under Soviet rule. Quotations from Marx and Lenin in seventy languages and dialects showed the internationalism of communism with photographs demonstrating 'the four-year plan for socialist emulation (home building, great public works, cooking stoves, cultural clubs)'.

The third section of the exhibition by the surrealists was on the first floor of the pavilion. Marcel Cachin describes it as 'particularly lively and original' due to 'the contents of the presentation'.[56] One room was dedicated to art of 'colonial peoples', with African (*l'art nègre*), Oceanic and North American 'native' objects (lent by collectors who had refused to lend them to the *Colonial Exposition*). Among the African objects was a chair from Cameroon made up of two sculpted figures 1.75 metres high and a 'motherhood' figure, a woman with a suckling baby outstretched on her knees. Oceanic works included a mask and several sculptures, while North American objects displayed included totem poles from British Colombia and Apache tribes. All the objects were accompanied by short quotes to contextualize them;

56 Ibid.

218

for example, one described the destruction of art by colonized peoples by European missionaries who, for the sake of 'Christian progress'; had collected and burnt what they considered 'fetishes'. In the same room were displayed what were labelled 'European fetishes', the paraphernalia of Church propaganda, colour images of piety, an infant Jesus and black virgins – adapted by Christians for a different race. According to Cachin, a display of 'gaudy colour postcards' published by the *Colonial Exposition* had an effect to 'comically underline that blacks are not the only ones to like trinkets'.[57] This surrealist installation at the anti-colonial exhibition is shown in their two photographs of it, published in their review *Le Surréalisme au service de la révolution* in 1931 (see Figure 38).

Across these three sections of *The Truth of the Colonies* exhibition, the contributors attempted, in a relatively modest way, a dissident counter-criticism of the *Colonial Exposition*. We can begin to see here the unity of the different organizing factions in their opposition to the *Colonial Exposition*, but also some differences.

Divided Unity

Collectively the participants assembled an impressive amount of materials from a variety of sources across the three sections. The Anti-Imperialism League, with its international links, had information, statistics and photographs and reports of atrocities, poverty and famine, while the Communist Party had access to a whole Soviet industry of publicity materials for their exhibition. The surrealists brought their own skills and experience in mounting exhibitions, while those like André Breton and Paul Eluard as avid collectors of African and Oceanic objects lent objects to the anti-colonial exhibition.

The different exhibition rooms were brought together as indigenous music filtered throughout them from a phonograph or wireless radio. Lectures, discussions and guided tours were held and books were laid out around the exhibition, where visitors could contribute their opinions, remarks and make criticisms or proposals. The exhibition grew each day, with more documents arriving to enrich the information available, maintaining the exhibition as a living event. Press reviews and reporting

57 Ibid.

on *La Vérité sur les colonies* was limited, but through trade unions, large numbers did visit the exhibition. Party members, workers, social, cultural and trade unions etc. organized group visits to it, while pamphlets and leaflets were distributed beyond the exhibition. Little evidence remains of the exhibition as a whole or its various parts.[58] We can guess the original source for some things; for example, photographs of soldiers holding decapitated heads were probably trophy photographs, originally taken to mark a 'victory' by soldiers. Yet, semiotically, such a picture has no necessary allegiance and what was once used to serve victors can easily be used against them. In this respect, the various parties involved in the exhibition employed different semiotic strategies to oppose the *Colonial Exposition*.

Both the Anti-Imperialist League and Communist/Soviet sections were dependent, in different ways, on representing a different reality from the one portrayed in the *Colonial Exposition*. The Anti-Imperialist League showed, in general, the atrocities of colonialism, the negative view of it, while the Communist/Soviet section presented another reality, that of 'humanist' socialism.

It is here that we can return to the criticisms laid down by Edward Said at the beginning, that in anti-colonial criticism there was only criticism of the '*abuses*' of imperialism by the West, not the ideology of imperialism itself. We find that in *La Vérité sur les colonies* the Anti-Imperialist League and Communist Party sections of the exhibition offer an identification with anti-colonialism through a humanist rhetoric against abuse. By asking an (assumed) already sympathetic audience to look at those (pictured in the exhibition) subject to colonialist atrocities, existing Western workers were meant to be reinforced as anti-colonialist. But the use of shocking, guilt-ridden evidence to appeal to the anti-colonialist exhibition spectator's conscience about human indignity and exploitation anyway 'preached to the converted'. The human abuses within colonialism by colonialists and their agents were displayed with the hope that they would appeal to a humane compassion in the viewing public. As Said points out, appeals to the abuses of imperialism appeal to just that, explicit abuses ('ideological mistakes'), not the 'normal' everyday im-

58 Some parts of the exhibition may exist in collections.

plicit oppression of colonialism as an ideological practice. Paradoxically, for a humanist argument, the spectator is left with nothing, a negation of the belief in humanism. This is 'corrected' by the alternative humanism of the Soviet Union, the idealized 'community' of happy Soviets pictured precisely in order to enunciate another reality in the name of another power.

As for the surrealists, it is in their written tract distributed at the time that their anti-colonial argument is clearest. It claimed: *Ne visitez pas l'Exposition coloniale* (Boycott the Colonial Exposition). Signed by André Breton, Paul Eluard, Benjamin Péret, Georges Sadoul, Pierre Unik, André Thirion, René Crevel, Louis Aragon, René Char, Maxime Alexandre, Yves Tanguy and Georges Malkine, it protested:

> The dogma of French territorial integrity, so piously
> advanced in moral justification of the massacres we
> perpetrate, is a semantic fraud; it blinds no one to the
> fact that not one week goes by without someone being
> killed in the colonies. The presence at the Exposi-
> tion opening of the President of the Republic, of the
> Emperor of Annam, of the cardinal-archbishop of Paris,
> and of assorted governors and roughnecks cheek by
> jowl with the missionary pavilions and the Citroën
> and Renault stands, clearly marks the complicity of
> the bourgeoisie in the birth of a new and particularly
> loathsome concept, the notion of Greater France. It
> was to implant this larcenous notion that the pavilions
> were built for the Vincennes Exposition. For of course
> we must imbue our citizens with the requisite landlord
> mentality if they are to bear the sound of distant gun-
> fire without flinching.

The surrealists mocked the 'landlord mentality' identification at stake in the imperialist view given by the *Colonial Exposition*, a strategy repeated by the surrealists elsewhere.

The tract was also published with *Le Surréalisme au service de la révolution* (nos 3–4), December 1931. In that issue of the magazine they published the two photographs of their exhibition installation (see Figure 38).[59] These two photographs of the anti-colonial exhibition should not be taken for granted, as simply

59 *Le Surréalisme au service de la révolution*, no. 3–4, (December 1931).

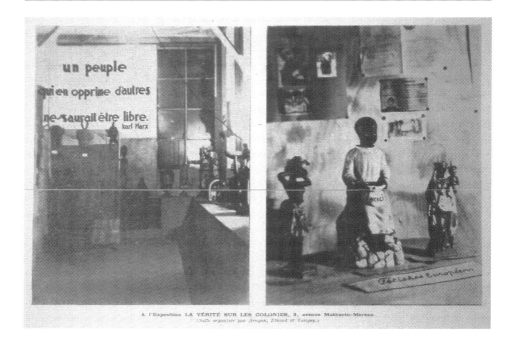

A l'Exposition LA VÉRITÉ SUR LES COLONIES, 3, avenue Mathurin-Moreau
(Salle organisée par Aragon, Éluard et Tanguy.)

38 The two photographs titled *La Vérité sur les colonies* as printed across a full page in *Le Surréalisme au service de la révolution*, no. 3–4, December 1931.

documentary evidence of the exhibition. Of course, any temporary exhibition has the problem that it is just that, temporary, that it is documentation of exhibitions which remain permanent. No doubt these two photographs do serve as a record of the exhibition, as mimetic 'documents', and in this respect they can be used as simply two representations as any other of the exhibition. Yet this underestimates the extent to which the surrealist journal is 'surrealist'. To treat the photographs as simply secondary reproductions of a primary event ignores the fact that these photographs are how the surrealists chose to represent 'anti-colonialism' in the journal. They are not merely denotative reproductions of an exhibition, but also a source of connotative meanings.

Prophotographic Fetishes

The photograph on the left shows a room with a number of African objects in the distance. On the left of the picture is a tall chair like the one already described as from Cameroon, with two figures as backrests. On the right-hand side, a series of sculpted figures has an anchoring text, apparently draped behind these objects

and in front of a window with a phrase attributed to Marx: '*A people who oppress others can not possibly be free*'. One set of objects, '*l'art nègre*', is held up with esteem by the surrealists (still regarded as fetishes of 'primitives' by many in Europe), held up here under the banner of Marx. Thus the indigenous cultural objects in the photograph are signified as a positivity, valued in a struggle against oppression.

The photograph on the right shows three statues with a handwritten label in the foreground anchoring the objects as '*fetishes Européens*'. The central object/figure is a colonial collection box, a black boy with a collection sack. On the left is an unspecified black 'Hottentot' 'Venus' figurine, a kind of exotic doll (modelled on Josephine Baker?). To the right is a Catholic crusade figure of Virgin and child. These three figures, the black exotic dancer, black virgin mother and black boy charity statue, signify a sort of inversion of the Christian trilogy, faith, hope and charity. In a reading reinforced by the caption, 'European fetishes', colonialist assumptions about the 'primitive' fetishistic cult value of other cultures are reversed and redirected back on to the ideology of European values. In the background of the image can be seen included some pinned-up photographs. Again, we might recall that the photograph itself, as a European invention of the industrial revolution, is identified as a 'fetish', as a cultural commodity and structure of fetishistic pleasure (warding off death) and itself a structural feature of colonialism. In contrast to the other photograph of indigenous objects from the colonies, this one shows objects of a European culture, with its values of low esteem: junk, trite, 'kitsch' and fetishistic. Thus the pairing of the two photographs across the magazine page produces a contrast between *objects from colonies* on the left (struggle against oppression) and the 'debased' (fetish) *objects from European colonial* (oppressive) *culture* on the right. This visual strategy of putting different things together to create a *conflictual image* is a familiar surrealist technique of the marvellous. Striking in this particular juxtaposition is how the surrealists have tried to shift the cultural assumptions attached to the objects represented. Rather than an appeal to an actual 'truth' of the colonies to contest the *Colonial Exposition*, as in the other two

sections of the exhibition, the surrealist display attempts to destabilize the very meanings of things *within* Western culture. In terms of Althusser's concept of ideology as an *imaginary* resolution of a conflict between imaginary and real, the surrealists refuse this possibility in the production of a conflictual image. In short, the mode of treating signs in surrealism is aimed at destabilizing the implicit ideological assumptions of colonialist culture itself.

Without exaggerating or over-interpreting the differences between the three sections, it is only the surrealists who really attack the *ideology* of colonialism. They take to task the common-sense assumptions of a colonialist culture (charity, piety, the Christian good etc.) and reinvest them to show the implicit racism, making colonialist values visible. The surrealist exhibition installation, along with the two photographs of them, addresses the *means* of imperialism, by disrupting the identificatory cultural logic which enables the ideology of imperialism to function. The signs of colonialist thought (the other as primitive, savage etc.) are subject to scrutiny as the unconscious of colonialism. The mimesis of the two photographs (albeit somewhat poor in reproduction) in *Le Surréalisme au service de la révolution* serves this end. The ideological fantasy construction of the other – the supplement to the discourse which actually sustains the colonia*list* culture – is critiqued.

Such is the difference between a rhetoric of anti-*humanist realism* ('look how badly they treat Africans etc.'); a different *social*(ist) *realism* of the Soviets ('look how well we treat our brethren in the Soviet Union'); and a *sur-realist* (above realism) critique by the surrealists. In surrealism, dissidence is not through an inversion of the *Colonial Exposition*'s power relations, the hidden terror, violence and abuse of power, but a disturbance of the very assumptions upon which colonialism depended.

Dissident Consciousness

This whole approach in the thinking and strategy of the surrealists is taken even further in the same issue of *Le Surréalisme au service de la révolution* as the above tract and photographs of the anti-colonial exhibition. An article by René Crevel, called 'Le patriotisme de l'inconscient' ('The Patriotism of the Unconscious')

also tackled the implicitly racist psyche of the French psychiatric imaginary.[60] Crevel's essay critiques an essay which appeared in the journal *Société psychoanalytique de Paris* (Psychoanalytic Society of Paris). In an analysis of a black man (of unspecified ethnicity) a case study had concluded that mental 'conflicts' were the same in white and black races. Crevel detects an insinuation by the author that the investigation had not been very probing since it had not investigated unconscious conflicts, thus implying, in an underhand way, that 'unconscious conflicts' would show a racialized *mental* difference between races. Quick to the attack of an implicit racism in psychiatric theory, Crevel takes the author to task for his sloppy pseudo-objectivity dressed as a supposed impartiality, while actually passing off vague comments and insinuating racist assumptions about racial differences not investigated by the author himself. French psychiatry had already been criticized by the surrealists for its notion of a specific 'Gallic unconscious', which was nothing like the 'unconscious' of a Freud or Lacan, but further evidence of a sickening *'patriotic* unconscious' of French psychiatry.

It was in such a vein of critical analysis that the surrealists, before and after their close ties with communism, developed a critique of colonialism dressed as humanism. The surrealist project of invoking the 'unconscious', even in their most politically explicit work as part of a critical practice, was the fundamental premise which differentiated them from both theory and practice of the Communist Party. This, perhaps inevitably, led them to their separate social and political paths.

Surrealism and Communism

It is a well-known 'controversy' that the surrealists came close to the French Communist Party in 1927, with some joining it until all were expelled in 1932. The launch of the surrealist journal *Le Surréalisme au service de la révolution* in 1929 marked this increasing political consciousness, distinguishing itself from the previous title 'The Surrealist Revolution' to 'Surrealism at the Service of the Revolution'. (The journal appeared after they joined the Communist Party in 1930 and ended after leaving the Party in 1933.) The French Communist

60 René Crevel, 'Le patriotisme de l'inconscient', *Le Surréalisme au service de la révolution*, no. 4 (December 1931), pp. 3–6.

225

Party (Parti Communiste Français or PCF) was formed in late December 1920 at a congress in Tours where it immediately adopted the '21 Conditions' of the Second International Congress, a preamble for the Third International.[61] Two of these 21 Conditions (2 and 4) were directly concerned with colonial activity. It was not long before support for these conditions would be called upon. When in April 1925 the French (Poincaré) government finally decided to help Spain defeat Abd-el-Krim and the independence movement within Morocco by sending French troops to fight them, the French Communist Party organized protests against it (until Abd-el-Krim eventually surrendered on 27 May 1926).[62] Protesting against the war in a delegation to the *siège du président du Conseil*, they organized a general strike. Widows from the First World War and mothers of soldiers in Morocco participated in mass demonstrations in what was, arguably, the first French political strike against a colonial war.[63] At this time, the surrealists made their independent contributions to anti-colonialism. In a tract called 'Revolution First and Always' (1925) they explicitly condemned the Moroccan war and co-signed anti-war delegations with other intellectual groups. Yet the parallel common political commitments to anti-colonialism of the surrealists and the Communist Party did not necessarily make the relations between them very easy or generally interdependent. For example, in later interviews André Breton recalled having to justify his membership of surrealism as not mutually exclusive of communism and the Communist Party. He describes being called in front of 'supervisory committees':

These committees were composed of three members, never known to me personally, who used only their first names. Usually they were foreigners with a very sketchy command of French. Apart from that, nothing seemed more like a police interrogation, when you think about it … My explanations [of surrealism] were deemed satisfactory soon enough, but there was always a moment when one of the inquisitors would brandish a copy of *La Révolution surréaliste* and put everything back in question. At a distance (so to speak), the most amusing part of all this is that what inevitably

61 Jacob Moneta, *La Politique du parti communiste français dans la question coloniale 1920–1963* (Paris: François Maspero, 1971), p. 18. Membership: 130,000 at its foundation to 78,000 in 1922 and 48,000 by 1924. It never went above 50,000 again until December 1936, when it reached 285,000 (p. 45).

62 Ibid., p. 40.

63 Ibid.

sent them into a rage were some of the illustrations – above all, the reproductions of Picasso's work. Seeing these, they egged each other on as best they could, each trying to be more caustic than the others: which was the right-side up, could I tell them what that 'meant', so I felt I could waste my time with this petty-bourgeois nonsense, did I really find this compatible with the Revolution, etc.[64]

Clearly a lesson in tolerance, Breton's own attempt to maintain an identity for surrealism also had to tread along a delicate path of frontiers and boundaries as to what constituted the surrealist group. Asked in an interview to clarify whether the surrealist group was 'unanimous in its revolutionary ambitions', Breton replied:

When it came to the firm intention to break open closed rationalism; or the absolute rejection of reigning moral laws; or the attempt to liberate man using poetry, dreams, and the marvellous; or our concern with promoting a new order of values – on these various points, we were in total agreement. But we could not avoid certain differences about the means of realising these goals, given each one's psychological make-up.[65]

Although Breton was a Communist Party member, it did not stop him from rejecting those who reduced surrealism to the political line of the Communist Party. As members of surrealism could testify, the strain of serving more than one master could take its toll. While some surrealists, like Antonin Artaud, dropped surrealism for livelihoods in their creative skills (acting and the theatre), others like Pierre Naville and Louis Aragon abandoned, 'defected' from 'surrealist demands' completely to pursue politics in the Communist Party. These internal tensions about the identity of surrealist activity flared in 1926 and 1929.[66] In 1929 Breton 'expelled' a large number of individuals from surrealism, having asked them to clarify and define their 'ideological position' *as surrealists* on a range of issues. Breton did 'exile' disloyal surrealists (not quite the same as Stalin's expulsion of Trotsky into exile in Mexico): Man Ray, for example, was one of those excluded from surrealism at this time, but let back in afterwards.[67] Breton's actions

64 Breton, *Conversations*, p. 100.
65 Ibid., p. 81.
66 See Nadeau, 'The Crisis of 1929', in his *The History of Surrealism*. Breton is hostile to Nadeau's account, no doubt due to the descriptions of a 'crisis' and Breton's 'excommuniation mania' (see the *Second Manifesto* [1930] for Breton's contemporary argument).
67 See Nadeau, *The History of Surrealism*, p. 156. Man Ray does not mention this in his autobiography.

here can be seen as parallel to issues within international communism.

In a report on the Third International Fourth Congress (1922), Leon Trotsky quoted the argument made by the Party section from Sidi-bel-Abbès. They were opposed to any independent Algerian mass action on the grounds that their victory, without also being accompanied by a victory of the proletariat in France, would only signal a return to a sort of 'feudalism' in Algeria.[68] Trotsky's reply was that any colonial movement which weakened the dominance of capitalism in metropoles was progressive, since it aided the goal of the proletariat in those metropoles.[69] However far from inevitable the destiny of the revolution was to become (and aside from historical interest in revolutionary politics), in these anti-colonialist political debates is the question of nationalism and or international socialism and their roles in the unfolding of international communism. For the Sidi-bel-Abbès delegates, an identification with the 'national' posed a problem, a contradiction, the risk of the loss of identification with the eventuality of trans-national struggle. This 'classic debate' 'dominated the discussion of the Third International with regard to the course of revolutions in colonial and semi-colonial countries'.[70] The options appeared as either an identification with the universalized proletariat, or a 'factional' national identification in an anti-colonial movement. For Trotsky (and for Breton with the surrealists) the latter anti-colonialist movement could be justified since it would 'inevitably' be joined with the metropolitan movement – the destiny of the international revolution that was supposed to come. Crucial here is that identification with national or international struggle is not just a theoretical or abstract problem, but also, as the writings of many testify, a historical problem for *all* social and political identities. Here is a very different example by Ernesto Laclau:

Consider the German economic crisis of the 1920s, for example, and its devastating effects on the middle classes. All routine expectations and practices – even the sense of self-identity – had been entirely shattered. … That National Socialist discourse emerged as a

68 Moneta, *La Politique du parti communiste français*, p. 19.

69 Trotsky's view was not shared by Stalin, who did not want any 'independent political forces'.

70 See Ernesto Laclau, *New Reflections on the Revolution of Our Time* (London: Verso, 1990), (pp. 166–7.

possible response to the crisis and offered a principle of intelligibility for the new situation is not something that stemmed *necessarily* from the crisis itself. That the crisis was resolved in favour of Nazism cannot be deduced *from the terms* of the crisis themselves. What occurred was something different: it was that Nazi discourse was the only one in the circumstances that addressed the problems experienced by the middle classes as a whole … Its victory was the result of its availability on a terrain and in a situation where no other discourse presented itself as a real hegemonic alternative.[71]

In this example, the identificatory discourse of power lacks a 'democratic imaginary' despite the fact that it announces itself as emancipatory.[72] To speak of the identity of someone seems immediately 'obvious', but, as Michel Pêcheux points out: 'the "evidentness" of [a colonial] identity conceals the fact that it is the result of an identification–interpellation of the subject, whose alien origin is nevertheless "strangely familiar" to him'.[73] In this constitution of an ideological 'norm' Pêcheux gives the example of the phrase: ' "a French soldier does not retreat" signifies in fact "if *you* are a *true* French soldier, which is what you are, you *cannot/ must not* retreat" '.[74] In such different instances of the process of identification with a discourse, whatever the contradictions or imagined fantasy relation involved (nationalism, fascism or the military), forms of identity matter to social politics. In other words, the structure and process of identification is crucial to imperialism *and* anti-colonialism.

Yet it is also clear that, in any social identification, the process of imagining 'who I am' is also subject to being undermined by the unconscious (itself a product of identification) where what is called 'identity' as a static and fixed is really only *a process* of belongingness which can never be fulfilled or completed.[75] It is precisely the lack of possibility of ever completing this identity which pulls the subject into (desire for) its fantasy fulfilment. It is in this sense that surrealism founds its identity upon this very contradiction, and ultimately could not share the project of communism because it had succumbed to the fantasy of a self-fulfilled identity in history (what

71 Ibid., pp. 65–6.

72 The term 'democratic imaginary' is Laclau's and proposes 'equivalences' between identities, not as a 'positivity' which inevitably has its *'negative'* (another 'identity') (ibid., p. 187).

73 Pêcheux, *Language, Semantics and Ideology*, p. 107.

74 Ibid., p. 110 (italics in original).

75 See Laclau, *New Reflections on the Revolution of Our Time*, p. 66.

today would be called an 'identity politics') without contradiction. Surrealism, on the other hand, never gave up contradiction and conflict as at the centre of its dissident practice.

This was the identification that surrealism required to maintain itself as a group, without it collapsing under the pressure of the other discourses and practices with which it was also involved: art, literature, poetry, film, theatre, philosophy, psychoanalysis, politics and communism. Surrealism entailed the same sort of processes, issues and questions of identification as required by any other social group. Trying to establish and maintain a distinct 'identity' from the directional pull of communism was clearly an issue. Reflecting on this, Breton later considered:

> When it came to the social transformation of the world, several urgent considerations prevailed over all the others. The tool needed for this transformation existed and had proved itself: it was called Marxism–Leninism. We had no reason as yet to suspect that its tip had been coated with poison.[76]

Without this hindsight, the complicated relations with the Communist Party nevertheless offered a political forum for Breton and the surrealists to represent their views, despite the theoretical differences and problems between communism and surrealism. This situation was sustained until just after the collaboration on *The Truth of the Colonies*. Louis Aragon, Georges Sadoul (fresh back from the Soviet Union where they had betrayed surrealism by signing a document condemning it), André Breton, René Crevel and Paul Eluard were all active surrealists and all members of the Communist Party. But the surrealist antagonisms with the Communist Party eventually led to their expulsion from it the following year (1932), with the exception of Aragon and Sadoul, who left surrealism for communism. The ideological differences between these respective groups are clear in *The Truth of the Colonies* exhibition and no doubt, despite the commonality, it hastened their separation.

But the surrealists continued their own active opposition to colonial and imperialist assumptions; indeed, their criticism of *humanist* colonialism became even clearer. Three years later, a surrealist tract published in

76 Breton, *Conversations*, p. 105.

Nancy Cunard's massive English book, *Negro: Anthology, 1931–1933* (1934),[77] challenged humanist ideology in the very title: '*Murderous Humanitarianism*' (see Figure 39). This astonishing text, translated by Samuel Beckett, is a critique of imperialism worth quoting from at length:

… For centuries the soldiers, priests and civil agents of imperialism, in a welter of looting, outrage and wholesale murder, have battened with impunity on the coloured races; now it is the turn of the demagogues, with their counterfeit liberalism …

When whole peoples had been decimated with fire and the sword it became necessary to round up the survivors and domesticate them in such a cult of labour as could only proceed from the notions of original sin and atonement. The clergy and professional philanthropists have always collaborated with the army in this bloody exploitation. The colonial machinery that extracts the last penny from natural advantages hammers away with the joyful regularity of a poleaxe. The white man preaches, doses, vaccinates, assassinates and (from himself) receives absolution. With his psalms, his speeches, his guarantees of liberty, equality and

39 The collective text by the surrealists called *Murderous Humanitarianism* as translated by Samuel Beckett in Nancy Cunard's *Negro: Anthology, 1931–1933* (1934). An anonymous photograph is inset in the surrealists' essay.

77 Nancy Cunard (ed.), *Negro: Anthology, 1931–1933* (London: Nancy Cunard/Wishart, 1934). In this product of two years' collecting and editing of materials by Nancy Cunard, with Raymond Michelet, contributions are from diverse sources and a testament to the scope, range and importance then of 'black cultural issues'. There are few easy cultural binarisms or facile narratives in the book, ranging from fashionable cosmopolitanism to lynching in the USA.

fraternity, he seeks to drown the noise of his machine-guns.

It is no good objecting that these periods of rapine are only a necessary phase and pave the way, in the words of the time honoured formula, for an era of prosperity founded on a close and intelligent collaboration between the natives and the metropolis! It is no good trying to palliate collective outrage and butchery by jury in the new colonies by inviting us to consider the old, and the peace and prosperity they have so long enjoyed. It is no good blustering about the Antilles and the 'happy evolution' that has enabled them to be assimilated, or very nearly, by France.[78]

In this extract (signed by André Breton, Roger Caillois, René Char, René Crevel, Paul Eluard, J.-M. Monnerot, Benjamin Péret, Yves Tanguy, André Thirion, Pierre Unik and Pierre Yoyotte), the surrealists weave an argument between historical, economic, political and ideological aspects of colonialism. Two of the signatories, Pierre Yoyotte and Jules Monnerot, were young Martiniquan students at the Sorbonne and avid surrealists; they went on to form the *Légitime défense* anti-colonialist group.[79] The collective essay is accompanied by an anonymous photograph of a black man whose full frontal gaze at the camera offers his social identity for scrutiny by the viewer. The caption reads 'Colonial Negro tailor in a small factory in France'. As in the surrealist part of the anti-colonial exhibition, they emphasize, in their choice of this picture, a confrontation with the social contradictions of colonialism. In the picture, a worker is 'foreign' and 'French' (European clothes), 'other', but familiar, black *and* French. The image of this 'colonial' subject is dignified, not as a humanist gesture, but rather in that through this image of an indigenous factory worker in France can be seen exactly what a colonial 'assimilation' into 'Greater France' really meant: a servant industrial worker making clothes for the French bourgeoisie. We find, in his direct gaze at the viewer, an image that anticipates Roland Barthes's critique of *The Family of Man* some twenty years later. When Barthes asks 'let us also ask the North African workers in Paris what they think of *The Great*

78 Ibid., p. 574.
79 See Michael Richardson (ed.), *Refusal of the Shadow*, trans. Krysztof Fijilkowski and Michael Richardson (London: Verso, 1996), pp. 4–5.

Family of Man', we find that voice represented here in the look at 'us'.

From the voice of the colonized we can hear the psychical damage of the 'unconscious' of colonial ideology. In the comments of Frantz Fanon, from 1957, he notes that 'The black schoolboy in the Antilles, who in his lessons is forever talking about "our ancestors, the Gauls", identifies himself with the explorer, the bringer of civilization, the white man who carries truth to savages ... '[80]

Fanon notes in a footnote, as though the unconscious of his own argument:

> One always sees a smile when one reports this aspect of education in Martinique. The smile comes because the comicality of the thing is obvious, but no one pursues it to its later consequences. Yet these are the important aspects, because three or four such phrases are the basis on which the young Antillean works out his view of the world.[81]

It is this sense of 'the comicality of the thing' that the surrealists bring to bear on the identifications within colonialist culture because they sensed the dangers of the imagined identities engendered there and, perhaps, of the directions in which communism was going. In that context it is startling to read Freud's cultural concern when it comes to communism, written in 1929:

> The communists believe that they have found the path to deliverance from our evils. According to them, man is wholly good and is well-disposed to his neighbour; but the institution of private property has corrupted his nature ... I cannot inquire into whether the abolition of private property is expedient or advantageous. But I am able to recognise that the psychological premises on which the system is based are an untenable illusion.[82]

For Freud, depriving 'the human love of aggression' through which property is one of its instruments is what constitutes a problem. He notes, 'Aggressiveness was not created by property.'[83] And without wondering where it will go, he says, ' ... and it is intelligible that the attempt to establish a new, communist civilization in Russia should find its psychological support in the

80 Frantz Fanon, *Black Skins, White Masks*, trans. Charles Lam Markmann (London: Pluto, 1986), p. 147.
81 Ibid.
82 Freud, 'Civilization and Its Discontents', PFL 12, pp. 303–4.
83 Ibid., p. 304.

233

persecution of the bourgeois. One only wonders, with concern, what the Soviets will do after they have wiped out their bourgeois.'[84]

The same question might well have been asked of the surrealists, but it would be a dismal 'historical' project which undertook to make such a comparison. Surrealism was anyway condemned to the margins, with or without the sort of social revolution in Russia which gave the Communist Party a legitimated voice. The surrealist project of 'liberating the mind' ran into full conflict with 'civilization'; this is precisely Freud's point. However, that the very possibility of the surrealists ever fulfilling their project was itself dissolved during the decade of the 1930s was as much to do with external factors as any internal contradictions about identity that could not be resolved.

84 Ibid., pp. 305–6.

8 · Fascism and exile

> The surrealist institution masked the silent gestures that
> cleared the space in front of them … we are presently in the
> hollow space that Breton left behind him. *Michel Foucault*[1]

In the dawning light of 14 June 1940, Hitler's troops
rolled into Paris after negotiations with the French
military (the French government had already left for
Bordeaux), 'without a shot being fired'.[2] Although the
city was left intact, culturally it was to be devastated.
Certainly the invasion and occupation of France by
Nazi military and governmental powers in 1940 changed
France completely, with the Third Republic actually
dissolved in July 1940 by the Vichy regime. This was
followed by the German occupation across all France.
Yet it would also be an oversimplification to say that,
as part of this, fascism destroyed surrealism.

From 1933 the surrealists no longer had their own
journal. As the consequences of the 1929 New York
stock market crash finally hit France, the journal *Le
Surréalisme au service de la révolution* (mostly paid for by
the surrealists) also suffered a drop in sales. This was
at a time when the surrealists, along with everyone
else, were increasingly finding it hard to sustain even
themselves through their livelihoods.[3] The last issue of
the magazine *Le Surréalisme au service de la révolution*
in May 1933 held an advertisement for a journal that
had started in February 1933 and which would come
to serve as a replacement vehicle for surrealism. It
was called *Minotaure* (see Figure 40). Even though
Minotaure was never entirely within the control of the
surrealists, as their previous journals had been, it was
this journal, ironically, which made surrealism respectable
and established it as an international movement in art.
Financed by Albert Skira and Tériade, *Minotaure* had
a print run of three thousand and was intended to
compete with *Cahiers d'art*, then the most established
art review in Paris. *Minotaure* had similar high-quality
reproduction values and Skira wanted quality essays and
images to match it. He asked Pablo Picasso to design

1 Michel Foucault, 'A Swim-
mer Between Two Worlds' (inter-
viewed by C. Bonnefoy, *Arts et
loisirs* 54, October, 1966), in James
D. Faubion (ed.), *Michel Foucault:
Aesthetics; Essential Works of
Foucault, Volume Two 1954–1984*,
(London: Penguin, 2000), p. 171.

2 William L. Shirer, *The
Collapse of the Third Republic; an
Inquiry into the Fall of France in
1940* (London: William
Heinemann/Secker and Warburg,
1970), p. 752. Such a claim needs
qualifying; invading troops met
resistance.

3 See José Pierre, 'André
Breton and/or *Minotaure*' in
Musée Rath (eds), *Focus on
Minotaure* (Geneva: Musée d'Art
et d'Histoire, 1987).

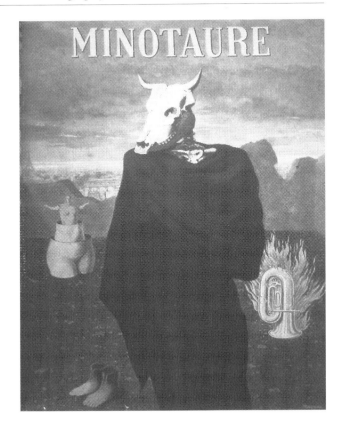

40 Cover of *Minotaure* magazine (no. 10, 1937) designed by Magritte as a montage of his own work.

the first cover and invited André Breton, Georges Bataille and the individuals around them (surrealists of *Le Surréalisme au service de la révolution* and the 'dissidents' around Bataille's *Documents*) to collaborate. Breton and Bataille refused to collaborate on the journal, but it anyway looked as if they had, with contributors from different camps brought together by simply being in it. The high-quality production made the pictures crisp and sharp in a manner that was lacking in the surrealist *La Révolution surréaliste* and *Le Surréalisme au service de la révolution*. Colour images were possible in *Minotaure* too and there was more space generally for more images by more artists and visual works overall, and with written essays.

In effect, *Minotaure* combined in a single review the interests of different parties and factions, so that, essentially, it became a multi-disciplinary art and cultural

review. Ranging from anthropology and art through to literature and zoology, *Minotaure* embraced an Enlightenment-style 'universalism', albeit eclectic and polyvocal. So, to call it a *surrealist* journal is to conflate the multi-disciplinary review with the *inter*-disciplinary surrealist project itself. Certainly, the surrealists had claimed to dismantle binary oppositions in the liberation of 'mankind', but this was not in the manner of the eclecticism in *Minotaure*.

Even if, as André Breton claimed, the surrealists did increasingly gain control of the review, the political and philosophical dimensions of surrealism were obviously less present than in either *La Révolution surréaliste* or *Le Surréalisme au service de la révolution* (where politics was explicitly within surrealism).[4] Indeed, any explicit politics of surrealism are clearly toned down in *Minotaure*, absent even. Breton later acknowledged that surrealism, during this time, effectively split its activities between that which could appear in *Minotaure* (as main forum for visual and literary work) and the otherwise more immediate urgent, political field of surrealist activities, now separated off into published pamphlets.[5] The consequence of this splitting was that surrealism became *internationalized* as a visual art and literature movement through *Minotaure* and *localized* as a political/intellectual faction in leftist French politics in manifestos and tracts.[6] Even if such a separation was never complete or ever actually existed in the minds of the surrealists at that time (despite their expulsion from the French Communist Party in 1933 they were still internationally orientated in left politics via the Internationale), this splitting was none the less crucial for the consequent public image of surrealism: as primarily an art and literary movement. Did these 'compromises' mean that surrealism betrayed its principles? Had the surrealists lost interest in a revolutionary struggle?

Art and Politics

Certainly the thirties became difficult economically and politically. In January 1933, Hitler had become Reich Chancellor in Germany. In the same year in France, one radical government cabinet was overturned in the chamber as fast as another was elected. Exploiting the

4 In *Minotaure* 10, 11, 12–13 (1938–39), surrealists gained control with the new editorial group: André Breton, Marcel Duchamp, Maurice Heine and Pierre Mabille (see Breton's account in *Conversations: The Autobiography of Surrealism* [New York: Paragon, 1993], p. 142; also José Pierre, 'Le Surréalisme en 1938', in *La planète affolée; surréalisme, dispersion et influences 1938–1947* [Paris: Flammarion and Musée de Marseilles, 1986]). Thanks to Kate Bush for this reference.

5 Breton, *Conversations*, p. 142.

6 This split in surrealism is amplified by writers: Maurice Nadeau's *The History of Surrealism*, trans. Richard Howard (London: Plantin, 1987) puts 'Surrealist Politics' and 'Towards a Surrealist Art' into separate chapters.

contradictions and chaos of leftist factions the right-wing *Action Française* and allied fascist leagues attempted a *coup d'état* in Paris on 6 February 1934. After an estimated six-hour street fight between demonstrators and police, with at least fifteen dead, the attempted coup withered away.[7] (Although it failed, the French government collapsed anyway and was re-formed under the previous President Doumergue.) Breton later recalled how the surrealists had immediately met to 'define possible means of resistance' to the situation:

> This meeting, which lasted all night, led to our drafting a text entitled 'Appel à la lutte' [Call to Battle], which exhorted the unionist and political organizations of the working class to take united action and called for a general strike. This call appeared on February 10, bearing almost ninety signatures.[8]

Indeed, a general strike did occur. The surrealists' efforts to organize resistance were part of the beginning of a coalition of left intellectual politics that became increasingly important against the national and international rise of fascism.

Elsewhere, in the Soviet Union, a quietly violent bureaucratization of the Communist Party under Stalin was taking place. Stalin stamped out his political opposition by accusing and convicting them as guilty of treason at the sham Moscow trials in the early thirties, after which they were either exiled or murdered by his henchmen. Under Stalin's new regime in Soviet Russia during the same year as the attempted coup in France (August 1934), Andrei Zdanov opened the pan-Soviet Literary Congress in Moscow and officially proposed 'socialist realism' as the only valid aesthetic form for Soviet arts and literature.[9] The surrealists, with Breton in particular still sympathetic to revolutionary culture, opposed this dogma and sided with the leftist opposition to Stalinism who were, of course, dubbed as 'counter-revolutionary'. After the Paris *International Exhibition of Surrealism* in the spring of 1938, André Breton went to Mexico (out of financial need, taking up an offer by the French Ministry of Foreign Affairs to give talks there on French culture) and met Leon Trotsky. When Breton

7 The attempted *coup d'état* attacked the government Chamber of Deputies building, with 'some six hours of street-fighting between thousands of demonstrators', fourteen killed and two hundred sufficiently injured to be taken to hospital (Alfred Cobban, *A History of Modern France*, Vol. 3 [Harmondsworth: Penguin, 1990], p. 145).

8 Breton, *Conversations*, p. 137.

9 Herbert S. Gershman, *The Surrealist Revolution in France* (University of Michigan Press, 1974), p. 102.

and Trotsky met, they co-wrote a manifesto demanding the Independence of Revolutionary Art: 'Pour un art révolutionnaire indépendant', a foundation document for the International Federation of Independent Revolutionary Artists.[10] This was far from a 'bourgeois' claim to an autonomy of art, devoid of political commitment, but rather represented the ideological position proposed by Lenin and Trotsky, as a necessity in the 'withering away of the state' within the early conception of the Soviet state 'as a vast commune'.[11] The position of Trotsky and Breton (with the alliance of Diego Rivera) was rather, against Joseph Stalin's tautological conviction, that 'we advance towards the abolition of the state by way of strengthening the state'. It was as a counterweight to such state control of cultural production that both Trotsky, as a Marxist, and Breton, as a surrealist, could at least agree on an essential demand: the necessity of independence for artists, writers and other producers in the cultural domain. In retrospect, the surrealists were early detractors of Stalinism from an intellectual position in the West. It was only those who blindly supported the Communist Party in France who could condemn and dismiss the surrealists as having an obsession with a bourgeois sense of liberty.

With the hardening of European politics into greater militancy, polarization and social instability during the 1930s, the surrealists made strategic alliances to represent their collective views alongside and with other intellectuals, and sympathetic politically conscious groups. In this climate, it can be seen that the coalition and tolerance that was struck, more or less implicitly, in *Minotaure* enabled the surrealists to continue the publication of their work. Such a strategy was also necessary, paralleled in the more direct political field of surrealist activity too. Surrealists joined with others: even with Georges Bataille, the intellectual enemy of Breton who had gathered around him those who had been expelled from surrealism. They temporarily joined forces, for example, in Contre-Attaque (the 'Battle Union of Revolutionary Intellectuals'),[12] and put aside differences for a greater political good, co-publishing tracts and arguments as contributors to the public forum of journals and periodicals that had a political

10 Breton and Diego Rivera signed the manifesto. Trotsky was banned from political activity by the Mexican government. Trotsky and Breton actually wrote the document (see Helena Lewis, *The Politics of Surrealism* [New York: Paragon, 1988], p. 146; see Leon Trotsky, 'Manifesto: Towards a Free Revolutionary Art', in *Culture and Socialism* [London: New Park, 1975]).

11 Victor Serge, *From Lenin to Stalin*, trans. Ralph Manheim (New York: Pioneer Publishers, 1937), p. 55.

12 This manifesto was signed, October 1935 and included former surrealists as well as other sympathizers like Claude Cahun, Roger Blin and Maurice Heine (see Nadeau, *The History of Surrealism*, p. 196).

commitment. As such they belonged to the tradition of intellectual political critical commentary that is still valued in France today on cultural issues.

In this situation, the surrealists negotiated a path between the slippery slope of communism into Stalinism and its orthodox aesthetic of 'socialist realism' on one side and the rise of fascism within an increasing socially violent intolerance on the other. (An early symptom is the right-wing attack, resulting in a riot, on surrealists at Luis Buñuel's first film showing of *L'Age d'or* at Studio 8[13] in December 1930.) Such political pressures were certainly also felt within the internal politics of surrealism: Louis Aragon is a major example, leaving for communism, but also Paul Eluard, after Breton had complained that he published works in right-wing and even German and Italian fascist journals.[14] These were fights over what relations culture had to politics, not just personal quarrels. Breton's aim was not to separate culture from politics, but to recognize the importance of culture for political parties and factions at this time. While the surrealists strove to maintain and fight for an autonomy in their own cultural production they were simultaneously fighting for this right within the political field of the left and party-led communism. Yet they also had to contend with the equally fraught problems of autonomy, but ultimately less damaging problems in relation to the industry of art.

Surrealism as 'Art'

The surge of international surrealist exhibitions during the 1930s reinforced and consolidated a perception of surrealism as primarily an art movement, with exhibitions: 'in Tokyo, Copenhagen, Tenerife, London and Paris'.[15]

The *Exposition Internationale du Surréalisme* in Paris in 1938 was collectively organized by the Parisian surrealists with Marcel Duchamp and held at Galérie des Beaux Arts. Truly international, it had more than sixty artists from forty different countries participating[16] including Oscar Dominguez from the Canaries, the Austrian-born Wolfgang Paalen, the Swiss Kurt Seligmann, the American Kay Sage and Roland Penrose from England.[17] Instead of an exhibition catalogue of works, Breton

13 The 'Studio 8' Montmartre cinema is still operating.

14 See 'The Aragon Affair' in Nadeau's *The History of Surrealism* and in Lewis, *The Politics of Surrealism*. Paul Eluard's abdication from surrealism was less dramatic but no less painful or political (see Breton's discussion in *Conversations*, p. 151).

15 Breton in his list has 'forgotten' the Museum of Modern Art exhibition, New York, 1936 (Breton, *Conversations*, p. 142). Perhaps due to the way that Barr linked surrealism with a whole history of 'Fantastic Art' and 'Dada', distorting the kind of profile that surrealism had in other international exhibitions (see Alfred Barrs, *Fantastic Art, Dada, Surrealism* [New York: Museum of Modern Art, 1936]).

16 José Pierre, 'Le surréalisme en 1938', in *La planète affolée*, p. 28.

17 Sarane Alexandrian, *Surrealist Art* (London: Thames and Hudson, 1993), pp. 151–60.

and Eluard published a *Dictionnaire abrégé du surréalisme* (*Abridged Dictionary of Surrealism*) with a variety of photographs, film stills, paintings and drawings to accompany the things they considered worthy of definition as the A–Z lexicon of surrealism.[18]

In the exhibition, the floor was covered with dead leaves and the ceiling had one thousand two hundred sacks of coal hanging from it. Lighting, organized by Man Ray, intentionally flicked on and off, so visitors were given torches to negotiate their way around. Smells and odours (coal and Brazilian coffee) circulated the exhibition space. The 'exhibits' included a pond, unmade brothel beds, imitation French street signs dedicated to favourite streets and authors of the surrealists, and the infamous mannequins, fifteen of them. Intended for shop windows, each was dressed by a surrealist according to their own fantasies and distributed around the 'streets'. In the courtyard entrance adjacent to the gallery, Salvador Dali's *Raining Taxi* had a blonde female mannequin in the back and another as taxi driver in the front, with shark jaws over the head. Water rained on them inside the taxi. On the evening of the opening (17 January 1938) a dancer, Hélène Vanel, gave a performance called *L'Acte manqué*. Does all this sound like meaningless fun, or an incomprehensible enigma?

In an interpretative sense, the exhibits certainly did have a set of meanings. The coal hanging from the ceiling was not simply a ludicrous idea, but could stand as the displaced signifier for the not-yet-lit fires of passion, a passion that was clearly intimated in the exhibition objects of the installation. In case no one got this metaphor for passion, the signified meaning of the coal was displayed in the exhibition: a coal brazier in the room presented a burning fire with coal by the side of it. Even metaphorically, of course, a fire of passion expires, dies or falls off, like the leaves that were on the floor. Thus, sandwiched between the ceiling of coal and the floor of leaves, were the passionate objects: mannequins, unmade bed, paintings and so on. In fact, this exhibition emphasized a ruthless deconstruction of a bourgeois femininity. In this mockery of Paris as surrealist streets, the dressing of the shop mannequins distorted their usual purpose as ideal contemporary body shapes upon which

18 A facsimile of *Dictionnaire abrégé du surréalisme* was published by José Corti (Paris) in 1995 (and Georges Wildenstein, Galérie des Beaux Arts in 1938).

241

to hang fashion clothing and accessories. Instead, the embarrassingly lifelike qualities of these new modern mannequins were exploited, eroticized and fetishized beyond the decorum of fashion house design. If this was not obvious enough to signal the emphasis of the exhibition, Hélène Vanel's performance title, *L'Acte manqué*, is the title of Freud's 'Bungled Actions' essay in French. In his *The Psychopathology of Everyday Life*, Freud argued that a bungled action is not simply an error or accident, but an action motivated by an unconscious wish – a classic 'Freudian slip'. The reference to *L'Acte manqué* alone shows that the surrealist streets in the exhibition and their bizarre contents were similarly the irruption of one discourse into another: the gallery, turned inside out, as the Parisian street which then in its turn is transformed into a psychical street of desire – then a conscious space contradicted by the presence of another, unconscious, desire. How could one fix the meaning of the exhibition as, simplistically, a big joke? The exhibition simply transformed a traditional gallery space into the imagery of Parisian street culture, but undermined by its own repressed content: violence, death, crime and sexual activity. The surrealist exhibition transported its amazed viewers to a place filled with the sexual, social and historical politics of the Parisian street. Even Dali's *Raining Taxi* could be loosely read as a social critique of the predatory 'shark' taxi driver, and the blonde in the back. Despite the possibility of such potential readings, reviewers and critics of these international surrealism exhibitions tended to look on the works as insults to decency or an affront to art – which, of course, they were. The excited abuse hurled at the surrealists by reviewers nevertheless attracted an even larger public, now curious to see this 'surrealist art' that was so shocking. It was thus that surrealism became familiar as a movement famous for breaking the rules of academy art and scandalizing critics, much to the surprise, delight and affront of its audiences. But such views hardly constituted the abdication of sexual or social politics in surrealism itself, nor was it a symptom of surrealism collapsing its critical distance towards conventional art. It was, rather, a symptom of the fact that the surrealists were no longer in control of the discourse on their own work.

In *Minotaure* the boundaries between surrealism and other contributors, especially in early issues, lacked clear distinction and the effect of this blurring on readers was that surrealism simply looked broader in scope, more polished and smart as art. Jostling in the same issue would be works by surrealists and those who were not surrealists, but who had taken something from surrealism to their own disciplines, like Michel Leiris in ethnography, Jacques Lacan in psychoanalysis or 'documentary' photographers, like Eli Lotar, a young Bill Brandt and later Lee Miller.[19] It is also here in *Minotaure* that much of the criticism of surrealist works as misogynist is focused, with its increased use and emphasis on the forms of the female *nude* body.[20] Hans Bellmer, Georges Hugnet, Salvador Dali, Brassaï, Man Ray, René Magritte and others who either were, or gravitated towards, surrealism (Brassaï, for example, was never officially a surrealist, but his work was used by them) all had visual images (photographs, paintings, drawings and sculpture-objects etc.) reproduced in *Minotaure* which interrogated, dismantled and reassembled the *image fixe* of femininity. They reorganized the representation and signification of her visual form – or *informe* as both Salvador Dali and Georges Bataille had named it then.[21] Hans Bellmer's *poupée* mannequins and his photographs of them were certainly disturbing of anyone's sense of corporeality, but more as polymorphous perverse than fetishistic. In any case, these *poupée* were *not* women, but reworked mannequins to reorganize objects for desire. (As doubly removed from reality, the objections to them as 'misrepresenting women' fall into this trap [see Figure 41].) Read in the historical context in which they were published, the politics of these images is 'deconstructive' and certainly unlike that of an idealized femininity advocated in the 'degrading servility' of Stalinism, as Trotsky's and Breton's manifesto put it.[22] In communism women were represented as heroic workers but, in theory (if not in practice), sexual politics was subjugated as secondary to the political revolution (even Lenin and Trotsky had read Freud but did not see any use of it in a revolution).[23]

Surrealist representations of the female body were also quite unlike the contemporary attitude of fascist

19 See *Eli Lotar* (Paris: Georges Pompidou, 1994); and Anthony Penrose (ed.), *Lee Miller's War* (London: Condé Naste, 1992).

20 See Mary Ann Caws et al. (eds), *Surrealism and Women* (London: Cambridge University Press, 1991).

21 Rosalind Krauss, 'Corpus Delicti', in Krauss, Jane Livingstone and Dawn Ades, *L'Amour Fou; Photography and Surrealism* (New York: Abbeville Press, 1985), pp. 64–5.

22 Trotsky and Breton, 'Manifesto: Towards a Free Revolutionary Art', p. 33.

23 Trotsky also defended Zola and realism – it is hard to imagine how he and Breton really got on (Jean van Heijenoort, *With Trotsky in Exile* [London: Harvard University Press, 1978]).

41 Hans Bellmer's *Poupée* (*Dolls*) in *Minotaure*, no. 6, 1934–35, showing their 'deconstruction'.

24 See Hal Foster on Hans Bellmer, *Compulsive Beauty* (London: MIT Press, 1993), pp. 114–18.

25 Klaus Theweleit, *Male Fantasies*, vol. 1, trans. Stephen Conway, Crica Carter and Chris Turner (London: Polity Press, 1987), p. 299 (italics in original).

26 Ibid., p. 362. Theweleit's propositions tend to be reductive and monolithic, like fascism itself.

27 See Chapter 5.

aesthetics and its socialized images of women.[24] In fascism, the female figure was used as a good/bad *mother* image. The preoccupation in fascism was a 'conceptualization of the body of *all women* as the body of the mother' – certainly not something that interested surrealists.[25] In other words, fascist male fantasies circulated around reproduction of the species, 'the family', with phallic omnipotence and female abjection riven deep in anxieties about male reproductive potential. Fatherhood was deeply intertwined with nationhood as blood and soil, so self-identity and preservation of the 'race' were crucial. Anyway, Nazi ideology, if it is true, exalted the male body above the female.[26] This is all quite different from – opposite to – the surrealist exaltation of the female form as *impossible* object of desire.[27]

Surrealism drew upon and tapped into a different historical iconography: woman as allegory of liberty and equality. This tradition is prevalent in French thought since at least the French Revolution, as mythologized by Eugène Delacroix (who himself had a radical passion and impatience with Academy rules) as in his famous painting, *Liberty Leading the People* (1830). In this picture 'Liberty' is allegorically represented by a revolutionary

woman, a gun in one hand and the French tricolour in the other, leading 'the People' (men in the painting) to the barricades.[28] As with other politics, for surrealism sexual and social freedoms were not separate issues. Liberty in love for the surrealists was not about availability of sexual partners, but a revolutionary call to reject the social repression acting on individuals and thwart the binary categories operating on men and women.

In *Minotaure*, February 1934 (no. 5) (the same month as the attempted coup), André Breton published an essay that was to become the first part of his 1937 book, *L'Amour fou*. The extract, called 'La Beauté sera convulsive' ('Beauty will be convulsive') takes up where *Nadja* had left off, literally, by using its final lines, *La Beauté sera convulsive*, as the title. Breton, once again, draws on the imagery of the hysteric, like a revolutionary woman for Delacroix is 'Liberty'. (Breton substitutes liberty for the hysteric; the mad and insane were set free in the 1789 French Revolution.) In convulsive beauty a hysteric had involuntary images erupt across the body, a surrealist writing. Breton advocates three conditions for the emergence of a convulsive beauty, *érotique-voilée*, *explosante-fixe* and *magique-circonstancielle* (veiled-erotic, fixed-explosive and magic-circumstantial). These categories, developed from classifications of hysterical attack by Jean Charcot and Pierre Janet, belong to a revised theory of the surrealist poetic act. Hysteria by itself is no longer enough as a surrealist gesture and it is modified through Breton's reading of the Freudian concept of 'lost object'.

Losing Things

Breton now recognizes that displacement is at work in the choice of a love object. The (latest) love object is merely a substitution of one thing (or person) for another one (or a condensation of several things/people into one love object), in a substitutive chain that goes back to an original lost object. Building on this, Breton proposes the *objet trouville* (found object), as a surrealist delight – a psychical conflict – in 'the dissimilarity itself which exists between the object wished for and the object found'.[29] Thus, despite the difference between the two objects, the one *wished for* and the one *found*, Breton notes: 'What attracts me in such a manner of seeing is

28 Bartholdi's 1880s *Statue of Liberty* donated to the USA is often compared with Delacroix's painting (see Kaja Silverman, 'Liberty, Maternity, Commodification', *New Formations* [no. 5, summer 1988] pp. 72–3).

29 This quote is from Mary Ann Caws's translation in André Breton, *Mad Love* (London: University of Nebraska Press, 1987), p. 13. My own would reverse the last two words: 'found object'.

that, as far as the eye can see, it re-creates desire.'[30] In a sense, Breton proposes a radical conception of loss, saying that the experience of difference between the latest actual object from the original one is something that should be celebrated and enjoyed.

As if to demonstrate the three conditions deemed necessary for this, Breton's text is accompanied by three photographs, by Man Ray and Brassaï. Each photograph has a title as *érotique-voilée*, *explosante-fixe* and *magique-circonstancielle*. The image of *érotique-voilée* is a Man Ray photograph (see Figure 42). (Although it is published in *Minotaure*, it is not printed in *L'Amour fou*.) Taken from a suite of photographs made in the printing studio of Marcoussis, it shows Meret Oppenheim, then an assistant to the photographer, standing naked against a printing press, with ink on her hand and forearm.

The incongruity of the prophotographic scenario renders the figure of woman in close proximity to the act of printing. The version in *Minotaure* has the phallic handle at the bottom of the press – protruding like a substitute penis – cropped off. Nevertheless, the 'joke' about print-making is made clear. It is precisely the *veiled* eroticism in print-making that turns the wheel, incites the desire of the printer. In the picture, Meret Oppenheim's right hand grips the wheel while her left hand is thrown up to her forehead in a theatrical gesture for 'woe', 'stop' or 'no'. Yet this hand, facing the viewer, is also a gesture of showing, of 'revealing the hand' – covered in ink. The black ink on her hand matches the tone of the printing wheel itself and, as if somehow united, we see that one is l-inked to the other. In fact, it is precisely the juxtaposition of her slim torso and the crude machinery that shows the impossible relation between processes and (lost) love object. The scenario seems anachronistic; the old printing press and scruffy background are far from a 'machine age' aesthetic and this artisan studio is a long way from any idea of 'woman as machine' or as fodder for it. On the contrary, her right hand holds the wheel (as perhaps the 'phallus') while her left arm relaxes upon it, almost in harmony. Although her eyes are cast downwards, the pose has a knowingness of being looked at, with thoughts elsewhere than the viewer, rather than as submission or powerlessness. In

30 Breton, *Mad Love*, p. 15.

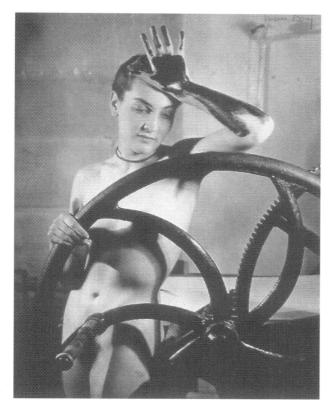

42 Man Ray's photograph *Erotique-voilée* (*Veiled-eroticism*) appeared in André Breton's essay on 'L'Amour fou' in *Minotaure* no. 5, 1934. The photograph is cropped across the bottom in the *Minotaure* version made by Man Ray. The photograph is one of a series showing Meret Oppenheim (then Man Ray's photographic assistant) in the printing studio of Marcoussis.

no sense does this metaphorical scene represent her in struggle with the machine. Man Ray's picture shows the displacement at work from one love object to another, as the love of printing – sublimation – having something of the impossibility of a lost object. (The ink on her hand can be read as this lost void.) In Breton's text, this *érotique-voilée* is only one condition of convulsive beauty, the delight in the dissimilarity between an object wished for and the object found. This new surrealist theory has another practical use, in terms of thinking what happened to the surrealists themselves.

Exits and Exile

As the war hit France, the lost object of the surrealists would in fact turn out to be Paris itself. By June 1940 an estimated six to eight million refugees were moving about France including a fifth of the French population who were surging south.[31] For the surrealists this was

31 Michael Marrus, *The Unwanted; European Refugees in the Twentieth Century* (Oxford: Oxford University Press, 1985), p. 200 (see also Michael Marrus and Robert O. Paxton, *Vichy France and the Jews* [New York: Basic Books, 1981]).

the moment of their own dispersion too. In their lives as well as their work, Paris now became their collective city-object condemned to restless displacement into other cities and places, as surrealists fled into exile. Any yearning for its eternal return would anyway never be gratified, since the object left behind, the Paris of the 1920s and 1930s, could never be re-found. After the war it was never to be the same.

In 1939 France was officially 'at war'. André Breton was mobilized as a doctor 'medic' in Poitiers, but returned to Paris to meet friends and fellow surrealists when he could.[32] By the summer of 1940 all such conscripts were demobilized, as under Nazi occupation France was divided into two zones, occupied and unoccupied. The Occupied Zone was the northern half of France, including Paris and the west coast down to Spain. With the Nazi occupation of Paris, huge numbers of people left it. The Unoccupied Zone was governed by the so-called Vichy government, based in the health resort town of Vichy under the leadership of Marshal Pétain. Essentially a right-wing bureaucracy (heavily supported by the Action Française), Vichy was no friend to radicals or, for that matter, any kind of refugee. Nevertheless, many intellectuals, artists and radicals, unsure of their fate at the hands of Nazi rule in Paris, fled to the Unoccupied or so-called Free Zone, until 1942, when it was occupied by the Nazis. Many refugees headed for Marseilles where, through the Comité de Secours Americain aux Intellectuels (directed by William Fry), they could meet compatriots, at the villa Air-Bel.[33] Some, with an appropriate visa, could hope to exit France for a ship to the Americas. 'Hope' was all some could have, as the USA tightened visa rules for immigration, a consequence of the rising unemployment in the 1930s depression and a suspicion about Nazi agents secretly infiltrating America disguised as refugees.[34]

André Breton, at that time in the Unoccupied Zone, was one of those who made the journey to Marseilles. As a well-known literary figure of France with contacts in the USA he had a greater chance than many of gaining a visa. Even so, his application for a visa was delayed when his flat in Paris (rue Fontaine) was raided and his arrest by the Vichy regime was only narrowly avoided. It

32 See Michel Fauré, *Histoire du surréalisme sous l'Occupation* (Paris: La table ronde, 1982), p. 43.

33 Ibid., p. 47.

34 David S. Wyman, *Paper Walls: America and the Refugee Crisis, 1938–1941* (Amhurst: University of Massachusetts Press, 1968).

was eventually in March 1941 that André Breton found himself on a ship headed for Martinique. On the same small black steamship were Marcel Duchamp, Victor Serge (once a companion of Lenin) and Claude Lévi-Strauss, the anthropologist (who became friends with Breton).[35] Upon arrival in Martinique they went their different ways and eventually Breton arrived in New York, where he joined other surrealists in exile.

Other people headed for where they could, for example, Walter Benjamin escaped Paris and travelled south to his (presumed) suicide at the French–Spanish border in autumn 1940.[36] André Masson was living in the north of France in early 1940 with his wife Rose (who was Jewish). They moved south to Fréluc in the (Unoccupied) Auvergne to join with Rose's sister Sylvia and husband Georges Bataille. The Batailles were also accompanied by Jacques Lacan, who later married Sylvia Bataille. Pablo Picasso and Dora Maar went to the Occupied Zone seaside resort of Royan, above Bordeaux on the Atlantic coast. René Magritte went to Carcasonne in May 1940, but returned to occupied Brussels in August, where he stayed and managed to work throughout the war. Man Ray initially headed for the south by car with Ady (Adrienne) Lacroix, but was turned back to Paris by the military. She stayed with her parents in Paris, while Man Ray was advised to leave Europe and he went back south, this time by train, travelling through Spain to arrive on 25 July in Lisbon, Portugal.[37] He met Gala and Salvador Dali also trying to leave and they all ended up on the same ship to New York, with Brogna and René Clair. When they arrived in New York it was Dali whom the journalists turned out for, expecting a 'surrealist' spectacle from him. Man Ray was quietly met by his family. Rather than stay in New York where he had lived before, Man Ray headed west and lived in Hollywood, married Juliet Browner and stayed there until 1951. Man Ray devoted himself mostly to painting and shunned the fashion work in photography that he had enjoyed in Paris.[38] This was a luxury he could now afford, even though the work was not successful in Hollywood or the USA generally.[39] In contrast, Dali's career took off in America and through this celebrity status he helped to create

35 Claude Lévi-Strauss notes they discussed and exchanged letters (see his *Tristes Tropiques* [Harmondsworth: Penguin, 1976], p. 26). Lévi-Strauss's account of his trip is instructive in the suspicion levied by all parties during this period.

36 See Susan Buck-Morss on Benjamin's final hours, 'Afterword: Revolutionary Inheritance', *The Dialectics of Seeing* (London: MIT Press, 1991), pp. 331–5.

37 Neil Baldwin, *Man Ray* (London: Hamish Hamilton, 1988), pp. 224–8.

38 Man Ray described California as a 'beautiful prison'. Robert Berman, et al., *Man Ray; Paris–LA* (Santa Monica, CA: Smart Press, 1996), p. 25.

39 Man Ray lived off savings from fashion and photography work in Paris.

the public image of surrealism as wild, wacky and wonderful. Already 'excommunicated' and despite his earlier brilliant contributions to surrealism, the anagram of his name by Breton branded Dali as 'Avida Dollars',[40] epitomizing the surrealist view of Dali as a commercialist devoid of ethics and their politics (his enthusiasm for Franco and, worse, his admiration for Hitler).[41]

Max Ernst had left the surrealists in 1938 due to their response to Paul Eluard's poetry (in right-wing magazines) and lived near Avignon. In 1939, as a German in France he was interned as an 'enemy alien' in a camp at Les Milles, near Aix-en-Provence. His cell mate there was another German, the artist and photographer Hans Bellmer.[42] Ernst was vouched for by Paul Eluard and consequently freed, but again interned in 1940. This time he escaped and was on a Gestapo wanted list and tried to flee Europe.[43] In Marseilles he met Breton and they reconciled, but Breton managed to get a visa and left. Ernst, as a German, had difficulty in obtaining a visa and went to Lisbon, leaving there with Peggy Guggenheim whom he later married in New York (and then separated from a short while after).[44] In 1943 he moved to Arizona with Dorothea Tanning, where they stayed until returning to Europe in 1953.

Some surrealists tried to stay in Paris, like Benjamin Péret (who had bought his way out of a Nazi prison in Rennes, in 1940), but it was difficult to continue working there. In the end he fled to Mexico in 1941.[45] Others, like Tristan Tzara and Robert Desnos, went on to fight in the French *résistance*. Desnos was eventually caught and arrested. Sent to Buchenwald concentration camp, he died of typhus after being liberated in 1945. Pierre Unik, after evading imprisonment in a camp in early 1945, disappeared and was never seen again. Of course, there are many such stories during a war and its impact: the decisions people make, what happens to their lives, the turmoil, the pain and joys of separation, upheaval, return or death. While it is not possible to recount them all here, the significance of the impact of invasion on surrealism is clear: none could escape the effects of war on their lives. In Breton's view, 'War – this or any other war – means the eclipse of all things of the mind.'[46]

40 Breton: 'the picaresque imposture of that neo-falangist-night-table, Avida Dollars', Breton, 'Prolegomena to a Third Manifesto of Surrealism or Else' [*VVV*, June 1942), in Franklin Rosemont (ed.), *What is Surrealism?* (London: Pluto, 1989), p. 210.

41 Dali not only made energetic contributions across painting, film scripting and objects, but also writing (see, for example, his 'Non-Euclidian Psychology of a Photograph', *Minotaure*, no. 7 [June 1935]).

42 Martica Sawin, *Surrealism in Exile and the Beginning of the New York School* (London: MIT Press, 1979), p. 72.

43 Max Ernst, 'An Informal Life of M. E.', *Max Ernst* (London: Arts Council/Tate Gallery, 1961).

44 Peggy Guggenheim, 'My Life with Max Ernst', *Out of This Century* (London: André Deutsch, 1980).

45 Benjamin Péret (*La Parole est à Péret*, New York: Editions Surrealistes, 1943), cited in Gershman, *The Surrealist Revolution in France*, p. 108.

46 Breton, *Conversations*, p. 153.

Black Light

While in New York, Breton continued his activities, giving daily broadcasts for French audiences – including Resistance messages – on 'Voice of America' radio. With Marcel Duchamp he organized the 1942 *International Surrealist Exhibition* as an aid benefit for prisoners of war. From June 1942, Breton, Duchamp and Max Ernst with David Hare, the American photographer and sculptor, all edited the magazine *VVV*, outdoing Winston Churchill's 'V for Victory' finger sign three times.[47] The magazine reunited the activities of surrealism that had been split in the years of *Minotaure*: visual works, literature and the politics of surrealism were back together on the same page. Here, too, the weight of the 1940s war is heard in Breton's writings, even in talk of painting. In his 1942 'Prolegomena to a Third Manifesto of Surrealism or Else', Breton attacked the unthinking aesthetic conformism of a so-called *surrealist* painting that was sprouting up everywhere, 'imitating' the likes of de Chirico, Ernst, Miró, Picasso, Masson and Tanguy.[48] Imitation kills the oppositional and conflictual imagery that Breton argued was the surrealist politics of representation: opposition rather than triumph, resistance rather than agreement and informed rather than deferent. As Breton declared to his readers, he was *for* 'the minority'.[49] Indeed, in exile, the surrealists themselves were often better received by those still suffering oppression, in Haiti, Martinique, Indian tribes (in America), dissidents in Chile, Argentina and Mexico.

Still concerned with achieving surrealism, Breton's lecture, 'The Situation of Surrealism Between the Two Wars', given at Yale University in December 1942, took up the necessity to 'disinfect that immense and sombre region of the *id* where myths swell beyond measure and where at the same time wars are fomented'.[50] Invoking Freud's late term for the unconscious ('id'), 'where myths swell beyond measure' as 'irrational' infantile forces, Breton proposes the 'incorporation in the psychic apparatus of *black* humour', to help cleanse the mind of, presumably, fascism. Black humour was a way to tame the unconscious aggression (the death drive?) of these social myths, even if it did not get rid of them.[51] Social myths, as he called them, were an issue he pursued

47 The first issue justified the title. Breton gives an almost incomprehensible account of the logic of the *VVV* title in *Conversations*, p. 156.

48 Breton ('Prolegomena to a Third Manifesto of Surrealism or Else', *VVV*, June 1942), in Rosemont (ed.), *What is Surrealism?*, p. 213.

49 Ibid., pp. 213–14.

50 André Breton, 'The Situation of Surrealism Between the Two Wars', in ibid., p. 246.

51 Ibid.

52 Breton's interest in social myths continued into the 1950s, perhaps stimulated by his encounter with Claude Lévi-Strauss in 1940, or Georges Bataille's complaint (which Breton described as 'nostalgic') about the 'absence of myth'. Also parallel is Roland Barthes's 1950s essays, *Mythologies* (London: Paladin, 1972) (see Breton's interview in *Conversations*, pp. 216–17).

53 See, for example, 'Treatise on Light' (1943) (*Magritte*, p. 86 below). Magritte wrote in 1941: 'So I'm taking refuge in the ideal world of art. An idealist position, you'll tell me. Well – all right. But it's only a way of amusing myself, after all, and that's the main thing. And the noisier reality becomes, the less reluctant I am to escape from it as much as possible.' Magritte letter to Paul Eluard, in David Sylvester and Sarah Whitfield (eds), *Magritte* (London: South Bank Centre, 1992), p. 86.

54 See 'The Civilizer' (1944), 'A Stroke of Luck' (1945) in ibid., p. 89.

55 Alexandrian, *Surrealist Art*, p. 164.

56 Breton regarded this development as outside surrealism and the *psychic* automatism of surrealism: 'Others – and this mainly concerns American interests – tried to depreciate surrealist visual art to the benefit of so-called "non-figurative" art, whose authenticity, through its successive demonstrations, has proven to be more dubious with each passing day.' Breton, *Conversations*, p. 164.

57 See Martica Sawin, 'Aux Etats-Unis', in *La Planète affolée*, pp. 113–14; and Peter Wollen, 'The Triumph of American Painting', in *Raiding the Icebox* (London: Verso, 1993), pp. 92–5.

58 Even superficial comparisons between works by Jackson Pollock and Matta shows obvious differences between their types of abstraction as this time (see Sawin,

long after the war.[52] In wartime social myths needed puncturing and black humour was the tool to do it. To Breton, psychological repression and unconscious forces are linked to the emergence of certain ideas in the war and part of a larger problem in the roots of society. Such a view was hardly popular; war was surely not to be overcome by telling jokes. For Breton, it was *one* weapon in the armoury.

Yet humour is notably missing from many of the *visual* works in surrealism of this time. May Ray had turned to his painting and seemed anxious to reinvent the art works he had left in Paris, perhaps driven by the thought that he would never see them again. His photographs during wartime also seem to repeat themes which he had already dealt with in Paris in the 1920s and 1930s, only now more refined and bathed in Californian light. His works did not address the war at all. Some of Magritte's paintings in Brussels became military grey and green, and had even more emphasis on a stilled lifelessness than previously. Some could be read as allegories of the war machine treading through Europe and beyond, although he did also 'amuse himself' by making bright coloured 'impressionist'-looking pictures.[53] Some of his allegorical paintings used animals; in *The Companions of Fear*, 1942, ruffled owls (the surrealists?) look out over a desolate and barren landscape.[54] Max Ernst in his 1930s paintings was already dealing with the First World War (he had been in the trenches opposite Eluard), for example, *Europe After the Rain* (1936). But in the USA he returned to a more abstract type of painting, with his 'decalomania' and oscillation techniques of spinning discs with paint centrifugally spread. Ernst showed his techniques to the young Jackson Pollock, who developed them into dripping abstractions[55] – a tendency which Breton was later to complain of as a depreciation of surrealism.[56] The critic who was to promote Pollock, Clement Greenberg, rejected surrealism and even regarded it as reactionary.[57] Politics and art were separate for Greenberg – and worlds apart from the aims of surrealism.[58] Some of Ernst's paintings did address the Second World War, if obliquely and somewhat melancholically, as in *Napoleon in the Desert* (1941), *The Maddened Planet* (*La Planète affolée*) (1942), and *Day and Night* (1941–42).

Although surrealism was consolidated internationally as a cosmopolitan movement during these years, it was also simultaneously dissipated into a fragmentary identity, in bits and pieces. Although without a central surrealist journal between 1939 and 1942, there were nevertheless many others, small but dedicated, springing up over the world and the international popularity of surrealism grew immensely. Even in occupied Europe magazines appeared: *L'Invention collective* in Brussels, February 1940; *Géographie nocturne*, 1941 and *Poésie et Vérité*, 1942 both in Paris. Numerous others, published by La Main à plume and international groups, sprang up everywhere: Sweden, Denmark, Yugoslavia, Romania, Japan, Canada, England, Mexico and the USA. Surrealism, paradoxically, survived the war by its dispersion, canonized as an art movement, despite Breton's best efforts to avoid this. The sense of community and common project of surrealism that was formed in and by the Parisian gatherings was now as dismantled as the various individuals were geographically dispersed.

After-war(d)

Despite the regrouping of surrealists in Paris after the war, the effect of the previous dispersion was final. As surrealists gradually returned to Paris after the war, with the demise of the old cultural order they were seen as an older *establishment*. Breton fought on and new, younger members gathered around him in addition to those who returned from exile. While many of the surrealists had continued to work individually in exile, it seems that many of the previous bonds between them were broken. Paris, too, failed to recover its former excitement as a centre for avant-garde culture that it had in the 1920s and 1930s.[59] Although Jean-Paul Sartre and later Simone de Beauvoir took on the mantle of the fashionable intellectual 'left' figures after the war, their philosophical strain of 'existentialism' and phenomenology was far from compatible with surrealism. Indeed, as far as the surrealists were concerned, Sartre's position on 'freedom' represented a rearguard move politically, both in the neglect of the unconscious in philosophy and their attitudes towards the French Communist Party and the post-war Soviet Union.[60] However, right up to

'Aux Etats-Unis', *La Planète affolée*, pp. 126–42).

59 Parisian culture revived in the 1960s: new wave cinema, structuralism, etc.

60 See Breton's remarks on Sartre, 'Inaugural Break' (1947) in Rosemont (ed.), *What is Surrealism?*, pp. 341–2.

Breton's death in 1966 surrealists continued to campaign against the various wars that France became involved in: Algeria in the 1950s and Korea and Vietnam. Most problematic for the surrealists on their return to Paris was, according to Breton, the dominance of Stalinists occupying key cultural positions.[61] The submission of surrealism or art to a political state (USSR) or its ideology was anathema to Breton and those around him, and they were again caught between ideological currents of the day. Thus, even after the war, surrealism found itself between the dogmas of Communist Party positions and debased humanist notions of freedom in art tainted with romantic modernism.

As Michel Foucault puts it, the difference between the surrealists and the (German) Romantics was that the Romantics dreamt of the night being illuminated by the day, whereas for Breton, dreams were 'the unbreakable core of the night placed at the heart of the day'.[62] This wish was itself a dream-image that no one has been able to complete. As photography was again relegated to either a mimetic or modernist function, surrealism – historical surrealism as a movement and institution – mutated into a mere adjective and vague psychologism, as 'the surreal'.

61 Breton, *Conversations*, p. 162.
62 Michel Foucault, in *Michel Foucault: Aesthetics; Essential Works of Foucault, Volume Two 1954–1984*, p. 172.

Picture credits

One

1 Man Ray, *Centrale Surréaliste* (Surrealist Group), 1924, © Man Ray Trust/ADAGP, Paris and DACS, London 2003.

2 Man Ray, *The Enigma of Isidore Ducasse*, 1920 (replica 1970). Published in 'Preface' to *La Révolution surréaliste*, no. 1, December 1924, © Man Ray Trust/ADAGP, Paris and DACS, London 2003.

3 Man Ray, *Voici le domaine de Rrose Sélavy, Vue prise en aéroplane*, 1921. Reproduced in *Littérature*, no. 5, October 1922, more commonly known now as *Elevage de poussière* (*Dust Breeding*) by Marcel Duchamp, 1920, © Man Ray Trust/ADAGP, Paris and DACS, London 2003.

4 Cover of *La Révolution surréaliste*, no. 1, December 1924, photographs by Man Ray, © Man Ray Trust/ADAGP, Paris and DACS, London 2003.

5 Cover of *La Nature*, no. 2631, September 1924. Reproduced by kind permission of the British Library, London.

6 Anonymous photograph on cover of *La Révolution surréaliste*, no. 11, 15 March 1928.

7 Figure from Philip Ayres, *Emblem Amatoria* (texts in four languages) published in London: W. Likely, 1714.

8 Germaine Berton montage published in *La Révolution surréaliste*, no. 1, December 1924.

Two

9 'The Fiftieth Anniversary of Hysteria', double page from *La Révolution surréaliste*, no. 11, March 1928.

10 Film still from Man Ray's 'cinépoéme' *Emak-Bakia*, 1926, published as a photograph in *La Révolution surréaliste*, no. 9–10, October 1927 © Man Ray Trust/ADAGP, Paris and DACS, London 2003.

11 Man Ray, two rayograms, *Pensée d'une femme* (1922), *Vers le Soleil* (1927) and a photograph *Pièces de résistance* (1925) from André Breton, *Surréalisme et la peinture*, Paris: Gallimard, 1928, © Man Ray Trust/ADAGP, Paris and DACS, London 2004.

12 Man Ray, *Groupe Surréaliste* (Surrealist Group), 1924, © Man Ray Trust/ADAGP, Paris and DACS, London 2003.

13 Cover of *La Révolution surréaliste*, no. 9–10, October 1927.

14 Paul Nougé, *Les Vendanges du sommeil* (*The Harvests of Sleep*), from *Subversion des images*, 1929–30, © SOFAM – Belgique.

15 Photographic plates from *Nouvelle Iconographie de la Salpêtrière*, 1889, 2, plate XX and plate XLIII, 1891, 4, plate IX. Reproduced by kind permission of Bibliothèque Charcot, La Salpêtrière, Paris.

16 Paul Nougé, *La naissance de l'objet* (*Birth of the Object*), from the series *Subversion des images* (*Subversion of Images*), 1929–30, © SOFAM – Belgique 2003.

17 Brassaï, *Les Sculptures involontaires: Billet d'autobus roulé* (*Involuntary Sculptures: Rolled Bus Ticket*), from *Minotaure*, 1932, © Brassaï Estate.

Three

18 Jacques-André Boiffard, *Hotel des Grande Hommes* in *Nadja*, 1928, © ADAGP, Paris and DACS, London 2003.

19 Jacques-André Boiffard, *Place Dauphine* in *Nadja*, 1928, © ADAGP, Paris and DACS, London 2003.

20 Jacques-André Boiffard, photograph of L'Humanité bookshop in *Nadja*, 1928, © ADAGP, Paris and DACS, London 2003.

21 Photomontage of Nadja's eyes, added in revised edition of *Nadja* by André Breton in 1964, © ADAGP, Paris and DACS, London 2003.

Four

22 Man Ray, *Le Violon d'Ingres* (*Violin of Ingres*), 1924, originally published in *Littérature*, no. 13, June 1924, © Man Ray Trust/ADAGP, Paris and DACS, London 2003.

23 Jean-Auguste-Dominique Ingres (1780–1867), *Baigneuse de Valpinçon* (*Valpinçon Bather*), 1807, © RMN, Louvre, Paris – G. Blot/C. Jean.

24 Jean-Auguste-Dominique Ingres (1780–1867), *Le Bain turc* (*Turkish Bath*), 1863, © RMN, Louvre, Paris – G. Blot/C. Jean.

25 Cover of *La Renaissance de l'Art français et des Industries de Luxe*, year 4, issue no. 5, May 1921, by permission of V & A Picture Library, London.

Five

26 Man Ray, *Hommage to D.A.F. Sade*, published in *Le Surréalisme au service de la révolution*, no. 2, 1930, p. 37, © Man Ray Trust/ADAGP, Paris and DACS, London 2003.

27 Man Ray, *Monument to D.A.F. de Sade*, 1933, published in *Le Surréalisme au service de la révolution*, no. 5, 15 May 1933, © Man Ray Trust/ADAGP, Paris and DACS, London 2003.

28 Photomontage by René Magritte with his painting *Je ne vois pas la femme*, published in *La Révolution surréaliste*, no. 12, 1929, © Man Ray Trust/ADAGP, Paris and DACS, London.

29 Man Ray, *Primat de la matière sur la pensée*, 1929, published in *Le Surréalisme au service de la révolution*, no. 3, December 1931, © Man Ray Trust/ADAGP, Paris and DACS, London 2003.

30 Film still from Luis Buñuel's *Un Chien andalou*, 1928, © Contemporary Films, photograph courtesy of BFI Stills, Posters and Designs, London and details from two cosmetics advertisements (1929).

31 Paul Nougé, *Cils coupés* (Cut eyelashes), from *Subversion des images*, 1929–30, © SOFAM – Belgique 2003.

32 Man Ray, *Prayer* (*Prière*), 1930, © Man Ray Trust/ADAGP, Paris and DACS, London 2003.

33 Man Ray, Drawing: *Imaginary Portrait of D.A.F. de Sade*, 1938, © Man Ray Trust/ADAGP, Paris and DACS, London 2003.

Six

34 Man Ray's *Noire et blanche*, 1926, in *Vogue*, Paris, May 1926, © *Vogue*, Paris; Man Ray Trust/ADAGP, Paris and DACS, London 2003.

35 Man Ray's *Noire et blanche*, 1926, in *Variétés*, no. 3, 15 July 1928 and Halika illustrations from *Variétés*, June 1928, © Man Ray Trust/ADAGP, Paris and DACS, London 2003.

36 African mask on cover of *Variétés*, November 1928, Beauty Mask and Maison Jean advertisements in *Variétés* (1928).

Seven

37 Poster for *Exposition coloniale* [*Colonial Exhibition*], Paris, 1931.

38 Two photographs of *La Vérité sur les colonies* exhibition installation from *Le Surréalisme au service de la révolution*, no. 3–4, December 1931.

39 Collective text *Murderous Humanitarianism* by surrealists and anonymous photograph in *Negro: Anthology, 1931–1933*, published in 1934.

Eight

40 Cover of *Minotaure*, no. 10, Winter 1937. Montage by Magritte.

41 Double-page spread of Hans Bellmer's *Poupée* (*Dolls*) from *Minotaure*, no. 6, Winter 1934–35.

42 Man Ray, *Erotique-voilée* (*Veiled-eroticism*), 1933, published in *Minotaure*, no. 5, February 1934, © Man Ray Trust/ADAGP, Paris and DACS, London 2003.

Bibliography

Abraham, Karl, *Selected Papers of Karl Abraham*, trans. Douglas Bryan and Alix Strachey (London: Hogarth Press, 1928).

Abu-Lughod, Ibrahim, *Arab Rediscovery of Europe, a Study in Cultural Encounters* (Princeton, NJ: Princeton University Press, 1963).

Ades, Dawn, *Dada and Surrealism Reviewed* (London: Hayward Gallery/Arts Council of Great Britain, 1978).

— *Dalí* (London: Thames and Hudson, 1992).

Alazard, Jean, *Ingres et l'Ingrisme* (Paris: Albin Michel, 1950).

Alexandrian, Sarane, *Le Surréalisme et le rêve* (Paris: Gallimard, 1974).

— *Surrealist Art* (London: Thames and Hudson, 1993).

Althusser, Louis, *For Marx* (London: NLB/Verso, 1986).

— *Lenin and Philosophy* (New York: Monthly Review Press, 1987).

Andrews, C. M. and A. S. Kanya-Forstner, *France Overseas, the Great War and the Climax of French Imperial Expansion* (London: Thames and Hudson, 1981).

Ansprenger, Franz, *The Dissolution of the Colonial Empires* (London: Routledge, 1989).

Aragon, Louis, *Paris Peasant* (London: Pan Books, 1980).

Arwas, Victor, *Art Deco Sculpture* (London: Academy, 1975).

Babinski, Joseph, *Hysteria or Pithiatism* (London: University of London Press, 1918).

Baldwin, Neil, *Man Ray* (London: Hamish Hamilton, 1988).

Barr, Alfred H., *Fantastic Art, Dada, Surrealism* (New York: Museum of Modern Art, 1937).

Barthes, Roland, *Image–Music–Text*, ed. and trans. Stephen Heath (London: Fontana, 1979).

— *Mythologies*, trans. Annette Lavers (London: Paladin, 1980).

— *Camera Lucida; Reflections on Photography*, trans. Richard Howard (London: Fontana, 1984).

Batchelor, David, Bryony Fer and Paul Wood, *Realism, Rationalism, Surrealism* (London: Open University Press, 1993).

Bate, David, 'The *Mise-en-scène* of Desire', *Mise-en-Scène* (London: Institute of Contemporary Arts, 1994).

Battersby, Martin, *The Decorative Twenties* (London: Studio Vista, 1969).

Baudelaire, Charles, 'The Modern Public and Photography', in Alan Trachtenberg (ed.), *Classic Essays on Photography* (New Haven, CT: Leete's Island Books, 1980).

— *Art in Paris: 1845–1862, Salons and Other Exhibitions Reviewed by Charles Baudelaire*, ed. and trans. Jonathan Mayne (Oxford: Phaidon, 1981).

— *My Heart Laid Bare and Other Prose Writings*, trans. Norman Cameron (London: Soho, 1986).

Baum, Timothy, *Man Ray's Paris Portraits: 1921–1939* (Washington, DC: Middendorf Gallery, 1989).

Beauvoir, Simone de, *The Second Sex*, trans. H. M. Parshley (London: David Campbell, 1993.

Benjamin, Walter, *Understanding Brecht*, trans. Stanley Mitchell (London: New Left Books, 1977).

— *Illuminations*, trans. Harry Zohn (London: Fontana, 1979).

— *Classic Essays in Photography*, Alan Trachtenberg (ed.) (New Haven, CT: Leete's Island Books, 1980).

— 'Surrealism: The Last Snapshot of the European Intelligentsia', in *One Way Street and Other Writings*, trans. Edmund Jephcott and Kingsley Shorter (London: Verso, 1992).

Bennett, Tony et al. (eds), *Formations of Pleasure* (London: Routledge and Kegan Paul, 1983).

Bergson, Henri, *Matter and Memory*, trans. Nancy Margaret Paul and W. Scott Palmer (New York: Zone Books, 1991).

Bezcombes, Roger, *L'Exotisme dans l'art et la pensée* (Paris: Elsevier, 1953).

Bhabha, Homi, *The Location of Culture* (London: Routledge, 1994).

Bourgeade, Pierre, *Bonsoir, Man Ray* (Paris: Editions Pierre Belfond, 1971).

Bowman, Sara, *A Fashion of Extravagance* (London: Bell and Hyman, 1985).

Breton, André, *Le Surréalisme et la peinture* (Paris: Gallimard, 1928).

— *Misère de la poésie* (Paris: Editions Surréalistes, 1932).

— *Nadja*, trans. Richard Howard (New York: Grove Press, 1960).

— *Nadja* (Paris: Gallimard, 1963).

— *Surrealism and Painting*, trans. Simon Watson Taylor (London: Macdonald, 1972).

— *Mad Love*, trans. Mary Ann Caws (London: University of Nebraska Press, 1988).

— *Oeuvres complètes*, édition établie par Marguérite Bonnet, 2 Vols (Paris: Gallimard, 1988–92).

— 'What is Surrealism?', in Franklin Rosemont (ed.), *What is Surrealism?* (London: Pluto, 1989).

— *L'Amour Fou* (Paris: Gallimard, 1990).

— *Conversations: The Autobiography of Surrealism*, trans. Mark Polizzotti (New York: Paragon, 1993).

— *Manifestos of Surrealism*, trans. Richard Seaver and Helen R. Lane (Ann Arbor: University of Michigan Press, 1997).

Breton, André and P. Soupault, *Les Champs Magnétiques* (Paris: Au Sans Pareil, 1920).

— *The Magnetic Fields*, trans. David Gascoyne (London: Atlas, 1985).

Breunig, Leroy C. (ed), *Apollinaire on Art: Essays and Reviews 1902–1918*, trans. Susan Suleiman (New York: Da Capo, 1988).

Brockway, Fenner, *African Socialism* (London: Bodley Head, 1963).

— *The Colonial Revolution* (London: Hart-Davis, Macgibbon, 1973).

Brunschwing, Henri, *French Colonialism, 1871–1914* (London: Pall Mall, 1966).

Bryson, Norman, *Vision and Painting*, Basingstoke: Macmillan, 1988).

— *Tradition and Desire* (Cambridge: Cambridge University Press, 1984).

Bürger, Peter, *Theory of the Avant-Garde*, trans. Michael Shaw (Minneapolis: University of Minnesota Press, 1984).

Burgin, Victor (ed.), *Thinking Photography* (Basingstoke: Macmillan, 1982).

Cachin, Marcel, 'L'exposition anti-imperialiste: *La Vérité aux colonies*'; Note sur l'exposition anticoloniale (29 September 1931) (Paris: Institut Maurice Thorez, microfilm: bob 69, série 461).

Camard, Florence, *Ruhlmann, Master of Art Deco*, trans. David Macey (London: Thames and Hudson, 1984).

Cardinal, Roger and Robert Short, *Surrealism; Permanent Revelation* (London: Studio Vista, 1970).

Cassou, Jean and Geoffrey Grigson, *The Female Form in Painting* (London: Thames and Hudson, 1953).

Caws, Mary Ann (ed.), *Surrealism and Women* (London: MIT Press, 1991).

— *The Surrealist Look* (London: MIT Press, 1997).

Cazaux, Jean, *Surréalisme et psychologie* (Paris: Librarie José Corti, 1938).

Certeau, Michel de, *Heterologies; Discourse on the Other*, trans. Brian Massumi (Manchester: Manchester University Press, 1986).

Chadwick, Witney, *Women Artists and the Surrealist Movement* (London: Thames and Hudson, 1991).

Chazelas, Victor, *Territoires Africains sous mandat de la France*, Cameroun et Togo (Paris: Société d'Editions, 1931).

Clément, Catherine, *The Lives and Legends of Jacques Lacan*, trans. Arthur Goldhammer (New York: Columbia University Press, 1983).

Clifford, James, *The Predicament of Culture* (London: Harvard University Press, 1988).

Cobban, Alfred, *A History of Modern France*, Vol. 3 (London: Penguin, 1990).

Cohen, Margaret, *Profane Illumination, Walter Benjamin and the Paris of Surrealist Revolution* (London: University of California Press, 1993).

Collins Baker, C. H., 'Reflections on the Ingres Exhibition', *Burlington Magazine*, July 1921.

Cowling, Elizabeth, 'The Eskimos, the American Indians and the Surrealists', *Art History*, Vol. 1, no. 4, 1978.

Culler, Jonathan (ed.), *On Puns* (Oxford: Basil Blackwell, 1988).

Cunard, Nancy, *Black Man and White Ladyship* (marked as privately printed and not for sale) (Nancy Cunard, December 1930).

Cunard, Nancy (ed.), *Negro: Anthology, 1931–33* (London: Nancy Cunard/Wishart, 1934).

Daix, Pierre, *La Vie quotidienne des surréalistes, 1917–1932* (Paris: Hachette, 1993).

Delaborde, Henri, *Ingres: sa vie, ses travaux, sa doctrine* (Paris: Plon, 1870).

Denis, Maurice, *Nouvelles théories sur l'art moderne sur l'art sacré* (Paris: Rouart et J. Watelin, 1922).

Derrida, Jacques, 'Freud and the Scene of Writing', *Writing and Difference* (London: Routledge and Kegan Paul, 1981).

— 'Signature Event Context', *Limited Inc*, trans. Samuel Weber and Jeffrey Mehlman (Evanston, IL: Northwestern University, 1988).

Dick, Leslie, 'The Skull of Charlotte Corday', in J. X. Berger and O. Richon (eds), *Other than Itself* (Manchester: Cornerhouse, 1989).

Doane, Mary Ann, *Femmes Fatales: Feminism, Film Theory, Psychoanalysis* (London: Routledge, 1991).

Dolar, Mladen, 'I Shall be with You on Your Wedding Night: Lacan and the Uncanny', *October*, no. 58, Fall 1991.

Dubruck, Alfred, *Gérard de Nerval and the German Heritage* (London: Mouton and Co., 1965).

Duncan, Alistair, *Art Deco* (London: Thames and Hudson, 1988).

Durkheim, Emile, *Suicide*, trans. John Spalding and George Simpson (London: Routledge and Kegan Paul, 1970).

Eco, Umberto, *Semiotics and the Philosophy of Language* (Basingstoke: Macmillan, 1988).

Ecotais, Emmanuelle de l' and Alain Sayag (eds), *Man Ray, la photographie à l'envers* (Paris: Centre Georges Pompidou/Seuil, 1998).

Einstein, Carl, *Negerplastik* (1915).

Ellenberger, Henri F., *The Discovery of the Unconcious* (New York: Basic Books, 1970).

Ernst, Max, *La Femme 1000 têtes* (Paris: Editions du Carrefour, 1929).

— *Max Ernst, Retrospektive*, Werner Spies (ed.) (Munich: Haus der Kunst, 1979).

— *Max Ernst*, Werner Spies (ed.) (London: Tate Gallery, 1991).

Esten, John, et al., *Man Ray in Fashion* (New York: International Center of Photography, 1990).

Fanon, Frantz, *Black Skins, White Masks*, trans. Charles Lam Markmann (London: Pluto, 1990).

Faubion, James (ed.), *Michel Foucault: Aesthetics; Essential Works of Foucault, Volume Two, 1954–1984* (London: Penguin, 2000).

Fauré, Michel, *Histoire du surréalisme sous l'Occupation* (Paris: La table ronde, 1982).

Fenichel, Otto, *The Collected Papers of Otto Fenichel*, Vols I and II, ed. and trans. Hanna Fenichel and David Rapaport (London: Routledge and Kegan Paul, 1954 and 1955).

Fer, Bryony, 'Surrealism, Myth and Psychoanalysis', in Bryony Fer, David Batchelor and Paul Wood (eds), *Realism, Rationalism, Surrealism* (London: Open University Press, 1993).

Flaouter, Le, *Comment j'ai tué Philippe Daudet* (Paris: Le Flaouter, 1925).

Flournoy, Theodore, *Des Indes à la Planète Mars* (Paris: Fischbacher, 1899).

Foresta, M. et al., *Perpetual Motif: The Art of Man Ray* (London: Abbeville Press, 1988).

Foster, Hal, *Compulsive Beauty* (London: MIT Press, 1993).

Foucault, Michel, *The Archaeology of Knowledge*, trans. Alan Sheridan Smith (London: Tavistock, 1985).

— *Madness and Civilization* (London: Tavistock, 1987).

Freud, Sigmund, 'L'inquiétanté étrangeté', *Essais de psychanalyse appliquée* (Paris: Gallimard, 1933).

— *Introductory Lectures on Psychoanalysis*, Vol. 1 (Harmondsworth: Penguin Freud Library, 1979).

— and Breuer, *Studies on Hysteria*, Vol. 3 (Harmondsworth: Penguin Freud Library, 1988).

— *Interpretation of Dreams*, Vol. 4 (Harmondsworth: Penguin Freud Library, 1980).

— *The Psychopathology of Everyday Life*, Vol. 5 (Harmondsworth: Penguin Freud Library, 1980).

— *Jokes and Their Relation to the Unconscious*, Vol. 6 (Harmondsworth: Penguin Freud Library, 1980).

— *On Sexuality*, Vol. 7 (Harmondsworth: Penguin Freud Library, 1979).

— *Case Histories* I, Vol. 8 (Harmondsworth: Penguin Freud Library, 1980).

— *On Psychopathology*, Vol. 10 (Harmondsworth: Penguin Freud Library, 1981).

— *On Metapsychology*, Vol. 11 (Harmondsworth: Penguin Freud Library, 1986).

— *Civilization, Society and Religion*, Vol. 12 (Harmondsworth: Penguin Freud Library, 1985).

— *Art and Literature*, Vol. 14 (Harmondsworth: Penguin Freud Library, 1986).

— *Historical and Expository Works on Psychoanalysis*, Vol. 15 (Harmondsworth: Penguin Freud Library, 1986).

— 'The Antithetical Meaning of Primal Words' (1910), *The Standard Edition of the Complete Psychological Works*, Vol. XI (London: Hogarth, 1986).

— 'The "Uncanny"' (1919), *The Standard Edition of the Complete Psychological Works*, Vol. XVII (London: Hogarth, 1955).

— 'A Case of Homosexuality in a Woman', *The Standard Edition*, Vol. XVIII (London: Hogarth, 1955).

Frobenius, Leo, *The Voice of Africa* (London: Hutchinson, 1913).

Frolich-Bume, L., *Ingres, His Life and Art*, trans. Maude Valérié White (London: Heinemann, 1926).

Fry, Roger, *Vision and Design* (London: Chatto and Windus, 1920).

Gascoyne, David, *A Short Survey of Surrealism* (London: Cobden-Sanderson, 1935; reprinted 2000).

— 'Introduction', in *The Magnetic Fields* (London: Atlas, 1985).

Gauthier, Xavière, *Surréalisme et sexualité* (Paris: Gallimard, 1971).

Gide, André, *Travels in the Congo* (London: Alfred A. Knopf, 1930).

Giradet, Raoul, *L'idée coloniale en France de 1871 à 1962* (Paris: La table ronde, 1972).

Goldwater, Robert, *Primitivism in Modern Art* (New York: Vintage, 1967).

Goll, Iwan, *Germaine Berton, die rote Jungfrau* (Berlin: Verlag die Schmiede, 1925).

Greenhalgh, Paul, *Ephemeral Vistas, the Expositions Universelles, 1951–1939* (Manchester: Manchester University Press, 1988).

Grimal, Henri, *Decolonization* (London: Routledge and Kegan Paul, 1978).

Grimes, Mary K. and Georgiann Gersell, *The Impact of Art Deco: 1925–1940* (Indianapolis, IN: Indianapolis Museum of Art, 1976).

Gronberg, Tag, 'Beware Beautiful Women: The 1920s Shopwindow Mannequin and a Physiognomy of Effacement', *Art History*, Vol. 20, no. 3, September 1997.

Gross, Babette, *Willi Münzenberg: A Political Biography*, trans. Marion Jackson (Michigan: Michigan University Press, 1974).

Grosz, Elizabeth, *Jacques Lacan* (London: Routledge, 1990).

Guerry, Vincent, *La Vie quotidienne dans une village baoulé* (Côte d'Ivoire: Inades, 1970).

Guillaume, Paul, *Sculptures nègres* (Paris: Paul Guillaume, 1917).

Guillaume, Paul, and Thomas Munro, *Primitive Negro Sculpture* (London: Jonathan Cape, 1926).

Guiol-Benassaya, Elyette, *La Presse face au surréalisme de 1925 à 1938* (Paris: Centre National de la Recherche Scientifique, 1982).

Guitton, Marcel and André Seguin, *Du Scandale au meutre; La mort de Philippe Daudet* (Paris: Cahiers de la Quinzaine, 1925).

Gwynn, Dennis, *The 'Action Française' Condemnation* (London: Burns, Oates and Washbourne, 1928).

Hall, Carolyn, *The Twenties in Vogue* (London: Octopus, 1983).

Hall, Stuart, 'The Problem of Ideology', in *Stuart Hall; Critical Dialogues in Cultural Studies*, David Morley and Kuan-Hsing Chen (eds) (London: Routledge, 1996).

Hall-Duncan, Nancy, *The History of Fashion Photography* (New York: Alpine Press, 1979).

Hammond, Paul and Patrick Hughes, *Upon the Pun* (London: W. H. Allen, 1978).

Haslam, Malcolm, *Art Deco* (London: Macdonald, 1987).

Haynes, Carlton J. H., *France, a Nation of Patriots* (New York: Columbia University Press, 1930).

Heath, Stephen, *Questions of Cinema* (Basingstoke: Macmillan, 1981).

Hesnard, Angelo L. M., *De Freud à Lacan* (Paris: Editions ESF, 1970).

Hillier, Bevis, *Art Deco of the 20s and 30s* (London: Studio Vista, 1968).

Hirst, Paul, *On Law and Ideology* (Basingstoke: Macmillan, 1979).

Hirst, Paul, and Penny Woolley, *Social Relations and Human Attributes* (London: Tavistock, 1982).

Hobsbawm, Eric, *The Age of Empire, 1875–1914* (London: Weidenfeld and Nicolson, 1987).

— *Age of Extremes: The Short Twentieth Century, 1914–1991* (London: Michael Joseph, 1994).

Hödeir, Catherine and Michel Pierre, *L'Exposition coloniale* (Brussels: Editions Complexe, 1991).

Holas, B., *Masques Ivoiriens* (Paris: Geuthner, 1973).

Hollander, Anne, 'Women in Fashion', in *Women, the Arts and the 1920s in Paris and New York*, Kenneth W. Wheeler and Virginia Lee Lussier (eds) (London: Transaction, 1982).

Hollier, Denis (ed.), *A History of French Literature* (London: Harvard University Press, 1989).

Holme, Brian et al., *The World in Vogue, 1893–1963* (London: Secker and Warburg, 1963).

Jackson, Rosemary, *Fantasy: The Literature of Subversion* (London: Methuen, 1980).

Jaguer, Eduard, *Les Mystères de la chambre noire* (Paris: Flammarion, 1982).

Janet, Pierre, *L'Automatisme Psychologique* (Paris: Alcan, 1889).

— *The Mental State of Hystericals* (London: Knickerbocker Press, 1901).

— *Principles of Psychotherapy* (London: George Allen and Unwin, 1925).

Janus (ed.), *Man Ray, the Photographic Image*, trans. Murtha Baca (London: Gordon Fraser, 1980).

Josephson, Matthew, *Life Among the Surrealists* (New York: Holt, Rinehart and Winston, 1962).

Kamitsis, Lydia and Florence Müller, *Les Chapeaux* (Paris: Syros-Alternatives, 1993).

Kiki (Alice Prin), *Kiki's Memoirs*, trans. Samuel Putnam (Paris: Edward Fitus and Black Manikin Press, 1930).

Koch, Stephen, *Double Lives* (London: HarperCollins, 1995).

Kofman, Sara, *Freud and Fiction* (London: Polity Press, 1991).

Krauss, Rosalind, 'The Photographic Conditions of Surrealism', *October*, no. 19, Winter 1981.

Krauss, Rosalind, Jane Livingston and Dawn Ades, *L'Amour Fou; Photography and Surrealism* (New York: Abbeville Press, 1985).

Kristeva, Julia, *Desire in Language*, trans. T. Gora, A. Jardine, L. S. Roudiez (Oxford: Basil Blackwell, 1980).

— *Revolution in Poetic Language*, trans. Margaret Waller (New York: Columbia University Press, 1984).

— *Tales of Love*, trans. Leon S. Roudiez (New York: Columbia University Press, 1987).

— *Black Sun: Depression and Melancholia* (Oxford: Columbia University Press, 1989).

Lacan, Jacques, *The Four Fundamentals of Psychoanalysis*, trans. Alan Sheridan (Harmondsworth: Penguin, 1979).

— *Ecrits, a Selection*, trans. Alan Sheridan (London: Tavistock, 1982).

— *The Ethics of Psychoanalysis, 1959–1960* (Book VII), trans. Dennis Porter (London: Tavistock/Routledge, 1992).

— *The Psychoses, Book III 1955–1956*, trans. Russell Grigg (London: Routledge, 1993).

Laclau, Ernesto, *New Reflections on the Revolution of Our Time* (London: Verso, 1990).

Laclau, Ernesto and Chantal Mouffe, *Hegemony and Socialist Strategy* (London: Verso, 1989).

Lapauze, Henry, *Les Dessins de J. A. D. Ingres du Musée de Montauban* (Paris: I. E. Bulloz, 1901).

— *Ingres, sa vie et son oeuvre* (Paris: Georges Petit, 1911).

— 'Les Faux Ingres', *La Renaissance de l'art française et des industries de luxe*, November 1918.

— (ed.), *La Renaissance de l'art française et des industries de luxe*, May 1921.

Laplanche, Jean, *Life and Death in Psychoanalysis* (London: Johns Hopkins University Press, 1985).

— *New Foundations for Psychoanalysis*, trans. David Macey (Oxford: Basil Blackwell, 1989).

— *Seduction, Translation, Drives* (London: Institute of Contemporary Arts, 1992).

— *The Unconcious and the Id*, trans. Luke Thurston and Lindsay Watson (London: Rebus Press, 1999).

261

— *Essays on Otherness* (London: Routledge, 1999).

Laplanche, Jean and Serge Leclaire, 'The Unconscious: A Psychoanalytic Study', *Yale French Studies*, no. 48, 1972.

Laplanche, Jean and J.-B. Pontalis, 'Fantasy and the Origins of Sexuality', in Victor Burgin, James Donald and Cora Kaplan (eds), *Formations of Fantasy* (London: Methuen, 1986.

Laplanche, Jean and Jean-Bertrand Pontalis, *The Language of Psycho-analysis*, trans. Donald Nicholson-Smith (London: Karnac Books, 1988).

Leborgne, P. J., *Enfin, la vérité sur les Colonies, en response au J. Litte*, 24 Vendemiare, l'an III (1794).

Lebovics, Herman, *True France, the Wars Over Cultural Identity, 1900–1945* (London: Cornell University Press, 1992).

Leeks, Wendy, 'Ingres Other-Wise', *Oxford Art Journal*, 9: 1, 1986.

— *The 'Family Romance' and Repeated Themes in the Work of J.-A.-D. Ingres*, Ph.D. thesis, University of Leeds, March 1990.

Leiris, Michel and Jacqueline Delange, *African Art*, trans. Michael Ross (London: Thames and Hudson, 1968).

Lemaire, Anika, *Jacques Lacan* (London: Routledge and Kegan Paul, 1982).

Lévi-Strauss, Claude, *Triste Tropiques*, trans. John and Doreen Weightman (Harmondsworth: Penguin, 1984).

— *Totemism*, trans. Rodney Needham (London: Merlin Press, 1991).

— *Structural Anthropology*, Vol. 1, trans. Claire Jacobson and Brooke Grundfest Schoepf (Harmondsworth: Penguin, 1993).

Lewis, Helena, *The Politics of Surrealism* (New York: Paragon, 1988).

Lewis, Matthew, *The Monk* (Oxford University Press, 1973).

Livingston, Jane, 'Photography and the Surrealist Text', in Dawn Ades, Rosalind Krauss, Jane Livingston (eds), *L'Amour Fou* (New York: Abbeville/Cross River Press, 1985).

McCabe, Colin (ed.), *The Talking Cure* (Basingstoke: Macmillan, 1981).

Macey, David, *Lacan in Contexts* (London: Verso, 1988).

Man Ray: Photographs, trans. Carolyn Breakspear (London: Thames and Hudson, 1981).

Marks, Elaine and Isabelle de Courtivron (eds), *New French Feminisms* (Brighton: Harvester Press, 1981).

Marseille, Jacques, *Empire coloniale et capitalisme français* (Paris: Editions Albin Michel, 1984).

— *L'Age d'Or de la France Coloniale* (Paris: Editions Albins Michel, 1986).

Marx, Karl, and Frederick Engels, *On Colonialism* (Moscow: Progress Press, 1968).

Massis, Henri, *Defence of the West*, trans. F. S. Flint (London: Faber and Gwyer, 1927).

Maurer, Evan, 'Dada and Surrealism', in *'Primitivism' in 20th Century Art* (New York: Museum of Modern Art, 1984).

Ménil, René (ed.), *Légitime Défense* (Paris: Editions Jean-Michel Place, 1979).

Metz, Christian, 'Photography and Fetish', *October*, no. 34, Fall 1985.

Michel, Jean-Claude, *Les Ecrivains noirs et le surréalisme* (Québec, Sherbrooke: Editions Naaman, 1982).

Mitchell, Juliet, *Psychoanalysis and Feminism* (Harmondsworth: Penguin, 1979).

Mitchell, Juliet and Jacqueline Rose (eds), *Feminine Sexuality*, trans. Jacqueline Rose (London: Macmillan, 1982).

Moholy, Lucia, *A Hundred Years of Photography* (Harmondsworth: Pelican, 1939).

Momméja, Jules, 'Le Bain Turc d'Ingres', *Gazette des Beaux Arts*, III, 1906.

Moneta, Jacob, *La Politique du parti communiste français dans la question coloniale 1920–1963* (Paris: François Maspero, 1971).

Moreau, Charles, *Authentic Art Deco Interiors* (Woodbridge, Suffolk: Antique Collectors Club, 1989).

Müller, Florence and Lydia Kamitsis, *Les Chapeaux; une Histoire de tête* (Paris: Syros-Alternatives, 1993).

Mulvey, Laura, *Fetishism and Curiosity* (London: British Film Institute, 1996).

Myers, F. W. H., *Human Personality and Its Survival of Bodily Death*, Vols 1 and 2 (London: Longmans, 1903).

Nadeau, Maurice, *The History of Surrealism*, trans. Richard Howard (London: Plantin, 1987).

— *Le rêve d'une ville, Nantes et le surréalisme*

(Nantes: Musée des Beaux Arts de Nantes, 1994).

Naeyer, Christine de, *Paul Nougé et la photographie* (Brussels: Didier Devillez, 1995).

Naville, Pierre, *La révolution et les intellectuels* (Paris: Gallimard, 1975).

Nerval, Gerard de, *Oeuvres Completes*, Vol. 3 (Paris: Gallimard, 1993).

Nochlin, Linda, *The Politics of Vision* (London: Thames and Hudson, 1991).

Nooter, Mary H., *Secrecy, African Art that Conceals and Reveals* (New York: Museum of Modern Art, 1993).

Nora, Pierre (ed.), *Lieux de Memoire*, Vol. 1 (Paris: Gallimard, 1984).

Palà, Sylvia et al., *Documents, Exposition Coloniale*, 1931 (Paris: Bibliothèque de la Ville de Paris, 1981).

Pastre, J. L. Gaston, *Bonaparte en Egypte* (Paris: Editions des portiques, 1932).

Paudrat, Jean, 'From Africa', in William Rubin (ed.), *'Primitivism' in 20th Century Art*, Vol. 1 (New York: Museum of Modern Art, 1985).

Pêcheux, Michel, *Language, Semantics and Ideology*, trans. Harbans Nagpal (Basingstoke: Macmillan, 1986).

Penrose, Roland, *Man Ray* (London: Thames and Hudson, 1989).

Perl, Jed, *Paris without End* (San Francisco: North Point Press, 1988).

Philippi, Simone (ed.), *Alfred Stieglitz, Camera Work, the Complete Illustrations, 1903–1917* (London: Taschen, 1997).

Phillips, Adam, *On Kissing, Tickling and Being Bored* (London: Faber and Faber, 1993).

Phillips, Christopher (ed.), *Photography in the Modern Era* (New York: Aperture, 1989).

Pierre, José (ed.), *Investigating Sex, Surrealist Discussions, 1928–1932*, trans. Malcolm Imrie (London: Verso, 1992).

Pliny, *Natural History: A Selection* (Harmondsworth: Penguin, 1991).

Polizzotti, Mark, *Revolution of the Mind: The Life of André Breton* (London: Bloomsbury, 1995).

Pollock, Griselda, *Avant-Garde Gambits, 1888–1893* (London: Thames and Hudson, 1992).

Praz, Mario, *Studies in Seventeenth-Century Imagery*, Vol. 1 (London: Warburg, 1939/1963).

— *The Romantic Agony*, trans. Angus Davidson (London: Fontana, 1966).

Privat, Maurice, *L'Enigme Philippe Daudet* (Paris-Neuilly: Les Documents Secrets, 1931).

Pujo, Maurice, *Les Camelots du Roi* (Paris: Flammarion, 1933).

Ray, Man, *Self Portrait* (London: André Deutsch, 1963).

Read, Herbert, *A Concise History of Modern Painting* (London: Thames and Hudson, 1991).

Richardson, Michael (ed.), *Refusal of the Shadow*, trans. Krzysztof Fijalkowski and Michael Richardson (London: Verso, 1996).

Rifkin, Adrian, *Street Noises* (Manchester: Manchester University Press, 1993).

Roche, Simone et al., *Willi Münzenberg, 1889–1940* (Aix-en-Provence: La bibliothèque méjanes l'institut de l'image, 1993).

Rose, Jacqueline, *Sexuality in the Field of Vision* (London: Verso, 1986).

Rose, Phyllis, *Jazz Cleopatra* (London: Vintage, 1991).

Rosemont, Franklin, *André Breton and the First Principles of Surrealism* (London: Pluto, 1978).

Rosemont, Penelope, *Surrealist Women: An International Anthology* (London: Athlone, 1998).

Roudinescou, Elisabeth, *Jacques Lacan and Co.: A History of Psychoanalysis in France 1925–1985*, trans. Jeffrey Mehlman (London: Free Association, 1990).

Sade, Marquis de, *The Marquis de Sade* Richard Seaver, and Austryn Wainhouse (eds) (New York: Grove Press, 1966).

Said, Edward, *Orientalism* (London: Routledge and Kegan Paul, 1978).

— 'Representing the Colonized: Anthropology's Interlocutors', *Critical Inquiry*, Vol. 15, no. 2, Winter 1989.

— *Culture and Imperialism* (London: Vintage, 1993).

Salter, W. H., *The Society for Psychical Research, an Outline of Its History* (London: Society for Psychical Research, 1948).

Saussure, Ferdinand de, *Course in General Linguistics* (London: Fontana, 1981).

Schwarz, Arturo, *Man Ray: The Rigour of Imagination* (London: Thames and Hudson, 1977).

Serge, Victor, *From Lenin to Stalin*, trans. Ralph Manheim (New York: Pioneer, 1937).

Sharpe, Ella F., *Dream Analysis* (London: Hogarth Press, 1937).

Shattuck, Roger, *Perpetual Motif: The Art of Man Ray* (London: Abbeville Press, 1988).

Sheringham, Michael (ed), *Parisian Fields* (London: Reaktion Books, 1996).

Silver, Kenneth, *Esprit de Corps, Art of the Parisian Avant-Garde and the First World War, 1914–1925* (Princeton, NJ: Princeton University Press, 1989).

Slavin, David H., 'French Cinema's Other First Wave: Political and Racial Economies of *Cinéma colonial*, 1918 to 1934', *Cinema Journal*, 37, 1 (1997).

Sontag, Susan, *On Photography* (Harmondsworth: Penguin, 1980).

Stein, Gertrude and Leon M. Solomons, *Motor Automatism* (New York: Phoenix Book Shop, 1969).

Suleiman, Susan, *Subversive Intent: Gender, Politics, and the Avant Garde* (London: Harvard University Press, 1990).

Suret-Canale, Jean, *French Colonialism in Tropical Africa, 1900–1945*, trans. Till Gottheiner (London: C. Hurst, 1971).

Sweeney, James Johnson, *African Negro Art* (New York: Museum of Modern Art, 1935).

Tannenbaum, Edward R., *The Action Française: Die-hard Reactionaries in Twentieth-Century France* (London: John Wiley, 1962).

Tashjian, Dickram, *A Boatload of Madmen* (London: Thames and Hudson, 1995).

Therenin, Paul (ed.), *Bureau de recherches surréaliste: cahier de la pérmanance* (octobre 1924–avril 1925) (Archives du surréalisme; 1) (Paris: Gallimard, 1988).

Todorov, Tzvetan, *The Fantastic* (Ithaca, NY: Cornell University Press, 1980).

— *Theories of the Symbol,* trans. Catherine Porter (Ithaca, NY: Cornell University Press, 1982).

— *On Human Diversity*, trans. Catherine Porter (London: Harvard University Press, 1994).

Venturi, Lienello, *Modern Painters* (London: Charles Scribner's Sons, 1947).

Weber, Eugen, *Action Française; Royalism and Reaction in Twentieth-Century France* (Stanford, CA: Stanford University Press, 1962).

Webster, Jean-Paul, 'Nerval et les mains pleines de feux', *La table ronde*, no. 135 (1959).

Weiskel, Timothy C., *French Colonial Rule and the Baule Peoples* (Oxford: Clarendon Press, 1980).

White, Palmer, *Elsa Schiaparelli, Empress of Paris Fashion* (London: Aurum Press, 1986).

Williams, Linda, *Figures of Desire* (Oxford: University of California Press, 1992).

Williams, Raymond, *Keywords* (London: Fontana, 1981).

Wiser, William, *The Crazy Years, Paris in the Twenties* (London: Thames and Hudson, 1983).

Wollen, Peter, 'Fire and Ice', in John X. Berger and Olivier Richon (eds), *Other than Itself* (Manchester: Cornerhouse, 1986).

— *Signs and Meanings in the Cinema* (London: Secker and Warburg, 1987).

— *Raiding the Icebox* (London: Verso, 1993).

Wollheim, Richard, *Painting as an Art* (London: Thames and Hudson, 1987).

Woolman, David, *Rebels in the Riff: Abd-el-Krim and the Riff Rebellion* (London: Oxford University Press, 1969).

Wyman, David S., *Paper Walls: America and the Refugee Crisis, 1938–1941* (Amhurst: University of Massachusetts Press, 1968).

Yahya, Mahmoud, *Neo-Colonialism – France's Legacy to Africa* (Kaduna: Emwai Centre for Political and Economic Research, 1994).

Young, Robert, *White Mythologies* (London: Routledge, 1990).

Periodicals

Art et Décoration, no. 54, July–December 1928

Arts et Métiers graphique, 1931

Bulletin Coloniale, Mars–Avril, 1931

Bulletin du Musée d'ethnographie du trocadero

Burlington Magazine, July 1921

Crapouillet, 1931

Le Disque Vert, no. 1, 1925

Documents (facsimile)

Gazette des Beaux Arts, III, 1906; 1930–31

L'Humanité, 1931

L'Illustration, 1931

Journal of the Warburg and Courtauld Institutes, Vol. 44, 1981

Légitime défense (facsimile) (Paris: Jean-Michel Place, 1979)

Littérature, nos 1–13, 1919–24 and facsimile reprint (Paris: Editions Jean-Michel Place, 1978)

Le Livre d'Art International, 15 November 1931

Minotaure, nos 1–13 (Paris: Albert Skira, 1933–39)

New Literary History, no. 7, Spring 1976

Nouvelle revue française, no. 172, Vol. 15, 1967

La Renaissance de l'Art Française et des Industries de luxe, November 1918, May 1921.

La Révolution surréaliste, nos 1–12, 1924–29 and facsimile reprint (Paris: Jean-Michel Place, 1975)

Le Surréalisme même, no. 2, Paris, Spring 1957

Le Surréalisme au service de la révolution, nos 1–6, 1930–33 and facsimile reprint (New York: Arno Press, 1978)

Variétés, Brussels, 1928–31

Vie ouvrieré, 1931

Vogue, 1924–26

Vu, 1930

Index